MAX BECKMANN
SELF-PORTRAIT IN WORDS

MAX BECKMANN

SELF-PORTRAIT IN WORDS

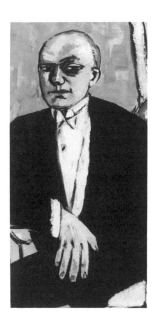

COLLECTED WRITINGS AND STATEMENTS, 1903 – 1950

Edited and annotated by BARBARA COPELAND BUENGER

With new translations by Barbara Copeland Buenger and Reinhold Heller and assistance from David Britt

THE UNIVERSITY OF CHICAGO PRESS
CHICAGO AND LONDON

BARBARA COPELAND BUENGER is associate professor and chair of the Department of Art History at the University of Wisconsin, Madison. She is currently completing a book on the first two decades of Beckmann's career in Berlin and Frankfurt. REINHOLD HELLER is professor of art and German at the University of Chicago. DAVID BRITT has translated numerous scholarly books.

The University of Chicago Press, Chicago 60637
The University of Chicago Press, Ltd., London
© 1997 by The University of Chicago
All rights reserved. Published 1997
Printed in the United States of America
06 05 04 03 02 01 00 99 98 97 1 2 3 4 5
ISBN: 0-226-04135-2 (cloth)
ISBN: 0-226-04136-0 (paper)

Library of Congress Cataloging-in-Publication Data

Beckmann, Max, 1884–1950.
 [Selections. English. 1997]
 Self-portrait in words : collected writings and statements, 1903–1950 /
 Max Beckmann : edited and annotated by Barbara Copeland Buenger :
 with new translations by Barbara Copeland Buenger and Reinhold Heller
 and assistance from David Britt.
 p. cm.
 Includes bibliographical references and index.
 ISBN 0-226-04135-2 (cloth).—ISBN 0-226-04136-0 (pbk.)
 1. Beckmann, Max, 1884–1950—Written works. I. Buenger,
 Barbara Copeland. II. Title.
 N6888.B4A2 1997
 760'.092—dc20 96-23422
 CIP

This book is printed on acid-free paper.

To my dear parents, Pat and Ted Buenger,
and to Becca, Laura, Amy, Akiva, Leslie, Peter,
Anna, and Erich

CONTENTS

Abbreviations

Works of art are referred to by their number in each catalogue raisonné of Max Beckmann, preceded by the first initial of the author's last name.

G. Erhard Göpel and Barbara Göpel. *Max Beckmann: Katalog der Gemälde.* 2 vols. Bern: Kornfeld and Cie, 1976.

H. James Hofmaier. *Max Beckmann: Catalogue Raisonné of His Prints.* 2 vols. Bern: Gallery Kornfeld, 1990.

W. Stephan von Wiese. *Max Beckmanns zeichnerisches Werk, 1903–1925.* Düsseldorf: Droste, 1978.

PLATES

Plates follow p. 168.

All works by Beckmann (nos. 4–12, 14–17) are copyright 1996 Artists Rights Society (ARS), New York/VG Bild-Kunst, Bonn.

1. Beckmann painting by the Baltic Sea, 1907. Photo: Max Beckmann Archiv.

2. The Beckmanns' home in Berlin-Hermsdorf, Ringstraße 8, 1968. Photo: Max Beckmann Archiv.

3. Beckmann in his studio in front of *The Sinking of the Titanic* (1912, G. 159), 1912/13. Photo: Max Beckmann Archiv.

4. *The Kaiserdamm in Berlin*, 1911, G. 142, Kunsthalle, Bremen, oil on canvas, 94 cm × 73 cm. Photo: Kunsthalle.

5. *Bearing of the Cross*, 1911, G. 139, private collection, oil on canvas, 175 cm × 174.5 cm. Photo: Max Beckmann Archiv.

6. *Mink, Frontal, with Elaborate Coiffure*, 1913, H. 63, drypoint, 17.2 cm × 13.8 cm. Photo: Max Beckmann Archiv.

7. *Self-Portrait Drawing*, May 10, 1915, W. 280, Staatsgalerie Stuttgart, Graphische Sammlung, Inv. No. C 68/1676, pen and ink, 31.7 cm × 24.3 cm. Photo: Staatsgalerie Stuttgart.

8. *Resurrection*, 1916–18, G. 190, Inv. No. 2673., oil on canvas, 345 cm × 497 cm. Photo: Staatsgalerie Stuttgart.

9. *Night*, 1918–19, G. 200, Kunstsammlung Nordrhein-Westfalen, Düsseldorf, oil on canvas, 133 cm ×

154 cm. Photo: Kunstsammlung Nordrhein-Westfalen.

10. Self-portrait on portfolio cover of *Hell,* 1919, H. 139/III, Kupferstichkabinett, Staatliche Museen zu Berlin, lithograph, 38.5 cm × 30.3 cm. Photo: Staatliche Museen zu Berlin.

11. *The Ideologues,* from *Hell,* 1919, H. 144, lithograph, 71.3 cm × 50.6 cm. Photo: Max Beckmann Archiv.

12. Illustration for *Ebbi,* 1924, H. 306/IIB, drypoint, 19.6 × 14.8 cm. Photo: Max Beckmann Archiv.

13. Max and Quappi Beckmann in St. Moritz, December 1928. Photo: Max Beckmann Archiv.

14. *Self-Portrait in Tuxedo,* 1927, G. 274, Harvard University, Busch-Reisinger Museum of German Culture No. BRM 1941.37 (1940), oil on canvas, 141 cm × 96 cm. Photo: Busch-Reisinger Museum, Harvard University Art Museums, Association Fund.

15. *Self-Portrait in Evening Dress,* 1937, G. 459, Art Institute No. 55.822 (1955), Chicago, oil on canvas, 192.5 cm × 89 cm. Photo: Art Institute.

16. *Temptation,* 1936–37, G. 439, Bayerische Staatsgemäldesammlungen, Staatsgalerie moderner Kunst, Munich, oil on canvas, triptych: central panel, 215.5 cm × 100 cm; side panels, 200 cm × 170 cm. Photo: Bayerische Staatsgemäldesammlungen.

17. *Portrait of Quappi in Gray,* 1948, G. 761, private collection, Germany, oil on canvas, 108.5 cm × 79 cm. Photo: Staatsgalerie Stuttgart.

18. Beckmann teaching at the Brooklyn Academy Museum School, 1950. Photo: Paul Weller.

PREFACE AND ACKNOWLEDGMENTS

MAX BECKMANN'S modernism is challenging and full of contradictions. Socially concerned and bent on making a new art that reached his contemporaries, Beckmann nonetheless felt distanced from both the aesthetics and the politics of the avant-garde. A proudly traditional figural painter absorbed with vigorous brushwork and handling, he found himself in an embattled position throughout his career: he came into controversy with abstract modernists such as Franz Marc and Wassily Kandinsky in the prewar period; he had no paintings acquired by Berlin's Nationalgalerie until 1927; and he received a less than hearty welcome at New York's Museum of Modern Art. Beckmann was never transcendentally abstract. He was intensely, sensuously, and often garishly realistic, and dealt obviously and deeply with content and meaning. Yet he was always profoundly engaged by art's abstracting powers, and he was unremitting in his insistence upon art's transcendence. (Readers of this volume would do well to keep by their side a well-illustrated volume of Beckmann's art—perhaps the English version of Carla Schulz-Hoffmann and Judith C. Weiss's catalogue for the Beckmann retrospective of 1984.)

Though Beckmann is unmistakably identified with the Wilhelmine, Weimar Republic, and Third Reich eras, and though he consistently emerges as a liberal, he rarely showed a tendency toward the left liberalism or activist political engagement that has long—and often erroneously—been identified with German modernism. By examining the stance of Beckmann and others who followed neither a straight line toward abstraction nor a resolute inclination toward the political left, we come to understand a great deal more about the richness, complexity, and contradictions of modernism itself. For this, Beckmann's writings are an excellent place to start.

Beckmann's symbol-laden works, extensive readings, and metaphysical involvements have long captivated art historians. As central as those concerns were to Beckmann himself, disproportionately more attention has been given to his philosophic and spiritual interests than to his fundamental and often pungent realism. The following texts and the impassioned and engaged tone in which so many are written help us rediscover a rounder Beckmann. Beckmann was a

thoughtful, sophisticated, and critical witness to his times; his own metaphysics notwithstanding, he never denied that he was both inescapably and receptively caught up in them.

Shortly after I began this project, Piper Verlag announced its definitive German edition of Beckmann's correspondence and asked me to exclude letters; I agreed, since the editors Klaus Gallwitz, Uwe Schneede, and Stephan von Wiese and their assistant Barbara Golz had immediate access to German archives and could cover far more ground than I alone. The final volume of the correspondence will appear after this book has gone to press; perhaps an edition in English will not be far behind.

Readers will also miss Beckmann's late diaries of 1940–1950. The German version of the diaries published in 1955 was substantially edited and abridged by Beckmann's second wife, Mathilde Q. Beckmann; since scholars should have access to the originals in the year 2000, it seems pointless to undertake a translation before those can be consulted. I thus also hope for a full English edition of the late diaries after that time.

I have included only the writings Beckmann conceived and wrote as statements or records. I have thus excluded more fragmentary passages such as the several short notes in his sketchbooks and the many spoken utterances recorded by his family and friends. I have also excluded Beckmann's notes in the books of his library, all of which have been published in an excellent German edition by the late Peter Beckmann and Joachim Schaffer. Although those notes would also be of interest to an English-speaking audience—and are often referred to in this volume—they are of little use divorced from the texts in which Beckmann wrote them.

Many of the following statements have been published several times in Germany. Most were collected in Rudolf Pillep's useful one-volume edition of Beckmann's writings and a few were previously annotated, notably in the fine publications of the early diaries by Doris Schmidt and Klaus Kinkel and in Uwe Schneede's and Stephan von Wiese's volumes of the letters. Though I have used those earlier annotations as a basis for my own, I felt compelled to undertake a more ambitious and systematic annotation for an English-speaking audience that might be unfamiliar with many of the names, places, and events to which Beckmann referred. My intent has been twofold: to place Beckmann and his writings within the various contexts in which he worked and to revive him as the worldly person he was.

Having spent many years preparing this volume in tandem with a monograph on Max Beckmann's early career, I owe warm thanks to many persons. My deepest gratitude goes to my collaborators. Reinhold Heller not only produced excellent translations of some of Beckmann's most importance pieces but helped keep this project on track. David Britt's superb revisions of the new translations—particularly of my own—helped bring out the vivacity of Beckmann's style and thoughts. I would also like to thank Robert L. Herbert, Victor H. Miesel, and Peter Wortsman and their publishers for permission to use their translations, works that first introduced me and many others to Beckmann. At the University of Chicago Press I am most grateful for the help of Paige Kennedy-Piehl, for the prodigious guidance of Leslie Keros, and for the continued encouragement and fortitude of Karen Wilson. I am also deeply indebted to Joann M. Hoy for her wonderfully astute and attentive editing and to Mitra Emad for the index. Finally, I owe thanks to Karl Werckmeister for convincing me of the importance of this undertaking and to Beth Lewis for suggesting several refinements.

I am grateful to my parents, to my sister Nancy Buenger, to my brother Dick Buenger, to my uncle Richard E. Buenger, and to my friend Annette Mahler for the several ways in which they helped me. For research assistance at the University of Wisconsin, Madison, I am indebted to many colleagues and to many students past and present: Robert C. Bless, Nicholas Cahill, Sarah E. Fancher, Kirsten Gilderhus, Niels Ingwersen, Thomas Jung, Alan Lareau, Judith G. Miller, Kim Nilsson, Andrew Reschovsky, Pamela Richardson, Eric Schatzberg, Willa E. Schmidt, Michael Shank, Marc Silberman, Ivan Soll, James Steakley, Steven Sundell, and Renata Wilk. I want to thank Qingling Wang for maps produced at the university's Cartographic Lab under a grant from the College of Letters and Sciences. I am also grateful for university research grants that have supported many of my searches.

Several persons provided me with archival materials and information about persons who came into contact with Beckmann in the United States, especially Will Barnet; Katherine B. Crum of the Mills College Art Gallery; David Foley of the Provincetown Art Association and Museum; Sonja M. Nielsen of Stephens College; Carole Prietto of Washington University; and Lori Sapanas of the Boone County Historical Society. My Ypres guide, Raoul Saesen, and the historian E. Van Hoonacker were of great assistance in decoding Beckmann's letters from Belgium. In Paris I was helped by

Margaret N. Frankston and several librarians at the Bibliothèque Nationale; in Berlin I was assisted by many different librarians at the Preussische Staatsbibliothek. Günther Rühle kindly provided me with a copy of one of Julius Meier-Graefe's plays.

I have long benefited from the warm support of a wide network of Beckmann family, friends, acquaintances, and scholars. The late Peter Beckmann, Maya Beckmann, and Mayen Beckmann have offered their kind help and encouragement for many years and have graciously granted the necessary permissions. Eugen Blume, Stephan Lackner, Christian Lenz, Uwe Schneede, Wolfgang Schocken, and Christiane Zeiler have been unstinting in their assistance. With her incomparable knowledge of Beckmann and the entire world in which he moved, Barbara Göpel has never ceased to become implicated in my work.

My final outpouring of thanks is reserved for my outstanding and indefatigable research assistant, Susan Laikin Funkenstein, without whom I could have never completed this project.

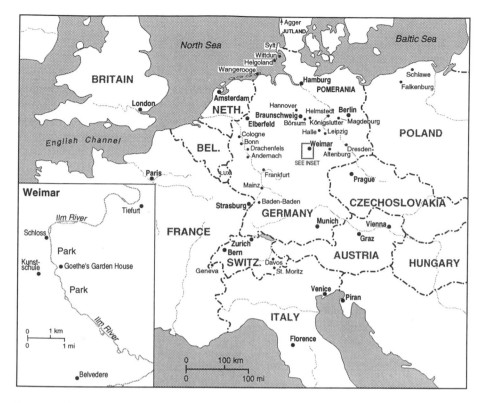

Europe and Weimar

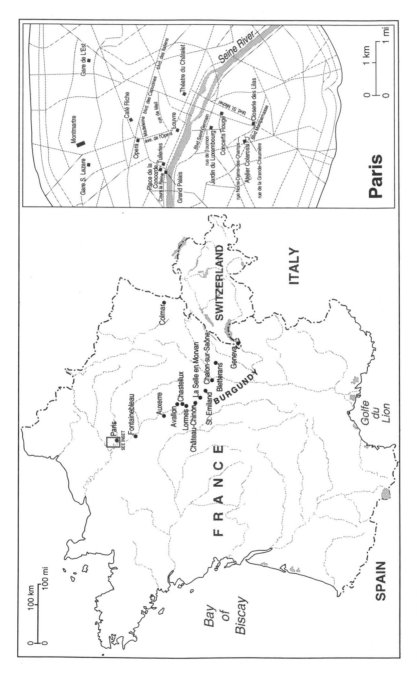

France and Paris

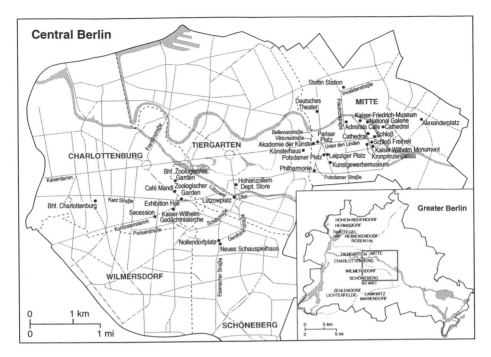

Greater Berlin and Central Berlin

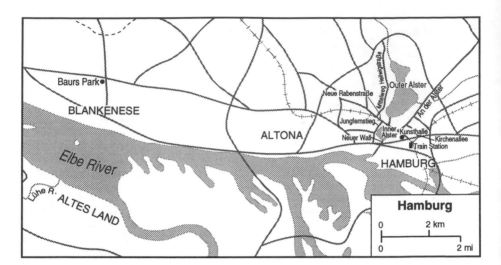

Hamburg

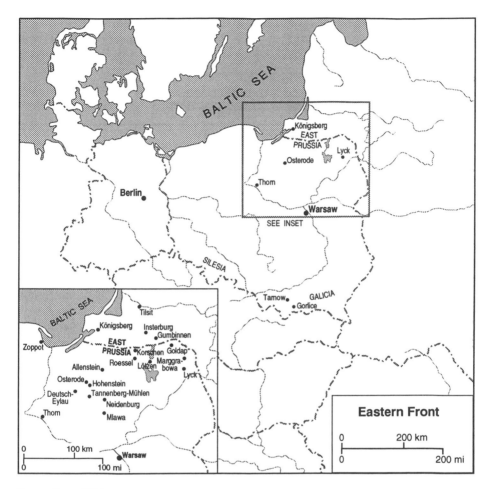

Eastern Front, 1914

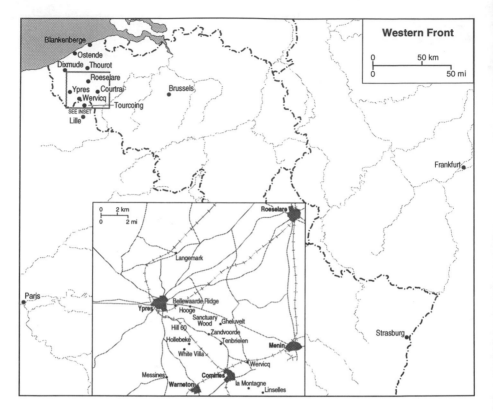

Western Front, 1915

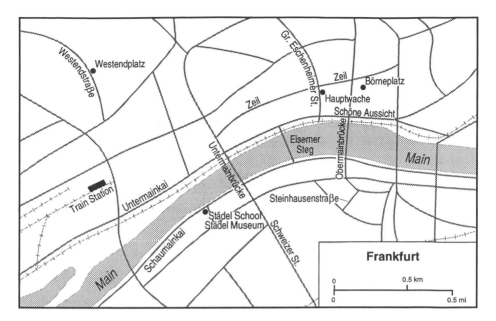

Frankfurt

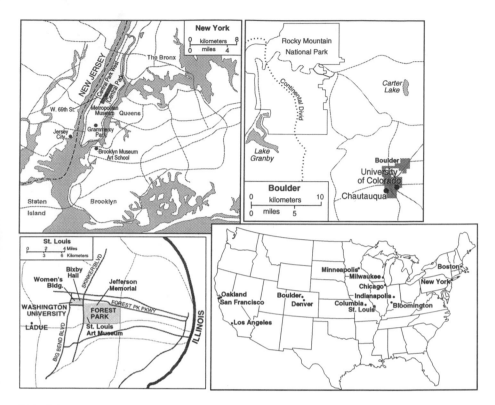

United States

INTRODUCTION

IN ENGLISH-speaking countries Max Beckmann first became known for the public statements of the last twelve years of his life: the celebrated "On My Painting" delivered at the *Exhibition of 20th Century German Art* in London in 1938, which was immediately translated into English and circulated in both England and the United States; and his speeches in the United States from 1947 to 1950, one of which, "Letters to a Woman Painter," was published in 1948. Only with Victor H. Miesel's 1970 translations of two of his earlier statements, the critical "Creative Credo" of 1918 and "The New Program" of 1914, and Peter Wortsman's 1989 translations of "The Social Stance of the Artist by the Black Tightrope Walker" and "The Artist in the State," has an English-speaking public become aware of the quite different and often problematic issues raised in Beckmann's earlier writings from both the Wilhelmine and Weimar Republic eras—those stimulating and challenging years in which both the artist and his art matured.

The sardonic "Social Stance of the Artist by the Black Tightrope Walker" was not published in Beckmann's lifetime, though he submitted it to the distinguished Viennese editor, Prince Karl Anton von Rohan, and seemingly wanted it published. The essay's mocking tone differentiates it from most of Beckmann's other public statements, which—though never devoid of personal inflections, irony, and humor—are generally more positive arguments about the aims of art and the need for human enrichment. The tougher, more critical side of Beckmann has always been known to us from his pictorial works, beginning chiefly in the Weimar Republic. It is also manifested in his three extant plays of the early 1920s, *Ebbi, The Hotel,* and *The Ladies' Man,* the first two of which are published here in English for the first time.

Given the predominance of images of actors and acting, circus and carnival entertainers, costuming, and rich symbolic attributes found throughout Beckmann's post–World War I oeuvre, and given Beckmann's own repeated comparison of his role to that of a tightrope walker, these earlier writings contribute immensely to our sense of him. To say that Beckmann was obsessed with the self, self-realization,

and self-revelation is no exaggeration: this is apparent not only in his extraordinary self-portraits but in virtually every work he did. At the same time, he repeatedly punctured his serious conception and posturing of himself as an artist. The self-consciousness with which he played the tightrope walker is especially clear in his writings.

The many frank passages of Beckmann's early diaries suggest that he saw those journals as purely personal; though he frequently re-read them and made a few minor additions, he never edited or refashioned them with an eye toward publication as, for instance, did Paul Klee. Similarly, the many clearly marked elisions of passages from Beckmann's diaries of 1940–50 suggest that his second wife, Mathilde Beckmann, found some of those comments too personal or unsuited for publication.

Beckmann never disguised his grand ambitions for himself or for his art. Knowing the German cult of artists and art-publishing business as he did—especially through his close alliances with the eminent Berlin art journal, *Kunst und Künstler*, and the Munich art publisher Reinhard Piper—he would always have been aware that almost anything he wrote might one day be scrutinized if not also published. This is perhaps why he wrote relatively few public state-ments and why he always evinced some awkwardness about express-ing himself in words. But this also seems to be why he took such care with the statements he did produce. His World War I letters are re-freshingly personal, for instance, but he would have known that he was writing potentially public statements soon after—if not already before—he began writing them. That is the reason those highly ed-ited letters, published soon after he wrote them, are included in this volume rather than in a separate volume of letters.

Beckmann liked to walk the line between public and private life. He wanted to put himself forth with his art, his statements, his ideas, and his passions, but he was equally given to retreats, taci-turnity, masks, and self-concealment. He was acutely aware of all the egoism, self-display, and desire for attention, recognition, and ap-proval that went with being an artist; and he knew that he always risked being taken for a charlatan, entertainer, or clown. Strongly stimulated by his early readings in Friedrich Wilhelm Nietzsche, he expressed a sharp sense of his own role-playing even as a young man.

In Germany Beckmann quickly became known for the several public statements he published before, during, and after World War I. In the following years he made a few more public statements, but largely stopped with the worsening of the German art situation in

the late 1920s. Beckmann ultimately left Germany after National Socialist art actions branded him and his art *entartet* (degenerate) in 1937. He wrote his last European statement—the 1938 "On My Painting"—in his Dutch exile.

In the post–World War II period Beckmann and other artists vilified by the Third Reich were not simply rehabilitated: they were given much greater attention than they had ever previously received. Beckmann's writings were published, republished, and extensively quoted. Under the lead of organizations such as the Max Beckmann Gesellschaft and museums enjoying the generous support of the German Federal Republic, Beckmann's works were widely exhibited. He and those known to have been related to or to have supported him were hailed as exemplars of a cultivated and critical Germany the National Socialists had never been able to crush.

The past twenty years, on the other hand, have seen the beginnings of a more scrupulous and questioning examination of Beckmann and the extensive Beckmann literature. A new wealth of material has arisen from a variety of sources: the excellent catalogues raisonnés of paintings, graphics, and drawings by Erhard and Barbara Göpel, James Hofmaier, and Stephan von Wiese; the fine editions of Beckmann's early diaries; and the increasing accessibility of the correspondence of both Beckmann, his family, and his friends. Together with his writings, these have provided us with a foundation on which a more rigorous historical assessment of Beckmann can now be built. Access to other sources of previously unavailable material has led to a fresh scrutiny of the data and of older methodologies that has already promoted new readings of both Beckmann and modern German art at large.

Though Beckmann is probably best known for his public statements, he was much more of a private than a public writer. The bulk of his writing is found in his diaries, correspondence, and marginalia in books and in sketchbooks rather than in his public statements and plays. Unlike many of his artist contemporaries, he wrote no criticism or promotional pieces, even though he always had to play a major role in the promotion of his art. He wrote only one of his formal statements—his 1912 reply to a statement by Franz Marc—solely on his own initiative. He began several of those statements with expressions of reluctance to speak at all, and he plainly felt that he could convey his passions and world view much better in art than in writing.

If Beckmann did not write regularly, he wrote engagingly and

produced an impressive written record. He left us an absorbing self-portrait in words. Like his pictorial works, Beckmann's written self-portrait was carefully constructed and could never be mistaken for unmediated reality. Yet, like his pictorial works, this portrait tells us a great deal about him and his world.

Beckmann initially wrote diaries only occasionally. After he began his career he quickly found he had little time for them and apparently became a consistent journal-writer only in the mid-1920s. Our record thus contains many gaps. Moreover, he apparently destroyed the diaries of 1925–40 when the Germans invaded the Netherlands in May 1940, and we do not yet have access to the final volume of his correspondence (1937–50) or to the originals of his late diaries.

Though the present volume contains only his earliest, pre–World War I diaries, those diaries, his World War I letters, his public statements, and his plays nonetheless provide us with an exceptionally rich human chronicle. They illuminate not just Beckmann but some of the most fascinating and challenging years of our century.

Beckmann hated school—he attended the practical *Realschule* rather than the humanistic *Gymnasium*—and left it at the age of fifteen. But he was always sensitive to the power of words, and he was attracted to both reading and writing. A fervent reader since youth, he worked hard to pass the German *Einjährig-Freiwilliger* exemption from military training given to students and artists, and he continued to read widely, eclectically, and autodidactically throughout his life. Writing was not only a means by which he "amused" himself and expressed his most immediate and urgent feelings; writing also permitted him to record and deal with his daily existence and to expound upon his larger views and plans. Those who have known only Beckmann's few public statements or the extended philosophical, theosophical, and literary musings frequently quoted from his late diaries will thus be grateful to see the many other sides of Beckmann revealed in this collection. He emerges as the modern, lively, humorous, stubborn, pessimistic, arrogant, selfish, and thoroughly human person we have long expected from his art.

The writings of the pre–World War I years record the history of an ambitious young artist on the make. He did not keep diaries continuously, but he wrote them at especially critical points in his career. Already in the late-adolescent expressions of his earliest diaries— begun at the age of nineteen just after he had finished his formal art training at the Großherzogliche Kunstschule in Weimar—Beckmann

began to present aesthetic and life orientations that would remain fairly consistent throughout his career. In those diaries, he fondly reviewed his youth and memories of his years at Weimar as he reflected on his future wife, Minna Tube, and their relationship. But he also recorded intimate observations of all sorts, his readings, his attempts to ground himself in metaphysics, and his philosophies of love and life. As "a well-brought-up German and the embodiment of so many expectations" he felt compelled to succeed both as an artist and as a person.

In January 1904 Beckmann noted that he had come to like "writing for its own sake." He regularly took refuge in his diary during his generally lonely stay abroad and lapsed into poetry, song, and quotations from his favorite writers or made impassioned comments about Tube, nature, and his moods. Throughout he presented himself as an incurable romantic and sensualist; he wrote almost nothing about his travels or study of art and almost everything about his passions.

The young Beckmann might not have been well educated, but he was well read and scrutinized many different authors' ideas. As might be expected of a German of his generation, he was intimate with the German classics Johann Wolfgang von Goethe and Friedrich Schiller—undoubtedly also influenced by his long residence in Weimar—and a passionate reader of the Romantics from the folk and fairy tales of Hans Christian Andersen, Ludwig Bechstein, and the Brothers Grimm to Heinrich Heine, E. T. A. Hoffmann, and Jean-Paul Richter. He was receptive to such sensuous moderns as Maurice Maeterlinck, Paul Verlaine, Wilhelm Bölsche, Richard Dehmel, Nietzsche, and the currently popular Scandinavian Jens Peter Jacobsen. As he prodded himself to read further in philosophy and to develop his own metaphysics of life and art he read in Immanuel Kant, Arthur Schopenhauer, and Schiller as well as in Nietzsche. He was also conversant with modern discussions of art. As an art student in Weimar he would have been exposed to modern German aesthetic philosophy from Johann Joachim Winckelmann to Conrad Fiedler and Hans Hildebrandt. As a young professional in Berlin, he continued to read theories and histories of art, especially in *Kunst und Künstler* and in volumes such as Julius Meier-Graefe's *Entwicklungsgeschichte der modernen Kunst* (History of modern art).

Oriented to modern art in Weimar, Paris, and Berlin in the early years of the century, Beckmann was well aware of the newest tendencies. In Weimar, influenced by that court city's desire to attain new

cultural heights as the center both of the Nietzsche cult and of the Jugendstil introduced by the Belgian Henry Van de Velde, Beckmann was initially attracted to several aspects of the Jugendstil. From the start, however, he was thoroughly grounded in modern realist, impressionist, and idealist traditions. He was exposed to many German and French impressionists and he initially found his way with such masters as Adolph von Menzel, Arnold Böcklin, Hans von Marées, Wilhelm Leibl, Max Liebermann, Wilhelm Trübner, Max Klinger, Dora Hitz, Lovis Corinth, Ludwig von Hofmann, Käthe Kollwitz, and Max Slevogt—art and artists with which he became more familiar after he moved to Berlin and became associated with the Berlin Secession. During his stay in Paris in 1903–4 and in the years following his move to Berlin he was responsive to many of the new artists. By his own account, he was immediately and overwhelmingly struck by Paul Cézanne already in 1903, and he was also attracted to Vincent van Gogh, Édouard Manet, Claude Monet, and James Abbott McNeill Whistler. He was especially taken by the Norwegian Edvard Munch and the Swiss Ferdinand Hodler, then the most consequential, internationally recognized modern artists working in German-speaking countries. He also attended the Paris Salon des Indépendants in 1904, where he would have seen works by the neo-impressionists and others who would subsequently become known as the fauves.

After his Paris sojourn Beckmann was impatient to return to Berlin to get to work and to start his new life, and he warmly appreciated that burgeoning new city and art center. Already on August 14, 1905, for instance, he wrote his friend Caesar Kunwald—who had since traveled to Paris himself—that Berlin had a much more vital artistic life than Paris.[1] Many years later, in his March 1923 letter to Reinhard Piper, Beckmann declared that his Berlin years constituted his "real" academy period.

In these first years Beckmann found the most inspiration in the older figures within the Berlin Secession, in the much older art in the museums, and in the work of his own German and Berlin contemporaries. Though he continued to look at a wide variety of art of all kinds and periods—a practice followed by few of his expressionist contemporaries—by his diary of 1908–9 Beckmann indicated he strongly disapproved of the radical simplification and naiveté of Henri Matisse and the spreading, abstracting modernism of many of his own contemporaries. He thought Matisse and his "herd" of followers had taken the wrong conclusions from van Gogh and Paul

Gauguin and had failed to achieve the sensuality, spatial depth, and serious meaning that Beckmann himself demanded of both traditional and modern art. As Matisse, the fauves, Pablo Picasso, and the expressionists became prominent on both the German and the international art scenes Beckmann increasingly criticized them. Simultaneously, however, he also began to express his differences from some of those older German masters who had initially inspired him. He dug into his position that art should show only the palpable reality of nature and modern life, and he found many in liberal Berlin art circles who shared his views. Indeed, Beckmann was one of the most celebrated young German artists in prewar Berlin. At the same time, many critics—including some of his strongest supporters—began to question why he continued to work with such increasingly outdated means.

In his first public statements of 1911–14 Beckmann gave further shape to the philosophies of art and representation that he had begun to express in his diaries. He continued to voice his preference for what he called the "Sachlich" or "objective," sensuously tangible qualities of realism, fine handling, and deep space, and he continued to align himself with the German realist tradition. Since the new and abstracting forms of painting were accompanied by much writing and theoretical justification, he joined many in criticizing the "new art" because it seemed so reliant on theory. He decried this art as decorative, unformed, and unfinished. To him it lacked the vitality of an art or painting that manifested an "individual, organic, entire world of its own."

As much as Beckmann decried the theoretical or programmatic aspects of the new art, he regularly articulated his own aims, which had much in common with his contemporaries'. He repeatedly voiced his desire to capture the raw vitality of life, the "terrible, crude, magnificent, ordinary, grotesque, and banal." From the intense realism of contemporary landscapes such as *Kaiserdamm* (1911, G. 142) to his intensely realistic baroque figural conceptions such as *Bearing of the Cross* (1911, G. 139), he demonstrated his desire both to be realist and to convey compelling modern content.

The young Beckmann presented views that would make us describe him as generally liberal. Like the vast majority of his contemporaries, he felt largely alienated from the world of politics, but he was continually confronted by political reality. He repeatedly sought to express what he saw as the contemporary cultural crisis in such ambitious figural works as *Scene from the Destruction of Messina*

(1909, G. 106), *Battle of the Amazons* (1911, G. 146), and *The Sinking of the Titanic* (1912, G. 159). His few diary comments about his discussions of the socialist ideas of his neighbor, the anarcho-socialist Gustav Landauer, or his discussions with his brother-in-law Martin Tube about the threat of world war in 1909 also indicate that he directed an interested eye toward the news and the world at large. He shared his generation's criticism of Wilhelmine smugness, pomp, and tastelessness, and he considered many criticisms of and alternatives to that order. Already in his March 1909 discussion with Martin Tube, for instance, both agreed that war might be a good thing to bind the "fragmented" modern Germany in a common cause.

Beckmann and his wife and son were vacationing in Zoppot, near Danzig, when World War I was declared; they immediately returned to Berlin, where Beckmann quickly supplied *Kunst und Künstler* with drawings that illustrated reactions to the first week of war in that city. Shortly afterward Beckmann traveled to East Prussia, was quickly impressed into the medical service, and remained there for slightly more than two months. After formal training as a medical orderly in Berlin in November and December, he resumed service in Belgium during the first eight months of 1915.

Kunst und Künstler's editor, Karl Scheffler, apparently asked Beckmann-Tube if she would submit some of Beckmann's letters from the front for publication, and both she and Beckmann agreed to this. Beckmann was interested and eager both to have and to report his war experiences. He warmly supported the German war effort and used the hiatus of his months on the front to observe and reflect on the "life-and-death drama," to serve his country, to sketch, and to plan his next paintings. Precisely because he was torn away from his usual milieu and pursuits and thrown upon some of life's worst realities, he also turned to more expansive reflections on life, death, and art.

During the Second Battle of Ypres (April 22–May 25, 1915), after he had finally fulfilled his desire to experience fighting directly on the front and was finally and thoroughly shocked, Beckmann declared that he had at last had enough. Nevertheless, he continued to support the war and found his experiences of immense importance to him and his art. By May 11, 1915, he declared not only that it was good to have the war but that he considered all of his previous work as no more than an apprenticeship.

By the end of the summer of 1915 Beckmann had gone to the Fifteenth Corps' headquarters in Strasburg on medical leave; by October a doctor he had known in Belgium arranged for his transfer to Frankfurt. Beckmann thereupon made Frankfurt his home (he would stay there until 1933) and continued to work as a medical orderly through November 1917.

In the winter of 1915 Minna Beckmann-Tube had inaugurated her career as an opera singer in Elberfeld. Beckmann visited her and their son and families in Berlin at the end of September, 1915, and many times subsequently, but they otherwise lived separately until they divorced in 1925. In an elided passage of her published memoirs Beckmann-Tube mentioned that when Beckmann returned from East Prussia she had discovered that other women were "after" him. Beckmann seems to have opposed her undertaking a career because he wanted her to devote all her energies to him; he also seems to have had little patience for raising a family. In any case, both desired careers and independent lifestyles, and they remained on amicable terms after their separation.[2]

In 1919 Beckmann wrote retrospectively of his relocation in Frankfurt to the Berlin critic Julius Meier-Graefe. He said that he was grateful that the war had forced him from a milieu that had begun to be dangerous for him and that in Frankfurt he hoped to realize the works he had previously only imagined.[3] Though Beckmann had flourished in prewar Berlin, he had also met mounting criticism with the arrival of the new art. He seemed to have felt he would do better as one of the few major artists in Frankfurt—a city that was not an art center—until he could finally take Berlin, which always remained his goal. In fact, the tumultuous changes of the war and postwar period dramatically changed Berlin's character as a city and art center. Beckmann was correct in supposing that he could build a stronger base for himself from outside.

With great deliberation—he produced only ten paintings from 1915 to 1918—Beckmann adopted a more critical, distorting mode of realism, in no small part influenced by the look of some of the new art as well as by his reexamination of much older German traditions. In his new paintings, such as the unfinished *Resurrection* (1916, G. 190), he introduced the drastically reduced palette, contours, and flattened spaces; the more mannered, anti-classical figural rhetoric; and the more hermetic, often wrenchingly ironic content—including highly skeptical renderings of religious subjects—that became characteristic of his new, more caustic wartime and postwar styles.

Beckmann's personal and professional life also changed mark-
edly. He seemed to enjoy his newly bohemian, bachelor's existence.
He also quickly found support and interest from some of Frankfurt's
leading promoters of the arts, especially in the circle of the distin-
guished editor of the *Frankfurter Zeitung*, Heinrich Simon, which
included the expressionist writer and apologist, Kasimir Edschmid,
and the renowned art historian and director of the Städelsches
Kunstinstitut, Georg Swarzenski. Beckmann regularly attended Si-
mon's celebrated Friday luncheons for figures in the arts and letters:
at least one contemporary noted that he stood out as discrepantly
refreshing, unorthodox, and rough-cut among the established
professionals of Simon's relatively conservative liberal milieu.[4]

During the war and immediate postwar years, when the market
was generally much better for prints than for paintings, Beckmann
worked more extensively at graphics than at any other time of his
career. His terse statement for a first major show of his new graphic
work at I. B. Neumann's Berlin gallery in November 1917 was no
shorter than that he had written for his last prewar exhibition at the
Hamburg Kunstverein in 1914, but it reflected something of the
newly enigmatic pose he now took in his life, art, and statements.
Here he cryptically cited the older northern artists van Gogh, Pieter
Bruegel, Matthias Grünewald, and Gabriel Mäleßkircher as admired
masters of a "masculine mysticism," fellow realists who nonetheless
conveyed a metaphysical "inner vision."

After he returned to the home front Beckmann would have
been exposed to the rapidly spreading public opposition to the war;
Kasimir Edschmid, a regular correspondent with many of Germany's
leading writers at home and in exile, would also have drawn his at-
tention to the anti-war stances of many artists and intellectuals. The
resilient and sharp tone of Beckmann's last wartime statement, the
"Creative Credo" written for Edschmid's anthology of that title in
September 1918, reflects his increasingly critical view of the war. Fed
up with the war and with the materialism that had led up to it, Beck-
mann expressed impatience with both sentimentality and religion
and voiced his desire for an art that directly addressed humanity. At
the end he even mused skeptically on a world view changed by the
"communistic principle."

Several of his writings from the first years of the Weimar Re-
public gave full expression to Beckmann's newly caustic, carnival-
esque humor. In the four statements that join works of art or stand

as works of art in themselves—the introduction to the *Hell* portfolio and the plays *Ebbi*, *The Hotel*, and the still-unpublished *The Ladies' Man*—Beckmann engaged in larger, highly personal statements about the chaotic postwar period of revolution and hyperinflation and about the crass world of modern experience at large.

In all Beckmann adopted theatrical forms, in no small part influenced by his increased experience of the modern theater in Frankfurt, then one of Germany's leading centers of expressionist and modern drama at large. But he was also stimulated by the more popular theatrical traditions of the *Jahrmarkt* (annual fair), variety shows, and cabaret known to him in both Frankfurt and Berlin. The ten plates of the *Hell* portfolio were presented as the grisly songs, or *Moritäten* (literally, songs of death deeds), sung by a bench-singer (*Bänkelsänger*) at an annual fair. Beckmann's Wedekindesque introduction below his self-portrait as a dazed clown or barker taunted the viewer to join in a walk through postwar Germany. The following prints presented a jumbled, angry, and ironic commentary on Germany in the troubled revolutionary year of 1918–19.

In the fifth print of the series, *The Ideologues* (1919, H. 144), Beckmann made a complicated and extensive comment about his own continued attraction and ambivalence toward politics by posing himself—bored, exhausted, or sickened—among several politicized intellectuals of the day, including Carl Einstein, Max Herrmann-Neisse, Annette Kolb, Heinrich Mann, Carl Sternheim, and his good friend, the Countess vom Hagen.[5] His rendering suggests he was critical, though not necessarily damning, of the "ideologues." He seemed to caricature their many statements about the need for a spiritual aristocracy to lead the new epoch: by surrounding them with scenes of violence and unrest they would be unlikely to stem and by showing them exhausted, he suggested that they, too, had reached an impasse. Nevertheless, Beckmann showed that all of them had arrived in a world in which politics had become impossible to ignore.

The profane and worldly images, grotesquerie, and earthy realism of Beckmann's plays present a further amplification of his distorting realism and of what would subsequently be seen as his *Neue Sachlichkeit*, or "new objectivity." His irony and humor, his use of dialect, and his many references to contemporary cabaret or popular hit songs or fads suggest that he was intrigued by popular culture. He used grossly materialistic characters generally representative of the 1920s to express and criticize philosophies of art, artists, life, and

the striving for both success and self-discovery. The plays are not simply autobiographical, but we sense many relations of his characters to himself and his circles and to types depicted in his contemporary prints and paintings. In the plays, just as in his contemporary pictorial works, Beckmann deliberately investigated humor as a vehicle for serious, and often dark and tragic, meanings.

As Germany moved into a genuinely more relaxed situation after economic stabilization in 1924, both Beckmann's professional and personal lives changed considerably. He moved more frequently in circles of high society in Frankfurt, Vienna, and Munich, meeting several individuals who would be important sources of support, including Irma Simon, an Austrian aristocrat who was married to Heinrich Simon, and the German aristocrat Lilly Mallinckrodt von Schnitzler, who was married to an executive of Frankfurt's I. G. Farben. These connections were also strengthened by his 1925 marriage to the Munich aristocrat, Mathilde von Kaulbach, and by his appointment as a master-teacher in the newly organized Frankfurt Art Schools the same year.

After their marriage the Beckmanns regularly wintered in Paris from 1925 through 1932. These winters were of enormous consequence for both Beckmann's art and his international reputation. He examined more closely the works of Georges Braque, Matisse, Picasso, and other French masters; though most had adopted more realistic styles and were probably more accessible to Beckmann than ever before, he assimilated many different, nonrealistic aspects of their colors, flattened forms and spaces, and imagery as well. During this period he began to develop the painterly, resonantly colored, symbolically layered style for which he is probably best known.

With the exception of "The Social Stance of the Artist by the Black Tightrope Walker" (1927), all of Beckmann's statements from the second period of the Weimar Republic (1924–29) are more formal, serious, and ambitiously metaphysical than his writings of the early 1920s. In all except his 1928 Mannheim statement he again broached the subjects of the artist's position in society and relation to politics. In the heady but unsteady new democracy of the much-maligned Weimar Republic and in the circles of Heinrich Simon, the *Frankfurter Zeitung,* and high society, Beckmann was much more exposed to the worlds of politics and affairs than ever before.

In October 1926, Beckmann joined a German delegation to attend a large international meeting of artists and intellectuals in

Vienna, the third annual meeting of the *Verband für kulturelle Zusammenarbeit* (League for cultural cooperation) organized by Prince von Rohan and by their mutual friend, Lilly von Schnitzler. Although Rohan was a pro-fascist, right-wing conservative (he would later become a National Socialist), the German delegation reflected the broad spectrum of views Rohan welcomed into both his journal and the Vienna meeting. The conference focused on issues of European unity, questions that concerned many groups in the aftermath of Germany's recent admission to the League of Nations and amid the hopes of building a new Europe.

Beckmann spoke little about the meeting in his letters and, when he did, referred to it only as "a sort of farce." The two statements he subsequently wrote for Rohan, "The Social Stance of the Artist by the Black Tightrope Walker" and "The Artist in the State," say nothing about European unity, but they do focus on issues of the social and political position of the artist that were raised at the conference and throughout the Weimar era.

In "The Social Stance of the Artist by the Black Tightrope Walker" Beckmann acted a role similar to those found in his plays and his early 1920s art, in which he often showed himself as a costumed entertainer, acrobat, or tightrope walker. In this he seemed to bluff, play, and walk the tightrope with Rohan, a powerful potential sponsor. Like the figures of Zwerch and Ebbi in his plays, Beckmann was provocative and dealt with issues that concerned him as both a man and an artist: the artist's lack of a seriously respected social position; the artist's necessary subservience to the forces of the market, power, and high society; and society's expectation of the artist to be obedient and to be ignorant of religion, politics, or life. Beckmann acted or played as if he thought the public wanted its artists to be only entertainers, not persons with individuality or decided views.

In "The Artist in the State"—the statement that Rohan finally published—Beckmann spoke more seriously and a bit more pompously. As has often been noted, the essay seems directly related to his celebrated *Self-Portrait in Tuxedo* (1927, G. 274), and both might also be related to his participation in the ceremony of Rohan's Vienna conference. In this essay Beckmann discussed what role a spiritual aristocracy or elite—what he now called an "aristocratic bolshevism"— might play in leading the state. He speculated grandly on the artist's high role as the formulator of a new metaphysics.

His reply to the *Frankfurter Zeitung*'s Christmas 1928 ques-

tionnaire also brought him back to the subject of politics. In this he disdained that politics could ever have anything to do with his metaphysical concerns, but he also squarely stated that he felt "displaced" in politics. In "The Artist in the State," buoyed by the Weimar Republic and Rohan's conference, Beckmann seemed to believe that the artist might have an impact in the state. By 1928, more confused or more cognizant, he had more doubts.

Most of the documentation for Beckmann from the late 1920s through his emigration in 1937 is found in his correspondence. He continued to enjoy new successes both before and after the onset of the depression in 1929: in 1926 I. B. Neumann mounted Beckmann's first one-man show in New York; in 1929 Beckmann won a fourth honorable mention in the Carnegie International; throughout the late 1920s he showed his work in several international exhibitions; and in 1927 the Berlin Nationalgalerie began to acquire and exhibit his paintings. Lilly von Schnitzler, Rohan, and an eminent group of French and German organizers supported Beckmann's Paris exhibition at the Galerie de la Renaissance in March 1931; the show opened amid rapidly growing international distrust of Germany and the National Socialists, however, and was accompanied by tensions both at home and abroad.

In Germany, Beckmann, the Frankfurt schools, and much modern art came under increasing attack from right-wing and Nazi forces; by April 1933, Beckmann, the schools' director, and most of the other professors had been fired. The Beckmanns took an apartment near the diplomatic section of Berlin's elegant Tiergarten district, correctly assuming that they would be less disturbed by the Nazis in Berlin. By the time of his fiftieth birthday in February 1934, Beckmann wrote his Munich dealer Günther Franke that he did not want anyone to attempt to celebrate his birthday, that he had decided not to exhibit for the time being, but also that he had good reason to hope that conditions might change within a year.[6]

Beckmann spoke with several friends and acquaintances as he considered the options of remaining in Germany or emigrating. He knew many who had fled Germany and many who stayed: some continued to live and work with the new regime and joined the National Socialist party; others distanced themselves from the Nazis but thought that the latter posed no real threat; still others thought that the Nazis would come around to support modern art. His circumspect correspondence of the mid- and late 1930s contains many ironic, pessimistic, and critical comments on the state of things in

Nazi Germany. Nevertheless, he remained reluctant to leave his home; he felt that the major audience for his works would be there and, apparently, that he could make things work out well for himself.

By December 1936, the new director of the Nationalgalerie, Eberhard Hanfstaengl, learned of the severity of the forthcoming actions against the *Entartete Kunst* (degenerate art), including the final closing of that museum, and encouraged Beckmann to leave Germany.[7] When Beckmann painted his *Self-Portrait in Evening Dress* (1937, G. 459), he must have known that he would soon leave Germany. He no longer showed himself in the self-confident pose of his 1927 *Self-Portrait in Tuxedo*. Indeed, in the latter portrait, the squat figure in black-and-white in the right background—ominously approached by wide-stepping figures in elegant black suits—is almost a double, an impish, annoying, garish echo of Beckmann in his 1927 self-portrait. In the 1937 portrait his face is as white as a clown's; his hands are enormously elongated and almost useless; and he stands without support. Coupled with his prodding double, he has become a fool.

Mathilde Beckmann's sister Hedda von Kaulbach had lived in the Netherlands since the 1920s, and the Beckmanns seemed to have planned an eventual exile in Holland for some time. They made a short summer visit there in 1936 and acted as if they were taking another short summer visit when they finally departed Germany for good on July 19, 1937, the day after the *Entartete Kunst* show opened in Munich. They settled in Amsterdam, but Beckmann also made a short visit to Paris in the late summer. He had established many ties there in the mid-1920s and early 1930s, and dealers and friends there and in Switzerland continued to promote his art on the continent. Curt Valentin joined I. B. Neumann to further Beckmann's reputation in the United States, and they also began to discuss emigration abroad.

The Beckmanns lived in Amsterdam during the winter and summer of 1937–38 and tried unsuccessfully to get visas to travel to the United States in both 1938 and 1940. They moved to Paris for the winter of 1938–39, obtained visitors' permits to stay there permanently, and would have moved there had they not been caught in the Netherlands by the outbreak of the war in September 1939. In Amsterdam, several supporters helped them. After the German occupation of the Netherlands in 1940 and through the first part of 1944 German friends and dealers brought Beckmann's works back for sale in Germany; others assisted in even more crucial ways.

During the winter and spring of 1938 Beckmann wrote "On My Painting." He delivered this, his last public statement before World War II and the first he ever read in public, at the *Exhibition of 20th Century German Art* in the New Burlington Galleries in London on July 21, 1938. In seemingly direct response to the concerns of the show's organizers about antagonizing their audiences and Germany, and perhaps also in response to Hitler's attack on the exhibition on June 11, 1938, Beckmann immediately stressed that he had never been political in any way. He pictured himself as a hermit, as if he were St. Anthony in his great triptych *Temptation* (1936, G. 439)—his major contribution to the London exhibition—and said he had suddenly awakened to find himself "in the midst of world turmoil."

Beckmann was clearly aware both of the state of the world and of the political implications of what he was doing. He said it was precisely the problems of the day that compelled him to speak in public, and he noted that it was a luxury to be able to make art and express one's own opinion. In Paris, however, he distanced himself from groups of anti-fascist émigrés who asked him to join them. He did not like what the Nazis were doing, but he did not feel that he should use his art to take a stance and he was unwilling to take more of a stance than he had already done by leaving Germany. He was highly critical of politicized artists whom he thought made merely tendentious or journalistic art, and he did not make strong protests himself. He somehow continued to believe he could remain above the fray and tried to lose himself in intense work and readings.

Beckmann's four American statements echo many of his older ideas. At the same time, they show a new animation and urgency, perhaps because they were directed toward new audiences to whom he was extremely grateful, including students with whom he had considerable interaction.

We will discover a new self-portrait with our eventual access to the late correspondence and unedited late diaries. The London talk, the edited diaries, and the Beckmann literature are frequently silent on what went on in Beckmann's life, particularly about how he reacted to the people and events of his exile, World War II, and American periods. Some of that silence will probably be lifted with that new information.

As the new documentation published in this and other volumes vividly demonstrates, this new self-portrait will be both more real and more challenging. Beckmann was not always, as he himself noted

in 1924, a "very nice man." He could well emerge less attractive, less liberal, and more politically compromised than we might want, but he will still be the complicated, gifted, and engrossing Beckmann we have always known. Beckmann's writings are as complex, contradictory, and intriguing as the man and the art. He can be humorous, engaging, but extremely repetitive; he can be pompous, condescending, and unnecessarily mystifying; and he can be arresting and amazingly compelling.

It is difficult to come to terms with an artist's simultaneous enthusiasm for Cézanne, Manet, Monet, Whistler *and* Böcklin, or championing of Hans Baluschek over Matisse. It is hard to grapple with a Weimar-period artist who manifested the critical sensibilities but not the critique of a Carl Sternheim, George Grosz, or Bertolt Brecht; or with a worldly vitalist who delved into Eastern religions, Schopenhauer, Madame Blavatsky's theosophy, and meditations on the world's origins as Hitler plunged the world into darkness. Beckmann was sometimes clear, sometimes obscure, as he articulated his concerns and observations, and he was far from alone in his stances. He is coming into better focus, and he will only continue to grow as we learn more both about him and his age.

1

Diary, August 14–September 20, 1903
(Braunschweig, Leipzig, Braunschweig, Paris)

BECKMANN wrote this first extant diary
mostly in pencil in a small notebook measuring 10.2 cm ×
15.6 cm and drew three sketches in the volume.[1] He scratched
out numerous passages and removed several pages both as he
wrote and later. Then and throughout his life he frequently re-
read his diaries—often aloud to Minna Beckmann-Tube—and
on a few occasions added short annotations. At some later point,
for instance, he signed the diary "Beckmann 1903."

The nineteen-year-old Beckmann began to write this ac-
count of his life during the summer of 1903, five weeks before
he went to live and study on his own in Paris. He wrote most of
the diary in Braunschweig, a city in the state of Lower Saxony
from which his family had originally come, and to which his
immediate family had returned just before his father's death in
1895.[2] When he began this journal, Beckmann had just com-
pleted three years of study at the Großherzogliche Kunstschule
(Grand ducal school of art) in Weimar.[3] The preceding year he
had met and fallen passionately in love with Minna Tube (1881–
1964) from Altenburg, one of the first women admitted to the
school in 1902.[4] Max and Minna had hoped to meet in Paris, but
since her mother would not permit this, Minna went instead to
Amsterdam. The two had apparently tried to break off their re-
lationship, but Max repeatedly returned to thinking of Minna,
especially after their short tryst in Leipzig just prior to his de-
parture for Paris.

The diary reads both like an extended conversation with
himself and a love letter to Minna Tube. Beckmann noted that
he sent the journal to her after he finished it and often wrote as
if trying to reach and impress her. He was quite frank in his
expressions of his feelings, sexual needs, and understanding of

their relationship. Throughout the diary he was trying to come to terms with himself and Tube, with his feelings of nostalgia and love for their time together in Weimar, with his philosophy of life and art, and with his strong yearnings for both independence and a sexual relationship.

In this journal Beckmann recorded his purchases of many books—mostly inexpensive volumes in popular editions such as those published by the Reclam and Hendel publishing companies[5]—that he was having bound and presumably took with him to Paris. His many diary references to his readings, amplified by our knowledge of other books then in his possession, introduce us to Beckmann's voracious and wide-ranging reading appetites.[6] Minna Beckmann-Tube, who came from a highly cultivated Lutheran pastor's family, later recalled that, although Beckmann's family was materialistic and totally uninterested in art, his mother had a great talent for telling stories and Beckmann himself was extremely well-read when she first met him.[7] He had studied hard to pass the examination that exempted him from a year's military training, and seems to have completed the exam in Braunschweig before or during the period in which he began this diary.[8] In this diary Beckmann, who had hated school and left it at fifteen, showed that he was bent on cultivating and educating himself; here, for instance, he took on no less than Kant, Schopenhauer's *Handschriftlicher Nachlaß* (Manuscript remains), Hegel's *Enzyklopädie der philosophischen Wissenschaften im Grundrisse* (Encyclopedia of the philosophical sciences), and Nietzsche's *Jenseits von Gut und Böse* (Beyond good and evil). Throughout his life Beckmann loved to read philosophers and philosophy. Already in this diary he recorded his efforts to come to terms with issues of metaphysics, morality, and aesthetics through his substantial—and sometimes dutiful—readings.

In these earliest diaries he was particularly taken by the writings of Friedrich Wilhelm Nietzsche, one of the most influential cultural forces in Germany at that time. He clearly loved and identified with Nietzsche's spirit, rebelliousness, diatribes against the church and conventional morality, and advocacy of the free spirit, individualism, and going against the grain. He also found much confirmation and stimulus in Nietzsche for his desire to be—or consciously to play the role of—an artist.[9] In this diary he frequently quoted from Nietzsche's *Jenseits von*

Gut und Böse (1886), which seems to have influenced many of his reflections on morality, rising above the herd mentality or banal "average," and being an artist. Both his interest in and criticism of Nietzsche were undoubtedly affected by his experience of the admiring cult of Nietzsche in the city of Weimar,[10] which had led major artistic figures such as Count Harry Kessler (1868–1937) and Henry van de Velde (1863–1957) to join Nietzsche's sister Elisabeth Förster-Nietzsche (1846–1935) in celebrating the testament of Nietzsche in the aftermath of the philosopher's death in 1900.[11]

At this time, too, Beckmann was already an engaged reader of Arthur Schopenhauer—a major formative influence on Nietzsche—who also shaped Beckmann's musings in these early diaries and continued to stimulate Beckmann's ideas about art, metaphysics, and aesthetic and ethical salvation throughout his life. Those two were often sources of Beckmann's knowledge and reading of other writers: his strong reaction to the "logarithmic" reasoning of Immanuel Kant, for instance, was undoubtedly reinforced by reading critiques of Kant in Schopenhauer and Nietzsche. Yet even in this diary Beckmann's terminology and semisystematic considerations of morality, aesthetics, and reason suggest that he had begun to read directly in Kant as well.

Beckmann would always ardently read literature of many kinds and regularly brought other authors' ideas to bear on his own considerations, as in the diary passage in which he noted how other authors dealt with erotic subjects. Beckmann-Tube has noted that their group loved to read fairy tales—a popular interest at the turn of the century—and Beckmann's fairy tales and poems in the diary also recall such readings.

From the start we are impressed by the tremendous human vitality of Beckmann's language; love of storytelling and writing; observations and strongly visual sensibility; self-consciousness, irony, and humor; and continuing self-discovery. His spirit and tenacity are abundantly evident as he pondered philosophical issues, wrote poetry and fairy tales to and about Minna Tube, and was alternately ironic and questioning in his reflections on himself and his high ambitions for his art, life, and love. He voiced impatience with his family and a burning desire to go to Paris and live alone, but he was predominantly preoccupied by Tube, her strong desire for independence, and her unwillingness to become as fully involved with him as he desired. For all of his read-

ing and musing, Beckmann was preeminently absorbed by life
and the people and world around him. His deep engagement with
nature and his ready tendency to compare his moods to those of
nature are striking, too, and help explain why he would always
make landscape one of his major subjects.

Braunschweig, August 14, 1903
I begin this book in a very uncertain mood. One of my most splen-
did hopes is shattered. She [Minna Tube] is not coming to Paris. I
suppose I really ought to be sad? But I just feel empty. As if some-
thing I had hitherto felt to be pleasant and peaceful had been
dragged out of me.

Now I have found another way to be contented.
I plan to be completely alone in Paris.
Shall I go on loving her, shall I forget her?
I don't know. I shall see. But I don't think so.
Because she does not love me as I need to be loved, though she
does love me.

I cannot tolerate compromises. And this is one, however
wrapped up in a cloak of self-sacrificing abstinence.

I know that in her place I would have acted differently. To hell
with this damned reflection. I think Verlaine wrote something like:
"Love has already fled, as soon as reason sets in." [12]

In five weeks I will be in Paris. Yes, yes. She had a neck—I
doubt I'll ever again see such a fine, delicate shade of gold as hers
had. And the nape of the neck, where the head rests on the top of
the spine, so fabulously elegant. When she wore her hair up, like a
crown, she was the most delightful, delicate fairy-tale princess you
could ever find in Grimm or in Bechstein. [13]

And it was such a delightfully comical contrast when she then
talked so plainly and intelligently. Oh yes, she's intelligent, all right:
too intelligent for comfort, and I think sometimes a bit bookishly
intelligent. But I don't want to be unfair.

It's a shame that too much reading so soon puts an end to that
delightful unawareness of one's own personality. And there's noth-
ing more beautiful than when this sometimes pierces through the
cold veil of conscious being (conscious being, not in the philosophi-
cal sense).

Yes, she had to have something, first it was love and now long-
ing. I do believe that longing for something specific can sometimes

be very beautiful. At least it fills, elevates, and even to some extent satisfies. The goal somewhere in the dim, uncertain distance—or, even better, no goal at all, just an endless longing for the infinite—and giving a concrete theme, of a sort, to that longing by focusing it on a specific object. And if that object is not adequate, add a little here and there, since it isn't there and you can't make anything stick to it.

It makes absolutely no difference to me where I go. Because Paris happens to have come into view, eh bien, that's where I'll go.

My art: that's terribly funny. My art: what is it to me, well, perhaps a great deal. If you want to call my diary a great deal, that is. Without aim or purpose, I now set off into the dark, and in the dark. Passionately calm—maybe that sounds a little paradoxical—I can already survey my entire life.

I believe that I shall achieve everything that I want, everything. But I don't know for certain whether I shall always be glad to do so.

•

On the goal of Nature? = It has none, because it is a goal.[14]

•

There on the nail hangs my black ceremonial gown, and on top of it her withered garland of roses. I have searched for the part of my gown with which I then hugged her. I think I wanted to kiss her. Then for a moment I felt pain—no, not pain, an aching, sad feeling. But, even so, all that day long I had been calm, almost contented.

•

I sometimes think that I have no feelings at all, that I am only acting the part of an artist, and that my contempt for everything else, for all that seems petty and stupid to me, is just something I need as a prompt so that I can play the part.

•

Jenseits von Gut und Böse. Paper cover. 50 Pf.[15]

•

Gone, the bells have just rung; gone, the trees rustle over in the park; gone, sing the scudding white clouds that herald the autumn.[16] The sun is trying to get through the clouds, but I don't want it to.

Yes, I want that gray melancholy out there. I don't mind confessing to myself that my melancholy is pure self-deception; but now I want to have it. And I don't believe it is not genuine.

Gone are the days when the strong autumn air blew around our ears, as we first took a walk together after the party, out to that ancient castle; gone are those dark, early spring nights when I first kissed you.[17] Gone is the spring with its many fresh, bright flowers that we all plucked, that evening when we sat out in the forest, where the mountain rears up so high toward Tiefurt, and the sun went down before us over old Weimar.[18] The Ilm flowed beneath us, and all the way to Weimar the dark expanse of the fields stretched out before us.[19] Gone, sings the wind again. We are in too much of a hurry to rush forward and enjoy happiness in the past and in the future, and in between we make big speeches about pleasure and life. If only we could be rid of the ludicrous past and the equally ludicrous future and always live in the eternal present. But what am I saying, as a human being I'm not even capable of thinking that way.

Farewell to the past! Whether it was wonderful I don't know, but it was a beautiful clear wind that blew through me, wonderful.

I no longer love you.

Farewell, farewell.

You'll bear it easily. Because if you couldn't I'd still love you.

·

So now you no longer belong to me.

I sit under an old beech tree, whose thick leaves shelter me from the rain that is pouring down. There is a clatter on the leaves, and the rain swishes down in a gentle monotone. The cold highlights on the green leaves gleam in the heavy rain, and the sky is uniformly blue-gray.

Why do I no longer love you?

I will gladly leave you your independence, but I need a love that loves me—oh, let's leave that too. My head is so empty today.

I am suffering neither from melancholy nor from anything else.

It was all stupid nonsense.

Gently and slowly, the last, golden evening clouds of my first love sail across the sky. Sadly I watch them go. They gradually turn into dreams, and I must soon awaken.

Fair you were, you golden days, you were fair; and fair you still are, you golden clouds. But they are slowly fading away. Give her my regards if you see her.[20]

•

—that the conductor has a big bald patch, which he showed just now without any great embarrassment. These German military bands are remarkably bad.

•

I have just sent the letter.
 So, February 6, 1903, to August 20, 1903.[21]
 Adieu, Adieu

•

Representative Men—Emerson Reclam.[22]
 Emerson: 3702–3. *Essays*.[23]

•

August 22, 1903
Outside it is raining. Gently and monotonously, the gleaming stripes traverse the greenery of the park opposite me. I have now more or less cut myself off from my entire past. Which is supposed to mean so much. I intend to come to terms with myself, totally alone.

At the moment I have rather upset my stomach by consuming too much philosophy. Otherwise I'm relatively well. I'm counting the days until I can be totally alone at last. I shall work hard. It is such a comfortable philosophy. And as a well-brought-up German, and the embodiment of so many expectations, that is probably just what I have to do anyway. Today I don't think the wellsprings of my joy in life, my affirmation of existence, flow quite so strongly as usual.

•

August 23, 1903
In a state of peevish suspense, I await the moment when I shall fall in love again. I don't really feel like dancing the same old dance again and again. In spite of this, I can picture the moment quite clearly, with all the usual symptoms of joy and pain, foolish cosmic

desire and intimations of God, gorgeous optimism and furious cosmic conspiracy.

It's just so banal. Yes, yes, I know I'll do it again. Because after all it is our aim in life to dance on ancient pastures, where the same flowers constantly sprout beneath our feet, smelling more or less good.[24] I may now be at the stage of being a well-educated hypochondriac, but I can't deny that beneath this misanthropic shell the waves of my vital impulse flow quietly and assuredly, waiting only for the moment when they swell again and irresistibly sweep away the shell and me with it. Anywhere.

I don't care.

•

August 23, 1903
I find that the ancient Egyptians are the unsurpassed masters of style and psychology in portraiture. This Ramses II: I don't believe he can ever be surpassed in his fabulous simplicity of characterization.[25]

•

Outside the rain is pouring down again. I cannot remember it ever raining so much. Down in the street there are large puddles that look totally white, because it is already dark and they reflect the grayish white sky. That was a flash of lightning. The thunder starts, very softly. As if a wagon were rolling this way out of the far, far distance. Now it sounds like the cough of a consumptive, and now it's getting very loud.

Today I have been thinking about you a lot. Might I still love you after all. Must I always want to be in love. The rain pours down, as powerful and slow and unstoppable as my life. Gray; and, when the light falls on it, it glitters like diamonds.

•

Now the storm sets in again more strongly. Just then the whole sky was veined with lightning. Such magnificent thunder. What a sound. They're all there, untamed, those fine, strong powers of Nature. Go on, heaven, thunder and lighten. Let's see more of those wondrous beauties of yours. Or can't you even manage a proper storm any more? There! Boo! The sky glowers at me, gray and stupid. Go on, show a bit of spirit, don't just exhaust yourself in this

tedious rain. Let go, show your power for once, make us feel we're going to die. Play your primeval, cosmic symphony once more. Its sounds will drown all that is ludicrous and petty in life. Yes, yes, thanks for the pale summer lightning, but more, stronger. You can see that I'm waiting. I'm waiting for the rift from above, in that gray ceiling through which I can look into infinity.

No, heaven won't oblige. The rain just pours even harder and I sit here with my unquenched longing.

•

Nitsche:[26] there is a point in every philosophy when the philosopher's conviction appears on stage; or, to use the language of an ancient mystery,

> Adventavit asinus
> Pulcher et fortissimus.
> [The ass arrived,
> beautiful and most brave.][27]

Nietzsche. Where the people eat and drink, and even where they venerate, it usually stinks. One should not go to church, if one wants to breathe pure air.[28]

(Very funny)

•

Notes on the philosophy of beauty.

The universe considered as the basic form of eternal beauty.

The comprehension of this beauty through study of its reflections and metaphors.

To be proved: that life is happiest when it most reflects the eternal repose and beauty of the universe.

To be proved: that life is unhappiest when it least reflects the eternal repose and beauty of the universe.

<u>Basic preconditions</u> for the purest and clearest apprehension of beauty:

(1) the firm and conscious conviction of being a part of that beauty;

(2) to consider the universe and thus also ourselves empirically, because even the shrewdest judgment of the impossibility of defining things a priori can only ever be an empirical one;

(3) to convey to ourselves, each in his own way, all that is fully conceived and understood of beauty.

Aim of that apprehension:
To seek beauty until it stands before us, clear and eternal.

The spontaneous ennoblement that even the lowliest person will experience through the apprehension of even the slightest beauty.

•

Death, a visible proof of the pulse of the universe; and the beauty of death.

•

This being so, even these tiny particles of the universe would reveal all the marvelous gradation and subordination that we admire so much in the universe at large. Then we would gradually shake off that horde of institutions and so-called constitutional forms that still thrive like lice on most of the tiny cosmic particles we call human beings—as a consequence of those particles' blindness to beauty—and which suck dry even many who might otherwise have become good explorers and pioneers in our realm.[29]

•

Pascal. *Thoughts* (Reclam) 80 Pf.[30]
 Schopenhauer. *Handschriftlicher Nachlaß* Reclam[31]
 Spinoza 80 Pf.[32]

•

Before me lies a huge field of lupines, of an intoxicating golden color; beyond are forests, and farther beyond, in the far, blue distance, the mountains. Such bounteous beauty. If you really know me, you'll laugh at me and know that it's not true that I don't love you.

But it doesn't work, however logically and remorselessly I dissect you. It doesn't work.

•

N.z.P.d.G.[33]
 I believe that humor is a part of beauty.
 What divine humor there is in the hands!

•

Now I am once again far, far away from the lupine field. A big, black mass of clouds hangs obliquely on the horizon, and on the left the sun still shines out across it and casts a sea of shimmering, radiating light across the wall. Splendid, tall poplars stand in front of it. And yet I can't help thinking about you again.

Now huge white mountains spring out of the black masses of cloud.[34]

•

Isn't it tragically funny that, now I have broken all links with her, I long for her more strongly than ever. In a grotesquely fantastic way, I already dream of seeing her again, etc. I am systematically passing through all of the stages that I have already enjoyed observing in others. I delight in your slightly bookish way of expressing yourself, the self-locked door whose key I myself have tossed into the sea. And I believe the sea never yields up iron; at the least, one would have to dive for it.

•

Let me have people about me who are like music across the water at evening, when the day has long since become a dream. (Nietzsche)[35]

Yes, sure, but where are they.

•

The Koran.

 (1043) 1.50[36]

 (1313) Musäus. *Volksmärchen.*[37]

 (1377) Ossian.[38]

•

OK, then.[39]

 Depart.

 Braunschweig 9:28

 Magdeburg 11:53

 depart 12:25.

 Halle.

Nope, that don't work,[40] try something else.

 Braunschweig 5:33

 Magdeburg 6:43

depart	7:40.
Halle	8:27
depart	8:30
Leipzig	9:00

•

Saturday, August 29, 1903

Logically enough, there's going to be a send-off, all in black.[41]

In grotesquely solemn oaths of friendship with many emphatic mutual good wishes for later. Oh yes, our hearts are full. Oh, I have to laugh, it's all so stupid, this stiff ceremony. With such pitiful self-consciousness, and not a trace of lunacy anywhere.

Oh yes, I know. After having made a serious, dignified, and almost mature farewell speech, I really am going to leave with a heavy heart. There—I can already see myself sitting on the train, with the two furrows of dejection on my brow, gazing out at the gray, melancholy landscape that flits past, in my breast faint surges of pain and self-mockery—in short, all the scenery necessary for this sequence of miniature dramas.

So let's play the usual roles well, so that at least a passable style emerges, because it's all a matter of style. That is the main thing.

Anyway, our worthy writers have seen to it that more or less every love affair that stands a bit above the general average can be classified according to specific styles and moods.

So, we have Keller moods.[42]

Many flowers, white clouds, a dose of healthy sensuality, and plenty of health altogether.

Maupassant moods.[43] Avoidance of natural settings, in general highly sensual and pathological.

Prévost.[44]

Witty self-celebration of sensuality.

Toujours spirituel. [Always witty.]

Goethe moods.[45]

Strictly for mountaineers, very much in the tightrope-walking vein.

Cosmos strongly predominant.

In general no longer in use.

Maeterlinck.[46]

Divides into M I and M II.

M I much prized. Horror, death. Compassion with a shot of metaphysics.

<u>M II</u>. Tends to lose himself too much in great cosmic wisdoms. Plenty of love, here and there a *touch* of horror. No longer very individual, it is said, because he is very popular.

Nietzsche. Well, c'est la femme pour tous [she's all things to all men].[47] With him, the great can be great and the small likewise; only those in between find themselves lacking something.

Expends much spirit, scolds out of compassion. Apparently writes in his heart's blood, and has read a lot. Ideal for those who conduct their love affairs in quotations.

In general, each love has its style more or less determined by the favorite writer, and we must once again humbly kiss the hand of the nature within us, which has so ingenious and pleasurable a way of blending this given range of recurrent individualities to maintain us in such a delightful state of change and variety.

.

Sunday, August 30, 1903
Yes, he's certainly a first-rate thinking machine, this Kant;[48] but what's it for, this lifetime spent investigating human intelligence. Is it really worth it. Haven't the most beautiful deeds sprung directly from unconscious action, and isn't that always by far the most beautiful. What has this tedious logarithmic table achieved? Something he can be proud of. Be comically proud of something.

The tree that grows toward the sky and bears its radiant blossoms and its fruits.[49] Without care or reflection about its life, just breathing clear air and beauty. Itself radiant in beauty. Now that would be worthy of a human being. To rediscover the old, buried path to the beauty from which we come—and which we can be. Suppress these foolish seekers, who solemnly and with a foolish, ponderous flourish insert veil after veil, and wall after wall, in front of life and beauty?

No, that they can't do. In fact, we need them: they are the manure from which our plant will emerge into the clear air of beauty.

And if none of you can do it, I will. I will plant it, and in it I will flower, like the plant itself.

Seek beauty, fight for it, strive for it, it will give you delight. Ah, delight.

.

All passion is beauty.

•

Rejoice and feel beauty in the pulse of life, passionately glowing life. Hear its voice in music, and see how the shining green leaves shine against the blue sky.

Feel the joy with me.

•

Tuesday, September 1, 1903, 8:45 P.M.
I leave tomorrow morning at 5:30. Mother is ill;[50] it doesn't matter. I can't abide to see people groaning and whimpering, though I can't rest while they're not well.

Ah, and there are fat domestics running all over the place. And it's all so nauseating. Death is so much more beautiful.

I can still hear that pitiful groaning in my mind's ear, and inwardly it disgusts me, I can almost hate it.

Sickness to me is what shame is to others. I don't like to look at it, I won't look at it, and when I'm sick I'd rather hide myself away in some abandoned corner. Away from those brutal, healthy helpers.

•

August 30, 1903
I'm behaving as befits a stupid human being who clumsily and childishly pursues his study of metaphysics—for what belongs to metaphysics if not humankind, and within it woman above all—and who, beyond his noisy optimism, has nothing to show for it but the smiling, discontented sensation of inability to know anything—and, in spite of it all, the awareness of the vast, world-dominating absurdity of metaphysics.

•

Whether good or bad is so infinitely immaterial. Whether large or small, so absurdly unimportant.

If only one could just live. Really live.

•

You all know it, this foolish gratification. The infinitely pleasurable sense of diving down into one's own thoughts. Blissfully confident that it is possible to have an original thought, to reach a conclusion.

It's nonsense. It's not worth living just for the sake of knowing whether and how one lives.

Not to know at all that one is alive. Unconsciously to feel oneself as the world.

Only then can one enjoy, as I would like to enjoy.

•

There are moments that must be unbelievably funny for a God. I say God, because surely only he, according to the qualities laid down in the catechism, could see it.[51]

One of those moments comes about when two human beings, far apart, simultaneously look in a mirror and wonder if they are good-looking enough for each other.

•

Wednesday morning, September 2, 1903, 5:45
I set off in a red dawn, so delicate and beautiful that I luxuriated in the light as I seldom can. Beauty, come to me.

•

September 2, 1903, 1:30
I was here six months ago, in the spring. Here in the Rosenthal in Leipzig.[52] Now it is almost fall. All the heat that held off so long seems to want to concentrate itself in these few days.

Another hour and then another half hour, then I'll be with her. She will come, because this is happening at her wish.

I am tired, nervous, and sad today, at the scene of my childhood.—

•

Another three-quarters of an hour. My heart's pounding like a schoolboy's. Why? Because I still don't really know whether I love her or not.

Yes, that's why!

Absurd, absurd, this stupid, childish excitement beforehand.

No trace of self-control.

At this moment I despise myself.

•

August [*sic*] 3, 1903
In the train.

At first I was very sad because I had to leave her again, but now I'm not any more. Because now I know for certain once more that I love her, yes, and always shall and will love her. She is so beautiful and pure and fine.

•

In the train, September 3, 1903
That was a beautiful sight. The cold, tranquil circles traced in the sky by a bird of prey, and the hasty, envious circles of the ravens. They swarmed around, scolding and quarreling, but that bird circled as calmly as if they had been no more than a part of the air in which it soared.

Oh, I do long for you.

My darling, my dear, good girl, I love you so much.

•

Evening of September 3, 1903
I have now completely absorbed her into me: that is, understood her. Everything is clear and simple and not the least bit ugly. If I ever stop loving her, I shall only pity myself.

At Christmas we'll see each other, my darling.

Yes, for sure.

•

> The blue hussars sound their trumpets
> And ride out the gate
> I come, my love, and bring you
> A rose bouquet.[53]

•

Sometimes it amazes me how joyously and patiently we carry this earth of ours around with us.

•

I am a childish, vain fool sometimes, and feel that I disgrace you.

Do help me, or I shall be engulfed by a flood of revulsion at this splendid life I lead.

To sleep, your hand tranquilly in mine for eternity.

To be tranquil like the universe is so little. But to sleep it out, with you.

And how absurdly naive, to write all this down. Yes, perhaps—no, patently, undoubtedly—I am playing out an eternal, poor imitation.

Phooey.

Sleep, eternal sleep, could I but find thee! Either alone or with you, I don't care.

•

Sunday, September 6, 1903
In the morning. The distant sound of bells reaches my ear. The morning sun lies golden on the drapes before me. It is so wonderfully quiet here in the room.

Only the flies buzz from time to time, and I occasionally hear the righteous footfall of the Sunday people. Today I am entirely composed of longing for her, for all the past and yet to come

And a bit of resignation par tous [*sic,* everywhere].

•

Sunday afternoon
There's nothing nicer than a touch of longing accompanied by a sound appetite, reveries with a sandwich, and an elevated train of thought with some good investments, well secured.

We live to love, we live to die, we die to love, we love to die, we love to love: you can juxtapose these words any way you like, the same tedious stuff always comes out in the end.

Nietzsche says that the poets are shameless, because they exploit their own experiences; if that applies to anyone, it applies to Heine.[54]

It is so comical that all poets and all mankind fear the faithlessness of woman.

But I fear only my own faithlessness.

Yes, my own, although I love her. Truly love her.

•

Sunday evening.
From *Die Fledermaus.*

"I'll play the innocent country girl, lightsome in short petticoats, tra la la la la la la la / tra la la la la la la la."[55] Today that bat

made me sad for the first time. Oh, I cannot and will not think of
her growing old and ugly. I could curse my own existence, if I have
to think that this must come. And I certainly don't want to. Beauty
is more necessary to me than air and light.

Calm down, my boy, you'll accept it all right, as you will all the
rest of the loathsome things.

Where, then, is total beauty. You're never going to find it, you
stupid, stereotypical sentimentalist.—

•

Drink your milk and go to bed.
Sleep is good for sorrow.
Tomorrow you will daintily dance
Your lonesome gaiety.

Enjoy the Weltschmerz on which
You gaily, ironically dance.
Drink your milk and go to bed,
You'll be a genius as usual.

Then in dreams you are allowed
Good, inconceivable happiness,
And obtain, piece by piece,
All that normally can't be got.

Drink your milk and go to bed
Dreaming is good for sorrow.
Tomorrow you will daintily dance
Your lonesome gaiety.

•

Quite a nice little poem, that—well, I have been reading a lot of
Heine lately.

•

September 7, 1903
No, I don't like looking at your picture anymore. It says nothing to
me. I now hold you much more exquisitely in my memory. You've
got class, my girl. Oh, such slender limbs, and that one, deliciously
slanting eye.[56] Hold on, Holbein once drew an English duchess—no,
I've just looked it up, it was a Lady Parker. In the Windsor Collec-
tion. She has an eye like that.[57] Only even more oblique. But your
forehead and hairline are just the same. Anyhow, the whole thing

looks like a self-portrait by you—lively, but not a very good likeness.

My dear little fairy-tale princess. You don't have to want to do anything, or paint it either. I think by now you ought to know what happened to your predecessors.[58]

Just think:

Once upon a time there was a princess who was very beautiful. But the princess was ambitious; her beauty was not enough for her. Oh no. And if ever any of her suitors had the temerity to love her for her beauty alone, two footmen in bookback-colored liveries threw him out the door.

And so her dutiful admirers then worked harder than ever at praising her pursuit of true and profound love, in which there was mercifully still matter for psychological problems, if they used the latest fashionable, academic jargon; and they went on sipping her weak tea and joining in her play readings.

But the impudent oafs, who had so complaisantly lent an ear to the brute within themselves, took themselves off to a tavern in the forest to drown the said brute in drink. So doing, they sang godless and cynical songs by the accursed atheist Heine,[59] to tunes of their own composition.

The princess, however, possessed *real* beauty, and anyone who possesses that must some day really begin to live.

And eventually her day came.

It had been sultry all day.

Her castle was by the sea, and everyone had gone down to the beach.

On a rock sat her respected parents, the royal couple, hands folded on stomachs, quite content.

And at the water's edge the princess danced a lively round dance with her well-behaved admirers and her female friends. The rhythm was set by the princess.

Today she saw them, and probably herself, in quite a new way.

She saw how comically and woodenly those worthy, self-disciplined admirers hopped about, and how her own little friends, whom she thought she had made happy by her understanding and advice, looked so longingly and sadly into the sunset.

She looked out over the sea, and all at once she heard its wonderful music quite differently.

And she thought of those poor, brutish fellows who were so despised in her own pure, sparkling circle.

She quickly left the dancers and ran down the beach, where it still caught the light of the setting sun.

Well she knew that by now she could never love those poor fellows, but they had reawakened her longing, and now it was so potent that everything else crumbled away like rotten tinder.

And all at once she knew that her longing was all for the beyond, for the setting sun, and that she must die that very day. Just as if she had no longer been there. She felt that quite clearly.

She looked around.

Yes, there was the long, narrow ship with the giant white sails.

In an instant she was aboard. And it quickly glided away from the shore. She watched as the beach with its colorful dancing dots slowly sank into the darkness. The ship now sailed at an unimaginable speed. Always toward the setting sun, which never quite sank beneath the ocean.

But she, the princess, was no longer alone. Her longing had become so powerful that she could see it, feel it, and kiss it.

On they sailed together, following the sun, across the eternal sea. She and her longing.

·

Once again the wave carries me into the valley
And there I lie in peace and beauty
Mountain air, dear mountain air, to me you are nothing.
I want to see no more of the heights and their golden
 splendor
Cover me over, O wave, cover me
I know that you are great, total, clear Understanding.

The air is soft and tenderly brings the autumn.
The trees wear gold already. Ah, I wish you were
Close to me, on your breast
I would forget evil and good, suffering and desire.
Only your hands can give me peace
I know then I can dream of
A happy, blessed existence.

Ah, come soon and
Give me quiet and slumberous peace
I will be good and
Stupid till cleverness us do part.

·

There really is nothing more pathetic than irony.

The brutal unveiling of a weakness. Phooey. And you still wallow in it, you dull fellow.

·

September 8, 1903
I really don't like those foolish letters of yours. But I can scarcely do without them.

They are always crammed with so much that is fearful and childish, so much that I can't possibly love. It must be her egoism.

They're so prudent, so calculating, all that you must not ever be. They always put me in a bad humor for a long time.

·

You dummkopf, you dumb little, wise-beyond-your-years Minna. Please don't be so foolish. Just fold your hands in your lap and stop thinking and stop acting. Just love me. All the rest is such dumb stuff, which harms your beauty.

And your beauty is worth much, much more than that.

·

What makes life possible for so many people?

"They all suppose themselves to possess some judgment."

·

And you must be very beautiful naked. So splendidly narrow-hipped, and the legs from the knee down so long and slender. There won't be much flesh on the hipbones, and they are very delicate. And your bust is wholly delicate and fine. Oddly enough, your collarbones scarcely stand out at all, although you are almost skinny. The base of the neck is fine and elegant, and I imagine the color of the body as a whole to be a totally matte gold. Oddly enough, again, your shoulders are quite rounded, and up to the elbow your arms are the beautiful, slender arms of a girl. The elbow bones must make themselves felt, just like the hipbones. And your forearm is only an extension of that splendid, powerful hand. Which has nothing in common with those feminine women's hands that are so white and lazy and beringed.

•

September 9, 1903
A feeling for some kind of morality, whether conceived on a small
or a large scale, is produced by the necessity of peaceful social inter-
course among human beings.

Because mutual peace is the pleasantest mode of interaction,
and because it encompasses those qualities that are designated as
good, the feeling of its vital necessity has given rise to another feel-
ing, that of strengthening and confirming in oneself those qualities
that had evolved to make peace possible.

Extending and becoming more and more comprehensive,
the feeling is passed on from generation to generation until it
gradually takes on the form of the concept of morality that is
denoted by many expressions and words. Such as good, right,
noble, etc.

It goes without saying that, along with the feeling for the pres-
ervation of those things that are necessary for social intercourse,
there has also evolved a tendency to suppress and to despise those
things that disturb it, and that are [sic] merely the logical conse-
quence of such words as good, right, noble, etc.

I think this whole morality could be called a morality of
necessity.

For that reason, this morality ought of necessity to be super-
seded, because nothing dogmatic is healthy.

And this morality is a dogma. Even if it has its good side.

If a morality is to be really viable, then it must be well aware
that it is constantly changing. That its main duty is always to feel
this in itself and in others, and to act accordingly.

Certainly, the morality of necessity is a precondition for the
forming of this individual morality, but it is only the fertile soil,
which, well cultivated and explored, spontaneously brings forth that
blossoming of individual morality.

This battle between dogmatic and individual morality goes on
in every human being who has any power of judgment.

And, according to the strength of that judgment, either dog-
matic or individual morality predominates—or, most often, a mix-
ture of the two.

Again, to get the individual morality concept perfectly clear:

(1) feeling the conviction that one is part of a Unity that constantly changes its form;

(2) attempting to see the concealed or evident logic in all these particles of form;

(3) the insights gained through this logic as the basis of morality;

(4) the word *morality* defined as follows: useful and salutary for ourselves and others. [60]

•

The most ingenious advice as to how to obtain enjoyment for oneself is given by Schopenhauer on p. 82, in the notes to Locke and Kant:

For shifting from an originally subjective mood into an objective contemplation, I can recommend an excellent means, namely, that with the power of imagination one forces oneself to the strange illusion that one is not present at all, is not on the spot now occupied by one, but only the surroundings exist.[61]

—So transpose a present action into one's memory and thus enjoy it in total objectivity.

•

September 10, 1903
Your letters contain a feminine logic that could scarcely be more typical or more facile. And also a not entirely dignified attempt to match every idea as quickly as possible with another idea of your own, usually mere generalizations.

You write facilely and almost banally: "Whatever we may say and write, we go the way preordained by our nature."

This is the usual sort of expression, used by the slightly above average crowd when they don't understand or haven't understood something and would nonetheless like to chip in with their own judgment or thoughts. It's all so easy.

It so nicely reduces to futility and absurdity anyone so foolish as to suppose himself able to observe Nature in its profoundest guise, in its very essence. And all this in a few words that are so easy to say without reflection.

In themselves, the better members of this average category are far from convinced of the truth of the words in question; it's likely that they will dig down and bring them out only when someone else's ideas look like going above their heads, or when they are otherwise stumped for something new to say in reply.

In principle, it is the same as the belief in fate or destiny.

It's not even clear and properly understood, this fatuous bromide. What was the phrase you used, "the way preordained by our nature?"

This means that you see the human being as continuing to evolve from the cell from which he first evolved, according to laws about which you yourself are not very clear, and whatever he says or writes he will always go by those laws, which you have yet to define.

Permit me to rephrase for you, in what seems to me a more correct form, that which you retail so lightly and foolishly and uncomprehendingly.

First I want to show you that thought and action are the path we follow. By which I mean our own thought and action, as well as those of all other human beings.

Every planned action or work, every movement—in short, even the smallest possible change—inevitably brings about another change. A change in outward form, that is. These endless changes in one and the same thing are caused by the optical and sensory illusions of an onward motion. The way, as you put it—and as I said earlier, because if I had said that thought and action are only a superficial change in the archetypal form, you might not have understood me.

So if you can now see that thought and action are roughly equivalent to the meaning of your words "the way preordained by our nature," you wouldn't any longer say that "whatever we may say and write, we go the way preordained by our nature," but that our thoughts and actions (approximately equivalent to what we say and write) and those of all other people are the main factors that continually change the outward form of our life.

Or, to put it even more simply:

Through thought and action, the outward changes give and receive the form.

So now I'll write out all this rigmarole for you and send you a fair copy, my darling. No, I won't. Can you understand what I mean[?]

1501–7.	(Koran)[62]	M 1.75
72.	(Heine)[63]	M 0.25
66.	(Andersen)[64]	0.25
1620–21.	(Eliot)[65]	0.50
1261.	(Maupassant)[66]	0.25
548.	(Ovid)[67]	0.25
276.	(Sophocles)[68]	0.25
364.	(Fischart)[69]	0.25
		M 3.75

•

All the same, thank you for loving me. You often save me from myself.

•

September 11, 1903

Late in the afternoon, when it's already getting dark:

I blow my cigarette smoke slowly and pleasurably forward. From time to time I make a ring. And then I gaze seriously at it. I think. Aha, he thinks! What about? Hmm, lots of things. Today the colorful chaos proceeds quite comfortably. If I now review my thoughts over the last ten minutes, they were approximately as follows.

The Paris trip in a week's time; a bit about the rainy weather and its pleasantly gloomy mood; then of course about you, Fräulein Tube, how very much you delighted me in Leipzig, where I brutally—excuse me a moment, I must just bring to life a new cigarette. There, now where were we? Ah yes, I brutally stripped you of all the odds and ends of cogitation and fine words, which suit you so badly, and which you'll never be able to give up, and there you stood with just a totally unreflecting love for me, such a delightful, helpless love, that, when I think about it, I smile and kiss the hem of your garment and forgive you your subsequent reversion to foolish independence, you poor little madonna.

Then I went on and thought about the indignant smile that would cross your face if you heard this, and I also smiled for a moment—not very pleasurably, I'm afraid.

Then came some misanthropic thoughts about the foolishness that lies in the human craving for independence: thoughts in which I myself didn't come off very well.

And now I have more or less reached the point where I started

writing this, and my thoughts were taken up with reconcentrating on the earlier ones.

Let's go on, and see what else the cerveau [brain] has in store for us. Aha, the new guests have already arrived.

That French word reminds me of my poor little French girl.[70] But with the best will in the world I don't like her, in spite of her nice waist.

No, legs too short, and that spoils the entire little person for me. Only how am I going to get out of la promenade.

Oh yes, the brother from America revertuus [*sic*] et c'est un bon moyen [returned and that's a good way].[71] Console yourself, you poor dear, you'll have plenty of students in the future. Vive la méthode de monsieur Berlitz [long live Monsieur Berlitz's method].[72]

Now it's quite some time since anything showed up in my worthy brain. So let's light another cigarette.

A shame Andersen didn't smoke cigarettes.[73] Otherwise he might easily have written a fourth book. Que dite la fume des Zigarettes [*sic*, what does the cigarette smoke say].

My dear mother has just thrown a major Meyerbeer scene because I threw Queen Louise out the window.[74] In justification I pleaded that I could no longer stand the sight of her, since she was made of silver-painted plaster.

But this excuse was rejected as inadequate.

At which point I was also accused of gold-painting the bald pate of the unoffending bronze Socrates, an equally profane and thankless outrage against the giver thereof.

Peace be with you, O ye Elysian fields of bad taste.

After I had read this to my dear mother, she opined that it was as finicky as Nietzsche, and that I would probably end up the same way.[75] Adieu, my dear book. I must now take some books to be bound.

.

Heine 73.74.75.[76]

.

September 11, 1903, 11 P.M.
I don't consider it out of the question that I might occasionally be unfaithful to you for the sake of the beauty of another, because you have no idea, my child, of what my senses often do to me, but it can only be for short moments. In which you are not there at all, and I

am not the one you love, but a piece of earth that must fulfill its duty. My senses are the only things that can still sometimes give me orders.

Oh, there are times when I find myself wrestling and struggling with myself, then I hate you and despise you, because you know what I sometimes am, and you even quite coolly calculate on it.

At such disgusting times, when Absolute Woman fully dominates me, I can hear you actually talking to yourself.

May he just learn to restrain and control himself, and if that makes him love some other woman, I'm not going to get cross with him about it, the poor boy.

O you cold, foolish virgin, you who imagine yourself to possess senses and believe that you also love me strongly and sensually, O you wise virgin, what do you know of senses. What do you know of those demeaning days on which every breath, every look, and every step is hot animal longing only for Woman, for the other sex. Where our objective feeling registers vileness after vileness, and is often nonexistent and gets totally lost.

Yes, that is life, the great driving force, but that force is not a pretty thing when you're alone.

Ah, even you, if you could see it, you would take pity on me and maybe advise me to take a mistress. You're so wonderfully understanding. But no—I really don't want to start giving an epic treatment to *that* side of my character. Disgusting it may be, but it's too good for that. And it also doesn't concern you, good, pure maiden that you are; you still have a well-developed sense of disgust, and you understand it roughly in the way a person fed to satiety might imagine the raging pangs of hunger.

•

September 12, 1903
I sometimes want to throw myself down full length, close my eyes, and shout to the world: Peace be with you, Peace peace peace, and very softly to myself, as I sink to sleep in the earth: Peace be with you and rest, you sad piece of earth.

•

Do I long for you, do I still love you? Suddenly I don't know, and it makes no difference to me. Nothing does, today.

•

Marcus Aurelius. Meditations.[77]

•

829. Hegel. *Enzyklopädie der philosophischen Wissenschaften im Grundrisse.*[78]

•

Here, behind me, my brother is talking about his trip to America. A poor specimen, despite his good health. He didn't find what he wanted there, and back here he dislikes it so much that he's starting to long for America again.

You think you're complicated. God, so simple, so absurdly simple, if only you didn't think you had to think. And you even want to do something.

I so want to do everything for you that we have to do. But I beg of you, please don't *you* do it, then I can love you much, much more.

But no, you won't. If you were to read this, you'd call me an amiable egotist and go right on with your foolish, useless activity.

You can't understand me—or really love me.

At least not the way I would like, or else all of that would just fall away from you, utterly naturally.

Yes, maybe for a few moments when I'm with you, but then it comes back again.

And as for you, my dear girl, you're proud of it, and you foster it and nurture the dear little seedling as a mother cares for her sick child. You want to love me, and yet you're bothered by the thought that, if we were together and didn't have much money, you'd have to cook for me and for yourself?

You take pleasure in seeing me as a great big, lovable, egotistical child. But just ask yourself, my clever beloved, what are you.

First the one toy has to be taken away from you, to make you realize how much you loved it, and then, OK, you'll forget the others. But once you get it back again, you'll have a revival of interest in all the other pretty things, and the toy you cried over so much and finally recovered is put back in line with the others—and singled out or generously associated with those others, just as the longing takes you.

If only I could have you wholly, just the way I want.

Oh, I do love you

I find it positively incredibly impertinent and intrusive, the way you thrust yourself into everything. I cannot read. You immediately turn into every tiresome, dreamy girl I read about. This has just happened in Andersen's Picture Book; if I start reading Marie Grubbe, there you are, lightly and gracefully walking around in it.[79] And when I read Nietzsche I join him in hurling insults at you.[80]

I must now earnestly request you to be a little more restrained, my sweet little Minna. Now what were your last hat and your last dress like.

Yes, that's right, very nice, very nice. A bit too loose in the waist.

In any case, I'll draw it.

No, can't do it tonight. As may be seen from the three pages I've torn out.[81]

·

September 15, 1903, 11:45 P.M.

They've gone to bed again, so I am pleasantly alone.

I have opened both windows wide, and so the mournful song of the rain reaches me loud and clear. Below, someone walks by slowly, whistling hideously. One of those patriotic popular songs. Ah, how pleasant, it grows fainter and fainter, and now it has gone altogether.

How happy I'll be when I'm completely alone at last.

Ah, how tedious they all are to me.

Not my dear mother, that is, but that sad brother of mine, who all too inadequately conceals his spiritual poverty from himself and others beneath the tattered cloak of his irony.

You wrote me today. Thank you for my drawing.

No, I'm not longing for you. You are so satisfied with your own longing, and I want something totally different. I don't know what it is, and I don't want to know, and I don't care.

Uh huh, now I want to read your letter again.

"A life of your own?" What for? How extraordinarily funny.

Everything is so ignobly funny, and so sad that it is so funny.—You're right. We'll stop writing each other. You can't write, I always get in a rage when I read you, and maybe I can't either.

No, let's not write each other any longer. But I love you and will love you, my darling, and will come to you and kneel before you and kiss your hands and ask your forgiveness for everything that I have done to you. Ah, it will be wonderful.

Christmas. Silent night, holy night.

•

Paris: Durand-Ruel et Fils, art dealers. Owner of Manet, Renoir, Cézanne, Sisley, etc.[82]

•

Schiller: Thekla, sentimental.[83]

> The forest rushes, the clouds go by,
> The maiden walks by the shore and sky,
> The wave, it is shattered with might, with might,
> And she sings far out to the somber night,
> Her eyes all bedimmed with her weeping.
> Her heart has expired, the world is still,
> Naught further has she to wish or to will.
> Thou Holy One, summon thy child to its own,
> Of earthly delight my share I have known,
> My full share of living and loving.[84]

•

September 16, 1903

My beloved, pure, beautiful girl, if I could only give you all the tenderness that I feel for you today.

Love me always, will you, even if I were to forget you, I shall still come and take from you the peace that you'll give me and I'll give back to you.

Do you remember.

Dance music, artists' home, my Jesuit hat, your two braids, the evening when I first saw how beautiful you were.[85] Fat Smith, Mili, Kunwald, and all the awful dance music as well.[86]

Above me they are playing the very same waltz as on our first evening. That time is lost and will never return.

Today I could die from sadness.

And we danced, I can still feel your delicate waist, round and round the big pillar in the artists' home.

Dance, dance, the world turns and we turn around it.

O my dear one, today I wish I had your hand again, I am so miserable.

·

September 18, 1903, late evening

I don't want to write you because at the moment I can do nothing but feel, feel you, and what am I to write about that.

I am so wonderfully tired tonight. I wish you were lying beside me, so that I could kiss your forehead and feel your body.

And then dream with you. Of peaceful, beautiful paths, with meadows bright with flowers and golden evening clouds.

We two would lie close together and watch ourselves walking. You know, everything so utterly quiet.

In all wondrous quiet, feeling everything, enjoying everything.

As we could, if we were quietly together.

My dear, dear Minna. Are you already asleep? Good night, my darling.[87]

Braunschweig[88] depart 4:55

Change at Börsum.[89]

Frankfurt 1:26

depart 1:43

in Mainz 2:21

Evening by steamer to Andernach.[90]

Tuesday to Bonn/Drachenfels[91] by steamer.

Tuesday evening to Cologne (rail)

Wednesday morning Cologne depart 9:07

arrive Paris 6:47 P.M.[92]

·

September 19, 1903

In the park.

Last day in Braunschweig. I'm sitting on a bench in a children's playground. Ah, I'm so glad to be finally leaving here. It's evening already.

·

My dear one, I'm at a big party with relatives. Just imagine, a farewell party in my honor.

The most grotesquely comical thing imaginable.

I am totally with you and love you very much. Permit me to share with you this thought, as new as it is original, while my brother is telling stories from America.

.

In the train, around 4 A.M.

The morning sun heralds its arrival with an orangeade-colored sky. Now the talent's all going to Paris.[93]

Oh, how interesting.

The future lies before me, the color of orangeade.

Be something, my boy. Whoops, the train's off again.

A shame there are no little morning clouds to carry my greetings to Fräulein Tube.

.

In Frankfurt.

Now I know what I'll do. Listen, my darling, I'll send you all the baloney I've cooked up in this book. Hope it won't upset your stomach. And then let's not write each other anymore. I know for certain that I love you, and therefore, as you yourself quite rightly say, it's unnecessary. It would just be tormenting ourselves.

Please write me *only* where you'll be living in Holland, and expect me every day.

My address is 117, rue de Notre Dame des Champs, Paris, c/o Madam Fusther.[94]

.

At the moment I'm lying elegantly stretched out on the soft upholstery of a second-class coach, totally alone, and on the way to Mainz-Kastell, from where I shall proceed by steamer down the Rhine to Andernach and Cologne.

I take all sorts of liberties with you. I kiss you, I take you on my lap, in short I behave as if we were on our honeymoon trip. You wonder why the last three lines are so neatly written? The train stopped, that's why. Now it's moving again. O my dear Minna, why can't I really have you here with me. Outside, sunny fields glide past me, and it's all as if you ought to be there with me. Why, why aren't you with me.

Mainz

Before me lies the Rhine. It's already evening. Keep loving me, my dear Minna. And write me your address right away. So I must say goodbye once again. I kiss you, my darling. And don't forget me, you hear?

You know, it's fearfully difficult for me, deciding not to write you anymore, because I long for you as never before. But I believe it is better so, and then—our reunion! Adieu, my dear, adieu, so long.

2

Diary, December 6, 1903 – January 6, 1904

(Paris, Amsterdam, Paris)

BECKMANN began this diary after settling in Paris, two-and-one-half months after he completed the previous diary. This notebook was also small (9.5 cm × 16.2 cm) and contained many drawings, among them several sketches of people in cafés and concerts, and drawings of figural ideas that he ultimately realized in his first major painting, *Young Men by the Sea* (1904–5, G. 18).[1] He tore several pages out of this diary as and after he wrote.

At the end of the previous diary Beckmann noted that he and Minna Tube had agreed not to write when separated because they would find it too painful to have to settle only for letters; he also asked for her address, however, and made clear his intention to visit her in Amsterdam over Christmas.

In his diaries Beckmann wrote little about his experiences, studies, or examination of other art in Paris: he elaborated upon those more fully only in letters written during and after his stay to his friend and colleague from Weimar, the Hungarian Caesar Kunwald.[2] From those letters, we know that he frequently studied models at the Julian and Colarossi academies—large studios where artists could readily study models by paying a fee—and that he preferred the latter, only a few blocks from his apartment at 117, rue Notre Dame des Champs.[3] He spent much time drinking and enjoying bars such as the Closerie des Lilas, just down the street from his apartment, and spent almost no time discussing readings or philosophy.[4] In this diary, for instance, he makes only a few passing references to Nietzsche and to Jean Paul Richter (1763–1825).

Paris, December 6, 1903
After pouring a chartreuse, I have begun the beautiful new book
with a crayon that I don't like, with two chartreuses already in my
stomach, at home, sitting by a warm stove.

It's not even cool here in Paris. Next to Paris my closest
thoughts always lie in Weimar. And yet what do I have there, in
that dump. My youth! By normal standards my youth is really just
beginning. And that isn't what makes me think about Weimar.

You think I'm not going to visit you in Amsterdam, don't you?
I am, though.

What are you thinking about me right now?

"I don't think he'll come. Him, still think of me, after nearly
three months in Paris? Am I silly enough to believe that?" That's
probably what you're writing. And yet without knowing it you still
think that I'm coming, that I'm definitely coming. Without know-
ing it.

I've now gotten a pen, the better to go on writing.

What?

Now I think a lot about one winter night in Weimar. Three of
us stood together in the park on a bridge over the Ilm, and the water
flowed so quickly, and behind were the tall trees totally covered
with snow, and a fine gray haze was over everything, and they
looked like weird, almost crazy shapes.[5] And the three of us went on
gazing into that gray infinity, without knowing or wanting to know
what was there or what they were supposed to be. That half-hour
on the Ilm bridge was so strangely fairy-tale-like and impersonal.
We were all so aware of our longing, without saying a word. And as
I stood next to you, I was thinking so powerfully of you, and I
never imagined that a month later, on that very spot, I would be
kissing the head that I then couldn't see but could only sense. And
you certainly didn't imagine so either.

Oh, memories, I believe you are the best parts of our lives.
(Presque Styl de Madm. Tube [almost the style of Madame Tube],
13 March 1905).[6]

·

The same evening. After three more chartreuses.
I'll be with you in one week! Just think of it, in one week. Won't
that be fine. Will you then be nice and good to me. I know I am to
you. Will you be the same to me. I hope so.

And yet another chartreuse, swallowed as an afterthought, to your health.

•

The same evening.
I am lifted way up yonder by the eternal emotions—those of drunkenness, to be precise.

Way up yonder as I otherwise never am. Tomorrow don't pull that ashen-gray face, my dear, beautiful, stupid, eternal Max.

•

December 9, 1903
Ta tatam, ta ta ta ta ta tatam, ta tam, and so on, grand march from *Die Meistersinger*,[7] fatigue, the café, and the rain outside,[8] my impending journey, all of that and the associated impressions keep going around in my head, with leaden weight and slowness. No more joyful anticipation of her. Little desire to work, and no inner strength. These of course are only consequences—or so a decent, healthy man would say. Sure. He may be right.

Only one thing is not yet extinguished in me.

My sensuality. It keeps on flaring up again. I believe you could hack it to pieces like an eel, and it would live on in every piece with redoubled strength.

How nice it would be, if I could get rid of that. The baser sensuality, I mean.

How nicely I could live. And if my life were a life without action, fine by me.

Outside the café, a covered hearse lumbers past, with its contents. Have a good journey. You've put dull stupidity behind you now. It rains and rains; my soul rains, too, but not fruitful tears.

•

Five hours later. In the evening.
Ha ha (Laughter)
Ha ha (Laughter)
That last, mourning and tears piece is a barrel of laughs.
Now, for a change, energy and desire for action swell in this well-frequented breast. I believe that my individuality—since in spite of eternal repetition every human being is in some absurd sense or non-sense an individual—consists of a moody chameleon (mis-

spelled into the bargain). I differ from Heine and Jean Paul in my total lack of their ability to forget themselves for moments or hours on end.[9]

·

Café Rouge.[10]
Finally I am comforted by having found something ugly in a very beautiful face.
 Nice, don't you think?

·

I have just come to the conclusion that I do not love her any more, and now it is as if I have lost something very beautiful.

·

Scherzo:
 Perhaps I do still love you.

·

December 10, 1903
Yes, it's almost Christmas. As one barely notices, here in Paris. The days slip away and prove to me, all over again, the nonsensicality of all concepts of time.
 The courage to meet the sheer dullness of life informs my accounts of life, whose highest joy is a totally feeble, foggy imitation of such a joy as I would like. And that in itself is a feeble imitation, because I can't even think it through ta tara ta ta ta ta ta tarata. Blossoming life and blossoming death. If I could imagine a God, I could make terrific use of him as a symbol of the Great Dullness.
 If I were not too tired to think at all, because even thinking bores me with its boring philistine boundaries. God, maybe there are no boundaries, and it's all just as unimportant ([or *as* great] please select according to mood) as it appears to us and as we can imagine.

·

Night. 1 o'clock. Chez moi.
Tonight I have once again behaved really stupidly. This damned irony, which I can't abandon and which I nevertheless really despise as foolish and stupid. All vanity, childish, foolish.

And why. And in front of people who mean nothing to me, which is why I need them. Yes, well.

•

December 11, 1903
Tears ought to fall. Aren't they such nice, wretched relief. But unfortunately I have run out of that wondrous liquid. I'll write it again anyway. And tears ought to fall, weep for me for I cannot.

•

Place Saint-Sulpice 6.[11]

•

Depart	12:40	Paris	
	5:11	Brussels	
	5:36	depart	
	6:08	Malines	
	6:37	depart	
	7:31	Antwerp	
		Roosendaal.	
	7:50	depart	
	8:28	Dordrecht	
	8:55	Rotterdam	
	8:59	depart	
	9:20	The Hague	} change trains
	10:06	Leyden	
	10:10	Amsterdam	

•

December 12, 1903
Evening, 12 o'clock, at my studio window. I have no matches and so cannot strike a light. The gaslight shines in a bit from outside. It is dreadful when one comes home full of so much agitation and so many thoughts, and then can do nothing but go straight to bed. Simply dreadful.

•

December 14 or rather 15, 1903. Night, one o'clock. In my studio. Last night before I leave. As usual. If I want to inject some action into the sketchbook of my soul. I'm just not calm enough to say

anything interesting about it for my person of the future. In a
funny way her impending presence has caused some changes in me.
I see her again as more beautiful, sweeter, and not with such grue-
somely ugly thoughts as I did only a short while ago. Must I re-
pent? No. I am so totally led by my own self, by my irony, and by
my cruel addiction to cutting things down to size, that repentance
would make no sense at all.

I would be so glad if she could give me peace and love.

I would like to have her with me in this small, beautiful, fool-
ishly sublime world, if only she has the strength to restrain me.

But no, she is a poor helpless girl. If only she is helpless. Then I
can love her the most. Strong virgins are so absurd. I would like
her to give me everything, so that I, rejecting everything, might
fully love her. Good night, Minna. Do you know that I am coming
to you?

•

Roosendaal, December 15, 1903
After the most expensive dinner possible I feel very well in the din-
ing car. Soon I shall be in Amsterdam. I am in a Christmas mood,
full of surprises.

•

Madame. Sur mon piano est une boite noir avec des lettres. Voulez-
vous m'envoyer les trois, qui ont des timbres hollandaises, il sont
deux lettres et une carte postale—toute suite dans une lettre rapide.
C'est pour une adresse perdue. [Madame. On my piano is a black
box with letters in it. Would you please send me immediately by
express mail the three that have the Dutch stamps, there are two
letters and a postcard. It's for a lost address.] [12]

Lodegast [13] M. Beckmann.

•

In the train, already well past Roosendaal. Isn't it incredibly funny
to want to visit someone, and your own fiancée at that, and to forget
her address.

My only hope of still finding the address is the name Lodegast,
but that could be from Andersen. Perhaps Lodewyks. Well, the poor
old city directory is going to take some punishment. Otherwise, I
can use the telegram.

·

At night, 1 o'clock, in a café.

<u>Amsterdam</u>
　　All right, so now I'm here. Voilà. I also think I've found
the address. We shall see. Oddly enough, I was right about the
Lodewycks.

·

In my hotel. Somewhat later. I believe this is the first time I have
ever sat down to write about a city in my blue book, or in any of my
other books. But this Amsterdam is just too delightful. Tonight,
after the café, I wandered around a bit. The fog cast a delicate veil
over all these brightly colored little houses, and they were all lit up
like something in a fairy tale. The canals so eagerly and earnestly
reflected everything that they saw, and the light globes looked like
veiled suns.
　　And then she has been all around here and will go on being
here, and above all she still is here.
　　I wish it would snow overnight, so that I could greet her in the
snow. And my hotel is clean and neat, the waiter is amiable and
wears a pince-nez, and I myself am as amiable as I seldom am, and
all over Amsterdam lies a mist that I find strangely congenial, a
fairy-tale quality, dreamy—woozy, if you like. The convivial croak-
ing of the Dutch, and their even more convivial sins, which display
their startlingly broad hindquarters all over the streets, are so tre-
mendously funny and so inseparable from the whole ensemble that
I wouldn't part with any of it. Shall I meet you tomorrow? And how
shall we like Amsterdam tomorrow?
　　Nous verrons [we'll see]. Good night.

·

<u>Amsterdam</u>
　　Franziskaner,[14] evening 4:30
　　Met. Wonderful satisfied tired see what happens.

·

10:30 in the evening
　　Even better mood and even more tired. Went to a concert of
Beethoven, Schubert, *Winterreise*.[15] She sat three rows in front of
me and I could always see her lovely neck and sometimes her face,
when

•

Three ripped-out pages! Isn't it beautiful that I have her. How beautiful.

•

I'm really falling more in love with you all the time.[16]

•

In some café-concert in Amsterdam. 9:30 in the evening.
Since I've nothing else to do in Amsterdam and feel well and think many tender thoughts of you all the while, I really ought to write something about Rembrandt,[17] however, but now it seems— wait a moment, *delay*, a vaudeville song person is going to sing, it's a special turn in the café-concert and with the best will in the world no one can write while that's going on.
About Rembrandt. Very beautiful sometimes, I find the *Night Watch* boring, I think that none of them could match his family portrait in Braunschweig.[18] Frans Hals is the best, and then Terborch and Vermeer van Delft.[19]
Not much sign of interest in painting, would you say? Ce [*sic*] ne fait rien [that doesn't matter].
Oh, I really couldn't care less about all that. But tomorrow morning I meet you again.[20]

At night, 12 o'clock. In my hotel.
My dear, dear Minna. Good night. Gradually, wholly new feelings for you are gathering in me. And very beautiful ones.[21]
Tralala, outside the bells of Amsterdam ring. I am tired and sad. Why? Probably because I have eaten and drunk very well.[22]

•

Paris, January 2, 1904
It's all over, all over. Because I could not love her, much as I wanted to. Adieu, my dear, and be happy.

•

Café Rouge
Oh God, how tragic. It makes oddly little difference to me, this end of a so-called love that lasted a whole year. C'est drol [*sic*]. All

the same, tonight I shall down a few in your honor, Minna Tube, and with every new one I shall say: "Cheers, Fräulein Tube. Cheers."

Hurrah.

•

Closerie, 12 o'clock [23]

I must drink a lot more to get into a sentimental mood. Cheers, Minna Tube, to your pains of self-denial.

•

Same night, somewhat later.

Am I ever going to get away from these eternal repetitions? For instance, I've been repeating myself ever since the beginning of this book.

Magnificently simple. And also so pointless again.

If only I could ever be something totally new, then that would be something of importance.

Je ne crois pas [I don't think so]. I would just produce a string of new repetitions.

•

Sitting in front of me there's a man who sits and writes and makes a face as if he's writing poems. Oh God, that is funny.

•

Isn't it really nice to find great, wonderful, like-minded persons and kick them in the teeth?

•

In front of me sits someone who is having an angina attack. To the left sits one who writes poetry, with the anxious face of one who is looking for rhymes; then to the right plein de [plenty of] sexuality, and I laugh at it all; that is just the mood that suits me.

•

The sentimental mood is on the way, with singing of May songs and writing over-life-size.[24]

•

It's all over between us, Fräulein Tube, all over, totally over.

•

Ta taran ta ta ta ta ta taranta.
 That's all I can think of, so I'll have to drink even more.

•

Of course, you don't know a thing yet, because the letter is still in
the mail. Well, for the moment I have the tout seul [all alone] feel-
ing. Mais ça suffit [but that's enough].

•

For a moment, there, I was too ashamed to order a sixth and dernier
drink. But then straightaway[25]

•

January 6, 1904, Paris, chez moi
 When I bought this book, I think I was more contented than I
am now. My youth is probably at an end, now that it's all over with
her. Once again, farewell. I am tired and sad, not about us but at
my own capacity to want without knowing what, my craving for
something unknown, my restlessness, and my existence in general.

•

Peace be with you.[26]

3

DIARY, JANUARY 6 OR AFTERWARD–
MARCH 9, 1904
(PARIS)

BECKMANN seems to have begun this third notebook soon, if not immediately, after completing the prior one and just after he had supposedly broken up with Minna Tube. He wrote in a small notebook (10.2 cm × 16.5 cm), drew many sketches and drawings,[1] and ripped out several pages. His drawings included free sketches of figures and scenes witnessed in Paris and more studies of figures in outdoor settings that he subsequently developed into *Young Men by the Sea*.

Beckmann wrote in his diary chiefly as he visited bars, including the Closerie des Lilas and the Concerts Rouges. He spoke mainly of what he saw as he drank and wrote, though he also mentioned working on huge paintings—far larger than his *Young Men by the Sea* (148 cm × 235 cm) would be—attending chamber music concerts, and reading Jean Paul, Schopenhauer, Andersen, Goethe, Richard Dehmel (1863–1920), and Wilhelm Bölsche (1861–1939). He increasingly expressed exasperation at his sexual desires and finally anger at Paris itself.

In two places Beckmann quoted extensively from Jean Paul's long, complex, frequently incoherent, and beautifully lyrical and compelling novel, *Hesperus, oder 45 Hundposttage: Eine Lebensbeschreibung* (Hesperus, or 45 dog-post days: A biography; 1795).[2] Jean Paul's works joined many of the moral, ethical, and emotional ideals of the Age of Sentiment with a strongly personal and fanciful sense of humor and pointed social satire. Beckmann excerpted sections that both mocked and admired the gushing romanticism of expressions of love as well as witty observations on poets, artists, and emotions. In this he reflected his love of Jean Paul's sentiment, lively treatment of frequently meek characters who are all passion and sensation, and absurd and fantastic humor.

This is the only early diary in which Beckmann mentioned other artists, Emil Feigerl (1877–1944), a German colleague who was a friend of Beckmann's Weimar friend Caesar Kunwald, and Edvard Munch. Though Beckmann mentioned Munch only briefly, he was clearly in awe of the "noble" Munch and expressed his longing to meet others who felt and "suffered" life as deeply as he himself did. Soon afterward he also mentioned visiting the 1904 Salon des Indépendants, where Munch exhibited alongside many other major modern artists.[3]

I have just torn out a page because I had written a few very foolish and stupid things about her. It isn't necessary and besides, as far as my memory goes, she has done nothing to deserve it.

If she had known how stupid I was, that she could have completely had me with a few subtle touches of dress or manner, perhaps she would not have displayed her pride quite so much in this very respect.

I am tired today and in desperate need of refreshment. Outside we have warm spring weather. Spring weather. Last spring, Mili Plump went around forsaken and arty and [sore?].[4] This time it's Fräulein Tube's turn. Oh God, perhaps they'll move in together and share the enjoyment of their suffering.

I already look forward to seeing some of the creations of those two choice specimens of poetry and uprightness.[5]

So, my boy (God, how funny "my boy" looks when you write it down), now you've chastised yourself a bit. Now you can write on.

I'm writing a lot, partly because I'm enjoying writing today, writing for its own sake. It may be because the pen is so good, or because I am unusually sparkling with wit. What of it. It's all relative, as Kunwald said.—

At all events, I do regret one thing: that I don't have even more past to wallow in.

O Minna Tube, how I envy you and your love pangs. Make the most of them. With luck, you'll survive them. Stay strong, do you hear, and try to give a form to your pain, then it will make you [strong?].[6]

I'm the only one you'll ever love, your whole life long. I've got you in my net, from which you can never escape; and, if I wanted, you'd have to forget all I've done to you and kiss me again and serve me. Poor rich slave.

•

Well, I'm pretty far gone. So what. I don't intend to write down how much I've drunk tonight.

•

January 15, 1904
Jean Paul: up in a tree a poet sits like a nightingale (which he resembles in plumage, throat, and lack of guile), and watches the women set traps, and hops right down into them.[7]

•

J. P.: Poets are nothing but drunken philosophers.[8]

•

People who don't even say I.[9]

•

Cookbook recipe for a good bourgeois romance.
 Take two big, young hearts and clean them, either in baptismal water or in printer's ink from German novels, set them on the fire and under a full moon and bring them to the boil, stir energetically with a stiletto, take them out, garnish like crabs with forget-me-nots or other wildflowers, and serve hot.[10]

•

"For bourgeois girls do not know how to talk, or at least they talk more in hate than in love." [11] (Jean Paul.)
— — —
 With me it was exactly the reverse.

•

January 15, 1904
I have just shut down the lid on the relics of my beautiful first springtime. They rest in peace.

•

Vast and lonely, the world lies before me once again.
 I still crave adventure. Rather a lot. A woman? It's a shame I trust myself so little in love. But you've elevated my taste, Minna Tube, and made me a connoisseur. Well, we shall see.

Now I want to wander the world. On foot, ceaselessly. No, not ceaselessly, and anywhere I like it I will stay. And seek beauty. You shall be my love today and always.[12]

•

Paris, January 20, 1904, at my place
Because I'm going to get a little drunk tonight, I don't see why I shouldn't let my blue book join in.

I have arranged everything around me to perfection. The stove burns well, the water pot purrs behind me, behind that is my big picture, let it stand, and in front of me are all the ingredients for making a person happy.[13] The small tablecloth brightly reflects the glow of my lamp, and everywhere my strong blue shines toward me. But the water's just boiling, goodbye.

•

Voilà, here I am again. But not drunk, just very peaceable.

•

January 22, 1904
I'm already getting almost bored with writing Closerie des Lilas every time. Writing that I sit here, that I'm intrigued by my fat German, who sits two tables away from me, that I'm still restless, that I went to the Café Rouge, and that I found Schubert's Trout Quintet delightful.[14]

And yet when I don't have my blue book I'm not content, because it is the only chance I have to chatter on a bit. Worldviews. No, those are far too much trouble to write down. What else? My eternal restlessness, reminiscences, nothing really. I just press on and on.

And if my life goes well, brilliantly if you like, what do I get out of it. Logically speaking, everything. To live on, to elevate humanity to a higher plane, and along with that the desire to go on farther, to fly higher—if only I could be rid of that damned bacillus.

No, I am not happy, and those objectives that are visible in the far-off mists only point to other objectives still farther off. Peaks of human endeavor that show the way to further peaks. Because there's no end, there can't be an end. The cosmos chases blindly and powerfully after the cosmos. Toward a goal that leads back to the beginning. Like a cat chasing its own tail.

But maybe the goal ought to be some temporal happiness? I

have in me such an infinite power to be happy. But for that I need people, many people, men and women. And time.

So is it possible?

Yes, it is possible, and I will be happy.[15]

•

January 28, 1904 (Concerts Rouges)[16]

Kunwald wrote me today. I got the letter through Feigerl.[17] Toujours la même chose [always the same thing]. Gloomily polite and discontented writing to Feigerl, just gloomy and discontented writing to me.

Nothing can be done there. Will there ever be a night, in my current life, when I shan't go to bed discontented?

I don't think so.

•

Closerie, January 28, 1904

The end again. The usual book in front of me and inside me.

I come here so often that the waiters are amused. Perhaps partly because we were so drunk yesterday. Je m'en fiche [I don't give a darn]. The air is always the same, the gloom is always the same, and so is the urge to create. The urge to cut off. If only I can get under way again. Alas, I'm not.

•

Closerie, January 29, 1904, 12 o'clock

It's so restless and mindless, drawing these instant sketches. Tonight I could say exactly the same thing about myself. My nudes are not exactly distinguished by their variety. Only one woman can set my only interesting aspect vibrating. Isn't that sad and absurd. Without that second human being, I am nothing, unstable, unthinking, and uneasy.

•

Jean Paul: "his heart, which occasionally appeared in his eye in the form of a tear . . ."[18]

•

Idem: "Then at last great tears of happiness flowed, like the lifeblood of their full hearts, from the lover's eyes into those of the beloved."[19]

·

"Suddenly he stood up, as if elevated by a boundless enthusiasm, and said softly, looking at her: 'Clotilde! I love you, God, and virtue forever.'"[20]

·

"He went with a heart that bled itself full."[21]

·

"As one transfigured to one transfigured, he bent, *withdrawn*, to her sacred lips."[22]

·

(funny, don't you think?)

·

Tuesday, February 2, 1904
A year ago. How infinitely long ago it is already. Because MT of course was probably my great love. Wait a minute. Did I actually really love her.
 I really cannot say.

·

February 2, 1904, 12:30
Usual reminiscence. Very good red wine, danced at the Moulin de la Galette with an old cocotte, a maid from the provinces, and a Negro woman, little appreciated by them because I danced badly and spoke French badly.[23]
 All with a rather deliberate feeling for a stylish mood, without really possessing any such mood.
 So now the Closerie.
 Here in the thick cigar smoke, Norwegian-speaking, appearing to myself and others partly interesting, partly absurd, over the aforesaid red wine. Oh, you poor fellow, you can't even be sad over lost beauties,
 All right, not. A new bottle of red wine has just arrived.
 It won't be 2 o'clock for a long time yet. So cheers, Minna Tube.
 For the last time. Although I[24]
 Cheers.

•

Now I just sit and listen. And would like[25]

No, leave it. The noble Munch, who is sitting opposite me.[26] I'd really like to meet him. My heart longs for human beings, human beings who also suffer as I do. Because I suffer too. All the time. If I can really get it clear. What else is the eternal unrest for?

•

Georges[?], February 5, 1904, 8 P.M.

There are some forms of self-assurance, well-rounded and almost bureaucratic, that allow you to observe just how well pleased they are with themselves. Not very. "No," they say to themselves as they mentally review their acquaintances; "yes, all right; not that one; that one will do; but then I understand them all pretty well. I have all that too, only in a nicely rounded form, and that's why I know who I am."—

Nothing can make him lose composure, though he never talks about himself, and in spite of it all, through everything he says there is a whiff of that wonderfully perfect, revolting self-assurance. Not much, as aforesaid; but just so that one can always feel it.

•

Rouge, 9 o'clock

There are people who, if you ask them to get something for you, always forget it and never do it, and there are others who get a thing for us when we have long since forgotten it, or when it has become irksome to us.

•

February 7, 1904

Back at the Closerie des Lilas (which, by the way, means lilac gardens, as I recently learned); red wine again, not quite so good as on previous pages. Have just once again read through the whole, meaningless jumble of moods and am very pleased that I still have more than a half bottle of red wine in front of me. That's all. Before me lies Schopenhauer. Out of duty. And in spite of him I have no desire to penetrate further into the dull, stupid mysteries of a man who seems mummified in his own lifetime.[27] I want to live. I swear it a thousand times. I want to.

Makes no difference even if I don't wish it at this moment; the feeling is almost automatic in me.

I want to, and I'm never going to be able to. (As it just occurs to me.)

•

Closerie, February 11, nearly 12

My birthday. Of course I consider it makes no sense to celebrate for that reason and get drunk on red wine all over again, but it's such a nice pretext, and those really weren't necessary—but since I do happen to need these. But it isn't true, so I use it anyway.

That must be a pretty odd sentence. So at least I'm not drunk yet.

•

Cheers Minna Tube, I shall go on toasting you until I love another or—

you again.[28]

Artistes indépendants 20 February.

•

Grandes Serres de la Cour de la Reine.[29]

•

Madame Poupart rue Dancourt dix.[30]

•

February 18 or 19

In the night of February 11–12 I wrote her again. I was drunk. The letter was about spring, love, and Minna; on the 16th, Tuesday, it was Mardi Gras. On the last day of Carnival I received it back unopened.

I must say that really pleased me. If she had sent me a good-humored and affectionate answer, I'd have died of boredom. Poor me.

Aside from which, on the evening of February 12 I wrote three or four letters to her, all so bad and in such bad taste that I tore them up. One contained the question whether the letter was going to be sent back unopened or not. That was nice of you. Now I can once more think back to you with feelings of happiness and pride.[31]

•

February 20, 2:30. In the morning.
Here I still am.

I'm still awake and wish I hadn't been born, but I've got to live.

Just now I passed a house. There was dance music, lighted windows, the doors were open, and figures surged past each other.

At the Closerie there was also dancing upstairs. Old, familiar waltz tunes in both places.

I stood in front of that house for a long time and listened and watched. Memory and joy in human happiness.

•

February 21, 1904
Concerts Rouges.

Today I had my beard shaved off. Max Beckmann.

•

February 21, 1904
At the Closerie, alone at last. Almost every other evening ensemble with autres [together with others]. Now here I sit once again and feel remarkably well. At the moment there is nothing inside me, neither dream, pain, nor delight, let alone joy, not dullness either. Rien mais aimable [nothing, but amiable].

•

Today must be the 24th or 25th, in any case it is horrible.

I have to stay home tonight and don't want to at all.

Upstairs my colleague or confrère is entertaining his woman. I hear it with dark rage.

Ah, I wish, I wish I could get out of this decrepit old dump. It makes me feel so bad I could die.

Upstairs they're in rut, below right someone is whistling, and down in the yard the concierge is yelling.

There is no quiet or peace in this hideous Paris.

Well, let's just eat a few figs. I've just been reading some poems by Dehmel.[32] Another who has said word for word the same things I say. So what do I really want now. To create new beauties. To experience new beauties. Experience new beauties? I don't believe in that. Yes, I shall probably still be able to love, and that will certainly happen. But can the one I shall love be better than she is? I knew

the answer in advance. Not better, but maybe more beautiful, and then I still have to win her; that is what is new. Because I still need a struggle, I want one, because I can't yet do without it.

●

What's the date today? In any case, the day after the last page. I am alone again, always alone. It must be rather late. The wind roars in the stove, otherwise it is silent all around me, or would be if the pleasant peace were not intermittently shattered by the horrible whistling of some Frenchman. Even my neighbor upstairs is asleep.

So now I sit and think about what I would like to write. I have just leafed through Andersen, Bölsche, and Goethe, in a delightful jumble.[33] None can really give me pleasure. Only I myself.

Oh come, experiences, come! No matter what kind, just come. Otherwise, I'm certainly going to suffocate in my own idleness.

Will you come? Is there one among you who will make me happy at last?

I see it quite clearly before me, the vast outline of the experiences, all still rolled up together, dividing occasionally and coming toward me individually, sometimes in quick succession, sometimes slowly, very slowly. They are all there already.

Oh, if only I could be further on.

I laugh.

●

March 3, 1904
Beethoven quartet recital.[34]

Just came from there; in front of me is my absinthe, and in the Café Riche.[35]

At the concert there was a neck just exactly like hers, and even a green velvet dress to go with it. That neck. How could I ever cease to love such fabulous grace? Even now I'm still sorry that I can't be sadder at her loss. I can't be, because I expect to be and really want to be. It's not impossible that I broke off with her, just so that not having her might make me love her more afterward. Because I know myself quite well, thank God. Unconsciously even better than consciously.

Ah God, if only I didn't know myself so well.

It's so tiresome and so spiritless.

Nice paradox, all the same. And it really did come unconsciously, because I didn't notice it until I read through.

•

Yes, of course, and later my worthy sister is coming with my fat brother-in-law.[36] They are at the Châtelet, *Oncle d'Amérique*, in order to take a look at Paris and Parisian life.[37]

Today they're hoping to see something really improper.

•

Closerie, March 9, 1904

Sometimes I think fleetingly, but with a secret shudder, of whether she is going to be able to hold out. I would so greatly like her to hold her head high and maybe vanquish me again. Is that true? Perhaps.

Funny how it's all already such a dead issue for me. Irrevocably dead. If I were now to hear that she was dead. I can't think myself into that situation. Absolutely not

For the rest, this evening I am extraordinarily empty.

•

The longing to be able to enjoy some intense mood fully and completely, often leads us to delay its possible fulfillment, so long as circumstances do not yet seem ripe and sufficiently matured. It is curious, and I often wonder whether a desired state doesn't contain the germ of its own destruction by virtue of that very desire; but, if you desire it honestly, even desiring might do no harm. But it—the desire[38]—is still both sad and comic. Doesn't it reveal an inner emptiness, or at least a histrionic talent? I believe there are many playactors of the soul. Are they to be despised? No, they are more to be pitied. Because what they express, in spite of it all, is still longing.[39']

•

R. d. Mail 13. Salle Erard.[40]

4

Diary, April 1–May 7, 1904

(Fontainebleau, Burgundy, Geneva, Berlin)

THE LAST dated entry in the previous diary was March 9; Beckmann began this journal on April 1, some days after he had left Paris and arrived in Fontainebleau. The notebook is smaller and thinner than his other early diaries (8.9 cm × 14.6 cm). It has many torn, removed, or empty pages and many drawings, a few of single figures, but most of compositions that anticipate *Young Men by the Sea*.[1]

This diary records Beckmann's travels through Burgundy on his way to Geneva, followed by his sudden return to Berlin. Beckmann intended to make a walking tour to Italy, but walked only relatively short distances between a few locations in Burgundy and at some point abandoned his Italian plans entirely. He described many of the experiences and sights on his travels. He journeyed chiefly to enjoy the walk and the natural beauties of that region and made no reference to the historic importance of the cities or monuments he might have seen. He began to chart his expenses (in many subsequent diaries and sketchbooks Beckmann routinely filled pages with notes of costs and prices), partly because he was running out of money, partly, as he noted, because he felt it appropriate to note his pecuniary reality alongside his great thoughts about being an artist. In this diary, too, Beckmann said nothing of other art he is known to have seen. He did not even mention his visit to the atelier of the famed Swiss artist Ferdinand Hodler (1853–1918) in Geneva, which, as he wrote to Kunwald, seemed to confirm everything he himself had been trying to work out in painting.[2] He also failed to note the stops he must have made on that trip to see Grünewald's Isenheim altarpiece in Colmar and other museums.[3]

Neither here nor in his letters to Kunwald did Beckmann account for the sudden change of mind and heart that caused him to return to Germany much sooner than expected. Upon his ar-

rival in Geneva he was delighted to be reunited with German, Germans, and German beer, and noted that it was the first time in his life that he had felt any particular affection for his homeland. On April 17 he still planned to proceed to other Swiss cities before he continued to Italy, but the next diary entry was written in Frankfurt am Main, where he said that his travels had temporarily stopped. On April 28 he delightedly wrote of his arrival in Berlin-Charlottenburg and immediately set off to find Minna Tube, who had moved to the city in January. He was bent on finding his love and ready to go to work.

Fontainebleau,[4] April 1, 1904

A hideous state all around me. I want to walk by way of Geneva, and then Italy. But all that is still so remote that I absolutely cannot imagine myself ever getting that far. When I left Paris I was abjectly miserable and forced to stay here for several days by lack of money and by the consequences of my indisposition on leaving Paris. So foreign a city is just too unpleasant. I have come here—into this book, that is—just to make a note of that. Hopefully I can soon find something better to note down about my pleasures. Paris is already far away.[5] And I'm a long way from being more unhappy.

•

In the night, 1:45

If I don't go crazy tonight then I never will. Two hours ago I blew out my light. I tossed about for a long time and had just found the way into the Land of Nod when bow wow, woowoo wow, a good yard dog nearby started to bark.

At first, a faint hope that some sound had caught his attention, and that he would quietly go back to sleep. But no. He went on barking. At first slow and gentle, with well-nuanced pauses, then more subtly. He lets you get half to sleep, before dragging you awake with another short burst of bow wow woo. Then he keeps quiet again, barks again, and so on. Followed by spell of silence.

I know what comes next. The roosters.

Cockadoodle-doo: one in a deep bass, then the descant, and then one far off. All in neat succession. These roosters are good-natured. They don't deceitfully stop for a while, like the dog (just now it was cats), but start up and keep right on—and now there's the dog again, and from time to time some cats. Good night.

•

April 6, 1904
On the train to Avallon.[6] Misfortune pursues me. Around me are
jabbering French peasants who kill every thought stone dead, even
those unfamiliar thoughts that I would like to understand. It is rain-
ing outside, and I am so empty. A playactor in life, who would like
to hear others tell him that he isn't one: Nietzsche said something to
that effect, and it probably applies to me.[7] Even now I still believe in
the histrionic pleasure of self-abasement.

•

Auxerre[8]
 St. Gervais[9]

•

Evening is gradually closing in. I whistle Schubert's Serenade and
allow myself to be sad. What about? Perhaps because everything
outside is so gray, perhaps because raindrops hang on the railroad-
car window, perhaps because I don't have any real reason to be sad.
Everything else that I am thinking is chaff.—
 Love is really the only means of filling up this psychological
weakness and even making it into a strength. Because love fits in
everywhere and lets itself be shoved in everywhere. So happily back
to love after all, love the eternal riddle.

•

Inside me, the outlook gets grayer and grayer. Shall I ever find joy?
I don't think so.

•

Chastellux,[10] April 7, 1904
First stopover. (Usual tourist's journal entry.)
 It's raining quite a lot, and twice it was fine: when the sun came
through the thick, soft fogs and rain clouds, and then when I put on
a clean shirt here in the Maréchal de Chastellux.[11]

•

Such cozy, greedy contentment is also worth something, ghastly
though it is.

•

Lormes: [12] White wine, tired, sunlight.

•

I'm not ashamed anyway, but it's necessary. [13]

April 7	Fr. 0.50	Kafé de Avallon [*sic*]
	0.10	Oranges
	3.00	Déjeuner.
	0.70	Cigarettes
	0.40	Picture postcards
April 8	0.70	Bottle of wine
	3.35	Dîner
	2.00	Chambre
	2.50	Déjeuner Lormes
	0.60	Café Chassy.
April 9	5.00	Château-Chinon [14]
	2.00	Déjeuner
	1.00	La Selle. [15] Lemonade.
	0.50	Postcards
April 9	0.75	Train to Autun [16]
	0.20	Tartedels [17] [*sic*]
	0.30	Oranges
	1.00	Bread and butter
April 10	4.50	Dîner et chambre

On April 7 total assets	92.50
	<u>22.35</u>
On April 9 total assets	70.25

Oh, to hell with writing everything down.
Au revoir respectability.

•

April 7, 1904
I leave the pages blank thus far in order to get an overview of my expenses once for all. I cannot stand not knowing, because after all I am still dependent, and all this flighty grandeur is pretty threadbare, if it shows itself in a false way, through spending money.

•

Still Lormes. If I did not have the consolation of going on again to-
morrow, then I would also still wait. I am so alone and yet eternally
hounded. It is terrible. All beauties: they may be nothing but fetid
bubbles. All wisdoms: they may be atoms in the bubbles. May be?
They are, for sure. But, unfortunately, even these atoms can be very
beautiful. Women. Ah, women. Behind me, babble from the kitchen.
On my right an old farmer, writing; in front of me two picture post-
cards; and beyond a piece of sunset sky with the silhouettes of houses
and trees.

•

La Lelle [*sic*].[18] 4:30
Now it's not really a woman I hanker after. No, it's the mastery of
everything imaginable. Perhaps the urge is nothing but ambition.
The urge to dominate. But first I want to know everything. So that
I may later outlive myself.
 It's really beautiful around me here. Cosmopolitics or no cos-
mopolitics, I'd rather hear the cries of German children than these.
But otherwise it is really beautiful.
 Just now, great, dark, evening clouds are engulfing the sun. I
have reached the foothills of a mountain range, through which I
have just passed. Before me is open country, and then mountains
everywhere. How beautiful it was just now, as I turned away from
that dark wall of cloud and saw the great, yellow-golden evening
cloud that the sun still sees.[19]

•

St. Emilion [*sic*].[20] Dazzling sunshine as I left Autun this morning.
Still is. I am tired and ready for breakfast. Bon appétit, numskull.

•

Bletterans.[21]

•

Chalon-sur-Saône[22]
In a stinking little café. Toute suite [*sic*], music. Before me a large
bridge over the Saône. This morning I thought I was about to fall
sick and had already familiarized myself with hospital facilities.
Now I'm OK. And the beer is lousy. And I am so gloomy. No hopes
at all for the future. And then flirting with the Void.

Upstairs there are approximately eight dull-brained musicians; in the whole café, three customers and one waiter. From time to time one of the violinists goes crazy and plays a few very high notes between pieces. The only beautiful thing is part of the sunlit bridge, which can be seen through the inanely painted-over café window.[23]

•

Really I can hardly imagine that there is still anything beautiful in the world.

•

It's demeaning, I know, to read Nietzsche in this place. Mais—

•

Chalon, April 11, 1904
And tomorrow I journey on, how pleasant.

•

In a fairy tale.[24]

•

Geneva,[25] April 14, 1904
The first finishing school. At last, after so long: feelings of home stirred in my breast, as I saw the peaceful couples trooping along, so upright and so surprised (but the impression of surprise was only superficial). And you see those familiar little dashes of red in the hands of fashionably dressed gentlemen and ladies. Baedeker était mort, vive Baedeker.[26] And real German beer advertisements, truly German; as a Frenchman, you'd need a translation. Ah, how beautiful it is, this distant reflection of home. One feels German again. Between German clerks and business travelers, our heart quivers with new, unprecedented feelings of belonging; the consciousness of home. Well, then. Germany.

•

Monnaie [currency].

•

Hurrah, hurrah, hurrah, the snow-capped mountains loom over the buildings, and the dark patches of fir trees shade off wonderfully into a whiteness that is softened by distance. They stand there as

magical, as unmotivated, as if a person were to wake up in the
morning, look around drowsily, and see great giants with snow on
their heads, standing around the bed.[27]

•

At Bellevue, half an hour from Geneva.[28]
The white mountains before me once again. I am devoid of desire,
devoid of essence, without thoughts of any kind. I am just sunning
myself.

•

On we go. It's both beautiful and bleak.

•

Geneva: on a lake bridge.
 There it is, my soul is totally contaminated by reading.
 It has lost its virginity.

•

The men are charming; tall and well built, they take off their hats as
soon as they enter a bar and before they close the door. Then a mag-
nificent confusion of movements comes about. The hand that ought
to be closing the door finds to its surprise that it has the hat in it,
and now strays helplessly back and forth; the entire body is already
bent forward and about to walk in, and yet is held back by a hin-
drance that it does not fully understand.
 All this, of course, lasts only a moment.

•

Veyrier.[29]

•

Geneva,[30] April 17, 1904
Café, 11 P.M. How debased are my indications of time here. Quite
unlike Paris. Paris and my life there are now already like a dream to
me, but a dream to which I do not long to return.
 The day after tomorrow I leave Geneva, then comes some more
of Switzerland, and then Italy. What will it bring me: more disap-
pointments, or rather no satisfaction again?[31]

Frankfurt![32]
The song of the road comes to a temporary end. One must once
more turn one's concentration backward. Bad luck[?]—what—

•

Charlottenburg,[33] April 28, 1904
Wonderful
 Wonderful,

•

But I have little desire for anything new. But I have found—though
not touched—much matter for my melancholy.[34]

•

Can't I manage a great emotion of my own? Always the donkey be-
tween two or even more bales of hay. Here even energy doesn't help
at all: this is something I inherit from my parents.

•

May 4, 1904
English Etchers.[35]
 Frank Brangwyn, excellent.[36] Etches so deeply that the print
gives the effect of high relief. He thus achieves an extraordinary
power and an almost monumental bigness of scale.

•

May 1904
Shall I never find you again, Minna? *Never* see you again? Never
again meet you.[37]

•

Saturday, May 7, 1904
In a café, catty-corner from her apartment.[38] Wouldn't it be strange
if I were to go on sitting and waiting here for her to come out of her
apartment, and maybe she moved out long ago or is long since dead.

•

Do you sometimes think about me, Minkchen

> And now my dearest, you must ride
> And through the blue remoteness wide
> My longing tracks you night and day.

Will you be true to me in spite of myself.
> Will I ever see you again Minna Tube [39]

5

Diary, December 26, 1908–April 4, 1909

(Berlin, Hermsdorf)

MUCH HAD transpired since Beckmann completed the final entry in his previous diary in Berlin-Charlottenburg in May 1904. That summer he returned to Braunschweig and vacationed at the sea, and in the autumn he moved into an apartment/studio at Eisenacherstraße 103 in Berlin-Wilmersdorf. According to Minna Beckmann-Tube's later memoirs, the two did not really see each other again until about a year after their parting in Amsterdam at Christmas 1903. Minna subsequently returned to Berlin and began to study with the eminent impressionist and Berlin Secessionist, Lovis Corinth (1858–1925). As she remembered, it was only the following winter (1904–5), as she returned from an evening drawing class, that she again ran into Max.

Minna's mother had moved to Berlin-Wilmersdorf in January 1904. After Minna and Max resumed their courtship, he was introduced to Frau Tube and regularly associated with the family and their acquaintances.[1] Beckmann's mother and siblings had all moved to Berlin by 1905, but his mother died in Braunschweig in August 1906.[2]

Minna later said that when she first saw Max again he had completed a great deal of work, including the large *Young Men by the Sea* in the spring of 1905. From 1906 on he exhibited with the Berlin Secession, the city's major organization for modern art.[3] He enjoyed his first major success, however, when his long-planned *Young Men by the Sea* was awarded a first prize at the exhibition of the Deutscher Künstlerbund (German artists' league) in Weimar in the spring of 1906. The distinction brought Beckmann a six months' stipend to stay at the league's newly acquired Villa Romana in Florence.

At the end of the summer of 1906, a month after his mother's death, Max and Minna were married, spent a month in Paris

on their honeymoon, and traveled to Florence by way of Munich to begin their residency at the Villa Romana on November 1. Shortly before their marriage they had purchased property at the edge of the large Hermsdorf forest at Ringstraße 8, Hermsdorf, a newly developing suburb at the extreme northern end of the city above Tegel. They built a home according to plans drawn by Minna and finally moved into their Hermsdorf residence in the autumn of 1907.

The success of *Young Men by the Sea* immediately brought Beckmann major acclaim within the Berlin art world. Notable artists, critics, and museum directors such as Count Harry Kessler, Max Klinger (1857–1920), and Julius Meier-Graefe (1867–1935) had sat on the jury that awarded Beckmann the prize, and he met with all three on several occasions during the following months. The connection with Meier-Graefe would be particularly crucial to Beckmann, and the two would remain in contact for the next three decades.[4] Already one of the most important critics in Germany and Europe, Meier-Graefe had been an early champion of the decorative arts, art nouveau, and the Jugendstil; one of the first German critics to write on Edvard Munch;[5] the celebrated author of the influential *Die Entwicklungsgeschichte der modernen Kunst* (History of modern art, 1904);[6] and a major contributor to the important show of nineteenth-century German art, the *Ausstellung deutscher Kunst aus der Zeit von 1775–1875*, held in Berlin in 1906.[7] At several points in the following diary Beckmann spoke of Meier-Graefe and of how he wanted to win him to his own cause, even though he also spoke critically of Meier-Graefe's views.

Perhaps because he identified the critic with the latter's early advocacy of the decorative arts, Beckmann repeatedly found Meier-Graefe's tastes "too aesthetic." Though Meier-Graefe had stirred Beckmann and many of his generation with his writings on modern French art, he surprised and disappointed most of those same people by reserving judgment on the young German painters of his own time. When he finally did speak out on the new art in lectures during the winter of 1912–13, Meier-Graefe was highly critical of it.[8] He would not write anything on Beckmann himself—one of the few younger German artists he tolerated, and that with many reservations—until 1918.

The success of *Young Men by the Sea* also won Beckmann the attention of Berlin's leading dealer of modern art, Paul Cas-

sirer (1871–1926), and Cassirer offered Beckmann his first Berlin show in January 1907.[9] In order to complete arrangements for the exhibition and to visit their families, Max and Minna returned to Berlin over Christmas and socialized with Cassirer and his circle before they resumed their Florence stay through the spring of 1907.

Beckmann-Tube later wrote that when they returned to Berlin at Christmas 1906–7 Beckmann had already felt other artists' and critics' resentment toward him and the success he had enjoyed with *Young Men by the Sea*. After he began to exhibit the quite different works he had subsequently produced, Beckmann began to receive some sharp criticism. He continued to participate and exhibit in the Secession, which he officially joined in 1907. Max and Minna enjoyed many different circles of family, friends, and acquaintances in Hermsdorf and Berlin. They met not only celebrated older members of the Secession such as Corinth, their good friend Dora Hitz (1856–1924), Ludwig von Hofmann (1861–1945), and Max Liebermann (1847–1935), but also such leading personalities in the arts as Gerhart Hauptmann (1862–1946), their longtime friend Wilhelm von Scholz (1874–1969), Rudolf Alexander Schröder (1878–1962), Frank Wedekind (1864–1918), and many other artists of the Secession.

Beckmann began the following diary at the end of December 1908, when he decided to take a break from painting over the Christmas period. At one point he even wrote that it seemed he was doing nothing but keep his diary. He had exhibited in the spring Secession show of 1908 and again received some hard criticism; he exhibited in the Secession's annual winter show of prints and drawings as he wrote much of this diary.[10] In 1908 the Secession was in the midst of crisis. One of its oldest and most conciliatory members, Walter Leistikow (1865–1908), had died in the summer, and from that point on the group had become increasingly divided. The younger members resented the older generation's rejection of their art and what they saw as the excessive power of Paul Cassirer, who had a major say in all that was done and shown in the Secession.

Although many of the young artists who ultimately became known as expressionists had shown in the Secession through 1907, they were increasingly rejected in the following years. Whereas Beckmann was artistically more conservative, contin-

ued to have his works accepted in the Secession, and commanded
relatively high prices when he sold pictures, he had not yet sold
many pieces.[11] He, too, felt hostility toward the older fathers of
the Secession, and especially toward Cassirer, whom he some-
times stereotyped as an arrogant Jewish businessman, reflecting
the anti-Semitism that persisted even in relatively liberal Berlin
circles. Although Cassirer had already given him an exhibition
and purchased some works, Beckmann still had financial con-
cerns and felt Cassirer had not done enough for him. He contin-
ued to resent Cassirer and quarrelled with him for most of the
years during which they were associated.

Beckmann was quite a different person from the moody
young man of the early diaries when he wrote this journal,
which was larger than the earlier volumes (12.1 cm × 18.4 cm)
and written evenly in ink, with little crossed or torn out.[12] His
and Minna's son, Peter, had been born the previous summer, on
August 31, 1908. They regularly saw friends and family, at-
tended concerts and exhibitions, visited the city, and walked in
the Hermsdorf forest. They also struggled with the difficulty of
heating their new home, something that eventually caused them
to take an additional apartment in Berlin.[13]

By 1908 Minna seems to have abandoned her painting, be-
gun to take voice lessons, and tried to teach Max to play piano;
throughout this and the other diaries he showed a good sensi-
tivity toward music. His diary's continued, lengthy observations
about nature and about Berlin and its surroundings are also
noteworthy, and tell a great deal about middle-class life in Berlin
in the early 1900s. Beckmann welcomed the city both for the
opportunity to be close to nature in Hermsdorf and the outlying
suburbs and for the stimulus of living in a great city that he saw
as one of the most exciting new centers for art.[14] Like most of
his contemporaries he loved the city for its vitality and variety
and traversed it regularly on foot and via public transportation,
noting the grandeur of its finest monuments, the pomposity of
Wilhelmine tastes, and the newly emergent sections of the west,
south, and north into which he and his friends were moving.
Beckmann admired nature, then, both in the natural elements
and in the energies of the people, streets, and lights of the bur-
geoning Berlin.

Though Beckmann continued to jot down notes and obser-
vations from his readings and kept on reading, he now hardly

had the time for the extended musing on philosophy found in his earliest diaries. On the other hand, he wrote much more extensively about his ideas and observations of art. At this moment, as he was bursting with impatience at the state of the Berlin art world, Cassirer, and the Secession, he found it timely and fitting to start another diary. He recorded a lively and engaging situation of which he was a part and conveyed his views on art, artists, critics, and the Secession with great urgency and insight.

Beckmann's discernment of and statements on other art are crucial to an understanding of his own position and practice. He was an admirer of great older traditions, but he was equally bent on making a new art that gave expression to the energies and feelings of his own time. He studied a much wider range of art than did most of his contemporaries: he had found major stimulus in the works of Gustave Courbet, Édouard Manet, Edgar Degas, James McNeill Whistler, Paul Cézanne, Claude Monet, Paul Gauguin, Vincent van Gogh, Ferdinand Hodler, and Edvard Munch,[15] but he also remained deeply attuned to the art of his German contemporaries. In this diary, for instance, one of his most extensive and impassioned discussions is devoted to the art of the Berlin working-class artist and Social Democrat, Hans Baluschek (1870–1935). Unlike many of his expressionist contemporaries he continued to find sustenance in the distinguished German realist and impressionist traditions of Adolph von Menzel (1815–1905), Wilhelm Leibl (1844–1900), Wilhelm Trübner (1851–1917), Corinth, Liebermann, and Slevogt, and in the idealist figural art of Arnold Böcklin (1827–1901), Hans von Marées (1837–1887), and Klinger.

In 1908–9, questions about tradition, and the modern German tradition in particular, were central to discussions of modern art in Germany.[16] A lively and critical debate on German artistic identity had recently been unleashed by Meier-Graefe's harsh 1905 attack on the Swiss artist Böcklin—hitherto one of the most admired artistic figures in Germany—and the art historian Henry Thode's (1857–1920) extensive retorts to Meier-Graefe, and by the 1906 *Ausstellung deutscher Kunst aus der Zeit von 1775–1875* (Meier-Graefe's role in that exhibition had to be concealed from Kaiser Wilhelm II because of the Böcklin controversy).[17]

Because of their international, cosmopolitan tastes, championing of French art, and Jewishness—traits that increasingly

were considered synonymous by their more conservative attack-
ers—Meier-Graefe and Cassirer increasingly bore the brunt of
attacks, not just from German nationalists and populists opposed
to the importation of French art, but also from others concerned
about maintaining a distinctive identity. Beckmann, who was
strongly influenced by the modern French tradition, did not
share the views of the most conservative opponents of Cassirer
and Meier-Graefe. Yet he often found Meier-Graefe's tastes too
much the product of a literary imagination; too distant from the
real practice of art; too colored by Meier-Graefe's own variously
decorative, impressionistic, painterly, and Francophile aesthetic;
and too little concerned with the new art produced in Germany.

Thus, while Beckmann recognized the importance of win-
ning a critic of Meier-Graefe's stature to his side, he disagreed
with many of Meier-Graefe's views, especially with what he saw
as the critic's too narrowly aesthetic celebration of the recently
rediscovered Spaniard El Greco; his inability to distinguish Beck-
mann's work from that of his contemporaries; and his attack on
Böcklin. Going against the current tendency—led by Meier-
Graefe—to reject Böcklin's look, sentiment, and vast popular
success in Germany, Beckmann stood up for Böcklin and what
he admired as modern in Böcklin's grotesque vitality, even if he,
too, saw the dangers of the vast Böcklin following. Similarly,
Beckmann disagreed with Meier-Graefe's current championing
of Marées, whom Beckmann said he found too cold and intellec-
tual, even though he, too, had been influenced by Marées in his
own early *Young Men by the Sea*. In fact, Beckmann now even
voiced disapproval of his earliest masterpiece—which he called
his "most impersonal" work—demonstrating that he had moved
away from his earlier attraction to the more aesthetic art of Ma-
rées and the Jugendstil to a more vulgar and energetic ideal.

Beckmann had initially oriented himself toward the modern
German art of the Secession, impressionism, realism, and neo-
idealism. Nonetheless, he found some major limitations in what
he saw as "dry" and "intellectual" in Liebermann, Klinger, and
Marées and concluded that, though they were useful teachers
who provided a base from which to proceed, he and his contem-
poraries had to go a new way. He was thus extremely pleased to
meet Rudolf Klein (1871–1925), a critic who had written two
highly favorable reviews of Beckmann's work in the revisionist
socialist journal, *Sozialistische Monatshefte*.[18] He found that
Klein, another champion of the modern German tradition,

shared similar criticisms of that tradition and a common desire for a lively and engaged art that reflected the feelings of its own place and time.

Given those views,[19] it is no surprise that Beckmann had absolutely no use for the abstracting modernism of Henri Matisse, which he considered insolently unfinished, simplified, flat, and decorative when he saw the first Matisse show in Berlin in January 1909.[20] Beckmann thought that Matisse was intelligent but felt he had drawn the wrong conclusions from van Gogh, Gauguin, and Cézanne. Though Beckmann's views might seem hopelessly provincial and wrong-headed in the face of the history of modernism, they were the views shared by many liberal minded people in the German art world. Among the few exceptions were Cassirer, who had mounted that Berlin exhibition;[21] the Secessionists Oskar Moll (1875–1947) and Greta Moll (1884–1977), two of the several German artists who had studied with Matisse in Paris; and expressionists such as Ernst Ludwig Kirchner.[22]

Beckmann was keenly modern both in his attempt to make an art out of the art of his own day and in his socially responsive attention to what he saw as the most real and urgent issues of his time. In 1909 he felt Matisse had little pertinence to those goals. He began to look carefully at Matisse only after protracted periods in Paris in the later 1920s and 1930s.

Saturday, December 26, 1908
Got up late. Then wanted to work on self-portrait if possible.[23] Everything was already under way when a telegram arrived from Missis Roller announcing that she and her daughter would visit on Sunday. Minkchen and I then deliberated as to what to do, on the sofa in the warm studio, in front of the mirror that I had set up to paint the self-portrait. Which gave me the idea of painting a big double self-portrait.[24]

Then after dinner I went downtown to tell Missis we could not meet tomorrow, and to invite them for New Year's. Found her not at home and was there writing her a note to convey the essentials when she and her daughter arrived. It was very pleasant. It is amazing when you come across people who really do feel the same way you do yourself.

Then I stopped by the Café Mandl for a moment,[25] then at the station I met the Molls,[26] who were on their way downtown, and

arrived home around 8 o'clock, where dear Mink had already served
dinner and everything had a very calming and harmonious effect on
my agitated nerves. After supper we each read our own copy of *Des
Knaben Wunderhorn,* which we had unknowingly given to each
other for Christmas.[27]

At the moment I don't really relate to it. Apart from a few
things that have strongly affected me, I have not yet really caught
the charm of the folk style.

I guess I'm too much of a painter and not enough of a man of
letters.

Sunday, December 27, 1908
In the morning picked up the Röslers from the train.[28] They came
three trains too late, so that I had time to drink a glass of beer and
get a shave. Then we looked at houses in the new development,
about which the Röslers were very enthusiastic and might buy.[29] On
the way back for lunch met the Schockens, who had also walked
over from Tegel with a view to house buying.[30] Unfortunately, I
could not invite them to lunch because we didn't have enough space
or food, but they promised to come around in the afternoon.

At home Buschchen, Anne-Marie, Martin, and Tutti Jackstein
were already there.[31] Before lunch there was a lengthy picture-
viewing session. Schocken (when they both came after lunch) found
the *Resurrection* especially good; Frau Rösler, on the other hand, did
not, but [liked] *Deluge.*[32] Tutti was all for *Resurrection.*

A really nice and lively day. Schocken played piano, Beethoven.
Minkchen sang very beautifully. Then Frau Rösler had to leave, and
Tutti Jackstein went to keep her company, and soon afterward the
Tubes went too, so that, since Minkchen and Frau Schocken were
with Peter, we three painters had time for a thorough argument.

I pointed out how Hans von Marées, whose stock is so high at
the moment, makes his figures strongly individual, and for that
reason I ranked Böcklin higher—as an artistic principle—on the
grounds that he has a more naive and more powerful way of bring-
ing his figures alive, whereas to me the figures in Marées are much
too deliberately the bearers of line and shadow, and thus too ab-
stract; they give me a certain aesthetic pleasure, but don't command
such a direct, individualized feeling of life as some of Böcklin's ef-
forts.[33] Not to speak of Rubens and Rembrandt, of course.[34] I likened
Marées to Stefan George.[35] Both not vulgar enough. Schocken and
Rösler shared my view to some extent, though Schocken still had

some reservations. Of course, I accept the legitimacy of Marées's kind of art, but it seems to me to belong to a specialized, overly artistic realm of art, presently incompatible with my own vital sense as a painter, which is totally concentrated on objectively individualized life.

Enlarging still further on this theme, we ate dinner, during which I finally came out with my idea for the new Secession. Schocken and Rösler delightful about it, wanted to join in straight away. Very nice of Rösler in particular, since he has just had his first success at the Secession.[36] First practical plans. Seriously considering whether to do it this very year. I suggested the exhibition hall by the Zoologischer Garten.[37]

Minkchen too was in favor of the plan (the new Secession), which especially pleased me.

We were all united in a sense of repugnance, and of the impossibility of developing our German art under the absolute domination of Cassirer's business interests, with all his indolence and his blasé attitude. To be discussed further at Schocken's, tomorrow afternoon. At the moment I don't believe the idea will come to fruition this year. But it won't be long now.

Monday, December 28, 1908
Got up very late at 12:30. After lunch set out for the train station in the blinding cold with Minkchen. Beautiful, clear frosty weather. Minkchen turned back before reaching the station because of Peter and the cold, otherwise she would also have come to the meeting. In the train I was amused by a small girl who, even though she was wrapped up as warmly as possible and in a perfectly warm compartment, could not keep still and kept desperately screaming "So cold! It's so cold!"—and the comic, pitiable embarrassment of her unfortunate relatives, who busied themselves trying to quiet her earsplitting screams.

At Schocken's, my usual, ironic fate befell me.[38] I arrived enthusiastic and full of plans and designs, was pleased to see (from their hats and coats) that Herr and Frau Rösler were already there, dashed into the room—and was received with a particularly friendly smile by Frau Schocken's very nice, kindly mother, among the others.[39] Of course, the secret conspiracy could not now be mentioned. To cover my nervousness somewhat, and also because it was necessary, I dashed out to take to Fräulein Hitz the galoshes that Minkchen had borrowed from her.[40] She was out. When I got back to the Schock-

ens' the opportunity for discussion soon came, and I made Frau
Rösler join in; with a terribly endearing mixture of pride and mod-
esty, she had been reluctant to intrude, on the grounds that the dis-
cussion was a matter for men. So then of course Frau Schocken took
part as well.

The talk produced little that was new. I was just delighted to see
that these nice people had not changed their minds since yesterday's
first flush of enthusiasm. I was particularly impressed by Rösler,
who really has very little positive reason to be dissatisfied with the
Secession, since he had a relatively big success at the last Secession
exhibition and sold his largest picture.[41] Then he and I went on to
the exhibition halls at the zoo, where we had the joyful surprise of
hearing that the rent for one month is around M 15,000.

That brought us rather forcibly down to earth. The prospect of
having a proper, independent exhibition venue, even if only for two
months, immediately dwindled to a one last minimal hope: that of
finding some noble money man. In the café, where I also briefly
spoke with Spiro, we tried to renew each other's courage.[42]

Came home around 9 o'clock, where Minkchen greeted me with
a nice thank-you telegram and a letter from Goyer, in which he
asked me where and when the mortgage of M 4,000 would be paid
off. Because Richard[43] hadn't kept me properly informed about this
payment, I had totally forgotten it, and the worry of finding the
money in a hurry did nothing to raise the spirits that had been
dampened when the new Secession project proved unworkable.

Tuesday, December 29, 1908
Richard told me that Grethe[44] would let us have the mortgage. At
1:25 we picked up Fräulein Erlenmeyer, who was here until 5.[45]
Very nice, pleasant person, but unfortunately has no general cul-
ture. Only interested in the particular. Then took her back to the
station. Afterward went to see the Landauers.[46] First Frau Landauer
alone. Very nice woman. Arguments with her about drama and po-
etry.[47] Then Landauer came in. We also talked with him about Ru-
dolf Klein; though toning it down for friendship's sake, Landauer
still shares the general low opinion of him—snob, fool, etc. So I
stood up for him.

I like Landauer a lot, so far, and I have yet to notice anything of
the woolly idealism that is attributed to him. I'm curious to see
what happens when we come to his hobbyhorse: peaceful anarchy,
revolution, etc.

Received letters from Nauen,[48] who asks me to name a day for a visit; from Mistress Roller, who unfortunately had to cry off Thursday because ill; from the purchaser of Lump,[49] a note of apology for not buying; from Arthur Stein, New Year's greetings. From Landauer received a gift of his short stories and borrowed Mombert and his own book *Revolution.*[50]

December 30, 1908
In the morning went to Grethe's about the mortgage. On the way to the Tubes', called at the Röslers' about afternoon visit to Tuch.[51] Lunch at Busch's: Martin, Anne-Marie, and Aunt Mariechen. Rösler picked me up; unfortunately Tuch was not at home, only his wife, his child, and a picture begun by him that in the darkness seemed somewhat Gauguin-like and Hodler-like to me.[52] But that means nothing, because it was too dark to tell. Then to café with Rösler, from where we telephoned and unfortunately found out that no trains run over New Year's, so the Röslers will have to leave the station here around 12 noon. At which this last engagement for New Year's fell by the wayside. Then we went to see the Schockens. Unfortunately, he was not at home either, so we talked for a while with Frau Sch. She was therefore the first member of the family to hear the bad news of the M 15,000 for the exhibition hall. Then she told us they were at Dora Hitz's on Tuesday evening. I was much amused to hear that (perhaps instinctively) my dear friend made a vigorous propaganda onslaught on my revolutionary ideas, with the occasional rather unflattering comment as to my own youth, overly high opinion of myself, etc. etc.—whereas to my face she has made quite explicit references to my godlike artistic genius.

Of course, she still talks to the Schockens in terms of respect and the keenest interest.

Minkchen thought not incorrectly that it may well have been a certain jealousy of Schocken, as being too remote from her influence etc., that led her to express these ideas, which are not fully compatible with her true views. It is such a shame that there are so few people one can really trust. At the moment, aside from my wife, I think Rösler is the most immediately trustworthy. We'll see for how long.

Rösler then had to go. In the meantime I procured a frame, telephoned Minkchen, half iced-in at Hermsdorf, and ate dinner at the Schockens'. Argument with Schocken about the structure of painting as the most penetrating criterion of criticism; he would

prefer to rank this below the overall impression, and I, to some extent, would place it above. The structure is the handwriting of the painting; to me, how the stroke is applied, or how others are placed over it, embodies the most comprehensive definition of an artist as honest, or not fully honest, or altogether untruthful. In this sense, "honest" is to be identified with strength and ability, with the absolutely most sensual feeling in painting.

Got home around 10:30. Everything was more or less frozen solid. It was 16 degrees below zero [3 degrees Fahrenheit]. Poor Minkchen had had Peter screaming all day, and it took me a while to thaw her out and put her into a good mood. But then it was really nice.

Thursday, December 31, 1908
Busy the whole morning with the heating, because the stove had picked the perfect moment, with temperatures at 18 below zero [zero Fahrenheit],to embark on its well-earned retirement. Around 4 P.M. I finally achieved my aim of making it roar. Then we went into the village to buy punch etc. for the evening. On the way, I pressed for the Landauers to be invited over for the evening, and Minkchen suggested inviting them to go sledding instead. So that was what we did. Landauer received us in a terribly cozy green silk dressing gown, also his very nice little girls Gudula and Brigitte[53]— they of all people had to be on the outing. They were delighted and willing. We also met Frau Landauer's brother, a very nice-looking, very quiet musician (singer). A strange person; after we got back from the outing, when I stayed on a while at the Landauers' and chatted, he scarcely said a thing, just constantly uttered oddly quiet, hissing sounds (I could not see him while he was talking with Landauer), which sounded like the noises made by a deaf-mute or a lunatic. I found it embarrassing. The Landauers didn't notice it, or at least not officially, and then when I caught sight of him he had such an indifferent, half-absent, half-interested expression that I didn't know what to make of him. Our outing was above all cold: via Waidmannslust and Tegel back to our house,[54] where we dropped Mink off on the way back to the Landauers'. High spirits in the snow, with much cigarette smoking, and cracking and eating of almonds. At the Landauers', very earnest chat about poetry and drama, also quite a bit about my art. Then at home it was pleasantly warm, Minkchen cheerful and already warmed up again.

During the meal we tried the punch we had brought, but (I at

least) very soon switched over to beer. I then read still more in the newspapers about the terrible disaster in Messina.[55] An account by a doctor—and specifically the part where some half-naked prisoners, who had been set free in the tumult, attacked other people and their property—gave me the idea for a new picture.[56] Then, while Minkchen was looking after the boy, I made the sketch for it.[57] I'm curious to see what will come of it. At the moment the subject interests me greatly.

Now it is 11:30. In a half hour the year will be over. Just now we concluded that the year 1908 has brought us much good inwardly, and the little boy too. Outwardly, on the other hand, not so much. Misunderstandings and unnecessary hostility. On the other hand, again, two valuable friends, Schocken and Rösler; Dora Hitz with some qualifications.

If only all years can make us as much happier, and me as much richer in my painting, as this one, then we'll be quite content with our lot. *Happy New Year!*

Friday, January 1, 1909
If the first day of the year were to be symbolic of all those to follow, then 1909 would turn out freezing and extremely uncomfortable. Waited in vain all afternoon for Nauen; once more, expectation without fulfillment. Then Mink gave me my first piano lesson. Pleasant dinner (Minkchen ate up the sauerkraut). In the evening looked at picture books. Then, while Mink was giving the boy his bottle, talk about art. New enthusiasm for my earthquake painting. Then to bed.

Saturday, January 2, 1909
In the afternoon went to Buschchen's to borrow the kerosene heater. Anne-Marie was there. Then to Schocken's. The Röslers came, and Rösler brought the news of two new exhibition possibilities. Then a Dr. Meier and his wife also came. I talked a lot of gratuitous, skeptical guff, using paradoxes to cover the rather cramping effect of the new acquaintances and the resulting pledge of silence about the revolutionary plans. In the café, before I went back to Buschchen's, I read the first part of Meier-Graefe's Spanish diary.[58] I'm annoyed that he squanders all that enthusiasm on El Greco, instead of opening his eyes to find the same—but for us moderns still more essential—things in my paintings, without the eternal aesthetic posturing.

Mightn't it be better to capture this intelligent soul-clown and exploit him for my own purposes? Then ordered the frame for *Earthquake.*

Sunday, January 3, 1909
With Minkchen went to see the Schockens, Tuchs, and Röslers. Found all three couples at home.

Talked about revolutionary ideas with all. Mood faint-hearted.

Tuch not averse, but demands guarantees, the idiot.

But I still think he'll join in, if it comes to it.

At the Röslers' it was very nice. Terrific liverwurst and breast of goose. We went on from the subject of revolution to talk about art. Both Röslers object to *Resurrection.* She even more than he. She finds it dirty and conventional. He finds it brilliant in parts but pieced together, and again conventional in parts. A shame. But otherwise really terribly nice people. Later had some champagne as well.

Monday, January 4, 1909
In the morning wrote Meier-Graefe to ask whether he would like to see my pictures.

In the afternoon the Landauers came. She looked at my paintings. Her way of looking at things, slowly and intensively, was pleasant, and her judgment not unsympathetic. At coffee I then brought him around to his socialism. As expected, his theory seems to me to be too idealistic, not taking the banal average enough into account, but always thinking only of exceptional persons. Perhaps realizable on a small scale, as Minkchen believed, among the Moravians, etc., but never on a large scale.[59]

Then Mink and I took a wonderful walk through the mild evening. It has suddenly turned warm again, and the snowy streets have turned into streets of slush. But there is already something like a first breath of spring in the wind. This very first herald of spring was wonderful when the long, thin, black trees were reflected in the great puddles at twilight, and the warm wind led us across a field still partly covered with snow.

In the evening a letter from Tuch that made us absurdly suspicious—as if, in spite of yesterday's promises, he had actually gone to talk with Kolbe after all.[60] Firstly because he seemed so very certain that Kolbe would *not* join in; secondly because, oddly enough, he used exactly the same stationery as Kolbe.

Still, it may be a mistake.

Tuesday, January 5, 1909

By the first mail, news from Meier-Graefe that he wants to come tomorrow. Extremely friendly. In the afternoon, downtown to the Schockens'. He has the idea of getting a certain Vogtländer to act as entrepreneur in setting up the art salon. Through Dora Hitz.

Then Rösler came; we took a walk and dropped into the café for a moment, where I met Spiro, who made an appointment for himself and his wife to come on Monday.

Chewed over a few things with Sch. and R. We come to no other conclusion than to find a money man whom we can influence. Soon came home. Somewhat nervous and also sickened at the prospect of the critic's visit tomorrow. One really ought not to mind so much about things like this.

I traveled into Berlin with Landauer. Boring.

Wednesday, January 6, 1909

Meier-Graefe has been here. Because of the difficult route I went to collect him in Berlin.[61] At his place also met a Dr. Grautoff.[62] On the way, art chatter. I declared to him my unfavorable view of Marées, on the grounds of his overly aesthetic isolation from life—as opposed to Rembrandt, Tintoretto, and also El Greco.[63] Also revealed that I felt less respect for Delacroix than for Rubens and Rembrandt; he had to agree, but attributed it to an inferior period, which of course makes no difference to me, and said that Delacroix had shown many French artists the right way.[64] A great din about El Greco from Meier, which was nothing new to me. Then my paintings. It was a comical mixture of stupefaction, fascination, censure, and other things. Went on talking a lot about El Greco. He found *Deluge* the most unobjectionable, *Resurrection* and some other smaller things the most interesting. All in all, it was not uninteresting. A pity he has only a literary response, even in matters of style; otherwise he would not have mistaken a painting by Schocken that hangs in our dining room for one of mine. He didn't like it anyway, but our styles are nonetheless so shriekingly different that he ought to have noticed. In the afternoon we took the 57 to Buschchen's. She was very happy to see her long-lost daughter again after the cold. Aunt Mariechen was also there.[65]

Then in the evening to Countess Hagen's, with Kellermann, Hollitscher, Herr and Frau von Bülow, Frau and Fräulein Lessing, Herr and Frau Schocken, and Gerda Schröder.[66]

Roast hare and champagne. As we afterward learned, the count-

ess's birthday. Some of it quite lively, after a few glasses of champagne. I had drunk quite a lot. Hollitscher told me he was about ready to end his relationship with Cassirer.[67] As a Jew, Schocken attacked Hollitscher, who as a Jew lapsed into an excessively smug description of the cultural advantages of his race. It was good to see how Schocken revealed a much freer and more authentic self-awareness than Hollitscher, who came off pretty poorly by comparison, with his forced, artificial ethnic awareness. Kellermann, who was sitting next to him on a tall, straw-bottomed chair, also angered him; whenever he found a new virtue to enthuse over, Kellermann bellowed in his ear, "Twaddle . . . twaddle." And repeated the same, stereotypically, every time, with a highly comic effect.

Herr von Bülow, whom I knew in Weimar and haven't seen in five years—he was a civil service recruit then, and now he's a painter—has grown very fat, wears an amusing pair of glasses, and is married. He sat about fat, cozy, and strangely altered, whereas earlier he was one of the most impudent, dissipated cochons [pigs] imaginable. Another who was "totally new" was Fräulein Lessing, a cheerful, engaging woman with lots of charm, agreeably modest. A great deal of champagne and a very great deal of roast hare.

Thursday, January 7, 1909
Got up late à cause de champagne. Then in the afternoon to the Cassirer gallery, where I met Schocken. Pictures by Matisse and Berneis.[68] I disliked the Matisse paintings intensely. One piece of brazen impudence after another.

Why don't these people just design cigarette posters, I said to Schocken, who fully shared my opinion. Curious that these Frenchmen—otherwise so intelligent—can't say to themselves that after the simplification practiced by van Gogh[69] and Gauguin it's time to go back to multiplicity. There is no way beyond those two: you have to take what they have achieved, turn back, and look for a new path from some earlier point on the route. Even the pictures by the German Jew Berneis were unfortunately no more than talented impersonalities: deliberate Corinths and even worse Slevogts.[70] A few very good portraits of a kind that even Slevogt hardly does any better. The trouble is that B. comes a bit too late.

Then I walked Schocken a bit farther; he had to go to his parents. Then I went into the free exhibition of Baluschek.[71]

Pity, the guy has some terrific ideas. It's really stupid; as a painter he just has not got a style. He works like a color photographer. But, as I was saying. There was a garden at a home for the

blind, with the poor inmates, mostly girls, walking around in it;[72] and a picture of the garden of a suburban dance hall in Berlin by moonlight. In the background the brightly lit dance hall; in the garden, lit by pale blue-gray-violet moonlight, a girl leaning on the palings has thrown her head back, so you can hear her gasping for breath. Additionally, right in the foreground, the ugly, banal face of a girl holding a handkerchief to her mouth. Both apparently have come out to get away from the heat and the crowd inside the hall. In the background, in the moonlight that floods and dissolves all forms, a couple. The state of the girls in the garden, hot and exhausted from dancing, and the brightly lit dance hall in the background are deeply felt. If only it had been painted with a bit more verve, the whole thing might have been something like a product of van Gogh's world of feeling. A shame he's such a crass painter.

Then went to the notary's office, where Grethe had the mortgage transferred to her name. Met a splendid specimen of the vilest, most repellent Berlin philistine in the person of my former mortgagee. As for the rest, a boring procedure. Jaded, went to meet Schocken at the Café Fürstenhof.[73] Very depressed. The inane visit from Meier Greco and the hangover from yesterday's champagne weighed heavily on my soul. Returned home in troubled mood. Gloomy images of the future. Incomprehension from those people who influence what happens in painting, and consequently little prospect of income. Reduced financial circumstances. Firm resolution to pay no more attention to anything connected with propaganda, new Secession, etc. No longer seek out anyone whom one does not profoundly desire to see. Maintain relations only with the Schockens, Röslers, and Countess Hagen, and go on loving Art, as ardently as possible, in the indestructible faith that she will return that love.

If ever I found she was unfaithful to me, I think I'd be in a bad way.

Friday, January 8, 1909
I do practically nothing but keep my diary. I must say, I'm looking forward terribly to being able to go back to work next week. You get grouchy and bad-tempered and pretty washed up.

We were just about to take a nice walk, Mink and I, but Nauen made his appearance at 2:30 sharp. Picture inspection. He was rather enthusiastic. Reaction to *Resurrection* just the opposite of Meier-Graefe's: the crowd behind very suggestive and necessary in its slightly unclear effect. However, he found the two foreground nudes too weak in relation to the others. Otherwise beautiful, marvelous,

etc. Of course, utterly enthusiastic about *Deluge*. Also many small
things. Stayed a long time, until 9:30. Talked a lot, and noticed that
he seems to be nice after all, an honest person who feels quite deeply.
Let's see more of each other. With Lump, walked him to the train.

Saturday, January 9, 1909
This morning, when I was still in bed, Dora Hitz telephoned to in-
vite one of us to Lampe's chamber concert.[74] I accepted, since Mink
wanted to go to the Secession, which closes tomorrow.[75] So we set
out in the morning, toward 12. First to the Chinese exhibition.[76]
Some beautiful things in it. A few girls, a few animals, and a few
landscapes of a remarkable Oriental mysticism. I was irritated by
people's readiness to admire, and thought of the arrogance with
which they presume to criticize contemporary things—though they
understand no more of these things than they do of the modern.—
And then I did find the Chinese too aesthetic for me, too delicate:
feminine, as Dora Hitz quite rightly said. This in spite of the some-
times grotesque and gruesome pieces. Also too decorative; I want a
stronger spatial emphasis. In short, here again, I'm just too one-
sided to appreciate this art, madly cultivated and elevated though it
doubtless is. My heart beats more for a rougher, commoner, more
vulgar art: not one that generates dreamy, fairy-tale moods between
one poem and the next, but one that offers direct access to the ter-
rible, the crude, the magnificent, the ordinary, the grotesque, and
the banal in life. An art that can always be right there for us, in the
realest things of life.

 Then to Schulte's, to look at the paintings of Herr von Bülow,
who had also convened there to that same end.[77] Still immature, not
without talent. Still caught between a practiced technique and the
uncertainty that it conceals, between joking objectivities and a pro-
founder art or sense of style. Still time to wait and see.

 Then ate lunch at Buschchen's with Martin and Mink. Politics.
Martin thinks there will be a war. Russia, England, France, against
Germany.[78] We agreed that it would be no bad thing for our present,
rather demoralized culture if all instincts and impulses were once
more bound to a single cause.

 Then to Dora Hitz. When I first called, she had the maid explain
to me that she had mistaken the starting time of the concert by one
hour, was not yet dressed, and didn't I still have some errand to run,
or would I rather wait for her. I walked out angrily and went to the
Schockens, where I was kindly taken in, refreshed with coffee, and

interested to look at Schocken's most recent painting of naked
women on the beach. Something just might come of that picture.
Then with D. H. in her auto to the concert. There met L. v.
[Ludwig von] Hofmann and was introduced to his wife.[79] The usual
beautiful sphinx, but a little bit crass. Nor were we spared Frau
Bohme, because she sat near us. Another major confrontation about
visits. I explained once again that on principle we expected her to
make us a return visit. To put an end to all this disagreeable chitchat,
I agreed that she might come to tea early in the year, which would
mean that she could then invite us, for God's sake. Then the music.

During the first Beethoven quintet I was still too preoccupied with
all this disagreeable, petty talk to get much out of it, and the same
went for the subsequent, short pieces by Ph. Bach,[80] Rameau, etc.

But then came a Brahms quintet with piano, which was unbe-
lievable.[81] Above all, the opening allegro non troppo was wonderful.
Those wonderful sounds lifted my soul high above all the petty
squalor of everyday life, in grand, jubilant lines like the rhythm of
the sea, or the trees when the first spring storms rush over them. So
much tragedy transfigured through powerful beauty. Life's deepest
beauty, sensed in the drama of life. Then walked with Dora Hitz to
her house. Ate dinner with her, companionable and *very* good. We
came a bit closer to each other in human terms and talked about
many things, both in art and in life.

Sunday, January 10, 1909
Made a sketch for a scene on Friedrichstraße, which I noticed on the
way home yesterday; I'd had something similar in mind for a long
time.[82] Men who turn around to look at a few prostitutes walking
along. The women likewise turn to look at them. The men garishly
lit by a street light, the women somewhat darker. I'd like to get into
it something of the twitch, of the magnetic tug between the sexes:
something that time and again—and it's on the street that I see
this—fills me with admiration at the immense splendor of Nature.

The effect—in this particular mechanical, stark, cheerlessly ob-
vious interaction between mostly ugly and banal people—is weird,
and yet not without a certain magnificence.

Nice walk with Mink in sunny forest with a dusting of snow.
Lump ought to be sold, but we can't bring ourselves to do it, in spite
of M 70 and the poor disappointed buyer. Then sorting letters that I
earlier wrote to Mink. Breathed old Weimar air. The letters occa-
sioned much pleasure, and a little shame.

Monday, January 11, 1909

Today I was delighted to get a letter from Lisbeth Färber in Brazil. I once had to abandon her, it must be four or five years ago. That was my worst period, and at that time she was the finest and dearest person. And yet fate forced me away from her. I stopped answering her letters. And now, today, there has come such a touching, almost heart-rending letter. She saw my picture in *Die Woche* and would just like to hear from me.[83] She is married.

I was so glad that fate had perhaps belatedly permitted me to make some amends for a youthful sin, and to ease, belatedly, the hurt that I gave. I wrote her immediately, as thankfully and as warmly as I could possibly manage—and as I really felt. She was a terribly dear, fine person. It was harsh of fate to cast her in my path at just the darkest and wildest time of my life and character, when I must have caused her so much pain.

I'm so happy that she had the energy and courage to give me this chance to express to her the deep feelings of friendship that I have always had for her, my sympathy and my sadness that I nevertheless had to part from her.

I hope the letter reaches her.

Then I had another small pleasure. Koch, publisher of *Kunst und Dekoration* in Darmstadt, asked for permission to reproduce two of my drawings from the Secession.[84]

This afternoon Herr and Frau Spiro were here. Nice little creatures. Innocuously good-natured and aesthetic. Very pleasant. This morning the marvelous opening of the Brahms Piano Quintet op. 34, the allegro non troppo, came to me, while I was still totally under the joyful impression of that welcome letter, and of a person whom I had won back; and those marvelous, jubilant rhythms still pursue me now. Today was a good day!

Tuesday, January 12, 1909

Worked in the morning. Still a few things in the background of the *Resurrection* and in the space of the painting of three female nudes.[85] In the afternoon the countess and Herr and Frau von Bülow came. Looked at pictures. *Crucifixion* greatly interested the Bülows.[86] Also some others. The new things, *Resurrection*, etc., left them still somewhat baffled. Afterward art and art politics. Discovery of a possible patroness. Finished at 9:30 P.M. Walked them to the train.

Wednesday, January 13, 1909

I went downtown quite early. Went into the museum (Kaiser-Friedrich).[87] Especially delighted by the *Rape of Proserpina*, a youthful work by Rembrandt.[88] It always makes me think of Böcklin. What a shame he could never do that, and yet he so wanted something like it. It is already fabulously finished. Grandeur of conception, despite the exquisite painting of detail?! And then, above all, Jan Steen.[89] He is my special pet. A great humorist and dramatist. My Rubens was monopolized by copyists.[90] It was really annoying.

The walk from the Kaiser-Friedrich Museum by way of the royal palace and Unter den Linden is always beautiful, if only it weren't for the damned cathedral and the repellent Kaiser Monument.[91] Every time I take it as an affront. Then to Kolbe's. There I met first Gerda Schröder, then Herr and Frau Rhein.[92] She's very nice.

With Kolbe in the café afterward, I revealed to him our future Secession plans. Happily, he was very much in favor. Then to Buschchen, and afterward with Mink, whom I met there, to the Röslers'. Met a fat, good-natured Frau v. Nieberschütz or something similar; then the Schockens came. Nice evening, ended up passing from Charlotte Berend's parturition to the Women's Question.[93] Great excitement, duel between Mink and me. Cheerful homeward journey. Automobile!

Thursday, January 14, 1909

Very bad mood, no colors. Model. Distracted morning. General inner bleakness. All washed up. Afternoon, downtown to do some drawing. No good model. Met Rösler in the café. Weary chitchat. In the evening, walk through the streets in the rain.

I left him at Leipziger Platz.[94]

At home, Mink had washed her hair and was harmonious and happy. Invitation from Secession to a beer evening at the Klinger opening.[95] Don't yet know whether to go. Outside the wind howls. Wet, splashy thaw weather. Mink is sticking stamps in for Frida.[96] Shall I ever again be calm and collected. People are lonely in each other's company.

Friday, January 15, 1909

In the morning painted the stiff round hat[97] on the street picture. Tried to impart to the bleak face some glimmer of that splendor that surrounds every human being on the street in the evening. The much-evoked and frequently discussed thing that is called "life." In

the afternoon, visit from Anni and Fräulein Langbein, who, by the way, is the shortest-legged person imaginable.[98] Anni was very nice and endearing. Looked at my paintings and seemed utterly worn out. Then we walked to the station together. They went off to their nook and I to Berlin to the Secession. High-strung atmosphere, since I can't stand the place. Chitchat with Cassirer. Mutual boredom. Then Klinger came with Liebermann, also the other usual characters. Meier Greco, Schröder again, later Dora escorted by Herr Herrmann.[99]

I sat with Kolbe, Tuch, Pottner, Nauen, and we did our best not to let the insidiously petty mood get the better of us.[100] Even so, we very soon sneaked out.

Afterward, the café, where Kolbe started to backtrack (on the new ideas). Learned that he had M 10,000 debts at Cassirer's. Of which he would like to rid himself, if the row were ever to materialize.

Well—!

Saturday, January 16, 1909
In the morning, did more work on the street painting. Then went downtown, a bit early, so as go to Schocken's. He was tired, and had an unexpected, necessary appointment, so soon had to go. Had a quick look at his new picture of women bathing, or rather drying themselves. Beautiful in parts, but at the moment it still doesn't quite hang together.

Then met Rösler in the café. Discovered that Herr Scheffler doesn't mention me at all in his review of the *Black and White Exhibition*, even though I exhibited fifteen drawings and had displaced Schocken and the [. . .].[101] Funny! Then ate dinner at Röslers'. Afterward café. Kolbe, Tuch, Rösler et moi. Kolbe sullen and tired. Showed even more clearly how distant he really is from me, in spite of his assurances of friendship. Not a pleasant tone. Fortunately, he left early, so that we three were left to ourselves for a bit, which was very nice and companionable. Date for next Saturday.

Sunday, January 17, 1909
Got up late. Then made a sketch for *Earthquake* with great passion and pleasure. In the afternoon took a lovely walk with Mink, who is still not altogether well (Friday evening she even had a slight fever). Magnificent, clear afternoon. Went on the path past the convent. Wonderful view from the high hill. Once again, Nature loved us. Suddenly it was like Weimar over again. Then home. Mink advised me to thank the Landauers for the tickets to the Chinese exhibition.

So I tramped over there. Stayed for ten minutes, disturbed his wife's bellowing brother, and didn't really know what to say, once I had said thank you and had ten eyes fixed on me. Didn't really know what I was doing there, with people who are perfectly nice but with whom I have nothing in common, so I left, bringing home with me an invitation for next Saturday.

Dinner good and companionable. Before and afterward, read aloud from old diaries that now belong to Mink. Ugh, I wasn't exactly happy then. Hell, just a mass of whimpering. Then had a charmingly pleasant and happy piano lesson with Mink.

Thursday, January 21, 1909
Restless days since Sunday. *Monday* morning I went downtown early to deal with the tax. Then, after lunch, walked to Cassirer and looked at Matisse once again; found him even more insignificant and unoriginal than the last time. With the same impersonality with which he imitates Monet and Degas in one of his older paintings, he now evolves into Gauguin, van Gogh, and assorted Indian or Chinese primitives. Then walked on to Dora Hitz's. Drank tea there. Noncommittal friendliness. A shame she can't really be trusted. Then to the Schockens'—to Buschchen's—to the café; there met Dohnányi, then concert by Fried.[102] Met Frau Kolbe there.[103] Warmly received. That will give people something to talk about, said she: Beckmann and *Frau* Kolbe alone at a concert. Sometimes she looks beautiful. More often, insignificant. A dreadfully boring piece by Scriabin, *Le Poème divin,* a beautiful aria by Mozart sung by a magnificent soprano, *and* the evening ended with the Meistersinger overture played at the worst possible tempo.[104] I had to sit next to Frau Kolbe. She was very strongly perfumed.

Early Tuesday I began to work on the Messina painting. In the afternoon with Mink to Eve,[105] there Buschchen, Tutti and Aunt Linka, and roast hare. Both before and afterward, much unnecessary bickering between Mink and me. Dohnányi concert, probably too tired and tense to follow it properly.[106] I liked the Schumann best. By chance I sat next to Gerda Schröder. I think he played Beethoven a bit boringly. After the concert, Café Josty, reconciliation on the way.[107] Peace declared at the train station. Just as we were leaving, Anni arrived and came with us.[108]

Early Wednesday I went back to work on *Messina.* Started on the foremost reclining figure. Great inspiration in gold and dirty pink-violet. In the evening I went to the Zechs' for dinner.[109] Richard, Grethe, Paul, and Frau Martini (whom I disliked at first).

Richard came late. He had had his coat stolen, he was somewhat
downcast, and had to endure some unmerciful teasing. Afterward it
turned out that someone had been playing a joke on him. Delicious
goose-liver pâté and mussels. Conversation trivial. On the train,
read Stifter's *Feldblumen,* some of which I enjoyed *very* much.[110]
Like Jean Paul in miniature.

Today I have been working with all my strength on *Messina.* In
the morning from the model, and in the afternoon from memory.
Started on the background from newspaper photos.[111] It greatly in-
terests me. Perhaps I'll get in something of the breathless terror, the
grisly beauty of the subject. In the morning, while I was still in bed,
Grethe telephoned to say that Mink's portrait (it belongs to Cas-
sirer), which currently is exhibited in the Hohenzollern department
store (*The Lady in Art and Fashion*),[112] is reproduced in *Weltspiegel.*[113]
So in the afternoon we both went round to the local café to look at
this marvel. It came out quite beautifully, and a nice surprise. We
waited in vain for Anni, and I am just waiting for dinner. It is 7:45
and probably nothing more will happen. And so good night.

Sunday, January 24, 1909
On *Friday* morning I worked on the new painting. In the afternoon
I went to Berlin and visited Schocken and Herr and Frau v. Bülow.
At the Bülows' I saw older things by him that I liked quite well. His
wife's things left me rather quiet, because they were good but very
impersonal.

Then, in the evening, café with Kolbe, Nauen, Bülow, Rösler,
and Schocken. Remarkable confusion, the usual discontent about
the Secession, and some chitchat about art and other things. *Satur-
day,* that is, yesterday, I finished the first figure, in the extreme
foreground. I hope she is beautiful. In the afternoon, Mink and I
went to Hohen Neuendorf to see Anni, and then suddenly—out of
a clear blue sky—a quarrel. Met Anni and brought her back with
us, then had coffee at our place with Busch. Buschchen, by the way,
has been staying with us since Wednesday. I was bothered by a
dumb carbuncle-like thing on my throat and was given a poultice.
In the evening at the Landauers', here in Hermsdorf, Rudolf Klein
and wife (Julie Wolfthorn); my fear of replying to a sentimental
prattler with some high-quality art criticism was not fulfilled.[114] He
was a poseur, all right, but with a not unpleasant naïveté; he was
circumspect and said some intelligent things. The fact is that he is
just about the only person who feels about art as I do. Even shares
my opinion of Marées, including the affinities of character with Lieber-

mann. Both far too cerebral as artists. No direct relation to life. We agreed, though each in his own entirely different way, that the third member of the triumvirate was Klinger, whose Brahms monument has just been exhibited at the Secession.[115] I saw it Friday on the way from the Schockens' to Bülow's. Terrible, simply unendurable in every respect. Otherwise, of course, Klinger not to be denied as a personality. Even though he is essentially unartistic. The line of succession running through Marées, Liebermann, Klinger. The good Landauers were rather upset by our iconoclasm. We, however, were very much agreed, as was Mink, that we would rather go back to the sources, to Rembrandt, Frans Hals, and Goya,[116] than to these somewhat dogmatic theorists. We wondered at this curious phenomenon, and agreed that we had never seen the likes of these strange, forcibly constructed characters among earlier artists. I have since come to the conclusion that they existed in the past as they do now. It's just that they're forgotten. They served as stepping stones to something higher; they were good teachers without meaning to be, because they produced something necessary for the period in too abstract a form, thereby gaining clarity, and in this the following generation found a firm foundation for its own growth without sacrificing any of its artistic naïveté.

Wednesday, January 27, 1909
The Schockens have just left, after spending the afternoon and evening here. Looked at paintings, talked and chatted a great deal. Also walked to Schulzendorf and back.[117] It always makes me sad to see how little one is really understood. By chance, a reproduction of my *Young Men by the Sea* hung there on the wall. Schocken was quite enthusiastic. But it is funny that everyone always likes the most impersonal things best. I tote my personality around with me, and I might as well be invisible. Ah God, if only you hadn't added to the gift of art this accursed pride, the mother love that artists feel for their pictures. How wonderful that might be. Because I did paint *Crucifixion, Battle*, the *Nudes, Deluge, Resurrection*, etc., etc., but not the *Young Men by the Sea*.[118] Well—
 On Sunday the 24th, Anni and Mink and I went to Tegel in the afternoon. Lovely walk.

Thursday, January 28, 1909
In Berlin this afternoon, to make costume studies for *Messina*.[119] But the room was closed. So I went into the reading room and sent for a new work, reproductions of Goya's rare etchings and litho-

graphs.[120] In it I found the four prints of bullfights that he made
when he was around eighty.[121] They are marvelous. It is as if all of
his other graphic work were only a preparation and gathering of
forces for this grand, magnificent, majestic pronouncement. There's
a sumptuous life in them, a sense of space!—it was a real delight for
me to see these things. They have so much of what I now want, to
work in that way with agitated masses. I also found them so very
much freer and more grandly composed than the earlier etched bull-
fights.[122] Brilliant distribution of space. This reminds me of another
great delight. At Cassirer's, recently, a Courbet, *Halali*.[123] A hunting
party has assembled at the end of the hunt, and a huntsman blows
the death halloo on a large horn. It seems to be early evening. A
couple of women are there; some men lie in the grass; in the fore-
ground hounds, dead deer, and other game. All dark against a
brighter blue sky. There is a strangely calm and collected mood in
the picture, and one cannot help but find the huntsman a kind of
symbolic figure, in the way he blows his joy out of the picture.
Something of a victory, of a beautiful clear triumph, hangs over the
painting. The people sit quiet on the grass, the horn sounds through
the clear air, and evening is falling.

It is remarkable how few paintings I still like, and how rarely I
still experience the sensation of a whole new personality in art. It
used to happen all the time, head over heels, and now a lull has set
in. Once you've looked around, you know who your friends are.
When will something new come to me through others.

I'm totally under the pressure of my new painting.[124] I'd really
like to paint it all at once. One thing demands the other so much,
and yet everything goes so slowly, although I haven't yet spent two
weeks on it. It's strange; I'd like to write down for myself some of
the things that interest me so in the work, but I just can't talk about
it. And yet maybe I can. I want space, space. Depth. Naturalness. As
much as possible, nothing forced. And pungent color. The greatest
possible liveliness, yet not overlively. The pallor of a stormy atmo-
sphere, yet the whole of throbbing, carnal life. New, still richer
variations on violet, red, and pale yellow gold. Something rustling,
sumptuous, like leafing through much silk, and wild, cruel, splendid
Life. Tomorrow it continues!

Friday, January 29, 1909
Anger at the models. Shameless greed, which I cannot satisfy be-
cause not enough cash in hand. Group in the afternoon. In the eve-
ning at the Schockens': the Röslers, Tuch.

Saturday, January 30, 1909

Worked again on the rape group with two models. In the evening, Secession. Committee election. The same barren, meaningless, but businesslike nonsense. Ate dinner at Dora Hitz's and then with her to the Secession. Met Brandenburg.[125] Nice man, doesn't look anywhere near as sentimental as his pictures. It was interesting how much Liebermann and Corinth opposed Schocken. In a nasty way I was glad, because I hope an angry Schocken will be a sure prop for my new Secession. Otherwise, powerfully nauseated by the whole phony, cold company, and by Dora.

It was good to leave them all and walk along the canal, in the still, clear, winter night, to Potsdamer Platz. A fierce wind had blown the snow against all the branches and trunks of the trees. Everywhere, giant white snakes of electric light stood out brightly against the dark night sky.

At the Stettin station I witnessed an unpleasant scene.[126] From a distance I saw two men fighting and heard vulgar screams of abuse. A policeman was trying to take away a man who was resisting, and when the man went on struggling, he brutally threw him to the ground. I yelled at the policeman, because everything in me revolted against this vile, brutal forcing of a human being, and this at least allowed the man to make his escape, which he did, not without much complaint and lamentation. "Dog, he said to me, dog! Me! Me! I am a human being, after all." His voice constantly veered between the most dreadful rage and a bellowing, gasping sob. Slowly they moved away, and the lamenting roars of the poor brutalized man could still be heard from the midst of the dark mass of curious bystanders that moved away with them. It was strange, that little black clump on the great square covered with snow; and the mournful, angry voice carried over the housetops into the huge, dark, night sky, in which long, narrow, pale racks of cloud scudded past.

Sunday, January 31, 1909

In the morning, worked for the last time on the rape group. I think it has turned out well. At lunch Tutti. Then, in the afternoon, Eve Meid. Nice quiet day. Around 7 o'clock we walked them both to the train and then took a further, wonderful night walk through the thick snow. The wind whistled cold, but our hearts were warm because we were happy. We felt happy and secure, each in our own calling, and believed in ourselves, and the world lay far out there in Berlin, and if it was unfriendly it could go to hell.

Monday, February 1, 1909
No model, of course. Mink substituted for the woman on the right.
In the afternoon went downtown to look for a model. To café with
the countess, then to the Schockens'.

The countess is really charming. At last, someone I can really
trust and who fully trusts and understands me. I told her I was
painting Messina, and she said that she had thought so. She is also
making an effort to find people who can support my ideas for a new
exhibition. Well, hopefully it will be of some use. At the Schock-
ens', the countess looked at his new painting of the women outdoors
but was not especially enthusiastic. I then went to Buschchen's and
ate dinner there. It was nice.

Tuesday, March 2, 1909
In the afternoon, two men modeled for the group behind. Worked
intensively. It took an effort to get the figures in the right depth.
The correctness of the distances of the figures in space is now so
enormously important to me. Then the Röslers came. I was rather
tired at first. They had been looking at apartments but had found
none. In the course of the evening we talked a lot about Schocken,
and Rösler and I both said that it would be a shame if such a good
talent were not more disciplined. He never makes any progress and
constantly whitewashes over his faults instead of tackling them
head-on. Mink stood up for him.

Wednesday, April 2, 1909
In the evening, Nauen! It was highly comic. He outlined to me a
proposition that looked terribly similar to a new Secession. With
Nolde, from whom the idea came, Weiß, Herrmann, Hofer, Haller,
etc.[127] The two last-named, by the way, have not yet even been asked.

Well, that would be just fine if only Nolde weren't in on it, be-
cause he considers himself a genius, isn't one, and nonetheless wants
to be treated as such.[128] Any collaboration with him would therefore
be impossible. Talked all evening and got nowhere, because, now
that he is involved with Nolde, Nauen as an honest man will find it
difficult to withdraw; and yet it would be very pleasant to have
Nauen in with me on my idea. Artistically, and also because he has
some monetary contacts. Adjourned until Saturday.

By the way, instead of painting the two models, spent the after-
noon digging channels, because it's high tide in our house. Thaw
and rainy weather.

Thursday, April 3, 1909

In the morning slept rather long. In the afternoon had the two models for the last time. Worked somewhat slackly. Then Bülows with Mink and Schocken. Discussion of the Salon d'Automne business. In the evening at the Schockens'. Songs by the countess, a lady highly popular with the Schockens in this respect. But our enthusiasm extremely moderate. Otherwise, friendly chitchat. The evening took on a certain dramatic tension, because before we went to Schockens' I telephoned home about Peter and was informed about that by Frida; then I asked if anything else had happened. "Yes, a telegram." "Please open it and read it to me." From that second on, I understood not one word more. After trying for a half hour I gave up. When we got home that night, it was from Cassirer, asking me to stop by tomorrow morning, about some illustration matter.

Friday, April 4, 1909

In the morning to Cassirer's. He was very friendly and really did have something there for me to illustrate. A book of verse, by a Herr Dr. Guthmann.[129] Mink and I suspect that he has somehow got wind of the revolution plans and now wants to get on the right side of me. I still do consider that possible. He asked me to decide by tomorrow afternoon. Not very keen at first. Then went to see Kolbe, with whom I then spoke about the Salon d'Automne business. He was highly enthusiastic! And very willing to join. On the way back, I read Guthmann's manuscript and found that it wasn't bad, and that something could be made of it. So I decided to do it. Mink also read it, and she too was unfavorably disposed to begin with and then changed her mind. In the afternoon I had a female model. At the moment the Messina painting is giving me some trouble. It's falling apart and looks a bit motley. I'm curious to know whether I shall get it finished. But my interest is still great . . .[130] The stones are shifting and starting to roll; I'm curious to see where they roll to. Lump stinks, I am exhausted, and the bright lights of existence do not greatly concern me.

6

RESPONSE TO *IN BATTLE FOR ART: THE ANSWER TO THE "PROTEST OF GERMAN ARTISTS"*

(WRITTEN APRIL–MAY 1911)

BY 1911 Beckmann was one of the leading young artists in Berlin and had begun to receive considerable critical attention, although his reputation was by no means established. After a group of younger artists opposed to Liebermann's and Cassirer's firm control over the Secession elected Beckmann to the group's board in 1910, Cassirer, Liebermann, and Slevogt temporarily left the organization, protesting that it might soon open its ranks to much lesser talents. They subsequently reached an agreement with the younger artists, however, and Liebermann and Slevogt returned to help choose the 1910 spring exhibition. The 1910 show, which Beckmann helped select, became notorious for its pointed exclusion of many of the artists who came to be known as expressionists—Heckel, Kirchner, Nolde, Pechstein, and Karl Schmidt-Rottluff (1884–1976)—who had previously shown in the Secession. The rejected group immediately formed an alternative organization, the New Secession, which lasted only two years.[1]

By the fall of 1910 Beckmann himself had become fed up with the politics of the Secession and particularly with the behavior of Cassirer.[2] Before the end of the year he resigned from the board, although not from the Secession itself. If Beckmann had already publicly distanced himself from many of the leading young artists of his own generation, then, he nevertheless remained unhappy with the state of the Secession.

On April 14, 1911, Carl Vinnen (1863–1922), an artist formerly associated with the artists' colony at Worpswede, published *Ein Protest deutscher Künstler* (A protest of German artists).[3] Although Vinnen had enjoyed some early successes (he had left Worpswede for Munich in 1903), when he published this tract at the age of forty-seven his luck had seemed to run out, and he voiced urgent concerns—shared by many contemporar-

ies—about the worsening financial plight of huge numbers of German artists. Vinnen's *Protest* published two of his essays under the provocative title of "Quo usque tandem" and the names and extracts from letters of 140 members of the Secessions and Deutscher Künstlerbund who had written in response to those essays. His baiting title, taken from Cicero's first oration against Catiline, undoubtedly provoked the group who contributed to *The Answer to the "Protest of German Artists"* to title their reply *In Battle for Art.*[4]

Vinnen had criticized the Bremen Kunsthalle's 1911 acquisition of van Gogh's *Poppy Field* (1890) and the seemingly controlling interests of critics such as Meier-Graefe and dealers such as Cassirer, all of which he took as evidence of the German art world's increased collusion with the French. Although Vinnen and those who joined his *Protest* were not in full agreement— some disagreed openly in their responses and one, Wilhelm Trübner, also signed the *Answer*—most generally subscribed to his position that the many German museum and gallery acquisitions of modern French art seemed to have had a negative effect on the new generation of German artists. In many respects the responses to the *Protest* did not differ greatly from those in the *Answer*. In 1911 artists and critics of all persuasions were commonly questioning the radically new and "unstudied" look of the works of the expressionists, Matisse, and the fauves, whom many dismissed as epigones or merely derivative artists.[5] The anti-French, populist, and racist tenor of Vinnen's essays, on the other hand, provoked considerable ire among many who contributed to the *Answer*.

In Munich, Alfred Walter Heymel, Franz Marc, and Reinhard Piper quickly rallied to produce an answer to Vinnen,[6] and Beckmann was one of several young artists from the Berlin and Munich Secessions who responded. The points of the seventy-five people who replied in the *Answer* were generally better argued, and their names—including Cassirer, Corinth, Hofer, Kandinsky, Kessler, Gustav Klimt, Kolbe, Alfred Lichtwark (1852– 1914), Liebermann, August Macke (1887–1914), Marc, Otto Modersohn (1865–1943), Arthur Moeller van den Bruck (1876– 1925), Nauen, Pechstein, Rösler, Slevogt, Trübner, van de Velde, and Wilhelm Worringer (1881–1965)—remain much better known to us than most of those who signed Vinnen's *Protest.*[7] The conflict was not simply one of progressives and conserva-

tives, however, and many who responded to the *Answer*—like Beckmann—were not champions of the "new art" of Matisse, the fauves, and the expressionists.

Beckmann was chiefly angered by the anti-French tone of Vinnen's *Protest*. In this response, however—the first time he wrote for the public record—he resumed complaints he had voiced in his 1908–9 diary about the emptiness, flatness, and merely decorative qualities of Matisse. He shared the concerns of many subscribers to both the *Protest* and the *Answer* about the need for German artists to heed their own heritage.

I find the protest of Herr Vinnen and his friends misguided, because the tendency that they attack has advantages far outweighing its disadvantages. I consider it just as essential to buy the best works of a Géricault, Delacroix, Courbet, Daumier, Renoir, or van Gogh,[8] as those of Signorelli, Grünewald, Cranach, Titian, Tintoretto, Greco, Velázquez, Goya, and the old Dutch masters.[9] Any good thing always brings in its train something similar, but weaker; that cannot be helped.

I myself have always taken every opportunity to speak out against the overvaluation of such intelligent but derivative talents as Matisse, Othon Friesz, Puy, etc.;[10] but it would never occur to me to mount a solemn protest against them, since I do not consider it very important if a number of untalented persons imitate Bastien-Lepage or Böcklin, the Scots or Matisse.[11] After all, they need some sort of cheap formula to fill the void of their imagination. They find it uncongenial to imitate instructive artists, such as Liebermann or Menzel or Leibl, who might do them some good.[12]

Nor can I discern that either the sales or the influence of the most recent French artists are so enormous as to require such deep chest tones of indignation.

A few pitiable snobs have succumbed, no doubt; but I believe that in private they are already bemoaning their misfortune and eagerly seeking to trade it for the next sensation that comes along.

There is, therefore, no purely artistic basis for the protest.

Hermsdorf, near Berlin

Max Beckmann

7

"THOUGHTS ON TIMELY AND UNTIMELY ART"

(PUBLISHED MARCH 14, 1912)

ALTHOUGH Beckmann had contributed to the *Answer* to *Ein Protest deutscher Künstler* edited by Franz Marc, he joined many of the other contributors in complaining about Matisse and the fauves and was no admirer of the new art championed by Marc and Wassily Kandinsky. "Thoughts on Timely and Untimely Art," which was published in Paul Cassirer's *Pan* magazine,[1] was his first extended public expression of his opposition to the more radically different formal look of the "new art."

Beckmann wrote this essay in response both to a specific article by Marc and to the success that the new art had begun to enjoy throughout Germany and France. A week earlier, on March 7, 1912, Marc had published an essay titled "Die neue Malerei" (The new painting) in *Pan*. Marc's essay was only the most recent in a long series of publications and exhibitions that championed the new international abstracting tendencies: the Rhineland Sonderbund exhibitions of 1910 and 1911; the first *Blauer Reiter* show held in Munich in the winter of 1911–12;[2] the publication of Kandinsky's *Über das Geistige in der Kunst* (Concerning the spiritual in art) in December 1911;[3] Paul Ferdinand Schmidt's (1886–1955) first article that spoke of "expressionism" as a German movement in December 1911;[4] and two years of Herwarth Walden's journal of the new art and literature, *Der Sturm*, followed by the opening of his Der Sturm gallery in March 1912 with an international group of "expressionists."[5] The following summer brought the publication of the *Blauer Reiter Almanac* and the tremendously successful Cologne Sonderbund exhibition.[6]

Herwarth Walden (1878–1941) had decided to open Der Sturm gallery with major new artists from both France and Germany, including artists from the Munich-based Blauer Reiter

and Die Brücke group of Dresden and Berlin, as well as Oskar
Kokoschka (1886–1980). Though Marc was well known in those
circles, his showing in Walden's initial Der Sturm exhibition was
his first major exhibition in Berlin. Marc's contribution of "Die
neue Malerei" and other essays to Cassirer's *Pan*, then, a journal
intimately associated with Berlin, was surely intended to help
make Marc and his ideas better known in that city.

The year 1912 would also be an important and successful
year for Beckmann. He received major one-man shows in Mag-
deburg and Weimar[7] and continued to be highly regarded as one
of the leading Secessionists in Berlin. When he wrote "Thoughts
on Timely and Untimely Art" in March 1912, Beckmann knew
little of Marc's art, but he knew much of the new art, particularly
works by Kandinsky, Matisse, and Pablo Picasso that were in-
creasingly shown in Berlin. Beckmann was angered that Marc's
celebration of "the new painting" seemed to imply that painting
such as Beckmann's was not "new." He turned that to his advan-
tage, however, proclaiming that he himself was happy to be "un-
timely" if that was what Marc's theorizing implied.

Beckmann's response was thus Nietzschean in both title and
tone. His title plainly echoed Nietzsche's *Unzeitgemässe Be-
trachtungen* (Untimely observations),[8] as did his position that it
was necessary to stand away from and above the mainstream and
to cultivate one's own individuality. As in his response to the
Vinnen *Protest,* he again criticized modern artists who seemed
dependent on groups and popular tendencies—as Nietzsche had
put it, those who moved in herds—and attacked the flat and
decorative nature of the art of Gauguin and Matisse. Beckmann
was especially vexed at Marc's championing of Cézanne, whom
Beckmann had long found of fundamental importance for his
own art.[9] He again railed against the flatness and the "unfin-
ished" and "unconstructed" look of the "new" art and applauded
the painterly vitality, spatial depth, solidity, sensuality, and ar-
tistic objectivity that he admired in the old masters, Leibl, Cé-
zanne, and his own work. He also charged that the primitivism
of Gauguin, Matisse, Kandinsky, and Picasso was merely af-
fected, decorative, and aesthetic, with little symbolic force or
relevance to the times.

The Beckmann-Marc controversy did not generate much re-
sponse at that time, probably because these issues were widely
debated throughout the German art world.[10] Beckmann's re-

sponse did arouse considerable ire in Marc, who replied to this essay, and in Kandinsky.[11] Several other champions of modern art, however, shared Beckmann's feelings that the new abstracting art seemed formless and meaningless, with little ability to communicate of and to the times.[12]

In the last number of *Pan*, Herr Marc speaks of what he—not without a certain self-confidence—calls the new painting.

It occurs to me that Cézanne, whom he hails as his special patron saint, said something that does not at all agree with the article in question. It is published in Bernard's reminiscences of Cézanne, *Kunst und Künstler*, 1908, p. 426:

"He was especially disparaging of Gauguin, whose influence he considered harmful. 'Gauguin loved your painting dearly,' I said, 'and often imitated it.' 'Yes, yes,' he retorted angrily, 'but he did not understand me. I never intended the lack of plastic values and tonal modulation, and I shall never reconcile myself to it; it's nonsense. Gauguin was not a painter, he only painted Chinese pictures.'"[13]

If this sounds implausible, one has only to read Cézanne's letters to Bernard, published with the above statement, in which there are things Herr Franz Marc and his friends really ought to read more often and with close attention.

Even if Cézanne had said nothing of the sort, it is written all over his work that his gift was essentially coloristic, and that the torture of his life was that he could never express strongly enough the objective truth of art, the spatial effect of depth, and the concomitant sense of plastic solidity.

I myself revere Cézanne as a genius. In his paintings he succeeded in finding a new manner in which to express that mysterious perception of the world that had inspired Signorelli, Tintoretto, El Greco, Goya, Géricault, and Delacroix before him.

If he succeeded in this, he did so only through his efforts to adapt his coloristic visions to artistic objectivity and to the sense of space, those two basic principles of visual art. Only thus was he able to preserve his good paintings from an arts and crafts flatness. His weaker things are not much different from a tasteful wallpaper or a tapestry; but his good pictures are magnificent in their greater objectivity and in the resulting spatial depth; they embody eternal human values, yet they are emblematic of the place and time in which he lived.

Thus, the tree is not just a tasteful arabesque—or a structural idea, to put it perhaps more learnedly—but also an organism in its own right, in which one is conscious of the bark, the air that surrounds it, and the ground in which it stands.

It is ludicrous, in any case, to talk so much about cubism or structural ideas.[14] As if there were not a structural idea embodied in every good painting, old and new—including, if you like, those calculated to achieve cubist effects. The great art lies in concealing these—in a sense—basic compositional ideas in such a way that the composition looks completely natural, and at the same time rhythmical and balanced: constructed in the best sense of the word.

What is feeble and overly aesthetic about this so-called new painting is its failure to distinguish between the idea of a wallpaper or poster and that of a "picture." I too can have pleasant and, if I feel like it, even mysterious feelings when looking at a beautiful wallpaper. And I am certainly not denying that a man who designs wallpapers or posters derives his stimulus from nature. But there is a very serious difference between these feelings and those that one has in the presence of a painting. In the one case I have a very general aesthetic pleasure, such as a pretty dress or a fine cabinet or lamp might give me. But a painting suggests to me an individual, organic, entire world of its own.

"Aha," the gentlemen concerned will now say, "but then who can tell where painting leaves off and applied art begins?" This is the objection that notoriously silences all burdensome critics.

There is one thing that always happens in good art. This is the conjunction of artistic sensuality with the artistic objectivity and actuality of the things to be represented. Abandon this, and you inevitably fall into the domain of the applied arts.

All great artists, from Signorelli through van Gogh and Cézanne, have known how to maintain quality.

So now it's my turn to talk about quality. Quality, as I understand it. The feeling, that is, for the peach-colored sheen of skin, for the glint of a nail, for the sensual in art, which resides in the softness of flesh in the depth and gradation of space, not only on the surface but also in depth. And, above all, in the fascination of the material. The lushness of oil paint, when I think of Rembrandt, Leibl, Cézanne, or the spirited structure of the brush stroke in Hals.

Then I would like to come back to one of the claims constantly made on behalf of this art: namely, that it is the new painting. I do not regard Gauguin as a world-shattering innovator, but as a person

of taste who succeeded in assembling a momentarily diverting decor out of Cézanne and tropical-island motifs. What I find feeble about him is his dependency on ancient, primitive styles, which in their own time had grown organically out of a shared religion and a shared, mystical, folk consciousness. Feeble, because he was not capable of extracting from our own time—murky and fragmented though it may be—types that might be for us, the people of the present, what gods and heroes were for those people then. Matisse is an even more deplorable representative of this ethnology museum art: the Asian department. Even this he gets at second-hand, from Gauguin and Munch. I have already stated where I stand on the cubism of a Picasso.

What is there about this art that is new? At best, it might be described as renewed, renovated—patched up, though not with the most practical materials. It's the same old story. The Scots, too, in their time, were personalities who upended everything. Again, with Böcklin, there was no choice but to imitate him, if one did not want to be decried as unmodern or academic. Then, too, in dear old Munich, a ''wealth'' of pictures appeared that reduced the philistine world to speechless admiration. And where were Leibl, Corinth, and Liebermann then? Poor, unreflecting, unrefined, frugal men, who wanted nothing to do with the new salvation of art. And yet, remarkably enough, they still exist.

It is perfectly understandable that these gentlemen feel certain of victory, since nothing seems safer—for the moment—than to have the greatest possible number of people united in pursuit of a single tendency. That is precisely why, for most of their careers, Rembrandt, Cézanne, Grünewald, and Tintoretto were eclipsed by their respective ''modern'' colleagues.

Not until the combined forces of pure and applied art have spent another ten years churning out their framed Gauguin wallpapers, Matisse fabrics, Picasso chessboards, and Siberian-Bavarian folk-icon posters will they realize, perhaps, that genuinely *new personalities* do exist—but that these have never, alas, been all that modern or contemporary.

I say *new personalities* intentionally, for that is the only new thing there is. The laws of art are eternal and unchangeable, like the moral law within us.

8

DIARY, DECEMBER 30, 1912–APRIL 17, 1913
(BERLIN, HAMBURG, BERLIN)

THIS DIARY was kept in a small notebook measuring 8.9 cm × 14.3 cm and contains several drawings and sketches.[1] It also contains numerous lists and sums, reflecting Beckmann's increasing tendency to inventory his works, sales, prices, and expenses.

During most of the diary's course Beckmann lived in or traveled to Hamburg to complete a commissioned family portrait for his first major patrons, the Hamburg export salesman Henry B. Simms (1861–1922) and his wife Gertrud Simms (1873–1936).[2] The portrait, which he said took him ninety-one days, was his chief concern in this period. It was not unusual for him to spend so much time on a painting, although he tended to several other works and concerns during these months. He spent days or weeks at a time in Hamburg, and returned to Berlin on several occasions.

The Simmses were collectors of late-nineteenth- and early-twentieth-century art who attempted to integrate their collection into the handsome Jugendstil interior of their new home at Heilwigstraße 29.[3] Beckmann said he hated Hamburg and felt uncomfortable with the Simmses and their family, who were then suffering the illness of their son Karl Frederic (1896–1915).[4] Beckmann worried that his works would not fit in with the decor and tastes of the Simmses' home and feared that the works they acquired—if they in fact purchased them—would remain unknown to the art world. Yet his Hamburg experiences were not altogether negative: Beckmann was proud that the Simmses acquired many of his best early works,[5] he had a show in the Commeter Gallery, and he began to make arrangements to exhibit in the Hamburg Kunstverein the next year. He was also intrigued by the seamy side of Hamburg and its brothels.[6]

In the diary, written at a time of relative well-being, Beck-

mann dwelt considerably on his doubts and insecurity. About eight months after his dispute with Marc in *Pan* and what he himself characterized as the "magnificent" year of 1912, he was worried about being overcome by his competition and vowed to keep his mind on his work and family, to be less selfish, and to remain untroubled by others. Throughout the diary he seems confused and pessimistic about his work, his dealer, his patrons, his needs, and the demands of his family.

At this time Beckmann might have felt successful. The first monograph on him by Hans Kaiser had just appeared,[7] and a large one-man exhibition of his works at Paul Cassirer's in Berlin opened at the end of January. Though both were generally warmly received, he wrote almost nothing about them; at one point, he even doubted the sincerity of his supporters. His diaries suggest that he did not ignore criticisms of his work, which included those of many admirers who wondered where he was going with his relatively traditional stylistic preferences and ambitious figural pieces. He affirmed that he liked his largest new masterpiece, *The Sinking of the Titanic*, when he sent it to the spring Secession show of 1913, but he wondered how it would be received.[8]

Beckmann continued to be disgruntled by the success of the new art. He finished the diary with an undated passage in which he complained about what he saw as Picasso's false mysticism.

In memory of old notebooks from lonely times.[9]

·

December 30, 1912
I don't really think it will ever be like that again; being with you has moderated the reckless upward and downward swings of my moods. All the same, I have the feeling . . . [10]it would ever be read.[11] But then, who knows, maybe I'm just convincing myself that I shall never show it to anyone, and then in the end maybe I would show it, maybe I wouldn't.[12]

At this moment I am on a train, right outside the Stettin station.

Much uncertainty at the close of the old year, whether the new year will make good the promise of 1912, which was really magnificent.[13] Now I've got to ride[14] hard and catch up with Giese.[15]

Although I'm still only twenty-eight, feelings of getting old
and fear of being left behind. Feelings of a race driver. Star players
when new champions appear. Rather ridiculous. Annoyed at this.
Deep and sincere feeling for you.

•

In bed at night.
Still almost exactly the same mood. How sad and disagreeable to be
thinking about oneself all the time. It would be so good to get away
from oneself sometimes. The task seems so thankless and uninter-
esting. And yet you have to go back to it again and again. Always
wondering whether Simms is going to write me tomorrow. Is he go-
ing to buy the big picture after all.[16] Giese, Kaiser, Simms, and—at
a greater distance—Aufsesser are on my mind all the time.[17] But
how can you expect devotion from others, when you don't devote
yourself to anyone. And does your art represent such a big idea that
you can expect that? Ideas find selfless adherents only if the creator
himself loves them selflessly. And there's still too much selfishness
about your love for your art. Learn to control yourself and stop
thinking about success, followers, prophetic status, and pathetic
things of that sort. Love Nature—you have talents in that direc-
tion—care for Hilde and Richard, and take pride in being able to
care for them.[18] And thank God thrice daily that you have your
wife. And remember Jesus' great saying. Care, but don't care too
much. "Thou art careful and troubled about many things"; but
don't forget the most important thing.[19] Great, immeasurable con-
cepts. Enigmatic, mysterious Energy, you who govern the fate of
humankind, give me the strength for selflessness. Through this
alone do I attain the purest enjoyment of the Self.

•

December 31, 1912
In a train again, this time to Reinickendorf-Rosenthal.[20] Mood
much the same as yesterday. A bit more composed. Probably M's[21]
influence. I've recovered some of my courage and faith in myself
and my art. What I want is to paint. Paint myself silly. What a great
line of work this is. What a pleasure. People, people, people! How
their skin stretches over their bones and tendons. How individuality
wondrously and endlessly varies.

The more secure I become, in financial terms, the more my pas-
sion for painting will become sure, untroubled, and free.

If only I could cast off these old cares. But it'll work out, I won't be beaten. I am going to create all that I want to. It will and must work out.

I'm on my way to see Richard.[22] I'm curious to see what the poor fellow is up to now. Mink has invited Cassirer around to look at paintings. My feelings are very mixed. But we've probably got a few more years of suffering ahead of us. Then we'll be free. Tonight is New Year's Eve. My year is ending on a nervous note, more jittery than last year. In some ways success is harder to take than failure. The prospect of losing all you've gained is unsettling. Just as in some ways the poor man is happier than the rich man. Yet it's no use being a total klutz and turning down the chance of living a richer life when it's on offer.

Even so, it's always terribly hard to know where to draw the line between professional relationships and one's personal sense of honor. Especially so in our case, with the firm of C.[23]

.

January 7, 1912
On board the express train to Hamburg.[24]

(1) Resurrection[25]
(2) Descent of the H[oly] G[host][26]
(3) Battle of the Amazons[27]
(4) Bicycle Race[28]
(5) St.'s Still Life[29]
(6) St.'s Self-Portrait[30]
(7) St.'s "
(8) Chicken Thieves[31]
(9) Messina[32]
(10) Conversation[33]
(11) Party[34]
(12) Portrait of Countess H.[35]
(13) " of H.R.[36]
(14) " of Mother[37]
(15) " of Grethe[38]
(16) " of Mink with Purple Shawl[39]
(17) ⎱ Three Portrait[s] of Simmses[40]
(18) ⎰ Judith and Holofernes[41]
(20)

(21) Water Tower [42]
(22) Festival [43]
(22) The Captives [44]
(23) Studio Nudes [45]
(24) Cleopatra [46]
(25) Crucifixion of Christ [47]
(26) Landscape near Hanover [48]
(27) " Wangerooge [49]
(28) The Shepherd [50]
(29) Aufsesser's Landscape [51]
(30) Stern's " [52]
(30) Deluge [53]
(31) Bearing of the Cross [54]
(32) Double Portrait at Halle [55]
(33) Mars and Venus [56]
(34) Clearing Weather [57]
(35) Sun Breaking Through [58]
(36) Self-Portrait Simms [59]
(37) Christ in the Wilderness [60]
(38) Landscape in Hermsdorf [61]
(39) Kaiserdamm [62]
(40) Couple [63]
(41) Lamentation [64]
(42) The Dance [65]
(43) Small Dance [66]
(44) Small Landscape Dr. Schaper [67]
(45) Rösler Pagel [68]
(46) The Drunk [69]
(46) Old Brick Factory [70]
(47) View toward Nollendorfplatz [71]
(48) Study for The Couple [72]
(49) Studio Interior [73]
(50) Still Life with Hyacinths [74]
(51) Anni's Landscape [75]
(52) Still Life [76]

Mood again somewhat lifted. Book [77] and Cassirer came out. On Sunday went out with T.

That was Wittenberge. [78]

Time out. Goodbye for now.

•

Group 3. 320[79]
 Brodersen Hamburg[80]
 6:30 Alster Café[81]
 Oh, jeez. There's the rub. And we think we're still judges of human nature. OK, my boy, now show what you're made of and face the music. Presque [almost] Pastor Diestelmann mood. The moral of the story. Never again in such matters without two or three . . . first.
 Whores' music. This Hamburg is nauseating. So philistine and vulgar.
 English café atmosphere without the elegance.

•

170 for Hilde.[82]
 Lodging to Frau Wellmann M 70
 M 40 to live on.

•

M 10 to live on.
 15 for shoes
 Oh, misery.

•

Travel bureau, Invalidenstraße 51.[83]

•

 (1) Simms has seven paintings already.[84]
 (2) It would be a real shame if they were all stuck in Hamburg. Unproductive assets; you can't exhibit them.[85]
 (3) And this is Bearing of the Cross, the smallest of my big pictures, thus the most saleable.[86]
 (4) Both are below Cassirer's price.
 (5) Is the subject's severity and nakedness unsuited for the space.[87]

If he starts in again, ask him to quit for the sake of my nerves.
 Just don't think about it, but devote all energies to the few hours of portrait painting.
 Go walking alone.

Don't work on anything else concurrently.

No reading in bed at night.

Read nothing of any great interest at all.

Write Minkchen faithfully, telling her everything, even totally trivial things.

Never mention the sale. But don't think about it either.

On the other hand, keep thinking that the S's are the first people ever to offer themselves for a group portrait.[88]

Be pretty glad.

•

Simms Group 6.[89]

3380

•

Hamburg, Thursday, January 16, 1913

Went to Gabriel Schilling.[90] Really very good. Didn't expect it to be. Then I walked home along the dark Alster (I almost said Neva).[91] Along the low riverbank, with the black bushes, with the frozen Alster beyond, and farther away the long, even rows of street lights. Tired and somewhat discouraged with life. But the copper-red sky, with stabbing yellow lights, and the speeding suburban train with green smoke was beautiful.

And the thought of your beauty and gentleness. What is a great artist, anyhow. So petty. We draw strength from our weaknesses, or so Hauptmann says.

But that means we're running at a loss.

•

Mittelweg 151, third floor.[92]

Frau Sauber.

•

Notes for Tuesday.[93]

Ring up Tieffenbach.[94]

Rösler?

In the afternoon

Scheffler.[95]

Wednesday

School[96]

•

Blankenese[97]

•

Lühe.[98]
 Alte Parks[99]
 Baurs Park[100]

•

Thursday, January 23, 1913
All the same, man is and remains a first-class R[eal?] Sw[ine?].[101]
The way he combines respectable or even noble sentiments with a
downright instinct for filth. Why is there no getting away from
that?
 Old story—
 On the way back to Hamburg.
 Exhibition hung at Cassirer's. Publicized in advance as interna-
tional celebrity. Faut voir [must see].[102]
 Life is funny. One time one[103] is underneath, another time the
other man's on top.[104] Now back to the dear S's. Fine for me.
 Across from me sits a fragrant gentleman, and we're trundling
across the Jungfernheide.[105]
 How I do love Berlin and you and the Hermsdorf forest![106]

•

Hamburg, Tuesday, March 10, 1912 [*sic*][107]
Evening, 5:30, at Simmses'. (Library)
 I'm daubing around a bit, because I'm too tired to do anything
serious. Have almost finished the group picture.—A curious stage
to be at. Rather successful. In Berlin I hear Peter's ill. Mink is cross
because I seem to have been working suspiciously hard again. And
my mood is such that I don't really give a damn about anything,
because I am tired.
 Art is about the only thing that can still get me going. But af-
terward I still want to sleep.
 It's a shame—when your nerves are in a good state you don't
know what to do with them, and when you might do something
you've lost them. I so much wish I could be totally alone and do
nothing but paint. Ah, how wonderful. To be totally alone. Not de-
pendent on anybody. And the situation is so utterly the opposite of

that. I'm dragged in all directions at once. And I have to admit that I can't help doing some of the pulling myself.

This is not a restful sort of house. There's always someone running or jumping around. Or falling over. It is as if the restless spirit of its owners were still moving about, even though they are far away in Davos.[108] Which is just what it is, in a way, because it's their children.

•

Notes for when I'm back in Berlin.

(1) Send reproduction to Velhagen and Klasing.[109]
(2) Lithograph[s?] for Mary Held.
(3) Aufsesser lithograph.
(4) Photograph for Mr. Müller the art dealer.
(5) My guardianship for Hilde, Hermsdorf.
(6) Lithograph to Nuremberg.
(7) Tone frame for Titanic.[110]
(8) Photo—[111]

•

Final curtain.

On the way back from Hamburg to Berlin. A! Dieu soit béni. [Ah! God be blessed.]

So, January 7 through March 23.

Ninety-one days spent on the group picture. That was a job. Rather tired and worn-out. No more painting for four weeks.

Holiday!—

March 23, 1913.

•

10,000
 4,200
 1,200
 700
 1,500
 4,000
21,650
[at bottom of page, upside down]: M 492.50[112]

•

For Kurt [113]

Board and school fees
M 1,050
M 440
M 1,600

•

Spring at the Wilkners', Waidmannslust
April 1, 1913
 No holiday as yet, however. Worked like mad on the Titanic for another ten days.[114] Now it's probably done and I am tired.
 Now on the way to the Secession to varnish my picture and take a look at the competition. Tired and despondent again, on account of new . . .[115] though I do think Titanic is very good!
 Wonderful morning. Birds sing, and a light haze hangs in the air.
 Spring is everywhere. Only I'm dead tired and spent.

•

Hermsdorf,[116] March 17, 1913
Today the picture went off at last. I don't really believe it will be a success, though there's a lot that I like about it.

•

Proofs at Birkholz [117]
 6 Admirals Café [118]
 6 Couple on Tegel Lake [119]

•

From Tieffenbach [120]
 3 Hell
 3 David and Bathsheba
 3 Tegel Swimming Area
 Samson and Delilah
 Self-Portrait [121]

·

Dresdner Bank
 Dr. Freud
 Berlin 1 W Friedrichstr. 204 [122]

·

In the forest as on April 17.
Eye trouble!
 Better now, thank God. Had some really amusing, tragic prospects of blindness.
 Stitch removed by doctor yesterday. [123]

·

The mysticism of a Picasso is the mood of deities borrowed from the ancient Mexicans and Aztecs, with a shot of Gothic. [124]
 What we mean by mysticism in art is not the artist's interposed intention of evoking mysterious, ancient folk cults, with an affectation of human sympathy: on the contrary, the mystical feeling originates in the viewer who admires, in a work of art, the greatness of the artist's feeling for nature. [125]

9

STATEMENT FOR EXHIBITION AT HAMBURG KUNSTVEREIN, *MAX BECKMANN (GEMÄLDE), WALTER GEFFCKEN (GEMÄLDE), JULES PASCIN (ZEICHNUNGEN)* (FEBRUARY 1914)

IN 1913, the year in which he had spent the better part of three months in Hamburg, Beckmann had first publicly exhibited in a show of that city's Deutscher Künstlerbund (German artists' league) at the Commeter Gallery.[1] As noted, he also seems to have begun making arrangements to show at the Hamburg Kunstverein as he worked on the Simmses' family portrait.

In this short statement Beckmann's focus on a program was probably related to his simultaneous development of a "program" for publication in *Kunst und Künstler* the following month.

My program is brief. That is, all the program I have, if any, is this: that all theory and all matters of principle in painting are hateful to me. I love the sublime and the ridiculous. Every form of life, because my ardent desire is to produce something living. So maybe I have a program, after all.

10

"THE NEW PROGRAM"

(MARCH 1914)

KARL SCHEFFLER, the editor of Germany's pre-
miere art journal, *Kunst und Künstler*, was one of Beckmann's
warmest champions in the prewar period. He and *Kunst und
Künstler* had been of central importance in reviving and inform-
ing the German art scene, especially in their promotion of the
art of German and French realism and impressionism.

Scheffler had much more difficulty in coming to terms with
the new art. Though initially a champion of Jugendstil and van
de Velde, he ultimately came to dismiss that art as empty, deco-
rative, and contributing to the whole tendency toward flat art
that he associated with the movements of fauvism, expression-
ism, and cubism. Scheffler continued to prefer the rich and sen-
suous art of impressionist, realist, and much older traditions. As
he saw the new art on the ascendancy, he clung to young im-
pressionists such as Beckmann and Rösler and praised them as
the great hopes for the future of German art.[1] After the war had
begun—six months after "The New Program" was published—
Scheffler continued to argue that solidly trained impressionists
such as Beckmann and Rösler would best represent the war's true
appearance.[2]

Though Scheffler was quite critical of Carl Vinnen and *Ein
Protest deutscher Künstler,*[3] in 1913 he joined the criticism of the
new art that Meier-Graefe had initiated in his lectures and tract
of the winter of 1912–13, *Wohin treiben wir?* (Where are we
drifting?).[4] In May 1913—just a month after he published his
exuberant review of Beckmann's Cassirer show—Scheffler made
his first extensive attack on the new tendencies in an article titled
"Die Jüngsten" (The latest ones).[5] Not surprisingly, Scheffler—
long scorned by leading younger artists who had never found
their work covered by *Kunst und Künstler*—was increasingly
dismissed by many of them.

In response to charges that he was unresponsive to the art of the younger generation, Scheffler offered a collection of younger artists' statements published under the title of "Das neue Program" in March 1914.[6] In addition to Beckmann, Arthur Degner (1888–1972), Rudolf Großmann (1882–1941), Heckel, Otto Hettner (1875–1931), August Macke, Ludwig Meidner (1884–1966), Moritz Melzer (1877–1966), Max Neumann (1885–1973), Max Oppenheimer (1885–1954), Rösler, Schmidt-Rottluff, and Georg Tappert (1880–1957) wrote responses for Scheffler.[7] All of these artists were members of the Berlin Secession or its splinter groups, both the New Secession and the Free Secession, the wing formed by Beckmann, Cassirer, Corinth, Liebermann, and Slevogt to separate from the parent organization in the fall of 1913.[8] Scheffler thus presented young artists whose work he knew and found sound, well-constructed, and promising. He was not, as he defensively indicated, totally hostile toward the new.

Beckmann's own ideas had much in common with Scheffler's. He did not say much more in his "New Program" statement than he had already articulated in his answer to the Vinnen protest and in his exchange with Marc. As in his exchange with Marc, he again insisted upon the importance of Cézanne for his own art, arguing that he, too—and not just the "new" artists[9]—was deeply influenced by Cézanne.

In my opinion there are two tendencies in art. One, which at this moment is in the ascendancy again, is a flat and stylized decorative art. The other is an art with deep spatial effects. It is Byzantine art and Giotto versus Rembrandt, Tintoretto, Goya, Courbet, and the early Cézanne. The former wants the whole effect on the surface and is consequently abstract and decorative, while the latter wants to get as close to life as possible using spatial and sculptural qualities. Sculptural mass and deep space in painting need not by any means be naturalistic in effect. It depends upon the vigor of presentation and the personal style.

Rembrandt, Goya, and the young Cézanne strove for important sculptural effects without succumbing to the danger of naturalism in the least.

It makes me sad to have to emphasize this, but thanks to the current fad for flat paintings, people have reached the point where

they condemn a picture a priori as naturalistic simply because it is not flat, thin, and decorative. I certainly don't want to deprive decorative painting of its right to exist as art. That would be absurdly narrow-minded. But I am of the opinion that not one of all the French followers of Cézanne has vindicated the principle of two-dimensionality that followed the inspired clumsiness of the late Cézanne, the holy simplicity of Giotto, and the religious folk cultures of Egypt and Byzantium. As for myself, I paint and try to develop my style exclusively in terms of deep space, something that in contrast to superficially decorative art penetrates as far as possible into the very core of nature and the spirit of things. I know full well that many of my feelings were already part of my makeup. But I also know that there is within me what I sense as new, new from this age and its spirit. This I will and cannot define. It is in my pictures.

11

WARTIME LETTERS: EAST PRUSSIA

(SEPTEMBER 14–OCTOBER 11, 1914)

WHEN WORLD WAR I began, Beckmann and his family were on vacation near Danzig at the seaside town of Zoppot, where Martin Tube, an infantryman in the Fifty-ninth Regiment of the Eighth Army, had apparently assured them that war would never come about. They immediately returned to Berlin,[1] where Beckmann illustrated several journalistic accounts of the war's first week for *Kunst und Künstler*.[2] A few weeks later, he completed a lithograph portrait of Martin Tube after the latter was wounded in the Battle of Tannenberg in East Prussia (August 26–31).[3]

Both Karl Scheffler and *Kunst und Künstler* were strongly supportive of the war in its first year and eager to engage the artists they admired to record it. According to Minna Beckmann-Tube, Scheffler asked her to select some of her husband's letters for publication soon after Beckmann went to East Prussia, and she did so, apparently over some objections from Beckmann. The published letters extended from September 14, 1914, to June 12, 1915. Two groups first appeared in installments in the December 1914 and July 1915 issues of *Kunst und Künstler;* and all were collected in the small volume *Briefe im Kriege,* published by *Kunst und Künstler*'s publisher, Bruno Cassirer, in 1916.[4]

Beckmann had initially traveled to the Eastern Front to deliver a box of provisions to the Countess vom Hagen, who had volunteered to serve as a medical assistant. A drawing indicates that he had arrived at the East Prussian town of Korschen by September 8,[5] and an annotation in his copy of Nietzsche's *Also sprach Zarathustra* indicates that he had moved to nearby Roessel by the following day.[6] By September 14, the date of his first published letter, Beckmann seems to have arrived at the Polish fortress of Mlawa, close to the southern border of East Prussia, which the Germans had taken on September 4.[7] The

Countess vom Hagen was stationed in Mlawa and helped Beck-
mann enlist as a volunteer medical orderly after authorities
wanted to press him into service. Though no record of his assign-
ment or unit has been found he seems to have been attached to a
division of the Eighth Army.[8]

Although Germany had suffered its humiliating defeat and
retreat from the Battle of the Marne from September 5 to 10, the
military command did not release this news to the public until
November. When Beckmann arrived in East Prussia Germans
were enthusiastically celebrating the great victory and capture
of thousands of Russians at the Battle of Tannenberg and were
entering the First Battle of the Masurian Lakes (September 9–
14). Because the Germans had initially planned to defeat France
before turning to Russia, they had left few troops to check the
Russian advance into East Prussia that had started on August 17.
During that first month the war had been tumultuous: by Au-
gust 26 the Russians moved as far as Rastenburg, in the center of
East Prussia, and they also threatened the capital of Königsberg.
At the initiative of Colonel Max Hoffmann (1869–1927), the
Germans finally began an offensive that turned into the brilliant
success at Tannenberg. The victory was immediately attributed to
General Paul von Beneckendorff und von Hindenburg, who had
been brought out of retirement to lead the eastern armies, and
to Hindenburg's chief of staff, Erich Ludendorff (1865–1937),
both of whom had just arrived on the Eastern Front.

Beckmann arrived on the Eastern Front as the second great
rout of the Russians, the First Battle of the Masurian Lakes, be-
gan. On September 18, the day Hindenburg was named com-
mander in chief, Beckmann eagerly reported joining in the jubi-
lation at seeing Hindenburg at Allenstein. During the subsequent
weeks Beckmann seems to have moved toward the northeast and
Russia with the Eighth Army, which proceeded to regain areas
that had been occupied by the Russians and advanced slightly
over the border area.

Military operations had proceeded quite differently in Gali-
cia, the area of southeast Poland and northwest Ukraine that
had once been an Austrian crown land. Austro-Hungarian losses
in Galicia were great and left a German flank unprotected. On
September 16 Hindenburg formed a new Ninth Army to pro-
tect that side and started an assault toward Warsaw to stop the ad-

vance of the Russians toward Silesia. When Beckmann last saw his brother-in-law Martin Tube on September 24, Martin was headed toward that action. During those maneuvers, on October 11, Martin was killed in the Battle of Ivangorod. Beckmann's last published letter from that period was written that day.

Beckmann's published letters were selected and edited and clearly did not comprise all that he wrote from the front. Censorship probably demanded that his references to specific places be limited to initials; it also would have demanded that he not speak of certain events or publish parts of letters that mentioned them. Moreover, in this period Max and Minna also began to take steps that would cause major changes in their lives—including their separation and her embarking on a career as an opera singer—that are scarcely or not at all reflected in these letters. Such personal matters were presumably the subject of other letters or other parts of letters not made public.

In spite of any unwillingness he might have had toward publishing the letters, Beckmann knew they were going to be published, at the very latest soon after he wrote the first group. The letters are candid and personal, at once realistic in what they told of his experiences and romantic in his inexperienced and optimistic expectations. Beckmann would have known that in these, too, he was making a potentially public statement, and he fully lived up to Scheffler's expectations. Like so many of his generation, he found the action and life at the front intoxicating after the years of his relatively rarified studio and social existence in Berlin. He was rarely in the center of the toughest action, but he was always in direct contact with the war's destruction and victims. Although dependent on official reports for his knowledge of what happened, he provided keen insights on war in its daily aspects, both mundane and dramatic. Here indeed, he thought, were the vitality, urgency, and life-and-death dramas he had long sought. As he observed on September 24, "in this short time, I've experienced more than I have in years before." Beckmann's war letters, one of the few written records left by a major German artist at the front, were widely admired and well known to those who wrote on him in the postwar period. Today they remain one of our chief sources of knowledge of Beckmann and his wartime experience.

September 14, 1914

Alea est jacta [the die is cast]! [9]

I am a volunteer medical orderly and will stay here. Hope to go along to Russia in about fourteen days. The doctor in charge kindly employed me here on the basis of the countess's recommendation.

This afternoon we already drove out to the ruins of H.[10]

I hope still to be able to experience a lot and am happy.

My trip here with five-and-a-half tons of baggage was far from dull. My car on the train was overfull. Fat-bellied, red-cheeked men, lumber dealers whose forest had burnt down and who yearned for their quiet game of skat, and between them sat a young miss who held a mangy mutt tightly on her lap.

All sorts of people were crowded onto the small train. Refugees, people from Tilsit chewing on bonbons,[11] a plucky friendly uhlan,[12] bunches of little kids, dignified men in the restaurant car, etc.

At Thorn, it was a struggle to get an entry pass for the border fortress—then I was able to continue the trip into the night anyway, with the women and children, with lights dampened and windows covered.[13]

At O. [Osterode], a few hours sleep and then I went on with a fabulous old cavalry captain who wore the Cross of the War of 1870 on his chest, soon passed through the beginnings of the battlefields of the Battle at Tannenberg.[14] His property is in the middle of it, near M. [Mühlen], and he experienced the whole thing, endless numbers of billeted soldiers and watching the battle from the hill on his property.[15]

He took me along on his wagon to M.,—M. [Mühlen] itself has suffered much damage.

You can well imagine how surprised the countess was that I came so soon. Our presents, especially the champagne and preserves, were appreciated immensely.

Tonight I'll sleep at the cavalry captain's. Tomorrow somewhere else . . .

Castle M. [Castle Mlawa],[16] September 16, 1914

I'm writing from the bench in front of the castle gate here. It's shortly before noon. The mood is quite bleak. To the left of me, at two huge old evergreen trees, two sisters and the wife of a man who died last night are picking branches for his funeral.

I helped with the autopsy of another man who also died last night. He looked very much like my model for the Lamentation of

Christ, had a grand sallow profile.[17] Then, of course, I saw the entire
military hospital with all the sick. Everything is very efficiently
and clearly managed. Fifteen Russians are there too. With no sign
of emotion the doctors courteously showed me the most horrible
wounds. The sharp smell of putrefaction was hovering over every-
thing, despite good ventilation and well-lit rooms. I was able to
take it for about an hour and a half, then I had to go out into the
open landscape. There, of course, everything is less somber, in spite
of many destroyed houses. The worst is already over, and every-
where along the road, in the potato fields, there are oblong little
mounds that have wooden crosses stuck into them and a few with
helmets on top.

Huge shell fragments still are scattered throughout the field.

The landscape is truly marvelous; I'll be going by automobile
to R.

Hotel Deutsches Haus [Allenstein], September 18, 1914
Right now I sit somewhat disappointed in the above named hotel.
Martin telegraphed me yesterday evening from D[eutsch]-Eylau
concerning the continued transport of Hugo C.'s cigar donation, and
to tell me he expects to meet me here this afternoon.[18] Because of
that I got up at three o'clock, rode seven hours in the train to get
here, and now he's not here.

Probably the reason for this is: once more the route Thorn-
Allenstein is open only to military trains, and Martin must have
thought that I wouldn't be able to come then. His instructions were
probably changed too, but now as volunteer nurse I can ride on all
the military trains with a leave certificate, and I rode here in an
empty military train. Absolutely unbelievable—at three o'clock in
the morning it takes three-quarters of an hour to get to the train
near the military hospital, and the path goes past numerous, very
fresh soldiers' graves.

Then a horrid narrow-gauge train to O. [Osterode], and then
after hours of waiting, here in an empty military train, all along
the way past the outposts of the Landsturm [home reserves]. Here
the whole of war is still felt: everywhere they're afraid of new in-
vasions by the Russians, but that's a fear I don't share. Yesterday,
N. [Neidenburg] was incredible.[19] As if after a great earthquake, half
the church tower collapsed, the houses at the marketplace simply
shaved off in the middle, people are glad if they still have an oven left
to crawl into, and in the center of it all, still intact, the war monument.

Allenstein remains untouched. Has two very beautiful old buildings, from the fifteenth century, I think.[20]

Sitting across from me, there are about forty officers and officer candidates eating lunch.—When I came in a while ago, the long table was occupied by officers. Most of them with the red stripe of the general staff on their pants. A typically elegant, very tall excellency concerned himself in obliging fashion with a remarkable man who had the order of Pour le mérite dangling from his neck.[21] It was Hindenburg and his entire general staff.[22]

After ten minutes they left the city in eight or ten military cars.

That remarkably strong, grim face with those sharp eyes caused even me to shout hurrah.[23]

Your purchases were the cause of much surprise and happiness. The poor shot-up fellows!

I just bought some humorous books and will read out loud from them tomorrow and generally make myself as useful as possible.

I was really lucky. The people here are such kind, charming persons. Our chief physician also is of half-Westphalian descent, and the countess is as sweet as always. It's just too bad that you aren't here with me. Then we could rejoice together that our Germany can still produce such people as Hindenburg. The phrase is a cliché, I know, but it's fitting here. He really does share something of the character of our oak trees. Truly a kind of gnarled, dramatically reserved strength.[24]

It would be very nice, by the way, if you would continue making your collections, because they need so much here.

Now I'm living in the village with its teacher. His house is romantically situated between the millpond and some shelled-out houses.—

L. [Lyck],[25] Thursday, September 24, 1914
—Now, for a change of pace, I am sitting up here very close to the border. An absolute mood of war reigns here. Thousands of soldiers, cuirassiers, uhlans, and infantry. I escorted a troop of hospital personnel here, spent another night in Allenstein. And who do you think I meet at the train station?—Herr Martin, who was waiting for the train that would bring his company. That was delightful of course. A few days ago (when we were supposed to meet), he came an hour too late, after I was gone. This time I could spend an hour—just now I heard military music and ran out so that I could

immerse myself in its heroic sounds, and wouldn't you know, a detachment of cuirassiers marched by, their captain in the lead, and then the band: "When a Girl Has a Man, Who Loves Her, and Whom She Likes," after which I calmed down a bit again—together with him, something that made me quite happy.[26]

He told me that he'd been awarded the Iron Cross, and looked hale and hearty.[27] He's going to Silesia with his regiment, and then probably to Austria.[28]

In this short time, I've experienced more than I have in years before. Above all, of course, the hospital. My activity in the mornings consists of entering into the patient's record any changes in the wounds while the sick lie naked on the table, often four or five of them.

Our mess-hall life is very amusing, the various military honors of their excellencies, the staff doctors, and the mixture of military pride and just good old human kindness.

Here in L., because of a letter from the head physician, I had to present myself to a staff doctor. He was from Hamburg and knew my paintings well.

This afternoon, God willing, I will accompany another doctor to a battlefield fifteen kilometers from here, where all the dead are still supposedly lying about. When I arrived yesterday evening, I was received by a transport with a hundred or two hundred Russian prisoners, who curiously stared at me. They looked strangely small and the worse for wear. Then yesterday I rode here from Allenstein in an open railroad car used to transport horses. That too is a wonderful feeling, to be able to ride without any regulations or rules in a train with hardly a single human being on it.

We most likely shall be going (outside there are more soldiers singing and the sound of horses' hoofs) to Galicia.[29] So far I have received no sign of life from you at all, but then everything here is restricted to troop transports to Austria. It's entirely possible you haven't heard from me.

Just now I was in Fortress B. [Boyen], something otherwise very difficult for a civilian.[30] It's a wild and wonderful life I'm leading right now. Nowhere else has the unspeakable contradiction of life been more obvious to me.

September 28, 1914
Today I had to change my living quarters. Because the daughter of my nice old school teacher is simply mad. And now she got it into

her head that I had to get out of my room. She is an extremely dis-
turbing creature. Real skinny and tall with dark, restless eyes and
strangely choppy movements. She walked around my room in a
highly affected way—I really had to get out, because certainly I had
to agree with that, that I had to get out!

Oh well, it was a nice change from the hospital. I finally got
scared, though, because this crazy woman constantly played with a
knife with disturbing familiarity and my room could not be locked,
and so I moved in with [religious] superintendents who had invited
me long before. They are charming people, apparently true Chris-
tians, filled with selfless goodness and childlike faith. Just the way it
is in Jean Paul.[31]

They live with inner peace in their bullet-riddled and battered
home. Rifle bullets still riddle the cupboards. Outside the wind
rages in the old fir trees, and up in the castle the poor shot-up
fellows hear its song. They probably can't sleep much and thou-
sands of flies torture them, so that we had to put pine branches over
their faces.

M.,[32] October 3, 1914
It really is grotesque. Today, Sunday, the letter you telegraphed
about on Friday still is not here.—I am sorry to say that the
weather recently has been awful and I had a touch of angina.[33] But
it's over now, and my will to live is stronger than ever right now,
although I have experienced some truly horrible things and even
died with a few already. But the more one dies, the more intensely
one lives. I made drawings. That protects a person from death and
danger.

This morning I went along to church and then looked on during
the Eucharist; there's a big demand for our dear old good Lord again
now. A few days ago a Herr L. was here looking for his dead son, his
only child. The graves were dug up, but in the one where he hoped
to find his son lay an officer, and in another, five officers. The super-
intendent and I also went out to the F. estate on Friday morning to
help look and exhume. A true Pole lived on the estate, and he'd
been nearly shot several times for espionage. He offered us a good
schnapps since we came in an icy storm with wind and rain that
soaked my riding pants, and it was an hour-and-a-half's ride. Really
weird Polish national heroes hung on the walls with Marat and
young-Napoleon faces, and it was absolutely filthy and the Pole as
gentle as a kitten.[34] Then the unhappy father came (we'd agreed to

meet there), but there were no exhumations since Herr F. could show that in his graves there was no young L. So we returned home with the matter unresolved. The poor father kept looking, a respectable old tanner who told of the entire tragic affair in a dry businesslike tone and reported that he was an elder in the church and church treasurer. So a very close relationship with the good Lord! And his wife had prayed every evening and now in the space of a week her hair has turned totally white.

N., October 9, 1914

So today I'm here. Not very far from the battle. It was a peculiar moment for me in K.,[35] deciding whether to go on or not, because endless streams of refugees came toward us. It was said that Lyck was occupied, etc. etc.[36]

Well, I went on anyway. Here again a wild mood of war dominates. There's talk of a great victory and of ten thousand prisoners. This evening I'm going to R., where I'm supposed to meet Baron v. K., who will get me closer to the front, I hope. Today I received all your dear letters at once.

G.,[37] October 11, 1914

Now I've heard the thunder of battle and was arrested as a spy. It's impossible to ask for more as a beginning.

The arrest was not without a certain charm. A small hotel. Characters: a drunken, bragging master baker, a rather dumb-looking civilian, a medical orderly in uniform, the host.

I wanted to read something in peace and drink my coffee, but soon aroused the attention of the worthy trio.

I like to talk with people like this, as you know, and with a feeling of lily-white innocence I calmly joined in their conversation, too.

It was hard to hide my antipathy toward the baker. He was of the most offensive type. One of the first who fled when the Russians came and one of the greatest heroes. "I'm sure not afraid. I have my two rifles hidden in back. Just let 'em come, the rascals," he babbled. Although his mind was already very fogged up, his apparently very highly developed vanity still noticed that in the wise conversation that I had with the others I always cut him out. And his irritation grew.

I noticed that, and when the others all left, I wanted to pay, too. There remained behind the fat burgher, the host, and the hero.

So I pay and want to get my coat. Then the baker threw himself on it; strangely enough, on the coat, not on me, and he shouted: "The coat stays here. You've acted suspiciously. The orderly gave me instructions. The coat stays here!"

When he shouts at me again after I quietly demand that he return the coat immediately, I grab the man and throw him against the wall.

But now the others suddenly ganged up on me too, and so I saw myself facing this mob. Nobody believed anything I said. Instincts of distrust and self-preservation have been aroused. I want to get to the door. It's locked immediately.—

I have to tell you, this moment was as uncomfortable as it was exciting for me. Suddenly, I again regained my composure totally. "I now demand that you immediately accompany me to my sleeping quarters. The host there will legitimize my identity," I said to the innkeeper. He had refused to do this twice already, but after I frightened him with horrible threats once more, he decided to come along while the other two heroes guarded my hat, coat, and book.

In the hotel here, too, the greatest mistrust suddenly arose among all the friendly and kind people who shared food and drink with me earlier—everyone was against me—the police came—until finally my military pass and the surrender of Antwerp dissolved everything into peace and shouts of hurrah.[38] Only the police in the background still had a fight ahead of them before they could take my coat away from the now wild, chained dogs.

Our automobile trip went through long, shaved-off avenues past Callot-like bombarded brickwork that appeared heavy and dark, like giant feelers at the horizon.[39] Through field camps with soldiers busy cooking, past dead, grotesquely wounded oxen and horses that showed their teeth to us in malicious grins. Over newly built bridges and train crossings just blown up and through destroyed cities. Finally we got to G.[40] The High Command, the mind of the entire battle! The entire city was nothing but soldiers' quarters. All the stores closed and abandoned by their owners. All hotels occupied by the military. Only with difficulty could I round up some cooked beets with mutton in a small inn.

Outside the wonderfully grand sound of battle. I went out past hordes of wounded and exhausted soldiers that came from the battlefield and listened to this unique, horridly grand music. It's as if the gates to eternity are being ripped open when one of these great salvos echoes toward you. Everything suggests space, distance, infinity

to you. I wish I could paint this sound. Oh, this immensity and terribly beautiful profundity! Hordes of people, "soldiers" moved in constant columns toward the center of this melody, toward the determination of their fates.

The trip back took place in storm and driving rain. Through the icy night wind in an open automobile.

12

WARTIME LETTERS: BELGIUM
(COURTRAI, ROESELARE, OSTENDE)
(FEBRUARY 24–MARCH 16, 1915)

MINNA Beckmann-Tube's family suffered tremendous losses during October and November 1914. Martin Tube's death in battle at the age of thirty-six was followed just over a month later by the death of his sister Elisabeth (Else) from a lung infection at the age of forty-two. These deaths, the family's mourning, and Beckmann's experiences at the front seem to have inspired his December sketches[1] and subsequent conceptions of the work that eventually became his huge unfinished *Resurrection* (1916, G. 190). He wrote frequently of that undertaking during his months on the Western Front.

Sometime in October or November Beckmann returned to Berlin. He undertook formal training to become a Red Cross medical orderly, completed several etchings and drawings, and looked forward to going to France by the end of December.[2] By February he had moved to the Western Front, where he worked in at least two different hospitals in Courtrai (Kortrijk) before he moved to Roeselare, the headquarters of the German troops facing the Ypres salient. For all or part of this time he was with a unit attached to the German Fifteenth Corps. During his first month in the west he had considerable time to observe the Belgian people, the countryside, the cities of Courtrai and Ostende, and the effects of the war at large. His desire to go directly to the front, however, would not be fulfilled until the following month.

In the first days of the war German troops had moved rapidly across Belgium and Luxembourg in violation of earlier promises to maintain neutrality. They rapidly took command of several cities in Belgium and France, including the Belgian capital, Brussels (on August 20), and the French city of Lille (on August 27). Germans entered the city of Ypres (Ieper) on October 3 but were forced to leave on October 18. By October 18 trenches had been established between Ypres on the British side

and Menin and Roeselare on the German side. During the First Battle of Ypres (October 30–November 24) the Germans had attempted to drive the British out of Ypres and move toward the North Sea and Channel coast; that progress was stopped, but at huge costs to the British Expeditionary Force. By November both sides had dug into trenches that would form the main lines of battle for the next four years. Although Ypres remained in British hands, the Germans could continue firing on the abutting landmass of the Ypres salient. The Germans began and continued the bombardment of Ypres throughout the winter and spring, soon destroying the city and making it uninhabitable.

The following installment of Beckmann's letters was published in *Kunst und Künstler* in July 1915 and was the last selection of his letters to be published in that journal. In fact, *Kunst und Künstler* would cease publishing artists' letters from the front with that issue.

Courtrai,[3] February 24, 1915

I just want to let you know that up to now I worked in the typhus hospital, but am out of it now again, and indeed live in conditions that are in sharpest contrast to it.[4] My duties are very light and leave me time to see a lot and to work as well.

Courtrai is a charming old Flemish city, and—disregarding the tragic events that agitated and upset me in my very deepest being, but that are over now—I have also experienced some strange and enjoyable things. I have experienced some very amusing evenings with my Belgian billeting hosts, an old spinster with a characteristic van Gogh face and black hair and her dwarflike old brother;[5] we chattered away endlessly about England and Belgium, God and politics, white bread and room rent, all of it in my poor French and they with their pronounced Flemish accents, on top of it drank grog, and outside the thunder of the cannons at Ypres.[6]

Now I'm in the monastery where all the monks have been swept together into a single wing of the huge house in order to make room for the wounded and the doctors. I have a view of the old monastery garden, which is surrounded by a tall colonnaded cloister in which dark-bearded monks often walk around, engaged in intense and gloomy conversation.[7]

There are wonderful old things in the city.

It is impressive when one sees what our country accomplishes,

how it expands with an elemental power, like a river spreading out
over its banks. One notes that most readily, strangely enough, in
the time. All the church-tower clocks are set to German time. And
all the Belgians live according to Belgian time, so that there was
constant confusion with our billeting hostess as to which time she
should wake us.

And then all this quiet, absolute control that extends to the
smallest detail.

On the first day I saw thirty captured Englishmen, brought in
by six uhlans. Clay-colored creatures, amusingly self-assured.

Courtrai, March 2, 1915
Our common mess in a huge kitchen is very interesting, a sort of
refectory where I eat with about thirty other men, all in fatigues.
There are some remarkable people and faces among them, many of
whom I like and all of whom I will sketch. Coarse, bony faces with
an intelligent expression and wonderfully primitive, unspoiled
points of view. Giant military cooks, plump and heavy. Masklike
faces, senselessly humorous ones talking constantly next to gro-
tesquely humorous, truly humorous ones. People with big heads
and black, thick eyebrows next to good-natured, smiling creatures
eating enormous amounts.

Yes, this is life again!

My little friend likes the women and has already introduced me
to a variety of estaminets [taverns]. I'll send you Flora and Gabriele
van Bellegem one of these days.[8] Flora is charming, like a Rubens
translated into aristocratic terms. It is too bad, however, that she's
also very filthy.

Together, my friend and I clean the operating room during the
afternoons, and in this way I also come to know the feelings of a
cleaning woman. I myself constantly vacillate between great excite-
ment at everything new that I see, depression at the loss of my indi-
viduality, and a feeling of deepest irony about myself and, occasion-
ally, the world. Finally, however, the world always compels my
admiration. Its capacity for variety is indescribable and its power of
invention is unlimited.

March 4, 1915
I'm writing in the operating room. There was not much to do today.
We finished early. I'm quite well and only regret that there is so
little free time. I have to be there from 8 to 1 and from 4 to 7. The

collection of people seen in the operating room is remarkable, showing dark unkempt faces, heavy beards, and white bandages.

During the evenings I go to the bars. The thunder of the guns lasts all day long and it's amusing to see how people have become accustomed to them, as if it were the sun, this horrible world conflagration. Love, petty arguments, business and ambition go on just as they did earlier, even though death sings its wild song only a few kilometers away. What a blessing is the human lack of imagination.

Later, in the evening in my room. The windows are wide open, outside a dogcart clatters across the pavement, in the dark night only a few illuminated Gothic windows can be seen somewhere, and the dark, heavy silhouette of an old towerlike mill.

From time to time I hear a salvo as it rumbles toward me through the dark.

Heavy, beautiful rhythms of forms and feeling lift my spirits, at least easing my life for me for a few moments.

Just now someone knocked, and a fine-looking soldier with smoking cigar entered: "I really would like to see the beautiful sketches and paintings you have made."

Now he's standing opposite me and is leafing through my products. He's a charming fellow, already been wounded three times by shrapnel, including one time when it ripped open his entire scalp. But now he's well again. I like him a lot, he's so natural and intelligent and alive that it's always a joy to have a conversation with him. Now he's shaking with laughter because he recognizes various scenes I drew.

But now I don't want to write any more. Instead, once my friend is out of here, I want to sketch the prayers. I like drawing so much, through it one becomes so much more aware of the essence of things. I believe that by means of all this drawing—but enough of theorizing. My friend has gone to the Pottelberg.[9]

March 10, 1915
At the Field Hospital Museum.[10]

I'm in charge of a whole group of patients who are not seriously ill, and the chief medical officer is also someone who knows my paintings very well. Most of these doctors do!

Today was very interesting. An English plane dropped three bombs on the train station three hundred meters away from me as I was watching a troop of soldiers. What wild turmoil was unleashed there! The powerful detonation. And this daring fellow sped over

me no more than twenty meters in the air. I caught sight of him and at almost the same moment the explosion followed. He hit nothing but empty railroad cars.—But now the Belgians arrive! All at once we were friend and enemy again. All of them came running in a wild mob. Filled with hope and uncontrolled in their excitement. Then the chatter of the gun fire. But he got away. Even though he flew over us one more time, but at a very high altitude.

I'm writing these lines in my old civilian quarters again after having happily come back to them. In P.[11] I was soon tossed out of my room, sad to say, and had to room with eight other men, which was simply horrible. A few days ago I was real close to the front, saw very interesting groups of soldiers come out of the trenches singing, soldiers covered head to foot in clay, mounted officers with glasses perched on their noses and with intelligent faces galloping on pure black horses toward the front. And the music of war, the thunder of cannons, was extremely close. I arrived at a small town in a short train. As it rounded the curve, an entire regiment could be seen standing in the marketplace along with a band that was playing something or other Verdi-Wagnerish to the accompaniment of the roar of cannons.[12]

What all have I not seen during this time. Saw people die of typhus and pneumonia. Saw nurses display wonderful dedication and the most solemn human compassion. Fat grotesque creatures possessed of a remarkable spirit. In the evenings I arrive in my quarters and find young volunteers aspiring to become officers who find a suggestion of home in the company of my strange Belgian hostess. They sit around me along with her little sixty-three-year-old brother, who is just a little taller than Peter and smokes a long pipe, and an unemployed Belgian traveler and family friend who is drinking the rest of my red wine right now.

March 14, 1915

Here we are very close to the front. This morning I rode on a hospital train until we were only half an hour behind the first trenches. From a slight elevation we looked down onto the broad Flemish landscape with its many small farmsteads. And through the fog could be heard dull explosions and the chatter of machine-gun fire, interspersed with low, almost dancing trumpet signals. We rode back with a number of wounded.

Our duty right now is not very hard and corresponds to my

mood. A long time of doing nothing and it's followed with so much work that it's impossible to figure out how to do it all.

Life here is quite charming. We eat in an abandoned house at a long table as if we were in an officers' canteen. The personnel in the platoon consists of nice people and the atmosphere is pleasant. Our duty consists of transferring the wounded and sick and in being careful not to get a bomb dropped on our heads.

R.,[13] March 16, 1915

Yesterday I was off duty. Instead of going on some short trip or another, I plunged like a wild man into drawing and made self-portrait for seven hours. I hope ultimately to become ever more simplified, ever more concentrated in expression, but I will never—this much I know—give up fullness, roundness, the vitally pulsating. Quite the contrary, I want to intensify it more all the time—you know what I mean by intensified roundness: no arabesques, no calligraphy, but rather fullness and plasticity.[14]

I work much, but most of all with my eyes and my memory. I always find it wonderful when people gather together. I have an insane passion for our species.

Ostende,[15] March 16, 1915

Yes, you're surprised, aren't you?—mais c'est la vérité. I'm in Ostende, came by car by way of Torhout, Ostende to Blankenberge, and then returned here by streetcar.[16]

This morning, just as I was recovering from the exertion of having written a long letter to you, I was in the watch station when a telephone call came from the central command that they wished to speak with me. I went there and faced a Prussian captain, Prof. Th. [Professor Ludwig Thormaehlen], the director of the Charlottenburg School of Applied Arts.[17] It turned out that he wanted to take me along to Ostende. Everything was arranged through the kindness of our platoon leader, and before I could even make a decision I was already in the car.

It's almost mysterious that my earnest desire to come to Ostende should be fulfilled so smoothly and totally in this fantastic fashion.

We traveled with the speed of an express train through the long highways of Flanders flanked with poplars. It was foggy today.

Here I sit in an elegant hotel room, have lit a cigarette, and have

a bottle of red wine before me. It amuses me to gaze at the smoke of
my cigarette and think about the drunken sailor with whom I just
now returned, or about the grotesque variations in my life. It has
hardly been any time at all since I lit fires eagerly and scrubbed the
floor or was occupied as typhus nurse. Today we were greeted with
military honors as we traversed all, even the most hidden attrac-
tions of Ostende. I was driven to the dunes on a paved street that
was like a parquet floor and the car like some sort of fabulous
storm bird.

Also most remarkable was the girl with beautiful dark eyes who
made my bed a little while ago. Arrived in Menin around midnight
to search for her lost mother and ten-year-old brother.[18] She came
totally alone. And her father remained behind in the bombarded
city of Dixmude.[19] Where are the mother and son? Hordes of refu-
gees on a wagon headed in the direction of France, suddenly—they
were gone. The poor young girl with her large dark eyes found no
one. In spite of the fact that all the officers recommended her to all
commanders. She cried.

Now I've lit another cigarette and go on thinking. About the
moment when I first saw the barren lines of the depopulated sea-
shore. About the uncanny silence amid the pale pointed silhouettes
of a few soldiers as they came toward us slowly. About the narrow,
alligator-like, long cannon barrels that looked out at the ocean
sharply, hidden by camouflage. And then the sea, my old friend, it's
been too long since I've been near you. You swirling infinity with
your dress spotted with lace. Oh, how my heart swelled! And the
loneliness. A herd of seemingly gloomy people were digging some-
thing military, silently and shadowlike. An isolated sentry at the
horizon. Otherwise, everything dead. All windows and stores locked
up. The casino, this great house of prostitutes, nailed shut with
huge boards.[20] Everything was silent and dreamlike, as if it were
three o'clock some summer morning. A pale, mood-filled dusk. Ev-
erything alive was gone. Off over there. If I were the emperor of the
earth, I would demand as my absolute right to be alone on the sea-
shore for a month during each year.

13

WARTIME LETTERS:
ROESELARE, WERVICQ, BRUSSELS
(MARCH 20–JUNE 12, 1915)

BY THE time Beckmann wrote these letters, he had already seen many horrifying sights of the aftermath of battle and of dead, dying, and wounded people in the hospitals, but he was probably unprepared for the scenes he would witness in the following three months during the Second Battle of Ypres from April 22 to May 25. During this time he was not only close to but also directly on the front, at least twice under heavy fire at the trenches. On May 4 he went out of his own curiosity, which caused him to say "now for the first time I've had enough" and to fear returning to the trenches; on May 21 he went on assignment with his group.

The Second Battle of Ypres is probably best remembered for the Germans' introduction of gas warfare: official German reports, on the other hand, mentioned neither the battle nor the use of gas warfare until 1926. Though Beckmann made a few references to green and yellow clouds and gas victims, the only gas victims he mentions were Germans. His published letters make no reference to the enormity of the preparations related to the implementation of the gas, something of which he would have been aware for at least a month, or of its introduction.[1]

In their introduction of gas the Germans had chiefly wanted to test its efficacy as a weapon and had not banked on a major success. Though preparations began in March and soldiers were called up regularly throughout March and April in anticipation of its possible use, General Erich von Falkenhayn (1861–1922) was more concerned with building up forces for the spring offensive in Russia.[2] He removed large numbers of troops from the area in which the gas was to be used five days before it was released. Though the Germans achieved a great tactical success with their use of the gas, taking the enemy by surprise and shocking the world with the new weapon (rapidly taken up by

other countries), they could not capitalize on the rapid gains they
made toward Ypres because they lacked sufficient reserve troops.
They thus achieved only limited success and again failed to take
Ypres.[3]

In these letters, too, Beckmann spoke of much more than
the horrors of the war. He noted a great deal about himself, his
feelings, his companions, his experiences, his readings, and his
art. He was excited to work on a commissioned "fresco" in a
delousing bath and continued to write about the work that be-
came his 1916 *Resurrection*. He remained shrewd, realistic, hu-
morous, ironic, and romantic as he reported the war and its tolls.
In spite of many truly frightening experiences and moments of
shock and disillusionment, he seems to have remained convinced
of the justness of Germany's cause throughout his time on the
front.

The letters stopped on June 6 with Beckmann's announce-
ment of the inception of his work on illustrations for a book of
war songs that would be published by Paul Cassirer.[4] Those
drawings and other works and correspondence indicate that he
remained in Belgium at least through July.

R. [Roeselare], March 20, 1915
Today I'm on night watch at the train station. We expect another
train of wounded at 12 o'clock, then maybe we'll be able to sleep.
Your suspicion about "driving to battle" is not totally unjustified.
The first trenches are only two hours from here, and I hope to get to
know them in detail soon.

It's a remarkable state of mind, this sitting on the edge of the
volcano all the time. Today, toward evening, after I had sketched in-
tensely, I went for a walk on some ruined paths out of the city and
arrived, by way of the shelled houses of a kind of suburb, over an
old broad canal, at a somber-looking farmyard in which six to eight
wild and threatening-looking fellows stood around.

The house was somewhat out of the way and up above, in the
not too great distance, a plane that seemed to be one of the enemy's
chattered in the clear evening sky. Farther back, the heavy detona-
tions of cannons.

I watched the aircraft as it slowly climbed higher. Then shots,
and ten to twenty small flashing bullets exploded real close to him.

But he wasn't hit, rather, flew calmly higher and ultimately vanished in the dark of evening. I, however, arrived late for my night watch.

About 12:45.

Now the train has gone and all the men are in their quarters.

One amusing incident, a civilian who wanted to have a hotel room. He aroused immense amounts of laughter.

V. [Wervicq],[5] March 27, 1915

Well, what do you say now! Life is certainly changeable. On Thursday, just as I was ending my watch at the train station in R. [Roeselare], U. K. enters and says to me with amusement: You're leaving. Wonderful opportunity. Huge bathing establishment at V. [Wervicq]. A professor as chief medical officer; he's very interested in cultural matters. Wants to have the walls of his bathing establishment decorated.[6] Field hospital directly at the front. You'll be able to see everything, thousands of naked men daily, etc. etc.

So, I could hardly sleep all night and the next morning, when the trip with ten others was supposed to start, I missed the train.—I was lucky. The only other possible train didn't come until evening, and I would have had a horrid night and trip, because the train trip has been made horrible, despite the short distance involved, due to very poor connections. So, instead a car filled with officers I knew, including a lieutenant who is a painter in private life, took me along and I rode in comfort and with a degree of excitement in the car to V.

Here everything turned out very well. Chief Medical Officer K.[7] is a clever and understanding person. I will have to try to solve the task he has assigned to me.

I intend to transform the bathhouse, a huge textile mill, into an Oriental bath, with desert and palm trees, oases, and the battles of the Dardanelles.[8]

I have my own room in a villa. The wind whistles through the windows, but it is my own room and I can even eat alone.

I believe I shall experience extraordinary things with those massed nudes. Now, while eating an orange, I can peacefully observe the most exquisite shooting at planes. At night I have the wonderful fireworks of rising and falling signal flares in friendly and in enemy trenches, and my ear is learning to distinguish machine-gun fire from infantry rifle fire, and can recognize French as well as German cannons.[9]

V. [Wervicq], March 28, 1915

If things continue as they are now, it could be quite pleasant here. I
live wonderfully alone, and that is—with the exception of a few at-
tacks of melancholy—also fabulously appealing. Today I worked
hard and made a detailed sketch for the most difficult wall surface,
one subdivided by numerous moldings attached to it and with chim-
neylike brick walls, and therefore it is very difficult to force a sense
of unity onto it. Otherwise, I spoke to hardly anyone all day long.

 Then after working so intensively I was overcome by an attack
of melancholy and lay down on the bed, cursed the whole world,
myself, and everything else, then I went for a walk on country
paths to C. [Comines], a small neighboring town.[10] It was a wonder-
ful, cold, sunny, and very windy day. Already here, fortunately, the
countryside is interrupted (but just a little bit) by a forested chain of
hills,[11] which I find extremely appealing, since otherwise the Flem-
ish landscape is flat as a board, horribly cultivated, and with nothing
but long, unremitting straight avenues.

 As I said, the air was sharp as glass, clear and cold, but spring
could already be sensed in it. I went across the fields, avoided the
straight chaussée [road] past the snipers' nests, where these people
shoot at a small forested hill whose spring flowers have been re-
placed by rows of graves with wooden crosses. To my left, they were
shooting with the harsh, hard shots of the infantry rifle, to my right
isolated cannon shots thundered over from the front, and above it
all, the clear sky and the sun, harsh and sharp above the wide plains.
It was so wonderful out there that even the wild insanity of this
gargantuan murder, whose music I constantly heard, could not dis-
turb my deep sense of enjoyment.

 I finally landed in a suburb of C. [Comines] in an out-of-the-
way inn that was, however, still occupied by beer-drinking artillery-
men and its French owners. I ordered and received coffee and bread
and butter, and had a good long conversation with the soldiers.
They told lots of stories and bragged a lot. The hostess, an unima-
ginably fat old woman who looks somewhat like Frau J., only with
more of a beard and her hair colored black, and a very strange
daughter with coal-black hair, chubby red cheeks and black eye-
lashes and eyes dark as prunes.

 The way home through the rose-colored evening air was pleas-
ant. A plane accompanied me with elegant cartwheels; I couldn't de-
termine whether friend or foe. Everywhere the songs of troops as

they returned from the front or marched toward it sounded through the air. Bands accompanied them once in a while. I seemed like a stranger, impersonal even to myself. Cut off from my earlier life and yet not in disharmony with myself, I felt strangely whole and satisfied.

At home my house companion, the spa's barber, received me. I cook water for myself and read a little in Zarathustra or the New Testament.[12]

I hope my life will not be disrupted again soon. Of course, I'll be able to do a lot of work for myself as well, and now I actually find the decorations to be interesting too. That is what keeps me going and sane right now.

V. [Wervicq], March 30, 1915
Today I received two wonderful letters from you. One from the 17th sent from Deutsch-Eylau and one of the 25th from Berlin.[13] It must have been terribly sad, having to clean out Martin's place. As if he'd died a second time. How I wish I could have helped you then, because it is surely small comfort to you that he died a hero's death.

Today I worked intensely drawing a cavalry lancer. I occupy myself a lot with foreshortening, draw such a rider from far down below in such a way that the head of the horse with its mysteriously expanded nostrils stands directly opposite the pompously brutal head of a rider. I want to include all this in what I paint on the walls. I've abandoned my plan to paint an Oriental bath and now paint what surrounds me. V. has a fabulous gray old Gothic church that stands tall and formally among the red roofs.[14] Down below, the River Lys flows,[15] then wildly torn-up terrain with an amusing mess wagon, then, before it, the rider seen from below, behind a rearing horse, and to the right an infantry soldier who leans on his rifle with a grotesque movement and has an expression on his face, as if to say: You can all go . . . yourselves. Harmony: olive colored uniforms, a white and a brown horse, clay-colored ground and yellow sky, in addition green and rose and deep blue faces. Lighting rather sharply from the left so that the figures, since they are lit from the side, appear partially as silhouettes against the light terrain and the sky, since only the area of the sun is lightly clouded with pale violet. But of course my manner of painting is coarse in facture, sometimes with heavy contours.

Lille,[16] April 3, 1915

So today it was Lille, where I was supposed to buy supplies, that was
the program for me. Already at 3:30 this morning I was about to go
to the train station, when the thought came to me that it would be
more pleasant to go as far as T. [Tourcoing] on foot and then to take
the electric train for half an hour to Lille.[17] So I stayed in my sweet
bed until 6:30, then took this tour in rather gray weather. This eve-
ning, for a change of pace, I now find myself in quite romantically
wild housing, to which the kind local command sent me. As I look
up right now, I can see myself wearing my dreary medical orderly's
uniform while sporting wild automobile goggles in surroundings
that vividly recalled the interior that I recently etched, the one with
the murdered man.[18] It is cold. During the day it rained a lot, and
Lille is in ruins. The very heart of the city was pierced with barbaric
severity, and the gaps between remaining houses make it look as if
the end of the world had come. I was told by a nice Frenchman that
in some places the bodies are still rotting in collapsed basements so
that the stench is unbearable. Everything here is disciplined and
cold. The sound of thundering cannons still lingers over the city.

I did meet one interesting person here, the illustrator A. from
Simplicissimus, who is working here with the Lille *Kriegszeitung*.[19]
After I saw it, he helped make the horribly cold mood that such a con-
quered city emits more bearable, and I am grateful to him for that.

Just now, with loud, cursing soldiers to either side of me, I drew
my self-portrait under the sharp illumination of the electric light.

An old renaissance townhouse here was unbelievably beautiful.
And the way home through the ruined streets was strange. So long,
my love. Loin d'ici [far from here]. A violent world. How distant is
peace.

V. [Wervicq], April 5, 1915

My trip back from Lille yesterday evening was eerie. Riding in an
unilluminated train all along the front, with its constant gunfire and
thundering cannons.[20] In pitch black darkness. The dark night sky
was constantly marked by rockets and flares that stayed aloft a few
seconds and then fell slowly. Other than me, the train was filled
only with soldiers and officers wanting to get to the front. The
trains here travel only at night because of aerial bombardment.
These illuminating flares are eerily frightening in their effect, like
horrible, pale faces that rise up for a few moments over the dark
ramparts and then disappear quickly.

At L. [Lille] I went to the wrong train station. There's a Belgian and a French one there, and I had to walk on through the dark night for another half an hour. Other than that I once fell down hard and twisted several muscles, the path was very pleasant. I was constantly accompanied by trembling circular holes in the sky that were produced by the spotlights of the French and Belgians and that seemed like strangely transcendental airplanes, as well as by the nervous, never-ending firing of the infantry and by the wonderfully apocalyptic tone of the giant cannons. In the dark, a rider at full gallop, and from time to time, big rats coming out of the slimy ditches at the sides of the road, creatures big as cats that now carry out the practical task of burying the corpses that lie in front of the trenches.

It is really amusing how the life of peace that we cursed and about which we complained so much is now being promoted with an iron logic into a paradisiacal existence.

V. [Wervicq], April 12, 1915
I am truly lucky. I am able to see and experience so much and under such ideal circumstances that soon I will certainly be like Frau Ilsebill when she wanted to be the good Lord himself so that she sat in . . . again, as that wonderful old fairy tale relates so humorously and characteristically.[21]

Yesterday I spent the entire day at the front and again saw remarkable things. In a totally destroyed village into which shells were still being fired, I sketched a dead horse that stretched its stiff legs—from which the hide had been partially stripped away—into the air. Then in the afternoon I went innocently for a walk and managed to get caught up in the firing at an airplane directly above me, so that I heroically saved my skin under a tree, the bits of shrapnel being uncomfortably hard affairs that usually hit harmless privates or civilians but almost never the plane's pilot, who in his apparatus, painted in charming red and brown stripes, continues to fly coolly through the wide open spaces in the glow of the sun and the azure of the sky.

In the evening, I collected my pay!

It seems strange that it's still possible to derive a sort of pleasure from this really miserable business—I mean life, not the war. I'm glad that you now have so many opportunities for your beautiful voice to be heard and as a result you are able to feel more yourself, because after all, that is what all of art has as its goal.[22] The

enjoyment of self. Naturally only in its highest form. The sensation of existence itself.

Brussels,[23] April 16, 1915
To begin with, Brussels really is fabulous: it is the most beautiful city that I have ever seen. We absolutely have to come here together. I bought paints for the hospital.

Could stay here longer but I'm bursting with the desire to get to work.

V. [Wervicq], April 17, 1915
I'm really sorry to hear about Peter. I hope the danger passes. The poor little fellow. How I wish I could be with you and could comfort you and myself as well.

Today I still have to tell you about Brussels. Think of the city as being in a deep valley and in the hills surrounding it are wonderful promenades with old trees and truly fabulous, elegant villas.[24] The churches are one glowing example of Gothic after the other, and the Grand-Place is a collection of renaissance and baroque, everything in black and gold and gray, crowned by the slender, wonderful Gothic tower of the town hall, almost surpassing St. Mark's square in Venice in its power and impact.[25] In the hills there are large squares surrounded by remarkable French empire facades and buildings, and always linked to views of the city, the city that climbs like an amphitheater up the hills and kisses the soles of their heights with its Gothic pointed and square towers.

If Brussels remains German, perhaps we will move here some year.[26] Because the race of people here interests me very much as well. It is very Germanic yet in a mixture that is simultaneously amusingly Gallic.

Incidentally, they are still stinking mad at us in Brussels. It's much more noticeable there than here, because that's where the leading people are. I saw wonderful Brueghels, some remarkable Rogier van der Weyden, who among the Belgian primitives appeals to me most of all.[27] But certainly a wonderful portrait by Cranach made the most intense impression on me. A man with slanted eyes, beard and wearing fur seen against a bare wall,[28] and some unknown German primitives, who seemed remarkable to me in their almost brutal, raw sincerity, their robust, almost peasantlike strength.

These paintings once again inspired me immensely and con-firmed me in my convictions. I felt myself to be near to all of them and felt at home while in enemy country. I was in the Musée Wiertz, too, but did not like it very much.[29] It only leaves you with the feeling of having to do with a hysterical Rubens and Ingres epi-gone who had much talent but was ruined artistically by excessive literary ambition.[30]

V. [Wervicq], April 18, 1915

After supper I again went up to my mountain fifteen minutes away from the hospital and saw the horizon constantly illuminated by the inverted pyramidal reflexes of the shrapnel and its somberly red, zigzaglike exploding flashes.[31]

It was a bright starlit night and the moon, three-quarters dark but illuminated at its sides, lighted my way across fallow clay ground and old, deserted trenches, whose clay mounds cast dark shadows. I forced my way up through underbrush and tree stumps to the top of the hill, where in the distance I can see large cities. Down below, near the factory, an automobile light snuck past lonely and ghostlike. Then the dark factory chimneys, a few bristly, bare poplars, and then the flaming horizon. Above, the cold stars and empty, unimaginable space and the moon, with a great bite taken out of it by its shadow.

And everywhere the howling of the guns.

It's a matter of some sort of revenge, since the foe took some hill or another away from us.[32] In reality it concerns the effort to finalize the already too short life span of several hundred people.

From somewhere voices warned me to go home. It is now pos-sible to be shot in the dark without ceremony.

This afternoon I painted fresco for the first time in my life.[33] One of my most wonderful experiences. It's as if it were made for me. Much is freed in me only on these grand flat surfaces. And it is remarkable how beautiful the colors appear on the plaster. It's also possible with fresco, something not always possible in oils, to leave large areas relatively empty in order that they interact all the more intensely with others.

For me the war is a miracle, even if a rather uncomfortable one.

My art can gorge itself here.

Too bad, our dear garden suffered greatly.

V. [Wervicq], April 20, 1915
How happy I am that Peter is feeling better again.

I'm working in full fury on my fresco. Right now I'm some-
what nervous, so that I feel as if I'm constantly surrounded by ene-
mies, which is very unpleasant. Probably there's absolutely no rea-
son for it.[34]

Things have become very dramatic here again. The English
have set their hearts on breaking through precisely at our position.[35]
Today everything here stood under alarm again. Toward evening, an
unbelievable cannon fusillade.[36] Now it is quieter—but that is worst
of all, because now they'll charge.

Earlier I went up to the hill where there's a white villa that has
been transformed into a field hospital.[37] There I climbed onto the
roof and was able to observe the entire massive front. Cold, small,
dark gray clouds were visible against the setting sun. In the dis-
tance, the heights of Ypres, and along the entire horizon nothing
but horrifying grenade and shrapnel explosions.

Below in the hospital many of the wounded from the past few
days were stretched out. One had just been brought in and lay
there dying; a huge bandage around his head was already dark with
blood although it was changed just half an hour earlier. His face
was still young, very delicate. Horrible, the way you could sud-
denly look right through his face, somewhere near the left eye, as
if it were a broken porcelain pitcher. He was unconscious and
moaned loudly and moved his hands restlessly back and forth.
He's lying in a sort of wooden box just like the typhus-infected
patients.

Outside, the lightly wounded crouched at the open window and
watched the battle. Their eyes wandered restlessly over the broad
expanse of the horizon.

Then, slowly, across the green field, I went home. I passed an
old farmyard with a small pond in which small, bordering willows
mirrored themselves. Heavy, dark, black silhouettes.

Down near my villa, the Bavarians were taking position to the
sound of march music.[38] They'd already been put on alert a few
hours earlier, and even from the hills I could watch the closed, dark
ranks of these people who had collected there under the thunder of
their fate. Now they were moving out. And a wild, insane music re-
sulted when the howling of the cannons mixed with the tones of
their brass band.

I wandered around aimlessly for a long time after that. Had the wildest urge just to follow them. That fire-spewing line of the horizon has a horrible fascination for me.

Logic reigned, however, since duty didn't permit me to go. And so, as so many others, this day, too, ended with letter writing.

Ugh, just now there was an explosion that caused not only the windows but the walls and doors to tremble.—

My friend is the bath attendant and barber who guards our villa as a sort of watchdog. He sleeps here and is supposed to be here at seven o'clock. But he only does that for a few days at a time, after a weekly chewing out; at other times, following his own wonderful habits, he gets here at about nine-thirty. A really nice fellow, only he talks a bit too much. But someone real, and despite all the barber mannerisms he's absolutely masculine.

V. [Wervicq], April 26, 1915[39]
I worked well today and it's really too bad that I can't show you what I'm doing. I am learning a lot from the fresco technique. It's enormously appealing.

The man I told you about yesterday died this afternoon. The cannons are silent today. A large number of new wounded arrived who were hurt during the horrible tumult of last night, and I received many totally direct impressions.[40]

This afternoon I read Kleist's *Amphytrion* with much pleasure.[41] Oh, how festive that is! Too bad the fellow let himself get discouraged in the end.[42] His sister seems to have been great. But sadly, not good enough, because in the end she abandoned him after all and didn't believe in him enough.[43] What might he had been able to achieve had he been tougher.

Or if Ulrike had been tougher.

Right now I'm often amused by my own, so stupidly tough will for life and art. I care for myself like a loving mother; spit, choke, shove, push, I must live and I want to live. I've never bowed down before God or anything like that in order to achieve success, but I would drag myself through all the sewers of the world, through every conceivable humiliation and abuse in order to paint. That I have to do. All the forms I imagine and that live within me must be wrung out of me to the last drop, then I will be glad to be rid of this damned torture.

V. [Wervicq], April 23, 1915

Today we had wonderful spring weather, fascinating antiaircraft fire, and only seldom any cannon fire. Once again the English failed to break through.[44]

V. [Wervicq], April 24, 1915

So far, then, the English have spared me. A few days ago they made the, for them, relatively successful advance onto Hill [60], quite near to us, but still an hour away on foot—but then, you will surely have heard about our successful counteroffensive yourself.

The successful attack over L. [Langemark] has the infinite advantage of permitting us to bombard Ypres from two sides now. In addition, there are the commanding heights of the valley of the Ypres Canal. So the English are caught in a sack and are in great danger of being cut off if there is an additional successful advance. So, without doubt, it is a great accomplishment. Yesterday and last night there was a cannonade here such as I never heard before. Not only the windows, even the walls trembled as if in an earthquake. The English must have been terribly angry.

How do you like it in H.? Very melancholy, I should think.— We simply have to assume that life is not everything. What, why, and how are simply none of our business. It's necessary to be prepared for anything and to continue to hold your head high.

I always feel the most sorry for Gerstel.[45] Sometimes I'm aware here of what it means to be captured. As far as I can determine, he's been a prisoner for half a year already. Poor fellow. What mustn't be written between the lines of his supposedly calm, pleasant cards.

A little while ago I looked through my drawings again and discovered once again that there are more than seventy.[46] Seen as a whole, they please me more than individually. It's then possible to see the will they share, which I'm not aware of in the individual drawing, since I only feel and do not think when I draw.

Since my fresco is also progressing, as I already told you, today I again have something of a feeling of satisfaction that the time is not totally wasted. Grit your teeth and carry on, through the war and through life. The two are not really so different. Today as I walked among the bare trees of springtime, the wind blew as it does near the ocean, and I even felt the way I did there sometimes during the loneliest times, absolutely alone and close to nature.

V. [Wervicq], April 27, 1915

It was very satisfying to ride a horse once again. Slowly I'm getting to know all the moods and possibilities of the war. We rode close to the front through nothing but bombarded villages, munitions columns, and soldiers. Sometimes my riding skills were tested to their utmost. Once, directly next to us, chaotic machine-gun fire directed at a plane went off directly above us, and my sorrel was more than a little upset! Then the constant thunder of the cannons, and the poor animals are so nervous.

We returned in a magnificent gallop along the banks of the Lys River. A military smithy in Tenbrielen,[47] where my sorrel had to be shod, was most impressive. A big mule was there, too, and a heavy Brabant horse and a fabulous military blacksmith and very amusing soldiers. I rode with an officer's orderly who's my friend—that is, we met this morning in the Café Rubens, a rather grubby pub.

V. [Wervicq], April 28, 1915

Today, then, I was actually at the front for the first time. Unforgettable and strange. In all those holes and sharp trenches. Those ghostly passageways and artificial forests and houses. That fatal hissing of the rifle bullets and the roar of the big guns. Strangely unreal cities, like lunar mountains, have emerged there. A strange sound is made by the air as it is torn apart with the firing of one of the big guns. It squeaks like a pig that's being butchered. Dead soldiers were carried past us. I sketched a Frenchman who stuck out partially from his grave. A grenade explosion had disturbed his rest.

I really wasn't very scared. A strange, fatalistic feeling of safety surrounded me, so that I was able to draw calmly while not too far from me sulfur grenades hit and the poisonous yellow and green clouds slowly wafted by.[48]

I was able to examine closely the Hollebeke château, which played such a significant role during the battle, very closely.[49] It appears strange and eerie standing in its bombarded park amid all the broken trees.

All of that is really not essential for what I want to do. Many of these actual details will be useless for me, but slowly the atmosphere does trickle into one's blood and provides me with confidence for those images that I saw earlier in spirit already.

I want to work through all this internally in order to be able to produce these things in an almost timeless manner later: that black

human visage gazing out of the grave and the silent corpses that
come toward me are the dark greetings of eternity, and it's as such
that I want to paint them later.

Tomorrow the field hospital plans a big parade.

V. [Wervicq], May 1, 1915
So, for the time being, everything here is very calm again.⁵⁰ My
"fresco" is finished and there's general satisfaction. Talked an awful
lot today and am very tired.—It's too bad that one always gets let-
ters after the mood has already changed again. Naturally, at the mo-
ment it seems as if it will never be able to change again. But it cer-
tainly will, despite everything.

V. [Wervicq], May 2, 1915
In the evening, as I was sitting alone in my room and the house-
owner's wife was lighting a fire for me, she happened to hold the
empty envelope in which the newspaper clippings were sent against
the window and there was still a letter in it. That was a nice surprise.

Took a wonderful walk over to L. [Linselles] to visit Lieutenant
P.⁵¹ Through blossoming spring landscape with white flowering
trees and cold, gray, windy sky—the very pleasant P. and a charm-
ing village doctor named Bonenfant, with whom I drank very nice
French white wine and looked at his wonderful garden—a lovable
original directly out of Flaubert.⁵²

V. [Wervicq], May 4, 1915
Well—a hundred thousand Russians are supposed to have been cap-
tured!⁵³ If it's true, it would be wonderful and bring peace a step
closer. My friend swears up and down that it's true. I won't believe it
until I've read it myself.

Spent the afternoon in L. [Linselles] again with Herr P. and
Dr. Bonenfant. It was very nice and I drank excellent yellow wine
and ate some delicious pâté. Then, accompanied by P. for a while, I
went home in a gentle rain after the storm. Wonderful. How much I
love the storm. I tried to make a drawing of it just now. The view
from the elevation of L., from the old mill looking out over a vast
expanse of land onto the little castle in the park. The sky was a mira-
cle of wild, exciting beauty, terrifying and fabulous simultaneously.

Yesterday was more dramatic. I helped drink an entire bottle of
champagne and a very good red wine that took the place of the yel-
low wine, after we first built up a solid foundation with caviar. Then

we went for a walk in the grenade fire.—I spent a long time in the totally ruined church.[54] It was humid and close, just before a thunderstorm, and the pale gray columns of the church contrasted wonderfully with the violet sky that could be seen darkly through holes in the church roof. Add to that the explosion of the grenades that sounds much like lightning striking.[55]

Standing there in the middle between life and death gave me a delirious, almost evil sense of joy.

While walking back home, I watched a few women and two farmers with huge hoes planting potatoes. Tall, sinister fellows hacked away at the ground with an overwhelming force. From the distance, it looked as if figures of Death were wielding scythes.

Now I've given in to temptation again and have been drawing this scene for almost an hour. Tomorrow I plan to go and sketch these people again [56] and then I will paint the scene here on the wall and then, after I come home, once again!

Well, just now ——— was here to see me again. It's official, then. Ten thousand prisoners and the dead.[57] Horrible, horrible. Tomorrow morning they want to capture Ypres—but first I have to sketch those farmers.[58]

My soul feels as if beset by tumultuous waves; I have to paint that picture.

V. [Wervicq], May 4, 1915

I'm absolutely incapable of writing to you, the swarms of flies are so thick here. These stupid creatures are falling constantly and a buzzing fills my room as if it were an ant hill.

Now for the first time, I've had enough.[59] I was at the foremost first aid station, which lies immediately behind the first trenches. In the center of the massive bombardment of Ypres. Ugh. To be completely honest I have to admit to you that I had not inconsiderable concern for my worthy, good, honorable life. I rode a bicycle to Tenbrielen, the last little village before the battlefront. It is largely deserted by the villagers, and I wanted to sketch my farmers from yesterday again, as well as visit a chief medical officer there to see if he didn't have anything for me to see. Mais il n'était pas là [but he wasn't there]. To make a long story short, I looked around for a while and could not find my models again. The whole time I moved between yellow flowering rape and endless munitions columns that came from the front only to turn around and go back. But finally I ran into the medical officer's orderly. "The surgeon has gone to the

front line of trenches," he tells me, "I'm on my way there, have to bring them more bandages there."

On the way to Tenbrielen, I was already scared, because today, I told myself, you are really doing something stupid. So, after Zandvoorde, it would be necessary to continue on foot for a quarter hour.[60] "Well, OK then, I'll come along."

Then it started. Our heavy guns are positioned immediately outside of Z. [Zandvoorde], and of course they had nothing else to do but wait until we were walking past to begin firing. Luckily, I caught sight of the officer just as he called out, "Fire!" but nonetheless I could hear nothing for several seconds and the air pressure hurled me back several steps. Like an enraged Fury, the shell flew over my head out into the measureless distance, and now the shells kept coming over my head with a wild, ironic, horrible howl. And I went on through the ruins of the village to the left, along the road that continued over the hills and twisted like a corkscrew instead of taking me straight ahead, as I expected it to do. To both left and right our cannons were now firing with a wild rage, and now I also heard the horrible sound of the enemy's hits. Well, I bucked up my courage and went on. At a ruined house along the deserted road, a soldier sat and sneered at me.

"What on earth are you doing here? Just come out of curiosity?"

"Yes, well," I replied in embarrassment.

"I would gladly stay at home if I didn't have to be here," he said, and again he grinned and sneered.

"Well," I said and looked at the white crosses with their melancholy, empty helmets that decorated the edges of the road. "That's just the way things are. Well, so long."

I went on! To go back would have been just as dangerous as to continue. I bucked up my courage again and followed the brave young orderly. First we had to go past another first aid station, and then finally I landed where my chief medical officer was, who received me with astonishment. So, now I was here. Nothing could be done about it anymore. I have to add that he had refused to take me along after a telephoned request. À cause du danger.

The noise was absolutely hellish. The air was filled with the shrill whistling of shrapnel and the dark droning of the heavy guns. More wounded were constantly being brought. Some who had been poisoned by gas rolled around with uncontrolled convulsions and wheezed heavily.[61] It was necessary to use a mouth clamp to hold the mouth of one of them open.

I saw some remarkable things. In the semidarkness of the shelter, half-naked, blood-covered men that were having white bandages applied. Grand and painful in expression. New visions of scourgings of Christ.

Then a first lieutenant was brought in who had just received a bad chest wound. A handsome face, already very pallid, with reddish hair and a grayish pink skin tone. He was absolutely calm and very feeble.

"The bullet entered here and went out there," he indicated on his naked chest. "Bad situation. Won't last long."

Distinguished and noble and calm. He spoke with the dry tone of an officer.—He won't recover. Outside lay two of this morning's dead who were supposed to be buried later. I lifted the cloths from their faces. The one was totally sallow and brownish white with a remarkable otherworldly expression on his face—the other had a brutal face, totally covered with blood, with a huge gaping wound in his lower face and on his neck, a ruby that was a deep, bloody abyss. They lay there silently. Nearby their comrades dug the shallow grave. Above us an enemy plane.—In camouflage.—In the meantime, the enemy must have noticed the assembly of people, and the grenades from the heavy English guns began to land ever closer to us. Surrounded by those torn-up remains of human beings I now stood, aware that at any second I could be one of them.

Fear was written on many of the faces around me. And ahead of me lay the way back over the exposed heights. Chief Medical Officer C. was remarkable. Not a trace of fear—he moved calmly and with self-assurance around the terrain, as if he were on a dance floor. He drove with the seriously wounded lieutenant by car to V. [Wervicq].

In the meantime, we continued to be bombarded, and we spent the time seeking out various hidden nooks and crannies.

Then the division pastor arrived in an ambulance.

The funeral was supposed to take place in the open space in front of the dugout, and it was of course very much exposed at the moment.

So we collected outside in that unbelievable noise. The pastor held a brief talk that sounded like a desperate plea that God, to whom we had always remained true, should save us from this distress. He raised his voice sometimes into a shout, since otherwise he could not have been heard, but also surely because his agitation and nerves forced him to.

The talk was brief, and never before did I hear the Our Father recited so quickly, but it remained recognizable. It was wonderful to see the deep, moving reverence of the soldiers, their young and old faces with expressions of hardship and submission but also of strength and the silent nobility of accepting the unalterable. In me, everything was in turmoil. My survival instinct was constantly listening, as if on the alert to save me from an incoming grenade, and my absolute determination to grant final honors to these two men, who in a sense had died for me, with a certain amount of self-control.

Now the Amen was said. I was the third to approach the graves and calmly—at the time, I was absolutely calm—toss a bit of sand onto their poor brown, shot-up hands and their covered heads.

And now, for a theatrical ending, a grenade arrived, too, and exploded fifty meters from us with a shrill sound. Everyone who was there threw himself onto the ground to gain cover. None of us was hurt.

On the trip back I was lucky. First I rode inside the automobile ambulance with those who had been gassed, then holding onto the outside while we crossed the hill.

Massive, dark storm clouds came toward us from the direction of Ypres.

V. [Wervicq], May 9, 1915
—but the most enjoyable part was the way home in the winds of a tumultuous storm and under a clear evening sky in which I felt myself to be more free than any god could be and my soul was filled to overflowing with a powerful will and desire to work. Then I constantly saw before me a shoulder or a hand the way I wanted to paint it. To capture the organic, the wonderful dynamic of these remarkable machines with their precious harmonies of flesh in pinks and pale greens, gray and black.—I see such wonderful things here so often. Today, a man wearing a coldly pink shirt, very startling in the sunlight, and bright blue trousers, with a yellowish face, carrying a bundle of dark twigs. He was wonderful. Before him walked a small child, carrying on its back two twigs that happened to form a cross. It all looked somewhat like this, although the color is sadly missing:

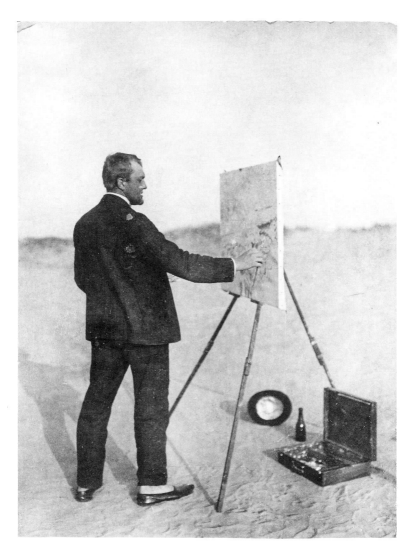

Beckmann painting by the Baltic Sea, 1907

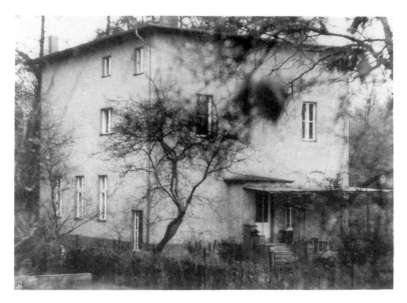

The Beckmanns' home in Berlin-Hermsdorf, Ringstraße 8, 1968

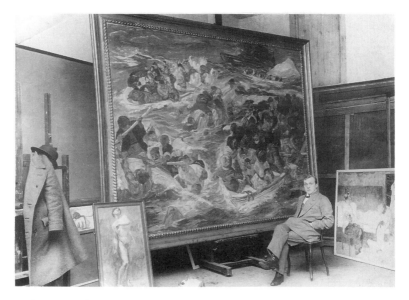

Beckmann in his studio in front of *The Sinking of the Titanic,* 1912/13

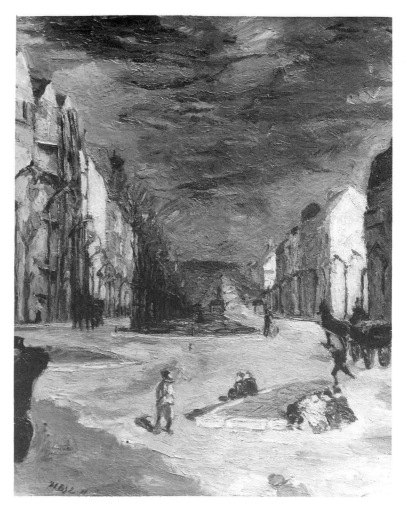

The Kaiserdamm in Berlin, 1911

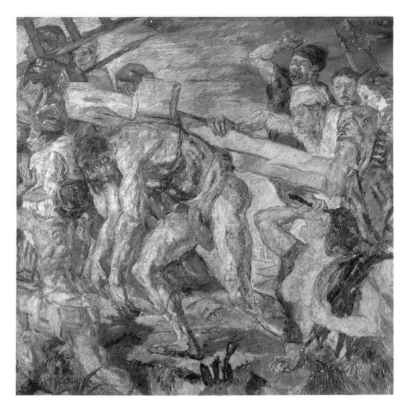

Bearing of the Cross, 1911

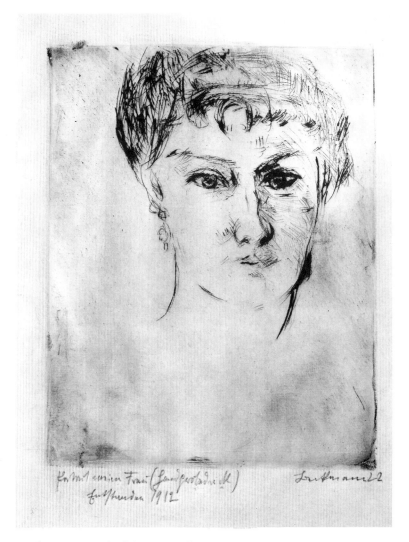

Mink, Frontal, with Elaborate Coiffure, 1913

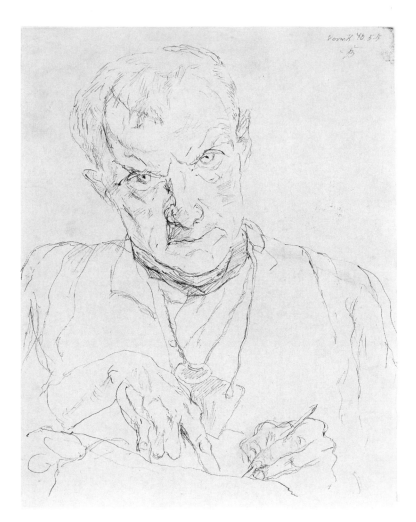

Self-Portrait Drawing, May 10, 1915

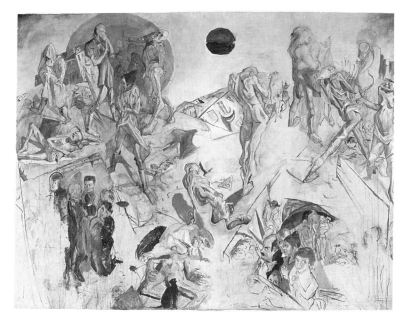

Resurrection, 1916–18

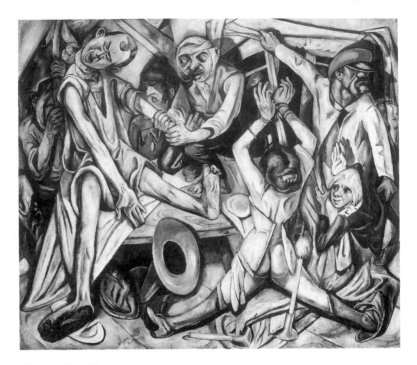

Night, 1918–19

Self-portrait on portfolio cover of *Hell*, 1919

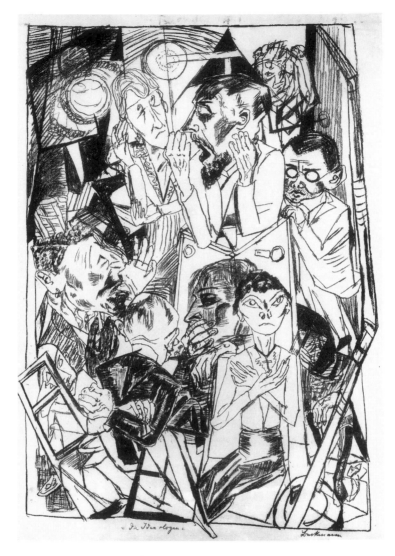

The Ideologues, from *Hell,* 1919

Illustration for *Ebbi,* 1924

Max and Quappi Beckmann in St. Moritz, December 1928

Self-Portrait in Evening Dress, 1937

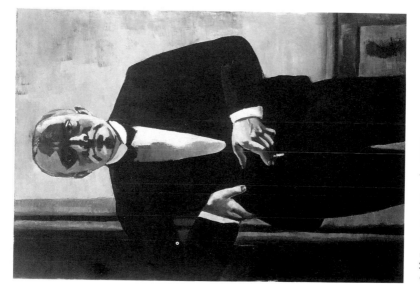

Self-Portrait in Tuxedo, 1927

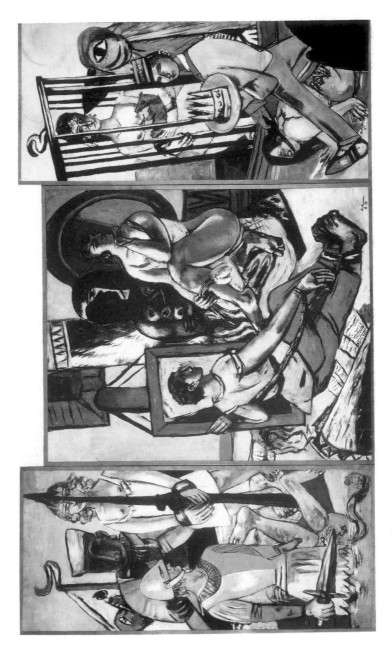

Temptation, 1936–37

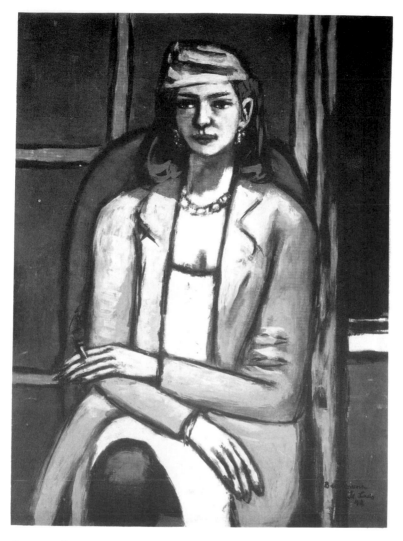

Portrait of Quappi in Gray, 1948

Beckmann teaching at the Brooklyn Academy Museum School, 1950

V. [Wervicq], May 11, 1915

I am painting a new "fresco," depicting the personnel of the bathing establishment here.[62] It provides me with the opportunity to note down the people that I see around me, something that can be quite humorous at times. I sketch noble noncommissioned officers, sporting Haby mustaches,[63] grotesque Belgian women, jealous medical orderlies, etc. Strongly resistant stuff that could easily lead into the temptation of anecdote.

I have such a passion for painting! I work at form constantly. While sketching and thinking and dreaming. Sometimes I think I'll go insane, so much does this painful passion exhaust and torture me. Everything else disappears, time and space, and I persistently think only, how will you paint the head of the risen Christ against the red stars in the sky of the Day of Judgment. Or how are you going to be able to fuse the mustache of Corporal D. together with his reddish nose to achieve a living ornament, or how will you paint Minkchen now as she draws up her knees and rests her head on her hand, the pink of her complexion seen against a yellow wall, or the glitter of light mirrored within the blinding white of antiaircraft grenades in the lead-white sunny sky, and the wet, sharp, pointed shadows of the houses as well, or, or I could fill up four more pages writing like this if I did not have to get some sleep so that I can paint just a hundredth part of all this.

It's good for me that there's war now. Everything I did previously was no more than an apprenticeship. I'm still learning and growing.

Last night I dreamed that your mother died. Never in my life did I feel such pain. It reminds me of the time I once dreamed that I would have to be separated from you forever and ever. Then I had similar feelings. In real life, painting consumes me. Poor bastard that I am, I can live only in my dreams.

V. [Wervicq], May 14, 1915[64]

—Since I was out there in the line of fire, I feel as if I'm there at every single shot and have the most horrible visions. The sketches for prints I want to engrave grow like a victory in Galicia.[65]

V. [Wervicq], May 19, 1915

Albert Weißgerber has fallen in the west.[66] The news upset me terribly.

Also because I continue to fare quite well. R. [Waldemar Rösler] wrote a very sad letter.[67]

V. [Wervicq], May 20, 1915

I have constantly been sketching her sister, the woman who owns this pub, but am still not satisfied with the results. I have still not been able to capture her grave, tragic look. Her husband is in Cairo, went there four months before the outbreak of the war to work with a Belgian machine factory.[68] She has had no news from him since the war began. Her old father sits here in an armchair, dying ever so slowly, struggling against the dropsy. He moans and leans back, his mouth open. The expression on his fading face is wonderful. I sketch him persistently and drink coffee all the while. An amusing little boy, charmingly ugly, always watches me closely and reminds me of Peter.

V. [Wervicq], May 21, 1915

Today I sweated more from infamous feelings than I ever did during the hottest hike. That the dump where we were had been shot to pieces down to the very bones hardly bothers one much anymore. It all began on a flat, overgrown elevation, past a mock artillery position. It was humid and storms were in the air. To the right and left, diaphanous farmhouses, cleanly reduced to their skeletal structure.

I must say, I imagined it would be a relatively quiet excursion, and when talk turned to the trenches, my mood didn't exactly become calmer.

Well, if you say "A," you also have to say "B," so off we went! To the left and right our own guns howled. Up on top of the hill, the major showed us the area and pointed to the enemy position from which—as he kindly told us—we could be observed. And true enough, something sped past us with an indefinable sound, like a bee or a bird flying very fast. I had already come to know the sound from my visit to another forest trench and knew what it meant.

It is terrible and unpleasant. All the fibers of my body tensed up and searched and felt for what would come next.

The grotesque movements made by people as death flies past are very amusing. Only the major did not flinch, but walked on calmly toward the entrance trench some two to three hundred meters distant.

They seem actually to have spotted us, so that one bullet after the other whizzed over us, past us, next to us. Even now, as I write

this, I can feel that fatalistic sound. It possesses an unmerciful sharpness and sounds somehow evil.

Finally we got to the trench, but ever and again, and now with definite frequency, those bees flew past one meter above us.

After a while the muddy path of the trench widened into a deep stream. So we had to go up above to go on. The major climbed up calmly—it was about ten meters' distance—and went his way, head held high. I cursed my existence and contemplated continuing to wade through the swamp. But finally pride or remnants of human dignity—I don't know which—triumphed. So up and over! But, of course, not in an upright position, but rather with bent back and head pulled in. That is of course totally useless, I thought to myself, but it was the only way that I could fool my danger-awakened survival instinct at all. Jesus Christ! There was a reason for it after all, because no more than fifty centimeters above me the bullets whizzed by one right after the other. Had I walked erect, I would have bitten the dust.

Half crawling, I was able to get below again. It was strange, but in those few minutes I felt the greatest fear and yet remained conscious of the rhythm and the intense, strained faces of fear and of horror in taut muscles. In myself and in the men in front of me.

Now we arrived at the actual trenches, where that species of people live that have bid farewell to life. Yesterday a corporal sitting before his men was killed immediately by a ricocheting bullet. We were greeted with this news by a most impressive captain as the music of the bullets continued above us.

The trenches twisted around like serpentine lines; from dark caverns white heads peeked out. Some were still taking up their positions, and mixed in everywhere were graves. On their benches, on their embankments, yes, even between the sandbags, crosses had been planted. Corpses squeezed in. As anecdotal as it may sound— on one grave next to a trench a man was frying potatoes for himself.

Here the existence of life truly was transformed into a paradoxical joke.

Which is not to say that it is not one at other times, if we only think of the circle of flames blazing around us. As a matter of fact, even that is not necessary. When my mother died, the world seemed no different to me either.[69] Everywhere the mystery of the corpse. The first lieutenant about whom I told you recently, the one with the red hair and grayish pink skin tone, died three hours later.

While I was in the forest trench they brought in one who was

hit near us and was still alive.[70] A very gloomy group collected around the convulsive man as he wildly reached out around himself.

We wandered and crawled around in the trenches for about an hour. Then we had to come back through a forest, into which bullets nonetheless penetrated again and burst with a loud crack against the trunks of the pines.—

May 23, 1915

Dr. Bonenfant is very handsome in his floppy frock coat, his stiff white collar and his boylike face, although it suffers somewhat from effects of drinking. He is also the maire [mayor] of the town and very much abandoned by wife and children. His son just left for the front, as he heard circuitously in correspondence from his wife. In addition, there is P. with his fine face, who however always seems somewhat reserved, like his brother, but at times also displays a joyful friendliness. They were my company today. Dr. B. disdains the Italians and opened a marvelous bottle of light Bordeaux in our honor. The fat man had brought along a bottle of Rhine wine in his saddlebags. The contest remained undecided.

Afterwards they continued drinking in an inn located on the way back to V. [Wervicq] and where we watched the worthy natives at their unique game of skittles and marveled at the fabulous hips of the Flemish-French women that inspired—immense erotic fantasies. It was very entertaining, watching the eccentric movements and grotesque physiognomies of the farmers.

I sketched a lot. That attracted vast interest and distracted from the games of skittles significantly.

Incidentally, the women here have a wonderful peach-colored skin and sometimes something of the primevally powerful vitality seen in Jordaens.[71]

Oh, if only I could work here peacefully some time. I feel myself closely related to all these people. They are such a novel Germanic race with a slight touch of the Spanish. In many ways charmingly grotesque.—Oh well, that time will come too.

Love to Peter and send my congratulations that he had as little trouble as he did with his ear. But he shouldn't play the hero too much; he still needs to get stronger.

V. [Wervicq], May 24, 1915

It's night again. Over in the field hospital the farewell celebration for the chief medical officer is going on, and they are once again singing:

Deutschland, Deutschland über alles . . . Every so often the thunder of a cannon sounds in the distance.[72] I sit alone, as I so often do.

Ugh, this unending void, whose foreground we constantly have to fill with stuff of some sort in order not to notice its horrifying depth so much. Whatever would we poor humans do if we did not create some idea such as nation, love, art, and religion with which to cover that dark black hole a little from time to time. This boundless forsakenness in eternity. This being alone.

Deutschland, Deu-eutschland über a-alles, über . . . in der Welt. We poor children.

This second day of Pentecost passed strangely quietly, in biting sun.[73]

—It's not as if I were participating in this business as an historian, so to speak, but rather that I feel my way into this thing, which is in and of itself a manifestation of life, like sickness, love, or lust. And just as I consciously and unconsciously pursue the terror of sickness and lust, love, and hate to their fullest extent—so I'm trying to do now with this war. Everything is life, wonderfully changing and overly abundant in invention. Everywhere I discover deep lines of beauty in the suffering and endurance of this terrible fate.

Last night I had a wonderful apocalyptic dream again. Now probably just about my twentieth.

The two of us were on a wide road, something like a mountain pass, that seemed to run along an endless ridge. We were in hasty flight from something or other. In the infinite vault of the sky, strange raylike white clouds, unbelievably huge in size and dense, compressed in form, could be seen against a sky that glowed metallic white and was illuminated by some unknown light. These white clouds had strange, black cores that spun incredibly far away. From these, the rays emerged that illuminated weirdly, unspeakably remote spaces. These were then broken down more by deep shadows.

Everything seemed as if it were dissolved in a sensation of infinite extent and height and in the terrible sensation of "the new."

My candle is flickering and reminds me to go to bed. The singers have become silent as well. The second day of Pentecost is at an end, and the Holy Spirit once again has been poured out over peaceable lands.—

V. [Wervicq], May 28, 1915[74]
For a change, today I am writing you from my coffee table in the estaminet, about which I told you already. The swelling of my old

friend's feet has gone down a little. The fluids have abated. I'm
drinking my coffee between his spittoon and the various items nec-
essary for his nocturnal ablutions. This is the place from which a
strong atmosphere of harmony continues to emanate and from
which I receive my strength to cope with the various concerns of
the day. What constantly attracts me to this place despite the not
very pleasant entourage is the posture of suffering in the old man
and the strong, powerful pain and tragedy in the face of the women
and of the amusing, charmingly ugly boy. In addition I have to add
that in order to get here I always have to walk half an hour, since
the estaminet is located at the other end of the city. Our field hos-
pital is on the other side, somewhat outside the city. The military
bath establishment is closer to the city center, in France, by the way.
At the moment I am in Belgium. As in the *Flegeljahre* with Quod
deus vult and Gottwald, where each of the sons is of a different na-
tionality, since the house was built on the border.[75]—

—I have little, horribly little devotion to my work for its own
sake, and that, I think, would be the greatest patriotism.

V. [Wervicq], June 1, 1915
—The sunsets here are wonderful. The great globe rests on the top
edge of the hill where the English are, and it's impossible to under-
stand how they could still exist, it presses down on the edge of the
earth so heavily.[76] Poetic? What! I'm in high spirits.

V. [Wervicq], June 6, 1915
I'm sitting in my den again with my old friend and just listened to
the complaints of the woman whom I have depicted so often. They
can no longer get Belgian beer because they sell German beer, and
yesterday apparently some damned guy was here and demanded
beer, one of those scruffy ones (Belgian), who's always loafing
around the bridge and has nothing to do. And since she didn't have
any, he apparently grinned and said: well, you'd better stay Ger-
man. You've certainly sold enough German beer, and then he left
the bar with a mocking laugh. And she showed me photos of her
beautiful lodging house where soldiers now are in residence and
into which she invested her Fr. 50,000 savings—oh, oh, oh! this
damned war.

I drank coffee all the while and watched her agitated facial ex-
pressions with relish.

In the afternoon at the Café Rubens I surprised Seline at her

toilette, that is, naturally, the second stage. It was very beautiful, the charming blondness and the passionate movements with which she combed her hair. Then another family joined us, and I sketched them all to the accompaniment of much laughter. The fantastically ugly mother, the other daughter, and the son with the little dog. After the meal, I tried to make another large drawing of a young girl who lives opposite me. After several hours of attempts, as the reports say, I had to give up the attack, however, and tore the whole thing up. I always have to live in a head and get to know it like a city in which one lived a long time.

In the evening with Lieutenant P. in the Café Rubens again, where they were dancing. Accordion and violin and soldiers danced with Seline and other women in wild, mad abandon. It was charming, and I sketched until finally I could stand it no longer and joined in the dancing myself. Then I sketched some more.

V. [Wervicq], June 7, 1915
Yesterday evening I did not want to write you because this morning I drove to the front, and now it's over already and I'm sitting next to the easy chair of my old friend and drinking coffee at twelve o'clock. As you know, I have to illustrate the military songbook for the army High Command.[77]

I saw Ypres appearing like a mirage in the hot mists of the distance.[78] Monstrous sulfurous yellow craters from explosions, over them the pale violet, hot sky, and the cold, rose-colored skeleton of a village church. Saw the entire strangely flat chain of Ypres's heights; it has in it something of the majestic barrenness and desertion of death and destruction. No more isolated house skeletons and destroyed churches—instead, entire plateaus of house skeletons, and wide, desolate plains thick with crosses, helmets, and churned up graves.

—Life is a wild, chaotic torture—I wish I were sitting on Mars reading Titan and asleep.[79]

V. [Wervicq], June 8, 1915
Is the storm coming now or not? Dust is being churned up all around us, and the air feels like hot water.

This morning I was at the dusty, white-gray front and saw remarkable, enchanted, and fiery things. A searing black, like golden gray-violet crossing over to lime-yellow, and a pale, dusty sky, and half- and totally naked men with weapons and bandages. Everything

in disorder. Staggering shadows. Majestically rose and ash-colored limbs with the dirty white of the bandages and the somber, heavy expression of suffering.

It's not coming, the storm, and yet a little while ago it was already almost here. Everything was deathly still and the first little white clouds of horror were already whirling toward town. The streets waited with expectation. In the distance, sounds of thunder. I have no idea if it is thunder or guns.

Yesterday we came across a cemetery that had been totally shot up by shells and grenades. The graves were torn open, and the coffins were everywhere in highly uncomfortable positions. The grenades pulled the cemetery's inhabitants indiscreetly into the light, and bones, hair, bits of clothing peeked out through the burst seams of coffins.

Oh, I wish I could paint again. Color's after all an instrument that one can't do without for long. All I have to do is just think of gray, green, and white, or of black-yellow, sulfur yellow, and violet, and a shudder of pleasure runs through me. Then I wish the war were over and I could paint.—

Yesterday I sketched the girl once again with an immense exertion of strength. I think I succeeded in capturing her to an extent. I tried to express everything essential immediately, while also always keeping hold of the objective.

V. [Wervicq], June 8, 1915
Today I am tired, will probably not be able to write much. I am much more comfortable drawing than talking.—Yesterday had night duty again. Two abdominal wounds and a severe brain contusion accompanied by constant convulsions. The entire night was taken up with wrestling the unconscious man. Dimly lit room, night and sheet lightning outside, the stink of decomposition and movements by the bodies, naked because of the heat, filled with deepest melancholy.

The way home at four in the morning was beautiful, wonderful rain as I lay down in bed in the gray of dawn. My flowers smell like a Sapphic ode. Wild sensuality, melancholy, and the smell of rain. You and the world are far away.

June 12, 1915
Last night I was awakened by drums. They were not signal drums, but rather march drums. Did you ever hear them, nothing but this

isolated, sharp, chopped-up rhythm. For me, it's the most wonderful thing there is. All of the wild energy, the charge, the will of which we humans are capable resides in these cut-up sound waves. I lay quietly in my bed and listened to the gray metallic tone as it came through the infinite darkness. And the distant rhythm, unaccompanied by music, moves away slowly. Going somewhere.

Then in the morning I rode the bicycle far forward toward the front over ground we had just conquered, dotted with graves, white wooden crosses, and craters from exploded mines, churned- and shot-up graves that covered the region like the exploded bowels of gargantuan prehistoric animals.

I sketched and was arrested once again as a spy.

I sat for three hours, a soldier at my side with loaded gun. It must be strange, just before an execution. It was steaming hot, around me the giant guns were going off, and mistrustful soldiers surrounded me, conversing pleasantly with each other as my existence was being questioned.

I thought about how much like the rest of my life this particular moment seemed to be. Imprisoned, watched, and doubted. And I had to laugh, although the situation naturally was wildly unpleasant.

After I had passed through the hands of various officers who presented me with the opportunity to observe how different temperaments handle a particular situation, I finally reached a very kind and insightful captain who understood the situation, for whom my pass was evidence enough, and who released me. It was no surprise when I met him, since on the way to him his men spoke enthusiastically to me about his kindness, his courage, and his humaneness.

It was noon before I rode home through the glowing heat of the long street. I glided along almost soundlessly through the destroyed little villages. Not a single human being anywhere. Everyone hiding from the heat and noon.

In one village a soldier walked slowly with a large pistol drawn. His head lowered. Pausing. I knew what he was doing. He was hunting rats.

The snow-white highways, eroded by the sun, were blinding when seen against the black-blue sky. Giant white clouds of dust in the distance were the only sign of life. From time to time, an explosion. Otherwise, silence.

14

CATALOGUE FOREWORD FOR EXHIBITION AT
I. B. NEUMANN GRAPHISCHES KABINETT,
BERLIN, *MAX BECKMANN GRAPHIK*
(NOVEMBER 1917)

THIS FOREWORD was Beckmann's first public wartime statement since the appearance of his war letters and war drawings in 1916. We have little documentation of his activities in the intervening period. Beckmann is said to have suffered nervous and physical exhaustion in the summer of 1915 and was given medical leave to move to Strasburg, the Fifteenth Corps's headquarters, by September. After he arrived in Strasburg, he completed a self-portrait (1915, G. 187) and the drawings for Paul Cassirer's book of war songs and did artistic work for the military. From late September through October 3 he visited his family in Hermsdorf and Berlin.[1] By October a doctor he had known in Belgium arranged for Beckmann to be transferred with him to Frankfurt am Main.[2] Although he was officially transferred to Frankfurt on medical leave, he continued to work as a medical orderly through 1917.[3]

Israel Ber Neumann (1887–1961) had been a dealer, publisher, and enthusiastic spokesman for modern art in Berlin since 1911. According to his unpublished memoirs, Neumann first met Beckmann when the latter visited his gallery to see an exhibition of Edvard Munch, and Neumann apparently began to publish some of Beckmann's prints in 1912.[4] Although Neumann was then still more interested in Munch and the expressionists than in Beckmann, the two had remained in contact. Beckmann, who had never been happy with the support given him by Cassirer, sensed that Neumann might be his best promoter, and the two continued to correspond during the war. Even as Neumann still served on the front, he planned a first show of Beckmann for his new gallery on the first floor at Kurfürstendamm 232 (near the Kaiser-Wilhelm Gedächtniskirche), the graphics show of November 1917 for which Beckmann wrote this short introduction. Neumann became Beckmann's chief dealer starting with

this exhibition and remained so for the next decade; he also introduced Beckmann's works to the United States after he moved there in 1923.[5]

In January 1917, the critic Paul Westheim (1886–1963) had inaugurated his new journal of expressionism, *Das Kunstblatt*, by noting how many artists had turned away from the world of outer experience to explore "inner visions."[6] In echoing Westheim's phrase in this foreword, Beckmann showed that he joined many German artists and intellectuals who tried to cope with the increasingly discouraging war by investigating new sources of spiritual inspiration. In addition to reading Schopenhauer, and partly influenced by him, Beckmann had begun to read in Buddha and the German mystics Heinrich Suso (ca. 1293–1366) and Jakob Böhme (1575–1624). Indeed, in April 1917, Reinhard Piper sent him volumes of all three in exchange for some prints.[7]

Beckmann's cryptic foreword suggests that he might also have begun to consider the implications of Gnosis, a body of ancient wisdom that taught release from the material world and that had intrigued Germans from Böhme to Goethe, Schopenhauer, and modern theologians. Beckmann might have been stimulated to do so through his contact with Gustav Hartlaub (1884–1963),[8] who had just published an article entitled "Die Kunst und die neue Gnosis" in *Das Kunstblatt*.[9] In August 1917, Hartlaub, acting director of the Mannheim Kunsthalle, asked Beckmann to participate in his show of modern religious art, *Neue religiöse Kunst* (1918); although he did not participate in that show, Beckmann expressed interest in Hartlaub's ideas.[10]

Many Germans had also come to reconsider older German art, now less from the nationalistic feelings that had moved them at the beginning of the war than from an attraction to what they saw as the spirituality of that art. In his phrase celebrating the "masculine mysticism" of van Gogh, Brueghel, Grünewald, and "Mäleßkircher," Beckmann praised types of art that seemed to inflect a hearty realism with transcendental or mystical meanings; he might also have sought to differentiate his tastes from what he would characterize as the implicitly feminine, "false, sentimental and swooning mysticism" of expressionism in his "Creative Credo" of August 1918. In this, he joined a general contemporary tendency to see older northern art as masculine, active, expansive, and revolutionary.[11]

Beckmann had long admired all the artists he mentioned. He

made frequent references to van Gogh in writings and works both during and before the war; he had admired Brueghel's works in the Royal Museum of Fine Arts in Brussels as well as in the many museums he had visited before the war; and he had made a special visit to see Grünewald's Isenheim altar in Colmar in 1904 and cited its importance both in a letter of 1906 and in his answer to the Vinnen protest in 1911.[12] In 1915, when Grünewald's altar was brought to Munich for safekeeping, a great new wave of veneration grew for an artist whose combination of painful realism and ecstatic fantasy seemed particularly poignant in wartime.

Before the war Beckmann would also have discovered "Mäleßkircher"—the name then attributed to the Master of the Tegernsee *Tabula Magna*—the maker of a remarkable grisaille *Crucifixion* in Munich's Alte Pinakothek.[13] As Beckmann changed his style in the midst of the war, he found these older German artists productively challenging for his newly complex art and meanings. He would frequently affirm his felt affinities by pointed references to or appropriations from them.

The editor of this catalogue has asked me to comment a bit on my work.

I don't have much to write:
Be the child of one's time.
Naturalism against one's own self.
Objectivity of the inner vision.
My heart goes out to the four great painters of masculine mysticism: Mäleßkircher, Grünewald, Brueghel, and van Gogh.

15

"CREATIVE CREDO"

(SEPTEMBER 1918)

UPON moving to Frankfurt Beckmann rapidly became familiar with his friend Ugi Battenberg's cousin, Kasimir Edschmid (1890–1966), a major expressionist writer and apologist. Edschmid, a Nietzschean sensualist who regularly contributed to journals such as *Die Aktion, Die weißen Blätter,* and the *Frankfurter Zeitung,* had many interactions with Beckmann. Beckmann illustrated Edschmid's short story *Die Fürstin* (The princess), in 1917.[1] In 1918—in the essay that follows—he was one of several respondents to Edschmid's collection of artists' statements for the volume titled *Schöpferische Konfession* (Creative credo);[2] and in the spring of 1919 he joined the Darmstadt Secession, a revolutionary artists' group organized by Edschmid. Edschmid himself wrote several pieces on Beckmann.

Edschmid and Beckmann were also allied as relatively conservative liberals.[3] Unlike Beckmann, Edschmid often openly stated his position and he was frequently attacked by more politicized leftist writers and activists for changing his stance so often. During the war Edschmid was a medical orderly and an official representative of the government. He also undoubtedly drew Beckmann's attention to current intellectual attitudes toward the war. Edschmid himself, for instance, was engaged in regular correspondence with a number of leading writers of many different political positions, including a core of writers associated with the pacifist *Die weißen Blätter,* Annette Kolb (1870–1967), Heinrich Mann (1871–1950), René Schickele, and Carl Sternheim.[4]

An indefatigable publicist, Edschmid set out to record the spirit of his time by editing a new series of essays on contemporary art and society, *Tribune der Kunst und Zeit* (Tribune of art and age).[5] The *Schöpferische Konfession* was the thirteenth volume in that series. Though Edschmid published a number of au-

thors of the Left and radical Left, the focus of both the *Tribune der Kunst und Zeit* and *Schöpferische Konfession* was more cultural than political. Edschmid wanted to document how the makers of the new art and literature saw themselves and their art in relation to some of the larger artistic, religious, and political issues of the day: "Never has the artist stood so much at the center of the world as today. Never has responsibility in such a great tragedy done so much to bind the artist with the age."[6] Although the *Schöpferische Konfession* anthology did not appear until January 1920, most of its statements (with the exceptions of those by Franz Marc and the playwright Ernst Toller[7]) seem to have been solicited shortly before the war's end in the summer of 1918.[8]

Beckmann's response differed greatly from his public statements of the prewar period, which focused mainly on art-political questions. Writing in the summer of 1918, he spoke more urgently about the artist's role in troubled times. Whereas his "Creative Credo" is often read as a reflection of his response to the revolutionary movements at the war's end, it was written well before those events. Its imagery more closely echoes the optimism about a new order that was widely held in the war's last years.

Since 1916 Beckmann's private correspondence had expressed increasing disillusionment with the war. By the summer of 1918, when disenchantment with the war was widespread, Beckmann spoke much more angrily of the war and the materialism and selfishness that had brought it about. As if adopting the role of one of the thugs in his *Night* (1918–19, G. 200)—a painting he had just begun—he presented himself as an artist / murderer engaged in fierce struggle with the ungainly "monster of life's vitality." As he had earlier noted in his comments on Schopenhauer and as he continued to write in his exactly contemporary annotations in his copy of Buddha, he could not accept philosophies that advocated asceticism and withdrawal from life.[9]

Beckmann now associated objectivity—or concentration on the object for its own sake—with the decline of materialism and saw it as a way to free oneself from the self and from selfish concerns. His reference to the development of the communistic principle—something, he said, he did not want—reflected a response to contemporary political developments. Edschmid later

recalled that after Beckmann wrote this statement, during the end-of-war revolutionary period, Beckmann had been fascinated with the Spartacists—since 1916 the leading, left-wing party of opposition to the war—and with the developments of Bolshevism in Russia.[10] Beckmann's statement of September 1918, however, suggests that he joined many Germans who abhorred what they knew of Bolshevism's more violent side—particularly in the aftermath of the execution of the czar and his family on July 16, 1918—even if attracted to some of the economic and spiritual underpinnings of socialism.

As has often been noted, Beckmann's final metaphor of building a new church from which suffering humanity could scream recalls the architectural symbolism of many of his expressionist contemporaries. The new wartime hope placed in architecture and art as renewing centers of faith was expressed in many contemporary tracts, especially in the writings of Bruno Taut (1880–1938), a former hiking companion from Beckmann's Berlin period who was an in-law of Hans Kaiser, the author of the first Beckmann monograph.[11] In his emphasis on giving voice to humanity Beckmann seems to partake of the "O Mensch" pathos of the expressionists. Throughout this essay, however,he emphatically insisted that he was an enemy of the sentimentality and subjectivity he typically associated with expressionism. He was interested chiefly in recording human reality, "its banality, its dullness, its cheap contentment, and its oh-so-very-rare heroism."

I paint and I'm satisfied to let it go at that, since I'm by nature tongue-tied and only a terrific interest in something can squeeze a few words out of me.

Nowadays whenever I listen to painters who have a way with words, frequently with real astonishment, I become a little uneasy about whether I can find language beautiful and spirited enough to convey my enthusiasm and passion for the objects of the visible world. However, I've finally calmed myself about this. I'm now satisfied to tell myself: "You are a painter, do your job and let those who can, talk." I believe that essentially I love painting so much because it forces me to be objective. There is nothing I hate more than sentimentality. The stronger my determination grows to grasp the unutterable things of this world, the deeper and more powerful

the emotion burning inside me about our existence, the tighter I
keep my mouth shut and the harder I try to capture the terrible,
thrilling monster of life's vitality and to confine it, to beat it down
and to strangle it with crystal-clear, razor-sharp lines and planes.

I don't cry. I hate tears, they are a sign of slavery. I keep my
mind on my business—on a leg, on an arm, on the penetration of
the surface thanks to the wonderful effects of foreshortening, on
the partitioning of space, on the relationship of straight and curved
lines, on the interesting placement of small, variously and curiously
shaped round forms next to straight and flat surfaces, walls, table-
tops, wooden crosses, or house facades. Most important for me is
volume, trapped in height and width; volume on the plane, depth
without losing the awareness of the plane, the architecture of the
picture.

Piety? God? O beautiful, much misused words. I'm both when I
have done my work in such a way that I can finally die. A painted or
drawn hand, a grinning or weeping face, that is my confession of
faith; if I have felt anything at all about life it can be found there.

The war has now dragged to a miserable end. But it hasn't
changed my ideas about life in the least, it has only confirmed them.
We are on our way to very difficult times. But right now, perhaps
more than before the war, I need to be with people. In the city. That
is just where we belong these days. We must be a part of all the
misery that is coming. We have to surrender our heart and our
nerves, we must abandon ourselves to the horrible cries of pain of a
deluded people. Right now we have to get as close to the people as
possible. It's the only course of action that might give some purpose
to our superfluous and selfish existence—that we give people a
picture of their fate. And we can do that only if we love humanity.

Actually it's stupid to love humanity, nothing but a heap of
egoism (and we are a part of it too). But I love it anyway. I love its
meanness, its banality, its dullness, its cheap contentment, and its
oh-so-very-rare heroism. But in spite of this, every single person
is a unique event, as if he had just fallen from Orion.[12] And isn't
the city the best place to experience this? They say that the air in
the country is cleaner and that there are fewer temptations. But
I believe that dirt is the same wherever you are. Cleanliness is a
matter of the will. Farmers and landscapes are all very beautiful and
occasionally even refreshing. But the great orchestra of humanity is
still in the city.[13]

What was really unhealthy and disgusting before the war was that business interests and a mania for success and influence had infected all of us in one form or another. Well, we have had four years of staring straight into the stupid face of horror. Perhaps a few people were really impressed. Assuming, of course, anyone had the slightest inclination to be impressed.

Complete withdrawal in order to achieve that famous purity people talk about as well as the loss of self in God, right now all that is too bloodless and also loveless for me. You don't dare do that kind of thing until your work is finished, and our work is painting.

I certainly hope we are finished with much of the past. Finished with the mindless imitation of visible reality; finished with feeble, archaistic, and empty decoration, and finished with that false, sentimental, and swooning mysticism! I hope we will achieve a transcendental objectivity out of a deep love for nature and humanity. The sort of thing you can see in the art of Mäleßkircher, Grünewald, Brueghel, Cézanne, and van Gogh.

Perhaps with the decline of business, perhaps (something I hardly dare hope) with the development of the communistic principle,[14] the love of objects for their own sake will become stronger. I believe this is the only possibility open to us for achieving a great universal style.

That is my crazy hope which I can't give up, which in spite of everything is stronger in me than ever before. And someday I want to make buildings along with my pictures. To build a tower in which humanity can shriek out its rage and despair and all its poor hopes and joys and wild yearning. A new church. Perhaps this age may help me.[15]

16

TEXT FOR *HELL* PORTFOLIO

(WRITTEN JULY 1919; PUBLISHED NOVEMBER 1919)

WHEN BECKMANN wrote his contribution for
Kasimir Edschmid's *Schöpferische Konfession* in the summer of
1918, many were talking about the end of the war and the pos-
sibility of revolutionary change, but no one had any idea of what
would follow. On November 9 the imperial chancellor Prince
Maximillian, or Prince Max of Baden (1867–1929), insisted that
Kaiser Wilhelm II abdicate and appointed the Social Democrat
Friedrich Ebert (1871–1925) chancellor of a temporary govern-
ment. The same day, Karl Liebknecht (1871–1919), the militant
leader of the Spartacists, who had opposed the war since its out-
break, declared a German soviet republic and the Social Demo-
crat Phillip Scheidemann (1865–1939) declared a German so-
cialist republic in response. During the following months, the
Ebert government was attacked by both the Left and the Right
as it attempted to establish its control. The first half of 1919 was
marked by several brutal encounters, including the abductions
and murders of Liebknecht and Rosa Luxemburg (1871–1919)
and extensive street fighting. In the middle of March more than
a thousand were killed after an initially peaceful demonstration
in Berlin; at the beginning of May an equally large number were
killed in Munich after government troops crushed a Soviet Re-
public that had tried to supplant a majority socialist government.
Wearied by more than four years of war and privations ex-
acted by the Allied blockade, everyone wondered where the
country was going. Depression and doubt about a war the Ger-
mans felt they had not lost were exacerbated by the Allies' ex-
cessive demands in the Treaty of Versailles. After many refusals
and resignations, Germany finally signed the treaty on June 28.
In *Hell*—executed for I. B. Neumann during June and July
1919—Beckmann represented a series of scenes that suggested a
walk through Berlin and Germany at large to observe some of

the disturbing scenes of life and violence found in the war's aftermath. Many of the prints refer to specific events and persons; many reflect more generally on the commotion, frustration, and anger of those months. Beckmann executed the lithographs in emphatically gestural drawings that were rich in symbol and suggestion and ironic and bitter in mood.

Beckmann showed himself in several scenes and on the portfolio cover, on which the following text was printed. In "The Ideologues," for instance, he showed himself yawning or disgusted amid a group of intellectuals—including Annette Kolb, Heinrich Mann, Carl Sternheim, the Countess vom Hagen, Carl Einstein, and Max Herrmann-Neiße (1886–1941)—engaged in discussing the politics of the situation.[1]

In the cover self-portrait (repeated within the portfolio without the text) Beckmann appears as a dazed, angry, and almost Mephistophelean clown, at once frightened and intrigued by the hellish Germany he had just experienced. For the introduction to *Hell* the clown/Beckmann adopted the role of a *Moritäten* singer (literally a singer of "death deeds"), the ironic circus hawker who entices, teases, and goads an audience into following the spectacle. In this he closely followed the practice of the playwright Frank Wedekind, who would be a major influence on Beckmann's plays of the following years.[2]

Hell. (Grand spectacle in ten images by Beckmann.) Honored ladies and gentlemen of the public, pray step up. We can offer you the pleasant prospect of ten minutes or so in which you will not be bored. Full satisfaction guaranteed, or else your money back. Published by I. B. Neumann, Berlin.

17

CONTRIBUTION TO "ON THE VALUE OF CRITICISM: AN INQUIRY OF ARTISTS"

(PUBLISHED APRIL 1921)

DER ARARAT was a journal published by the Munich art gallery of Hans Goltz (1873–1927), with whom Beckmann was briefly associated in 1921. Goltz had long showed and published new artists and in the latter years of the war and early 1920s had become principally identified with Giorgio de Chirico, George Grosz, and Paul Klee. Shortly after the war, in December 1918, Goltz began publishing *Der Ararat*, a timely title that referred to the supposed landing place of Noah's ark after the flood. In the coming months, the politically conservative Goltz grew highly critical of the events of the Munich revolution and attacked some of the artists he had previously supported.[1] Beginning in January 1920, Goltz decided to depoliticize his journal entirely: "The *Ararat*, which heretofore appeared as a political broadside, will from now on stand up for the New Art."[2]

In spring 1921 the Frankfurter Kunstverein mounted a major show of Beckmann's works (April 1–May 5), many of which were subsequently shown in the summer exhibition of the Munich Secession. Probably in conjunction with those showings, Goltz asked Beckmann to join eleven other artists in response to a questionnaire on the value of criticism.[3] The questions and their responses were part of a whole section that included views and excerpts of criticism from several centuries.[4]

Like several of the responses to the questionnaire, Beckmann's reply to Goltz's questions was short, but expressed a response to criticism that is also found in his private correspondence.[5] Beckmann definitely read, reacted to, and welcomed the criticism he received. At the same time, he never seems to have been terribly bothered by criticism and recognized that it helped

him regardless of what it said. Ultimately, he remained much more concerned with his work.

I consider criticism to be necessary. It makes no difference whether it comes from a layperson or a professional; its influence, for good and ill, is a fact that it would be absurd to ignore. All friction with the outer world is instructive, and this includes criticism.

18

EBBI: A COMEDY

(WRITTEN BY MARCH 12, 1923; PUBLISHED AUTUMN 1924)

IN HIS autobiography sent to Reinhard Piper on March 12, 1923, Beckmann noted that he also wrote "dramas and comedies and good people want to perform them."[1] Stephan Lackner (b. 1910), a good friend of Beckmann's from 1933 on, recalled that Beckmann said he wrote "five dramas and various comedies."[2] Only three plays—*Ebbi, The Hotel,* and *The Ladies' Man*[3]—are now known to us. Beckmann is thought to have begun writing them in 1920–21 and seems to have written all three by 1924.[4]

Beckmann's first references to *Ebbi* and two other plays come in letters written to Piper in the spring of 1923. At that time Piper was supervising the completion of the major Beckmann monograph written by Curt Glaser (1879–1943), Julius Meier-Graefe, Wilhelm Fraenger (1890–1964), and Wilhelm Hausenstein (1882–1957) that would appear in December.[5] In his letters Beckmann expressed hope that Meier-Graefe—who himself had a comedy premiered in Frankfurt in 1918[6]—or Fraenger might read *Ebbi* and mention it in their texts, but neither discussed it. Shortly afterward, much to Beckmann's disappointment, Piper proved uninterested in publishing *Ebbi*.[7] By April 23, 1924, however, the Viennese publisher and art dealer Otto Nirenstein (1894–1978) had agreed to publish the play and commissioned Beckmann to make six drypoint illustrations (H. 306–8) to accompany it.[8]

In the war and postwar period Frankfurt was renowned as a center of expressionist theater, especially during Carl Zeiss's (1871–1924) distinguished directorship of the Städtische Bühne. The Frankfurt theater often featured the acting and directing of the eminent German actor Heinrich George (1893–1946), whom Beckmann came to know. Alongside older and modern classics, Frankfurt presented many of the plays of German expressionism, including works by Georg Kaiser, Oskar Kokoschka, Paul

Kornfeld (1889–1942), Carl Sternheim, and Fritz von Unruh. Beckmann himself noted the central importance of expressionism in a February 1918 letter to Piper, when he wrote that "it is quite interesting for me to be here just now, because at the moment Frankfurt and the *Frankfurter Zeitung* are a stronghold of Expressionism."[9] Indeed, it was probably through the *Frankfurter Zeitung*, its editor, Heinrich Simon (1880–1941), and Kasimir Edschmid that Beckmann most frequently discussed contemporary playwrights and plays.[10] Beckmann and Simon had become good friends after Beckmann's move to Frankfurt in 1915, and Beckmann even lived in a room in the Simons' home for a short period in 1919. He was a regular guest at Simon's celebrated Friday luncheons, which brought together distinguished writers, critics, artists, and intellectuals from Frankfurt and other cities. There he would have frequently met von Unruh, possibly Sternheim, and other writers.[11]

Though Beckmann seemed to criticize expressionism in theater as much as he did in painting—his one extant comment about a Zeiss production of Goethe's *Urfaust* was savagely critical[12]—he continued to visit the theater in Frankfurt as he had in Berlin, apparently more on an occasional than on a regular basis. He was also an avid fan of the popular variety theaters and cabarets in both Berlin and Frankfurt. In *Ebbi* his use of the popular hit "Komm in meine Liebeslaube" (Come into my love bower) and the new cabaret song "Johnny, wenn Du Geburtstag hast" (Johnny, when it's your birthday; first performed in Berlin in 1920) not only dates the play but indicates Beckmann's acquaintance with the contemporary cabaret world.

Several artists of the period—most notably Kandinsky, Ernst Barlach (1870–1938), and Kokoschka—had also written plays and might have inspired Beckmann to try his hand at playwriting. As Thomas Schober has noted, Kokoschka's plays—three of which, *Job* (1917), *Mörder, Hoffnung der Frauen* (Murderer, hope of women, 1909), and *Orpheus und Eurydike* (1917–18), were directed by Heinrich George in Frankfurt in 1920–21— might have been a direct impetus to Beckmann.[13] Beckmann's plays were never as abstract as Kokoschka's, nor did they show Kokoschka's attention to visual details. Like many of his pictorial works of the war and postwar period, however, Beckmann's plays recall Kokoschka's thoroughly expressionistic conflation of the mythic, sexual, and personal.

More immediate models for Beckmann's plays were those of

the admired older master, Frank Wedekind, which Beckmann knew well through both publication and performance.[14] Although they are much simpler, more homey, more prosaic, and cruder, all three of Beckmann's plays readily recall Wedekind's mixture of naturalism and grotesquerie, casts of characters, humor, play with words, moralizing, and emphasis on sexuality. Beckmann's plays probably also had a direct starting point in Julius Meier-Graefe's comedy *Heinrich der Beglücker* (Heinrich the benefactor), which depicts a general manager of a successful mining concern so hardened by business that his wife leaves him. To a lesser extent, Beckmann's plays also recall the bourgeois satires of Carl Sternheim.[15]

Yet the worlds of Beckmann's plays are definitely of the early 1920s and of his own making, as personal, poignant, and critical as his contemporary pictorial works. All expand upon ideas and themes that had long preoccupied him both personally and artistically: the protagonists Ebbi, Zwerch, and Maxim von Plessart frequently remind us of aspects or experiences of Beckmann himself.

Ebbi's title comes from the nickname of its lead character, the salesman Eberhard Kautsch, although on the typescript Beckmann also indicated a subtitle for the play, "Ich will potent werden" (I want to become potent), a line and theme that are repeated throughout. Beckmann's choice of and play on names also recall Wedekind and much older German traditions of humor. The name Ebbi Kautsch, for instance, plays on *Ebbe*—wave or low-tide—and *Kautsch,* rubber or *Kautschuk.*[16] Ebbi is literally a will-less, impotent, or rubber man. He and the other characters are thoroughly middle class, although the Kautsches' friends, the Ostparks, have gained much greater wealth and are identified as "tasteless nouveaux riches." The name Ostpark draws attention to their move from more unfashionable beginnings: the east side of German cities was traditionally the less desirable side of the town or, indeed, the location of factories.[17] The seductive, Nietzschean, "liberated" woman artist who leads Ebbi astray is named Johanna Löffel, or Johanna Spoon.[18]

In its humor, earthiness, and lengthy expositions of themes about the artist, the self, and sexual longings, *Ebbi* greatly enhances our sense of Beckmann in this period. Although he echoed some of his own parvenu and stifling family background, womanizing, admiration for Nietzsche, role playing, and desire

to capture life, these are greatly generalized in his caricatured figures. Beckmann openly played with and manipulated identity just as he did in his contemporary paintings. The comedy contains reflections of Beckmann in Ebbi, Ostpark, and the criminal Jakob Nipsel (in the illustrations for the play Beckmann even gave Nipsel his own features), but the figures have many other banal bourgeois traits that also make them stereotypes of the 1920s.[19]

Unlike many of his contemporaries, Beckmann never rejected his bourgeois background for a bohemian existence and repeatedly stressed his identity as a bourgeois. From the earliest diary entries in which he complained of the narrowness and confines of his family's ways he nonetheless continued to feel his roots in that class. Indeed, as a nineteen-year-old Nietzschean Beckmann wondered if he were not just playing the role of an artist simply because all other callings were repugnant to him.[20] In *Ebbi* he continued and often parodied the self-questioning, doubting, and musing that was regularly expressed—and often made ironic—in his diaries. In both the characters and plot Beckmann repeatedly parodied his own vitalist thinking, writings, and high-minded aims and mocked the larger themes of finding life, humanity, and potency through poetry or art, a liberated but crude woman, a tough criminal, and prostitutes.

Johanna encourages Ebbi to flee the restraints of his bourgeois way of life; at the same time, maddened and seduced by her own life-seeking philosophy and sexual longings, she finds the greatest thrill and potency in the crook Nipsel. Ebbi and Johanna seek and find their release in sexuality, brothels, criminals, and cocaine, but Ebbi—who always evokes some sympathy—finally recognizes that this is not the reality he wants. Though he laments the complacent, petty, and tedious comforts of his home and friends, he ultimately returns to his original situation.

Ebbi is simply structured and unified by images and themes that are echoed throughout. Beckmann was primarily concerned with the development of the characters and their dialogue and did not pay the strong attention to visual detail found in Wedekind and Kokoschka. The only extra props he called for were the colored curtains and beasts used for the most fantastic scene—quasi-expressionist or mockingly expressionist—the narrations of the cocaine dreams in the third act. In that scene Nipsel, Johanna, and Ebbi all enlarge upon their characters, wrongdoings,

and sexual yearnings, Nipsel against a curtain of red, Johanna before curtains of fire and gold, Ebbi before a primeval forest. Ebbi imagined himself first in a forest, then in a theater. Still under the intoxication of the cocaine, he finally reads his poem, which depicts him as the embodiment of passion and virility instead of the reality of his impotent and fat self.

The irony with which Beckmann treated the themes of life, virility, and the amoral/immoral superman thus parodies the general Nietzscheanism of his many earlier statements and of the expressionist era at large. As in Beckmann's quarrels with Nietzsche in his earliest diaries, Ebbi ultimately finds that life is less dramatic and less heroic—and more concerned with the banal than with the great—than Nietzsche had proclaimed.

As far as can be determined, *Ebbi* was first performed on September 6, 1980, in Paderborn, West Germany, in a production by Gerd Udo Feller, who published a new edition of the play in 1984.[21]

Characters

Eberhard Kautsch, *salesman*
Frieda Kautsch, *his wife*
Adam Ostpark
Cecilia Ostpark, *his wife*
Johanna Löffel, *painter*
Erika, *prostitute*
Josephine, *prostitute*
Hulda, *prostitute*
Frau Olga Frisch, *bordello owner*
Jakob Nipsel, *professional criminal*

ACT 1

Room at the Ostparks', very richly but rather tastelessly decorated.
Nouveaux riches. Tea time. Eberhard Kautsch, Frieda Kautsch, Adam
and Cecilia Ostpark.

EBERHARD KAUTSCH *(Medium tall, blond, very fat and pale, walks up*
and down in a state of agitation): You just don't understand me!
ADAM OSTPARK: Please calm down. We really would like to hear
what you have to say. Please don't be so upset.
FRIEDA KAUTSCH: Oh God! Ebbi, dear, what's the matter with you?
Don't you love me at all anymore? What's bothering you? It used to
be so nice to sit together when you got home from the office. How
happy we were together about our little Karl. You always brought
him a little sugar cube and then after he sang so beautifully, our little
dickey bird, you gave it to him. Now it's more than two months since
you brought him any.
EBBI: That's it, there you've got it, haha, the little sugar cube, ha-
haha, hehe. And this is happening to me, happening to me!
CECILIA OSTPARK: Now stop behaving like this. If you think we're
too stupid for you, then at least stop trying to seem interesting.
ADAM: My dear Ebbi, I beg of you, won't you try to calm down.
EBBI: Haha, that sugar cube *(Runs his hands wildly through his*
hair and stares at the audience).
FRIEDA *(Frightened):* Ebbi, Ebbi, oh God, he's going crazy!
EBBI: Ebbi, Ebbi, I can't stand it anymore. You're killing me with
your constant Ebbi, Ebbi. You're always wrapping me in gentleness
and compassion as if they were diapers. And little Karl, the dickey
bird, it should make me forget that there's no meat on your bones,
oh, oh . . .
ADAM: But Ebbi, you're being crude. How can you treat your wife
like that!
EBBI: You wouldn't understand, Adam.
ADAM: But try me . . .
EBBI: OK. You're nothing but a bourgeois and you'll always be a
bourgeois, sleeping in a manner of speaking with your old lady over
there and together you brood one child after the other. But me . . .
(Beats himself on the chest) I can't go on like that. Didn't you always
admit my superiority when it came to art and culture? Wasn't I a
guide for you in the labyrinth of things? You always thought the way
I wanted you to. Ebbi was always here and Ebbi was always there.

(Disdainfully) Now, of course, since you got a lot of money I'm not good enough for you anymore. Now you've got lackeys that play up to you and you pay them to do it. Now you begin to criticize me. But you're just bourgeois and can't understand me.

ADAM: It's true, Ebbi, we do have money now. I can't deny it. Forgive us for it.

(Frieda cries in Cecilia Ostpark's arms.)

CECILIA: You should throw the guy out, he's lost his mind.

ADAM *(Anxiously to his wife):* Pst, pst, we have to listen to him. *(To Ebbi)* My dear Ebbi, come on now, be reasonable.

EBBI: But I don't mean to be reasonable anymore. I'm sick of being reasonable. A poet doesn't need to be reasonable or moral . . . I want life!!

ADAM: So that's it, you want to be a poet now? So that's it, hm. Did you really think it through, Ebbi?

CECILIA: It's just that damn woman, that Johanna, who's putting this nonsense into his head.

EBBI: How can you say something like that, you nothing you, you proud arrogant person. You have no right to say anything about this pure, noble woman . . . *(Froths at the mouth).*

CECILIA: Adam, did you hear how he insulted your wife?

ADAM: Just stop getting him so excited, can't you see he's already all worked up?

CECILIA: You're a wimp!

(The doorbell rings, all are suddenly quiet, the maid enters to announce Johanna.)

ALL: What, it's you!?

ADAM: Bring the young lady in.

JOHANNA: Here I am, oh, it's so lovely outdoors today. Hello, friends. What do you think of this blue sky? Oh—did you see the magnolias. Outside in the neighbor's garden. Wonderful, just splendid. Even the upright citizens of this town stand stupidly before them. Spring shouts into their faces, and the men stand there like petrified tomcats. The women glare at each others' hats. Oh, it really is spring.—What's the matter? Why are you all so quiet. You too, Ebbi? Isn't spring raging in your breast? That's poetry, isn't it?

CECILIA: I thought you were a painter, Johanna.

JOHANNA: It's all the same to me. I seek greatness, grandeur, the sublime. The wonderfulness of genius. Oh, but I'm just a woman and weak. But where there's genius, I know it. I sense it in an inner, related voice that sounds within me. Like a little bell. Right, Eberhard, we understand each other, don't we!?

EBBI *(Moved, with a dismissive glance toward the others)*: Yes, we understand each other.

CECILIA *(Mockingly)*: Is it really necessary for the genius to be a man every single time?

JOHANNA *(Stiffly)*: What do you mean, Ceci?

FRIEDA: She means the same as the others did: Is it really necessary for him to be *my* man, my husband?

JOHANNA: Wha-at, wha-at? *(Stares at the other two with angry eyes)*

EBBI: Ugh, but you're so common! How can you impugn our pure spiritual friendship that way? It's something I'll never forgive, Frieda.

ADAM: Children, children, let's not fight on this wonderful spring day. Why don't you enjoy what the dear Lord gave you and don't get mad at each other.

JOHANNA *(Harshly)*: Do you mean to say that I'm chasing your husband, Frieda?

FRIEDA: You're driving him crazy. Causing him to lose his equilibrium. Little by little you're depriving me of his soul. His, my Eberhard's, who's my legally married husband. You hypocritical creature, you!

EBBI: Shame on you, Frieda!

FRIEDA: It doesn't make any difference to me anymore. I can't stand it any longer. Having constantly to watch the two of you make eyes at each other and gush about each other. Your blubbering about emotions and your protestations about understanding each other. The one makes the other out to be ever greater, and I'm supposed to stand here and just watch and my little Karl, in the meantime, is being totally neglected.

EBBI: You're nuts, Frieda.

JOHANNA *(Compassionately to Ebbi)*: The poor child just doesn't understand us. I forgive her.

CECILIA: Marvelous, marvelous, your generosity of spirit. Johanna, you're the most conceited person I know. I'm telling you that now. And I don't care at all if you hold it against me or not. You've made our Eberhard crazy with your dumb twaddle. And now you sit there with your inflated delusions of grandeur and generously forgive us

so that we won't lose the will to exist. Who do you think you are, you washed-out plant? Nothin' but a failed artist who's fishing for a man, eh—?!

THE MEN: Ceci, what are you saying?

JOHANNA: You dare say that to me?—*(Stares straight ahead)* To me? so that's the thanks I get—. . . *(All of them stare at her.)* But that's the way it should be. We have to suffer. Suffering is necessary. It's the only path to greatness . . . But you, you old stable woman, you should keep your trap shut and look into your own pots instead. Instead of tormenting your husband and underpaying your servants, you old miser and petty tyrant. Yeah, just go on and stare. People in glass houses shouldn't throw stones. Haha. You're only trying to annoy me because Eberhard loves me and not you!

CECILIA *(Red with anger):* That is—that is unheard of. Get out, get out, you whore!

FRIEDA: Yes, get out, whore! My Eberhard, my sweet Ebbi *(Throws herself at Ebbi, who pushes her away in embarrassment).*

JOHANNA: As long as you don't get fattened up like a goose and trade in your ass's brain for a human one, you can cry for your Ebbi all you want. Ebbi *(Gazing steadily at him),* you're mine and I'm yours. Right, big man?

(Ebbi stands indecisive like a mule between two piles of hay.)

JOHANNA: Do you remember how our souls share each other's most intimate feelings, Eberhard?!

EBBI *(Mechanically and loud):* Yes, I remember.

JOHANNA: I'm leaving *(Leaves quickly, all others stand silently).*

EBBI *(Shouts):* She's leaving! You've chased her away!

CECILIA: Good riddance, finally.

ADAM: You were too hard on her. She's just a human being like us.

CECILIA: No, she's a poisonous toad that needs to be stomped on.

FRIEDA: Stay with us! Be nice! Think of our little Karl, of our peaceful evenings together while the street organ played downstairs and upstairs sausages were frying. *(Tragically)* Oh, our poor little Karl is so lonely and has been for so long.

EBBI: She's gone and you're the ones who chased her away! What can I do now? Can I live without her? Can I exist without her? She's the fire in my breast! She's taken it away! Should I drown in the commonplace again? *(Looks at his skinny wife, who stands before him with her nose red from crying)* I'd have to look at this skeleton

all over again. Be forever neutral? Sit forever in the office and get one hemorrhoid after the other? Where is life then, where is it? My work! Life! I have to find life so that I can create my work. My great poetry that I saw within me *(Stands there and rolls his eyes in the direction of the audience).*

THE OTHERS *(Call out anxiously):* Eberhard, Ebbi!

EBBI *(Stares straight ahead and suddenly cries out):* Empty, empty, empty. The fire's gone! She took it with her . . . My muse! My muse! I'm coming . . . *(Rushes out. The other three sit in dull sadness.)*

Curtain

ACT 2

Before a brothel. Dark street. Midnight. Ebbi and Johanna enter. Johanna in men's clothing and with a small mustache pasted on.

JOHANNA: This is it, Ebbi, now prove that you're a man.

EBBI: I will, I will, but you know, I don't feel well.

JOHANNA: What? Are you going to chicken out now? Now, when finally the depths of existence are opening to you. Come on, knock. Wait, there's a bell you can use too.

EBBI: For God's sake, is this necessary? I just don't know if . . . And then, what if they infect me?

JOHANNA *(With a shrill laugh):* If you first have to think everything through, then you'll never experience anything. If you can't be energetic now . . . oh, never mind, I'll ring myself.

EBBI: Hannah, Johnny, don't do it! It won't turn out well. Brr, how they're shouting in there! And it's cold here. Listen to the wind whistling, come on, let's go home.

JOHANNA: You are and will always be what you are if you don't risk anything. I'm ringing the bell *(Rings bell).*

EBBI: Oh God.

(The brothel madam [Olga Frisch] opens the door; silently the two remain standing.)

FRAU FRISCH: C'mon in, in th' formal room. It's warm in here.

JOHANNA: We want . . .

FRAU FRISCH: Sure, I know wha' ya want. The ladies 're in there.

Look 'em over first; if none of 'em 're your type, y' c'n leave again. There's no obligation to buy.

JOHANNA *(To Ebbi):* Come on!

(Grabs him by the arm and pulls him in after her; Ebbi stumbles along, half dragged, huffing and puffing behind her. The stage is briefly darkened. The brothel background is raised up, and one finds oneself in a room cheaply furnished with stuffed chairs. Three women with deep décolletage play cards. A gramophone plays "Come into my love bower."[22])

FRAU FRISCH: Here 're the ladies. Help yourself, gentlemen.

(The three women continue playing cards while staring at the "gentlemen.")

JOHANNA: Couldn't we drink a bottle of wine together first?

FRAU FRISCH: Sure, y' c'n have one. Come on, girls, make room for the gentlemen.

(Johanna sits down next to the black-haired Josephine on the sofa. Ebbi shyly sits on a chair between Erika and Hulda.)

JOHANNA: It's cold today, isn't it, ladies?

(The ladies laugh.)

ERIKA *(Puts her arm around Ebbi):* So, honey, don't ya wanna get warmed up a little?

EBBI: Oh, please, thank you so much.

(The three women laugh.)

HULDA: This must be your first time in a whorehouse?

EBBI *(Sits up straight and puffs out his chest):* Oh, no, of course not, actually I go to one every evening.

(Laughter)

JOHANNA: Don't brag, my boy. *(To Josephine):* You've got a great hairdo, child, and wonderful hair.

JOSEPHINE: It's just a wig, my hair is really blond. But I earn more when I put on the black one here. Men like it more.

FRAU FRISCH *(Enters with the wine):* I brought two right away. Otherwise y' run out too quick *(Pours)*. Prost, children! Now, let's celebrate a little. Olga will now play a pretty one-step on the gramophone, let's go!

JOHANNA *(To Josephine):* . . . but no, certainly no, we honor and respect your profession! It's the most sacred one we have. It's just that the damn bourgeoisie gave it a bad name.

JOSEPHINE *(Screams out loud):* Children, I think these two are absolutely perverse.

JOHANNA: But my dear Josephine, try to understand . . . Oh, what beautiful arms you have!

JOSEPHINE: Come on, we're supposed to dance a little! Or would you rather . . . ? *(Points upstairs)* My room is up there.

JOHANNA: No, not yet. OK, a one-step.

(Both dance to the music of the gramophone.)

ERIKA *(To Ebbi):* So, honey, will you finally come along? *(Points upstairs)* My room is upstairs too.

EBBI: I, sure, sure. No. *(Whines)* Oh, why don't we dance a little first?

(Ebbi and Erika start to dance too, but get tangled up with each other and fall onto each other. All cry out and laugh.)

HULDA: Why don't you just stay down there, children, we're not embarrassed! *(Ebbi laboriously gets up.)* More, more, more.

(Both hop awkwardly around the room. Pause in the dancing. They sit down again.)

JOHANNA *(Embraces and kisses Josephine, who sits on her lap):* You are truly divine. You smell musky like a sheep in the meadow.

EBBI *(To Erika):* Does your leg still hurt you, miss? Perhaps you would let me look at it? *(Holds her leg and strokes it)* What wonderful legs you have!

FRAU FRISCH *(Enters with a man. He is elegantly but somewhat suspiciously dressed. Sharply drawn part in his hair, face grayish with brutal, energetic chin):* Here, Hulda is free still!

NIPSEL *(To Hulda):* Come on, how much d'ya want?

HULDA: It'll have to be a sawbuck at least.

NIPSEL: Fine. Here *(Gives her the money).* Come on! *(Both leave.)*

FRAU FRISCH *(To the others):* That was Jakob, y' know!

THE TWO OTHER WOMEN: He seems to be in good shape again. Prost, Olga!

FRAU FRISCH: Would you mind if I join in on a glass?

JOHANNA: But of course, sure, after all, our good mama has to have something too! *(To Josephine)* So, the lieutenant abandoned you then?

JOSEPHINE: Yes, of course, and then the child came along and I had to go into the country for a while and then it started all over again. I wanted to get a job as a domestic but they found out I had a child and so they let me go and then the police heard that I was involved in an affair again, and then they wouldn't leave me alone anymore. They really frighten me. There's nothing that scares me more than the police!

ALL THREE: Yeah, the damn police, if only they didn't exist!

EBBI: Wonderful! Just divine! *(To Johanna)* Now, that's real dirt, isn't it? Finally something really . . . *(Stares enchanted at the two women).*

JOHANNA: But we're not done yet. Ebbi, you have to do it all.

EBBI: Oh God, Johanna.

JOHANNA: Yes, Eberhard. *(To the two others)* Now children, allons, show us that you're real love goddesses, come on, let's drink to divine Eros, the world generator and world provider, here in his holiest temple! Down with the bourgeoisie, that sad flaccid pelt! Ebbi, honey, you marvelous man, your time has come! Go on, gather your strength! Show that you can pass through all the hells of this earth!

EBBI *(Undecided):* Do I have to?

ERIKA: Come on, sweetie, come with me. I'll make it nice for you. *(Takes Ebbi with her. Ebbi waves longingly, complainingly one more time toward Johanna.)* So long, so long. *(Leaves.)*

JOHANNA *(To Josephine):* Now we'll go up too, come on, come on, my little one. *(Leaves.)*

(For a few moments the stage is empty.)

FRAU FRISCH *(Enters carrying her cat, sits down at the table and starts to drink all the wine left in the glasses. Then speaks to her cat):* Business is good today, ain't it, Willi? Prost, Willi! You'll get some liver sausage as a reward. We've already earned a thousand big ones

today, my lovely animal. Oh damn, oh my, how they're working up there. It's really good that the dear Lord invented love, how else would we live, Willi, hm, my dearest? Tonight you'll sleep with me again. OK, Willi, my sweet? We have to give something to our heart too, after all. Yes, my lovely creature. That's it, be a good cat. *(Steps are heard coming down the stairway.)* Some of 'em 're comin' back already. Oh well, that means they're done.

(Hulda and Jakob Nipsel enter.)

FRAU FRISCH: So, did you have fun?

NIPSEL: Shut up, gimme some wine!

HULDA: Go on, don't be so grouchy, Jakob, didn't I pull out all the stops up there, aren't you satisfied?

NIPSEL: So, where's the fat guy?

HULDA: Upstairs, with Erika, she always gets the hard jobs.

FRAU FRISCH *(Brings wine):* Prost, Jakob, you'll let me have a drink too, won't you?

NIPSEL: Prost, you old hag!

HULDA: 'Re ya planning a job, Jakie, or 're the cops on your tail already. Is that why you're in so bad a mood?

NIPSEL: I need cash. You leeches suck everything out of us right away. If I just had a good tip!

HULDA: When did they let ya out of the joint?

NIPSEL: Two weeks ago an' I haven't been able to do anything. Sniffed around all over the place, but nothing's appealed to me. I've had enough of the joint again now. Four years 's a long time.

HULDA: Be glad they couldn't prove anything, that knife stuck hard that time. Prost, Nipsel dear!

NIPSEL: Shut up, you damn bitch *(Looks around anxiously).* Ya wanna make me a head shorter?!

HULDA: Oh, keep quiet, you know I won't rat on ya.

NIPSEL *(Strokes her):* Yea, well, an' you're my good little Hulda too. Y' know that I always come back t'ya. An' I'll always be your customer.

(Upstairs, screams and pounding on the stairs; Johanna barges in without her mustache, with her hair messed up and her face red. Behind her, Josephine in a rage.)

JOSEPHINE: Would you believe it?! D'you have any idea who this man is? He's a woman, that's what! Just you wait, you bitch! *(Hurls herself at Johanna again)*
JOHANNA *(Screams):* Help, someone help me! She's choking me, this hyena.

(The others join in the fight, Hulda rolls around on the floor with them. All three scratch, bite, and hit each other.)

HULDA and JOSEPHINE *(Scream constantly):* A woman, a woman! What a hoax! Just you wait, you pig! You filthy swine!

(After some time, they are finally separated by Frau Frisch and Nipsel.)

NIPSEL: What is it that you want here, anyway, miss?
JOHANNA: Oh God *(Cries and begins to put up her hair again)*, I only came along to keep my friend Eberhard company. I wanted to meet you all. Ouch! *(Cries out and rubs her shoulder)* We had such a yearning for you! *(To Josephine)* Oh, you bad girl, you, why were you so mean to me. Oh, what beautiful legs you have, and your breasts, let me kiss them, please.
JOSEPHINE: Get away, you swine, get away!
JOHANNA *(Cries):* Why do you have to be so mean? You've beaten up on me enough already. Come here to me, hit me some more, I love you!
JOSEPHINE: Leave me alone, you old bitch, and give me the money for my lost time. *(Screams)* Give it to me! I want $100, or else . . .
JOHANNA: Of course, of course . . . *(Hands it to her; the others laugh.)*

(Meantime noise and laughter become loud upstairs again.)

ERIKA *(Comes in with Ebbi, who totters along behind her pale and exhausted):* Oh, ha! *(Erika laughs wildly.)* Oh ha, oh haha, haha, haha, heehee, oh God, oh God, I can't stop, oh God, haha, haha, hee-hee, haha . . .
NIPSEL: Now what, is he a woman too?
ERIKA *(Continues to laugh):* Oh, girls, this fat guy is so funny! He couldn't do anything, he really couldn't!

THE OTHERS *(All laugh):* Haha, so that's it, haha, heehee, hoho . . .
ERIKA: . . . and then he always said, "Excuse me, please, miss, I'm still pure, you know." Heehee, still pure, he said. "I'm not used to it yet, miss, oh, please excuse me, I'm somewhat nervous." Hahahaha . . . Yeah, I never seen nothin' like it before.

(All laugh uproariously.)

NIPSEL: And what does your fiancee say to that, Fatty?
EBBI *(Horrified):* Johanna, what . . . ? Oh, you found out about her!
JOHANNA *(Angry):* Shut up, you weakling! How could you embarrass yourself like that? I thought you were a man, or at least wanted to become one. I suffered shame and scandal for you. Just look at this, my hairdo is ruined!
EBBI: But I did everything I could do.

(The others laugh.)

NIPSEL: So, my friends, now calm down and relax. I think another bottle would help, wouldn't it?
HULDA: Yes, girls, we have to celebrate for Jakob! Two weeks ago he got out of Tegel prison and today's his first time with us.[23]
JOHANNA: What? Oh my, how interesting! *(Arranges her hair)* You've been in Tegel, sir? For a long time my greatest desire has been to meet one of those men.
EBBI *(Whispers to Johanna):* He's a criminal!
JOHANNA: Shut up, you ass. Luck and adventure await you here. *(Loud)* Frau Frisch, two more big bottles!
HULDA: Oh, he's really something! A hardened criminal!
NIPSEL: Will you shut up!

(All sit down at the table again.)

JOHANNA: Why did they lock you up?
NIPSEL: Breaking and entering.
JOHANNA: Too bad you got caught! In my opinion every criminal is a hero as long as he's not caught. Everybody steals and tries to do away with the other guy.
HULDA: Oh, but he knows how to do things that the others don't!
NIPSEL: Will you shut up!

EBBI: Yes indeed, it must be wonderful to commit a crime! If only they didn't lock you up afterward or do something even worse!

JOSEPHINE: Down with the police.

ALL: Down with the police!

JOHANNA: Oh, I know something you'd find interesting, Herr Nipsel. Won't you come tomorrow afternoon to tea at my place?

NIPSEL *(Looks at her a long time):* Sure, I'll come.

ERIKA: You're so lucky, Jakob. And with such a rich lady.

JOHANNA: Oh, you! I'm neither rich nor poor.

EBBI *(Has Erika sit in his lap):* I love you.

ERIKA: You good dunce, you.

JOHANNA *(To Nipsel):* You seem so strong, Herr Nipsel.

NIPSEL *(Nods):* Was a locksmith.

JOHANNA *(Leans on him):* You have such an energetic chin.

(Frau Frisch constantly refills the glasses and plays with her cat. Josephine has sat down on Ebbi's other knee.)

EBBI: I love you both. Oh, how wonderful your bodies are! How good you smell!

JOHANNA *(Leaps up):* We have to dance still. Frau Frisch, the gramophone! Come here, Jakob. It's such a nice day today. We're going to dance, to dance, dance, dance.

(All dance. Even Frau Frisch with her cat.)

Curtain

ACT 3

Room at Johanna's, a common room in a pension. Johanna alone at first, then joined by Ebbi.

JOHANNA *(Lowers a letter):* This woman is just too stupid, my God, how she behaves just because of her chubby husband. I would have given him up long ago if I had someone else. What else can I do? Where are the men for whom my heart cries out? Every time some guy works his way up just a little bit, there's some stupid bitch attached to him.—Oh, it's horrible to be alone in the world! I'm stuck having to occupy myself and my strength and fantasy with this hope-

less Ebbi. If he would at least be a man! Like Jakob Nipsel certainly was.—He has to come. If I find nobody else, I'll go with him. *(The doorbell rings.)* Here comes Ebbi.

(Ebbi enters slowly, with halting step.)

JOHANNA *(Kisses him):* There you are, lover. How's your work going?

EBBI: Four hours.

JOHANNA: What?

EBBI: For four hours I sat and brooded. Nothing comes to me. I drank, I smoked till I almost passed out, nothing helped. Do you have any wine?

JOHANNA: Did you try to work on your drama, "Raging Theodore" again?[24] *(Gets a bottle and pours)*

EBBI *(Nods moodily):* Prost!

JOHANNA: You mustn't give up so easily. I'm sure it takes a long time. You don't know your own strength. You have no idea what demons sleep beneath your heavy calm. I know you better than you know yourself. How wonderful were your poems about me! And now you're verging on despair because this drama isn't working out? It's just that you still don't have enough real-life experience.

EBBI: Thanks a lot. For the last two weeks I've spent every evening in that brothel. Sure, Erika's sweet and she's stopped laughing at me, but it's all for nothing, no matter how much I show her my compassion and my respect for her profession. Sometimes, it's true, I feel almost like Christ. I'd just like to know if . . . *(Hesitates)*

JOHANNA: What do you want to know? Come on, don't beat around the bush constantly! Out with it! Speak up! Otherwise I'll be bored!

EBBI: Oh, it's just that I wonder if . . . , I mean, that he . . . God, I can't say it like that . . . if he, with women like that, you know . . .

JOHANNA: Oh, Ebbi, what are you saying? Can we be allowed to think something like that?

EBBI: My heart is filled with compassion and love for everyone. My soul is grand and majestic. It's just this fat body of mine, nature's Greek gift[25] to me, that won't do what I want. It's these damned nerves. When I'm alone, I have the strength of ten oxen, only when a woman is actually there, then it won't do it. Oh, it's enough to drive a man crazy and I do so want to be a poet. You believe in me, don't you? Despite everything?

JOHANNA *(With a tone of mockery):* Sure, sure, my little boy.

There's nothing I want to do more. I just wish you would finally be a man. *(Sobs)* Oh, a man . . . Jakob Nipsel is a man. *(Dreamily)* Tomorrow night . . .

Ebbi: We agreed to meet at the corner of the Augustus Street at 1:30.[26]

Johanna: Will he bring the tools?

Ebbi: But of course. He's got everything, after all. Besides, he'll be coming at 6 o'clock.

Johanna: Thank God! Now, Ebbi, you will gain new strength and new inspiration!

Ebbi: Are we really going to go through with this break-in? Don't you think it's awful to steal from our best friends?

Johanna: You're driving me to despair! Why won't you finally understand what I've told you thousands of times? You have to commit evil. What is at stake is to lure you from your soft path of virtue so that you experience suffering and regret, so that you feel conflict like any true poet. What is a poet without conflicts? A dishrag. A little baa-baa lamb! Maybe you'll finally realize how beautiful evil is. Evil has not yet been loved enough. For a poet, only what is forbidden is appropriate—oh—oh—I wish I were a man!

Ebbi: I just don't know, my beloved Johanna, it's all so strange for me. When I'm at the Ostparks with my wife, then certainly I have a sense of who I am and I think of you and all the wild and demonic things you have awakened in me and I despise the well-fed bourgeoisie; but when I'm away from them and sit here next to you in the face of danger, then the longing for my afternoon naps and for sunshine on white curtains cries out in me. Then I want to be back in my hammock in our garden where I always have my afternoon naps, and I hear the buzzing of the bees, the quiet rustling of the green trees in our garden and I see the blue, *(Sobs)* oh, that blue sky with its puffy little white clouds.

Johanna *(Laughs with mockery, turns her back to him and walks up and down, yawning):* Basically you really are nothing but a dumb sheep, oh, I can't stand it with you anymore! *(Turns toward him suddenly so that Ebbi shrinks back)* Power, I tell you, I need power over this herd of slaves. How—that's immaterial to me by now. I don't want to be like them anymore! They all bore me to tears, and so at least I want to see them as a quivering mass crawling at my feet! I'm an ass to think you would help me. They always fall under the spell of a poet's babbling, but you, you, you're just a dishrag! You, with your bourgeois dreams of comfort. They're simply a part of you and

you wouldn't lure a dog out from behind the warmth of the stove with them!

EBBI *(Falls to his knees before her):* Oh God, yes, it's true, Johanna, my Johanna, you're right, I want power too, I can't stand the bourgeoisie anymore either, even if they do think I'm one of them. Johanna, don't leave me, give me strength again, you, my dear muse. I feel new strength within me . . .

THE MAID *(Knocks and enters while Ebbi gets up with embarrassment and brushes off his knees):* Madam, a gentleman wishes to see you. He says Herr Eberhard invited him.

JOHANNA: Let him in. *(To Ebbi)* It's Nipsel!

(Nipsel enters. He wears a gray suit and carries his hat in his hands.)

JOHANNA: Come in, come in my good Herr Nipsel. Hello! Won't you sit on the sofa? Are you hungry? Should I have tea brought for you?

NIPSEL: I ate.

EBBI *(Gets a bottle of cognac):* This will do you good *(Pours).* Prost, Herr Nipsel! How's Erika?

NIPSEL: She's got problems. The police 've got 'er again. *(Angry)* Those damn bloodhounds! I'll get 'em all with a hand grenade!

JOHANNA *(Quietly to herself):* That sounds so different from Ebbi. *(Out loud to Nipsel)* Your courage impresses me *(Takes a glass of cognac for herself).* Prost, Herr Jakob, to our new work together! Have you made the proper preparations for tomorrow night?

NIPSEL: I got everythin' ready. Don't think we'll risk much. Hope the jewelry and the cash 're there, that's what matters. If it goes accordin' to plan, I'll go t' my sister in Amsterdam and then we'll open one of those small gambling rooms with female service. Real nice. It's best in Holland. The rats are fattest there. And there's always reinforcement because of the harbor.

JOHANNA: I'm very impressed by that idea. Aren't you afraid because of tomorrow night?

NIPSEL *(Laughs):* Haha, it's all the same to me! I don't give a damn! I'm me!

JOHANNA *(Enchanted):* Oh, but you really are a real man! *(Looks at him with desire)* And you're so strong! I'd like to see you when you're angry *(Bends forward so that he can see down the front of her dress).*

NIPSEL *(Regards this area):* You're really built, miss!

JOHANNA *(Laughs as she draws back):* You evil man, you! *(But she puts her hand on his arm.)* Yes, I appreciate people who know what

they want. How many women have you made love to, Jakob?

NIPSEL: Since I'm out of the joint again, I've not come to any positive decisions *(Looks at her expectantly).*

JOHANNA *(Laughs hysterically):* You evil man, you! Well, I wish you luck *(Looks enticingly into Nipsel's eyes).* Prost!

EBBI *(Pleading):* Prost, Johanna!

(All three drink heartily and laugh.)

EBBI: I feel stronger already. I look forward to tomorrow. You're going to learn to admire me too, Johanna!

NIPSEL *(Pounds him on the shoulders compassionately):* Sure, sure, Eberhard, you'll turn into a real man yet.

JOHANNA: Children, I see a new life before me. *(To Ebbi)* I love you, my little elephant *(Embraces him while looking intensely at Nipsel. Then she walks over to a chest of drawers and brings back a little box.)* Here's something that should make us feel better yet.

NIPSEL *(Looks into the little box):* Hey, look at this, cocaine, that's special!

(Eagerly takes some. Ebbi too rushes to sniff, as does Johanna. Ebbi and Nipsel fall in a stupor onto the sofa, Johanna walks around slowly, then sits down on a chair. Slowly the stage darkens. A thin white gauze curtain slowly descends through which the three can be seen clearly but as if somewhat out of focus.)

NIPSEL *(After some time):* Something smells funny here. *(Stumbles from the sofa)* Something smells funny. *(Behind the curtain another curtain has descended on which huge, red clouds constantly blow up and down; Nipsel is visible only as a silhouette now.)* What's going on. It . . . it's rai-ai-ning blood. Well, well, so why shouldn't it rai-ain blood this once? *(Meantime the red has been transformed into gruesome creatures that rush toward him.)* Ouch. They bite. What d'ya want from me? I, I think you're funny! *(Hits them on the snout)* See, haha, now you've got to keep your traps shut! I think you're funny, you monsters. What d'ya want, d'you think you're better 'n me? ridiculous, utterly ridiculous! Come on, you there, the big one! *(Takes the one monster by the throat)* Now do you see, so, my sweet little pet, who's going to be vicious now? Come on, here's some sugar for you. Come on, eat. See, that's a good pet. What nice teeth you have. Where d'ya come from? Will you let me ride on you? *(Hops onto the*

*monster's back while another comes after him and threatens to eat
him. Turns around and hits the monster on the snout)* Will you . . .
will you behave! *(Meantime, on the white skeleton of a horse, a
corpse comes riding toward him slowly, a knife stuck in its chest.)*
Hey, you, you're here too? No, no, really? You won't hurt me? Please,
please, August, d'you want to torture me again already? You *(He
raises his fist in a threatening gesture)*, you, I'll kill you all over
again! Go away, you. *(He rides toward him.)* You old skeleton, will I
never be rid of you? *(The corpse reaches out toward Nipsel's throat.)*
Ouch, no you don't, where can I go? Hey *(Kicks his animal in the
haunches)*. Giddap, giddap. The beast won't go. You, August, listen
to me. I've a good cognac with me. Want some? Down there, there's
probably nothin' to drink.

(The corpse nods.)

Nipsel *(Passes him the bottle after first drinking himself. The corpse
drinks):* Prost, there y' are, now be good. Are ya still mad at me
'cause I killed ya? *(The corpse shakes its head.)* Yeah, y' know, cog-
nac's wonderful stuff. Is 't boring over there? *(The corpse nods.)* Well,
and what about Him? Ugh, you're in hell? *(The corpse makes two
grand gestures with his arms, empty gestures.)* There, ya see, ya just
can't win. *(All at once the corpse grins at him monstrously and
slowly disappears, still grinning, toward the back of the stage.)* Ugh,
what the devil? What was that?—Oh, what the hell, just a figment
of the imagination. Giddap, my little steed, giddap! *(The monster
leaps up and down the stage twice, then Nipsel is thrown from its
back.)* Ouch, oh, that hurt. Ya damn beast! Just wait'll I catch y'
again! *(Stumbles around)* Everything's red. Ugh, what the hell, is my
head made out of blood? Ah, now it's getting light. I always say, just
don't let things g-g-get to ya! But it really was weird! Why the hell
did August grin like that when I talked about Him? Oh well, the hell
with it, I've gotta live. Money, money, money, and then women!!!
*(Behind him, a jail has been lowered as the backdrop. Nipsel turns
around.)* What's this? The joint! *(A bell sounds.)* Damn, I think I
must be asleep. That damn bell is ringing. *(Frightened, he stares into
the audience.)* Did I fall asleep? Oh no, they're singing the morning
hymn. *(Weeps)* Jesus, lead us on our path, we do not want to tarry.[27]
Dumb stuff, nonsense, idiocy. You're drunk. I'm gonna go to Hulda.
I've gotta see some female flesh, the hell with everything else . . .
(The monsters reappear and everything becomes red again.) I'm

drowning, no, don't eat me, let me out! *(He chokes the beasts to death one after the other.)* There, now I'll get some peace. Will I finally find some peace? *(He stands up and stares at the audience. Darkness descends.)*

JOHANNA *(Emerges from the darkness):* I'm burning. Something's burning inside me. It's so hot. Hot, hot. *(The white curtain descends slowly, behind it, flames, then music is heard: the one-step, "Johnny, When It's Your Birthday."* [28] *She sings)*

> Johnny, wenn Du Geburtstag hast,
> Johnny, bin ich bei Dir zu Gast,
> Johnny, mein süßer Johnny . . .
> [Johnny, when it's your birthday,
> Johnny, I'll spend the night with you,
> Johnny, my sweet Johnny . . .]

(Continues singing. Pauses. The clock strikes one. In the background, the flames flicker.) A clock just struck one. The city must be on fire. Oh, how beautiful! I see them all, all of them. Burning beds, then they get cold, that's where they're running. Wow, it's burning! Now what, children, when things get too hot! There, that one, haha! Choke the thing to death, why not, everything burning up anyway. Throw the kid out the window! Why children? Children are an idiocy. Only we live, not the child that wants to devour us. Can you see the moon in the burning city? It's grinning. *(The background becomes blue-black.)* Dance with me, my friend! Brother Moon, my pale friend! You sad eunuch! I want men, men, men and find nothing but moons! But the moon is round. At least you can dance around with it *(Meantime the scene has changed and many men wearing formal dress stand around Johanna. Marionettes made up to look deathly white).* What do you want? Ugh, you're horrible! I've dreamed about all of you. Yes, yes indeed. But there are so many of you. Too many. You there, you with the slender hips, your hat fits you to a tee! Oh, and the medal on a ribbon around your stiff white collar looks perfect on you. Maybe I'm in love with you. You're so noble. Yes, that's it, you're well-bred. A noble race. Dumb, sure, you're dumb, I know that, but you're handsome. Come here, dummy, come and let's dance. Do you know "Sunflower?" *(Music in the background)* Sunflower, you know, rays of gold. Wonderful, flickering, stabbing gold. It glows toward the sky. To all sides. Listen, they're playing the song. There, above the dying city. Can you hear

the tones? Like bubbling champagne foaming up . . . *(They dance slowly.)* Listen, listen, it's nighttime. The city's burning. The world is bored, like always. But not us! Not you, you man with the slender hips. You're a real man! A man! A man! Did you know, you look a lot like Nipsel? Nipsel wearing a Pour le mérite medal! Oh, it's so remarkable. I think I must be dreaming. *(Resumes singing)* "Johnny, wenn Du Geburtstag hast, Johnny, bin ich bei Dir zu Gast . . ." Ah, that guy over there looks like Jakob. Come here to me. You might be short and fat but you have dark eyes and your mouth is so sweet. So broad and soft. I want to kiss you! *(Sings)* "Come, Johnny . . ." *(Leaves him behind)* Who's next here? Come to me! You look so lonely. Your mustache looks good. It seems so melancholy and cut close, and you look as if you'd wear silk underwear. Your suit is marvelous. *(They dance.)* Now it's your turn, you there with your fanatical gaze. *(They dance.)* I love you! Now you, young man, sweetest. You don't know the world yet, I realize that. And you should never get to know her. I'll drain the longing from your pale young eyes. And now you! *(Dances with the others)* And you! Always another one!

(Veils descend more densely, it gets darker.)

EBBI *(Slowly appears behind the veil, behind which in the meantime a landscape of primeval forest has been lowered):* Where am I now? Is this because of the cocaine? It smells so good here and there are parrots over there. Nah, nonsense, now I remember. Nipsel and the night at the Ostparks. Where is Johanna keeping herself? . . . Oh, oh, oh, I'm alone. The parrots are calling out "Mama" *(Calls out)* Mama . . . ! Ugh, there are big snakes here, bi-i-i-g snakes, so-o-o bi-i-i-g! Thank God, they disappeared into the bushes! What snakes! No, I must be dreaming still. *(The primeval forest vanishes, the veil is raised, and he gazes astounded into the audience.)* Now what do I see? A giant cave! Thousands of strange faces stare back at me. Are you really there? Oh, are you there! Yes, sure, you must be. You came here to listen to me. To listen to my immortal poetry. I knew that you would come. You love me. All of you, without knowing how much I love you! But certainly only if you applaud my immortal poetry. Otherwise you're nothing but the bourgeoisie, fat, ugly, and dull. Ostparks, Westparks, Nordparks. *(Slowly he turns around while the thin veils descends again and another huge auditorium appears*

behind it; dull shouting is heard: "Eberhard! Eberhard Kautsch!
Bravo, Eberhard! Take a bow, Eberhard!" With his back turned to
the actual audience) My brothers, I thank you! Thank you! That's
enough now! That's enough! *(Gestures in disdain)* Stop with your
stupid applause and just love me! *(Meantime the white curtain has*
been raised again and Ebbi has turned around.) There, now you're
nice and quiet again. My God, how many of you there are down
there! It's good that you're finally quiet! This perpetual applause was
downright embarrassing! Really it was. I am by nature a very humble
person, after all. You probably won't believe me! But it's true none-
theless. Oh, I wish I could embrace all of you. You down there. Flesh
of my flesh! Limb of my limb! You down there who are all sitting
there filled with such hatred and are waiting for me to embarrass
myself. I've embarrassed myself enough in life, but now I'm dream-
ing. So that's that. And these ghosts down there? What of them?
Sure, I see things that I like. Bare necks and breasts shine in the dark-
ness at me. There must be women there! Then those black blotches
with white triangles cut out from them must be the evil men who are
trying to take my woman away from me. Ah, and there come some
more women. Oh, the false goal of my sad longing. I can smell you
down there. You women. You over there, and you, and you. I would
like to love all of you and to throw myself at your feet. You would
find this fat man ridiculous . . . And yet, look!!! *(Two heavy laurel*
wreaths fall from above onto him.) There—look at this! Do you find
me more appealing now? *(Parades like a prize-winning boxer or ox*
across the stage) What d'ya say now? Who else has this? Does my
fat belly bother you now? Now that it's crowned with laurel?—Oh
well, get rid of this stuff! I get nothing from it! Hehe! *(Rips the*
wreaths off himself and throws them toward the back) You probably
wouldn't appeal to me anyway, you miserable bunch of humanity.
Were you the ones who sniffed cocaine, or was it me? Huh?!—I di-
vide women into two categories: those whose underwear stops at the
knees and those who keep it a modest two or three inches below the
knee. The first I love, every single one of them; they are the land of
my dreams. The others have resigned themselves or are "good girls."
Oh, underwear that stops before it reaches the knees, oh, the land of
my longings, never have I experienced it! My wife, where is she?
Where is my wife? Oh, Frieda, Frieda! I want to go home. Down
there there's a horrid monster with thousands of eyes that stare at
me and swallow me up. Swallow me, Frieda!! Mama, Mama,—

Frieda! *(Meantime the veil descends slowly and one sees Ebbi only as a silhouette. Behind it, the primeval forest descends as backdrop once again.)* I'm so lonely. Now what? All sorts of trees and snakes have come back! Horrible! A tiger with Erika's face. A female tiger. Pardon me, fräulein, honored Fräulein Tiger, but would you tell me how I can get home from here, number 14 Erfurt Street in Weimar, the capital of the Free State of Thüringen?[29] *(The tiger raises both front paws to his shoulders.)* Oh, eat me up, Erika! Eat me, please, oh, it feels so wonderful.

(The stage darkens, then becomes light again, the same primeval forest scene, with all three now visible on the stage behind the white veil. They stumble about.)

EBBI *(Cries out):* Erika, my sweet, eat me up, eat me!

NIPSEL: Where is the darn woman, there she is, no, here. Come here, you beast. Come here to me. Down, girl, lie down!

JOHANNA *(Singing):* "Wenn Du Geburtstag hast, Johnny," oh, Jakob with the medal of honor, oh Jakob, you hunk, here I am, I am yours! *(Both embrace fervently.)*

EBBI *(Afterward):* No, stop it, I'm here too! No, take me, me, come, Erika, come to me!

JOHANNA: Here you have me, men. Love me, tear me apart! First you! *(Kisses Ebbi)* You with the narrow hips, my sweet comfort. Now you! *(Kisses Nipsel)*

ALL THREE: Now I have you, I'll consume you. You're mine, I'll consume you.

JOHANNA: More, more, yes, come into me, everything that is manly. I am a deep fountain. There's nothing I can't drink. Can drink everything! *(The men kiss her.)* Here are my breasts, quickly, take them before they wilt, here. Come, here you have my hips. Hurry, hurry, they're taut and tight still.

NIPSEL *(Bellows):* Hm, hm, hm . . . meat *(Kicks Ebbi)*.

EBBI: Ouch, get away, you, she's mine, it's for me!

JOHANNA: You'll all have me, I need you all to quench my thirst. Oh, men, men, men!

(Johanna and Nipsel kiss on the sofa, the primeval forest has disappeared, the veil remains.)

EBBI *(Dancing about):*

>Yes, I am a man, I am,
>My body feels just like a ram.
>See my chest, how proud to be mine,
>The world today for me is wine.
>A woman's leg, a woman's body,
>Those two are my best hobby.
>I am a poet, great and strong,
>A true genius who can't go wrong.
>A woman and some poetry—
>Those two alone can tempt me.
>Come here, woman mine,
>My body, it's all thine.
>Get down onto your knee,
>It's genius you here see.

(Embraces Johanna again while Nipsel leans back and falls asleep.)

JOHANNA: Yes, now I'm yours, my genius. You, poet, great man, noble man. Divine man. *(Kisses him)* You are the creator, the primeval origin. Oh, how I love you! I love you! *(Kisses him again, then collapses and falls asleep)*

EBBI *(Stands alone and feels around with his eyes closed):* Where is she, where has she gone? My woman, my goddess! *(Feels around some more and calls out loudly)* Where are you? Where are you?

(The thin white curtain slowly rises, and the three are seen to be sleeping.)

Curtain

ACT 4

The Ostparks' dark room as in act 1. Initially no one is on the stage. Time is almost 4 in the morning. Outside a storm can be heard and rain beats against the windows. A door opens and a head can be seen, wearing a dark mask. It is Nipsel. He enters, pistol in hand; behind him slowly and quietly appear Johanna, who wears a leather coat, and Ebbi. Both wear black masks, both also have revolvers. They lug a bound, unconscious body with them.

NIPSEL: Throw him on the sofa.

JOHANNA: The blow on his temple was good, he's alive and yet quiet. Too bad this dunce of a porter had to sleep so lightly.

EBBI *(Concerns himself with the porter):* Oh God, poor man, oh no, I never wanted this!

JOHANNA: Shut up, have you lost your mind, shut up!

(Ebbi sobs quietly.)

NIPSEL: Where's the safe?

JOHANNA: Over there in the corner. I'll get the blowtorch. It's behind the door. My God, I hear voices. *(The Ostparks have awakened.)*

NIPSEL *(Calmly):* I'll take care of 'em.

(Slowly he goes toward the door with his revolver and flashlight, opens the door quietly. A beam of light falls into the room. A woman's scream is heard and a man's voice.)

NIPSEL: Another sound and you're history!

Voice of CECILIA OSTPARK: Oh, dear Herr Robber, don't hurt us. We'll give you everything you want! I beg of you, I plead with you, dear, kind Herr Robber . . .

NIPSEL: Quiet! Not another sound! *(His head appears in the doorway again. Quietly hisses)* Rope!

(Johanna disappears into the room with some rope.)

NIPSEL *(From the room):* There, now tie 'em up tight and then gag 'em with something or other. They'll shut up soon enough!

(After some time both appear in the doorway again.)

NIPSEL: The bastard won't hand over his key, too bad I can't just ice him. Oh well, let's get to work.

(The two get to work on the safe with the blowtorch. For a time only the hissing of the blowtorch is heard, interspersed by the sounds of the storm outside. Ebbi is seated stage front on the sofa with the unconscious porter.)

EBBI *(To the audience):* I'm so scared, what's going to happen now, it's horrible. The poor Ostparks, what if they suffocate? oh, oh, oh . . . *(Moans and thrashes about)* what's going to happen to me? My dear Lord, all merciful God, help me! Please help me! I promise to be good again. I promise never to do it again. I promise I won't even write poetry again. Oh, the hell with being a poet! That damned woman Johanna! Look, how cruel she is. And Nipsel, he's horrible . . . No, I must be dreaming again, like yesterday. None of this is happening. But the cocaine was better. Must have been a bad batch. Oh, I wish I could wake up! I can hardly breathe. And I'm soaked. Dear Lord, wake me! Send an angel to me! I promise I'll never ever do it again.

NIPSEL *(From the back of the room):* Bring the hammer and chisel!

EBBI *(Gets up quickly):* Yes, of course, I'm coming.

(Picks up the tools in a package near the door, brings it to Nipsel, and then comes forward again while hammer blows on a chisel are heard from the back of the room.)

EBBI: What am I going to do? Iron claws are digging into my throat. I see horrible visions everywhere around me. They're terrible men with drooping mustaches and helmets that press in toward me from all directions. Oh, and this dark scaffold with a hole in it! No, no, I won't go. I won't. My head is too fat. Don't you see, it won't fit into the hole. Let me go. I'm too fat. Much too fat. I have to lose weight first. Maybe then . . . Won't you forgive me?? I'm really a good person. Never hurt anybody. I only want what's good and beautiful. I want to help the masses rise above their poor lot. I only want to have an experience, an experience, experience. Yes, I must be strong. These are the conflicts Johanna told me about? But listen. What's that? Are they groaning in the other room? Yes, I can hear them clearly. Is that the death agony already? Ostpark agony? No, I can't stand it. I can't stand it! My God, my God, my God! *(Collapses onto the sofa with the porter)* I need a cigarette. Maybe then I'll calm down. *(Clumsily lights a cigarette but still moans painfully)* Oh, oh, oh!

(Meantime the porter has begun to regain consciousness. Porter first moans lowly, then incomprehensible words pour from his mouth.)

EBBI: He's alive, thank God, he's alive. *(Whispers to the porter)* How are you doing, my man?

PORTER: Oh no, the killer! *(Presses his hands against his face)*
EBBI: What? You think I'm the killer? Oh, it's the mask! *(To the audience)* No, I'm no killer and don't want to become one. *(To the porter)* Listen, my man, listen. *(Whispers in his ear)* I'm no murderer, I'm Eberhard Kautsch. Keep quiet, for God's sake, keep quiet! Look over there . . . *(Points to the two working at the safe)*.
PORTER: What, you're Herr Kautsch? And dressed like this? What's it all mean?
EBBI: Don't ask. I'll explain everything later. *(Listens for sounds from the neighboring room, then says to himself)* Oh, how they're moaning. No, they must not die! But if I ask Nipsel to spare them, he'll kill me too. *(Addresses the porter again)* Listen, my good man, let yourself down from the sofa very slowly and then crawl out the door. I hope to God that you succeed, and then get to the police as quick as you can!
PORTER: I'll try. *(He attempts his escape, and succeeds without attracting the attention of the two others.)*
EBBI: He got out. Now, dear God, have mercy on me! Oh, if I could just wake up! My soul's on fire. My body is drenched in sweat. I'm trembling. Oh no, I'm trembling at the sight of Nipsel!

(Johanna and Nipsel meantime have been occupied with the safe.)

NIPSEL: Damn this heat!
JOHANNA: Why don't you rest a while?
NIPSEL: Yeah, guess I have to. *(Gets up and both come forward.)*
NIPSEL: So, Herr Ebbi, nothing new? What do you say? Everything's working out fine! We'll soon be . . . But, where the hell is the porter?
EBBI: What, why, how, where, who? Oh, the porter . . .

(Nipsel and Johanna search the room.)

NIPSEL *(Grabs him by the throat):* Admit it, you bastard, you miserable coward. You let him go?
EBBI *(Gets to his knees before him):* Don't hurt me, oh, don't kill me. I, I, I . . . *(Sobbing as he covers his head with his arms)*.
NIPSEL: This damn bastard, he's siccing the police on us!
JOHANNA: You pig, you fat swine, so that's the way you are?
NIPSEL *(Chokes him):* Just you wait, you dog, just wait!
EBBI: Oh my, oh help! Help! *(Cries out)*

NIPSEL *(Red in the face):* Will you shut up! *(Hits him hard on the head. Ebbi sinks unconscious onto the sofa.)*

NIPSEL: Now he'll shut up.

JOHANNA: Served him right, the weakling! You, you're strong *(Embraces Nipsel)*, Jakob, I love you!

NIPSEL: Forget this nonsense now. We've gotta get outta here quick.

JOHANNA: I'll follow you to the ends of the earth, Jakob, my hero. You're the man for me!

NIPSEL: You got any money?

JOHANNA: Enough to last the two of us a couple of years.

NIPSEL: Good, you're a wonderful woman. Come along to Amsterdam. Come on, hurry! We'll leave this junk behind. A cop could come any minute.

JOHANNA: Let's go through the servant's entrance. I know where it is. Come on, we're on our way *(Stops to touch the unconscious Ebbi).* He's still alive. Well, so long. You fat fool. I hurl myself into the impossible now. But it is too bad for my fat poodle. It was nice to have him once in a while after all.

NIPSEL: Come on, woman. Let's go, hurry. We can still catch the early train to Holland.

JOHANNA: I'm coming. *(Both leave, stage left.)*

(A short pause ensues. In the meantime it has become light and the first sunbeams illuminate the form of the unconscious Ebbi. Outside, the sounds of birds and the first streetcars can be heard. From time to time, the clop of horses' hooves and the rolling of milk wagons. Finally, he begins to moan. Unconsciously Ebbi rubs his hand over his head jerkily as if shooing flies away.)

EBBI: Shoo, shoo, get away. *(He repeats these words four or five times. Then slowly he sits up and looks around with a confused, staring look. In confusion)* Mama, Mama, it hurts so. Ouch! *(Collapses again, then gets up slowly once more)* How wonderful it is to be home again. Mama, coffee, I want some coffee. *(Quiet)* Where is Papa now . . . Yes, yes, my father. A strange man, but a good man, really. If only I knew why he put me in this world? Such a highly unnecessary beginning. *(Outside on the street loud steps can be heard that slowly fade away.)* There's someone coming home or going to work already *(In the distance, the sound of a streetcar).* The first trolleys already? And I'm just sitting here? Why? Why am I here? However

did I get here? Is it morning or evening? Have I been asleep a long time? Oh, my head! There, the sound of a taxi. It must be evening *(Stares straight ahead)*. Now it's leaving again. *(The sound slowly fades away.)* Ah yes, my father. Actually he always seemed to feel awkward around me. Once he was supposed to spank me because I'd pulled something, I can remember it very clearly. I sat there and waited for the spanking and he came toward me slowly, a strange look in his eyes, as if he wanted to apologize. And he said very quietly: "Ebbi, I have to spank you now. After all, you lied and you also stole a dollar from your mother." And then he spanked me a little and I was so embarrassed there before him . . . Strange customs. Oh well, that's just the way it is with the bourgeois. We've come farther now. We, yes sir, we're poets, right Johanna? We can allow ourselves this. Now we would no longer steal a dollar! Leaders of humanity, hoho. We drive through the heights and the depths of humanity, indeed, a so-called higher humanity! And that's the way it should be. Certainly it's right. The herd must be herded.[30] Indeed, Johanna is right there. *(Outside a few drunks shout their way along.)* There, can you hear how they stumble along out there, each of them with some woman on his arm. How they're shouting. Poor, lost sheep. But they're necessary. No doubt about it, necessary. Where would we be without them? What would we be without their applause? If the dear Lord had not created the bourgeoisie, we'd have to invent them. What significance would we have? No, Johanna, I can't agree with you there. We have to love the bourgeoisie too. The bourgeoisie, b-o-u-r-g-e-o-i-s-i-e. *(He continues babbling and stares mindlessly into the audience.)* Now, what's my name? Eb-Eb-Eberhard Kautsch and weren't my friends the Ost-Ost-Ostparks . . . Ostparks! *(Calls out loudly and suddenly regains consciousness completely)* My God, what have we done! Yes, yes, now I remember where I am. I'm at their place. It's almost day. Oh, Johanna, faithless woman! Nipsel, the dirty skunk! They're stretched out over there. Whoa! *(He trembles and listens. There is no sound.)* I wonder if they're still alive. My dear Lord God, please let them be alive! *(Sounds of steps and voices are heard coming from behind the stage.)* Aha, they're on their way! Help! Help me! Help! *(Yells loudly, piercingly, and stumbles around, still wearing his mask, which has slipped somewhat. The police and the porter enter.)*

POLICEMAN: There, that's the criminal.

PORTER: But no, officer, not at all, that's Herr Kautsch. Herr

Kautsch, why don't you take off that mask now!
EBBI *(Tears it off and shouts):* Save them, save them!

(All rush into the neighboring room, loud shouts and a confusion of voices are heard. The Ostparks stumble in, looking disheveled.)

EBBI: Thank God, you're alive, thank God!
PORTER: You really did that very well, Herr Kautsch. Without you, there'd be three corpses here now.
OSTPARKS: You, Ebbi?
POLICEMAN: Herr Kautsch?
PORTER: Oh, indeed. He's a hero, he's a real hero. He pretended to be an accomplice and to join them, then he let me escape at the risk of his own life so that I could get the police.
POLICEMAN: My respect! You were able to observe the entire plan develop in order to interfere at just the right moment. I congratulate you for your courageous deed, Herr Kautsch. Who were the two criminals?
PORTER: The one was Fräulein Löffel and she was playing up to this man, and he was a real ugly looking criminal type, I tell you.
OSTPARKS: Johanna? Oh God, that woman, that, that, that . . .
EBBI *(Sits down on the sofa):* Oh, ouch, I can't go on. Oh, my head! They're gone, Jakob Nipsel and Johanna.
POLICEMAN: Nipsel? We know that guy! So he's run off with this Johanna Löffel. *(Walks over to the safe)* Well, they didn't get what they wanted, thanks to you, Herr Kautsch. But we'll catch up to them. *(Turns to the other policemen)* Immediate bulletins to all train stations about the two! Gentlemen, madame, I wish you a good morning.

(All three policemen leave with the porter.)

OSTPARKS *(On their knees at the sofa where Ebbi lies):* Ebbi, how can we ever thank you enough. You saved our lives.
EBBI: Oh, forget it!
ADAM: No, you're a hero and we shall love and honor you for the rest of your life.
CECILIA: Can you forgive the bitter words I uttered the other day, Ebbi?
EBBI: Oh God, please don't torture me so. Me, a hero! But I wanted

to join in, yes, I wanted to be part of it. After all, Johanna said I had to have experiences!

ADAM: I thought as much, but the good in you won out. Then you risked your life when you let our porter go free to rescue us. You didn't give in to yourself. You have my respect!

EBBI: No, no. I was scared, terribly scared!

CECILIA: You're our good Ebbi, you should come to your senses. Do you know who's still sleeping peacefully back there?

EBBI: Frieda!?

CECILIA: Yes indeed, Frieda. I'll go get her for you. *(Leaves.)*

ADAM: I'm so happy that you're back again, Ebbi. We really do need you. It was so empty here without you. You were missing in everything we did. Whenever a good roast was put on the table, we thought of you, you traitor. And in the evening, while we had punch in the garden, your place was empty and our souls missed the fire you always put into them. Even Cecilia was, I think, sad.

EBBI: Oh, Adam. *(Somewhat sadly but with a relieved expression on his face, he offers his hand.)* Oh, Adam, how good you all are to me!

(Frieda rushes in. Behind her, smiling, Cecilia.)

EBBI: Frieda! *(Embrace. Ostparks stand nearby and wipe tears from their eyes.)*

FRIEDA: You're back! Now everything is all right. Cecilia told me everything. Johanna, that monster, is gone. And now you're a hero . . . My hero again. Oh, Ebbi . . .

(Ebbi stands patiently and lets her pinch him all over. Meantime the maid enters and sets the coffee table.)

ADAM: Now, children, let our good Ebbi catch his breath. Look how nicely Lina set the table. Come on. Dig in.

(All sit down. Cecilia pours the coffee.)

ADAM *(After having taken a deep swallow)*: Brr, what a night this was, what a horrible dream. Should we believe that things like that exist? Today, as the sun shines so brightly.

FRIEDA: We're lucky the girls didn't wake up. They're always in such a bad mood when they don't sleep well.

CECILIA: Thank God, yes. And how wonderful that Johanna's gone

now. She always stirred everyone up with her modern ideas. Isn't that so, Ebbi, she was a bad person?

ADAM: Well now, let's stop talking abut what's past, at least not now. We want to enjoy ourselves and be happy that our Ebbi is back, right Ebbi, and you're glad too that you're home again?

(Before Ebbi can answer, a band begins playing a hymn out in the garden.)

ALL *(Except Ebbi):* What's that?

CECILIA *(Hits her forehead with her hand):* Oh God, dear God, it's your club, Adam! Have you forgotten that today's your business's twenty-fifth anniversary?

ADAM: You're right, yes indeed, and I did almost forget.

(All except Ebbi rush to the window through which the music pours in. Ebbi alone sits at the table, stage front, while the others lean out the window and wave in excitement.)

EBBI: At home, yes, at home, home again. *(Stares at the audience, then he calls out, almost sobbing)* And I wanted so much to become potent! *(Then sits slowly down at the table, sobbing while outside a hymn is played to its end)*

Curtain

19

THE HOTEL: DRAMA IN FOUR ACTS

(PROBABLY WRITTEN BY 1923; FIRST PUBLISHED IN 1984)

NOT PUBLISHED in Beckmann's lifetime, *The Hotel* was presumably one of the three plays Beckmann mentioned to Piper in the spring of 1923.

The Hotel is set in a shallow, flashy, 1920s hotel milieu in an unspecified large city in Switzerland.[1] The protagonist, the hotel director Friedrich Georg Walter Zwerch (whose name plays on *Zwerg*, "dwarf"), is an ambitious parvenu who has labored hard to become the successful director of three Swiss hotels. In the process he has sold his soul. Because of his readiness to please all his customers, particularly the women, his wife Clara—the only truly decent character in the play—despairs of their relationship. Clara, who originally came from a wealthy family but spent much of her earlier life working in a circus, represents a natural goodness in comparison to the corrupt and boorish guests and hotel operators: in this Beckmann echoed Wedekind's frequent celebration of the natural authenticity of circus entertainers. Clara's friend Ernesto—a ventriloquist who dies with voices and spittle spilling out of his stomach—represents a more grotesque good. Years ago, he saved Clara's life at the circus.

In the earthy, vulgar, and absurd *Hotel* Beckmann again gave vent to his desire to present "the realest things of life." His mixture of characters and the good traits that show through in Clara and, much less frequently, in Zwerch, remind us of the frequent caricatural mixture of personal and general identities in his pictorial works. In *Night*, for instance, Beckmann depicted his friends the Battenbergs and himself amid the cutthroat gang that murders a couple in their home.[2] In *Hotel* most of the figures are stereotypes of the nouveaux riches that were frequently made representative of the postwar inflationary period in contemporary art and literature. With the exception of Clara, all the women are either femmes fatales or whores; with the excep-

tion of Ernesto, all the men are selfish entrepreneurs and boors. Beckmann's particular mixture of aristocrats, middle-class parvenus, circus entertainers, and lower-class workers again recalls Wedekind.

Like *Ebbi* the substantially longer and more complex *Hotel* focuses on and parodies the aspirations, greed, and sexual obsessions Beckmann associated not only with the age but also with personal and professional longings. However fantastic, its dialogues frequently bring to mind some of his own encounters and relationships: they must contain more than an echo of conversations he might have had with the woman from whom he had separated.

In *Hotel*, on the other hand, the moods are much more angry, the outcome more violent and tragic. Zwerch is a basically hardworking, industrious businessman torn between the ideals of his first love, Clara, and the temptations of the flesh and senses offered by his business. He protestingly tells Clara this is a matter of personal freedom: he remains devoted to her, but he resents being held in her grip, and he damns her as a witch, spider, and scorpion.

Zwerch is a driven man, however, and from the start appears about to burst. He finally explodes into murder, madness, and imprecations to what he sees as a cruel god, haunted and goaded by his double. In his coarseness Zwerch even brings to mind some of the rough characters in the plays of the young Bertolt Brecht.[3]

As in *Ebbi* Beckmann paid more attention to flow of the text—often varied with the different textures of dialect, song, grotesque fantasy, and ranting—and to unities of imagery than to visual effects.

The play had a first public reading in 1972. It was first performed in a production by Gerd Udo Feller and the Theater der Veröffentlichung in Munich on March 15, 1984.

CHARACTERS

HOTEL DIRECTOR FRIEDRICH GEORG WALTER ZWERCH
CLARA ZWERCH, *his wife*
PAUL MÜLLER, *headwaiter*
BARON RENNÈ MANÔSCH
ELLY, *his wife*
IVAN LUDMANN
CRAMER, *hotel director*
PORTEN, *hotel director*
SCHULZ, *hotel director*
HASENBÜTTEL, *hotel director*
ERNESTO, *ventriloquist*
PAUL GRATZEWOHL, *hotel director*
ANNA, *lady's maid to the baroness*
HOTEL PORTER
THE BLONDE
ZWERCH II, *the double*
HOTEL EMPLOYEES
PROSTITUTES
GUESTS
DR. KALLA, *physician*

(The play takes place in a large Swiss city.)

ACT 1
Scene 1

Hallway leading to a hotel kitchen. Through the door are heard the typical sounds of a hotel kitchen. Clatter of dishes and voices. Director Zwerch and headwaiter Paul Müller converse with each other.

ZWERCH: I just cannot understand how you can go on enjoying women like that. I can no longer take a woman that I do not love.
PAUL: That's all well and good, but you've just been damned lucky. If I would've been able to have your wife, you know, well then maybe things would've been different with me too. But now it's all the same to me. I'm out for what I can get. Did you see the new one? The one helping in the kitchen now? She's got thighs, I tell you, real thighs. And an ass. A real looker.
ZWERCH: Don't be so unreasonable, Paul. With your talents, if it weren't for your never-ending lust for women, there's no reason you would have to go on playing headwaiter for me. You're ruining yourself. Look at yourself. Didn't you have enough with the bubo they had to cut out of you last year? After all, these women are almost all diseased.
PAUL: Ah, come on, I know what I have to do now. Nothing'll happen to me anymore. Don't worry. You just had all the luck, getting your lovely Clara and all her money too. But I don't want to be bitter. You've been good to me and gave me this job. That was really nice of you. But don't play at being the gentleman for me. I know you too well. From the time we were together in Cairo. Damn, but you chased after those Greek women there. The one you almost killed because of the Englishman, the one from the Atlantic Hotel. Why not be honest. You still drool, you old lecher. Only now you're afraid because of your position and your wife.
ZWERCH *(Sharply)*: I would prefer it, Müller, if you kept those old stories to yourself. That's not why I helped you get the job here . . . Besides, you might even be right, but one thing is certain: most women bore me.
PAUL *(Suspiciously)*: Oh, and your wife too?
ZWERCH: Let's drop the subject, Paul. You must still be in love with her! *(Laughs to himself, then goes on in a monotone)* . . . Oh, sometimes I wish we could think about something other than these endless numbers and these eternal women.
PAUL: So why don't you go back to your books? You used to sit and

read the whole blessed day. Or are you educated enough now? I think you'd rather be reading the baroness upstairs!

ZWERCH: You're nuts, Müller. I'm a fool to let myself get caught up in these conversations with you. Forget spying on me, my friend, or you'll get the sack, and definitively. Even my friendship has its limits . . . Now go and see if the new shipment of Bordeaux has finally arrived. Otherwise we'll have to get fifty bottles from the competition there to help us out with the celebrations tonight. I'll come back here later. *(Goes.)*

PAUL: There he goes, the most honored Herr Director. You pompous idiot *(Grins after him, making a face)*. Earlier, when things weren't going well, I was good enough for you.

CLARA ZWERCH *(Behind him)*: Have you seen my husband anywhere, Müller?

PAUL: Yes, he just left, wanted to come right back, though. Are you jealous again, beautiful Clara?

CLARA: Don't be rude, Müller.

PAUL: My God, lovely lady, I didn't mean anything by it. Just a little joke. But there are so many women, after all.

CLARA: If you think you can get me upset, you're making a mistake. I know my husband.

PAUL: The baroness too?

CLARA *(Hesitating)*: Hm, lots of them make eyes at him. I know that. But he loves only me, even if they would all do headstands just for him.

PAUL: Whatever you say. If you don't want to see it, then just forget it. But I feel sorry for you. I would have treated you better. I could've stayed with the circus. Oh, Clara, I still love you *(Approaches her flirtatiously)*.

CLARA: Oh, I know what you're after, you, you little sneak. You're only fishing around for something, but you'll have no success with me *(Leaves through the rear exit of the room)*.

PAUL *(Raises his fist behind her)*: Just you wait, you stuck-up bitch, I'll get you yet. Oh, the big ox is coming back already *(Off to the left)*.

ZWERCH *(Enters from the right with Clara)*: What are you doing here, Clara?

CLARA: I was looking for you to let you know that Ernesto is very sick this morning. Please, won't you call Dr. Kalla to come this evening? Since he's together with you for lunch all the time?

ZWERCH: I'll be happy to do it. Is your old admirer really so bad off?

CLARA: You shouldn't say things like that, Friedrich. It's not right. You know he's a respectable man and that he saved my life in the circus once. I simply consider it my duty to make his last difficult hours as easy as possible.

ZWERCH: Yes, yes, of course, whatever you say. You can love him too, if you want to, your old ventriloquist.

CLARA: Ugh, how mean of you, Friedrich. You know all too well how much I love you. Don't tell me too often, even if it's a joke, that I can love someone else. Otherwise, I'll actually do it some day . . . *(Grabs him by the arm, stiffly . . .)* Do you want to get rid of me?

ZWERCH: You women with your eternal concern with love. Can't you think of anything else?

CLARA: Do you really think about so much else?! During the first years that we were married, you were always so good to me. In the evenings you read to me from wonderful books and we went to concerts and plays whenever you were free. That was so nice. But since you became a hotel director, everything is so different. You're constantly hurrying and involved with business. I hardly ever see you anymore. It's all you can do to share lunch and dinner with me. And you're constantly with strangers, with those horrid women who don't even love you. People are already talking about you and this crazy Elly upstairs who flirts with every man she sees. You don't look at the people who really love you, but you chase after that conceited, dumb, arrogant skirt.

ZWERCH: What you are telling me is that you were probably together with Paul. It sounds like Paul speaking through your mouth. Don't be so petty. After all, I do have to speak with the guests from time to time. You should not deprive me of all freedom of movement, Clara. I really am good to you. But don't drive me to despair. Don't listen to silly accusations.

CLARA: I saw myself how she talked with you alone for almost an entire half hour in the garden yesterday.

ZWERCH: And do you think it's appropriate for you to make a scene with your jealousy here in the kitchen? You're making life a living hell for me. Clara, I beg of you, leave me alone. I love you, yes, yes I do. So, please, darling?

CLARA *(Gently tragic)*: And you must love me. If you don't, then life seems bleak to me. If I only think about you kissing someone else, it's as if two knives were boring through my head and my spine. No, you must not be faithless toward me. You must not. I was with you when things weren't going well for you, when you were all alone.

I've given you my life ten times over. I could be a countess and be worth millions, but I decided not to be. You remember, back then while I was riding Feodora. How wild you were then, and wanted to kill the poor count or me or yourself. Now I just don't know. Everything is so different. While you were still headwaiter over at the Atlantic Hotel, I was your happiness, your ideal. You couldn't live without me. But now after you finally became the great man, now that your desire and craving for success and for rising to the heights is finally beginning to be satisfied, you become cold and indifferent toward me.

ZWERCH: Stop. Stop it now, Clara. Have you lost your mind, to say such things to me here in the kitchen. Yes, yes, it's true, I don't love anyone else, I don't want anyone else. Now stop it. I have nothing more to say.

CLARA *(Suddenly gentle again)*: Friedrich, don't be angry. You have no idea how much I'm tortured by all this. Tell me, there's nothing between you and the baroness.

ZWERCH: No, no, no . . . *(Walks out, stage left)*.

CLARA: Don't be angry, Friedrich, Friedrich *(Calls softly after him)*.

Curtain

Scene 2

Elly and Rennè descend the grand staircase of the hotel slowly, dressed to go out. Ivan Ludmann is seated stage front in a lounge chair.

ELLY: Ah, good morning, Ivan. Sleep well?

IVAN: So-so, just so-so, my dear Elly. I think I really do have to begin doing some sort of work again.

RENNÈ: Yes, well, it's a mysterious thing, digestion.

ELLY: You're sitting here looking so melancholy. The spitting image of misery *(Sits down on another chair, the baron as well)*.

ELLY: What are your plans for the morning? *(Yawns widely)*

IVAN *(Yawns likewise)*: Nothin'. Just so I don't have to go for a walk *(Drinks his cognac)*.

(Rennè yawns likewise.)

ELLY: Boy, how boring you guys are again so early this morning . . . *(Pauses)* Has anyone seen our director?

Ivan *(Lazily)*: Oh right, your director. Yes, sure, a little while ago. I

saw him downstairs in what seemed like a very animated discussion with his wife. Strange guy, Zwerch. Always looks ready to explode. Not like me at all.

ELLY: But he's so handsome and has more life in him than you two dolts put together.

(Ivan shrugs his shoulders lackadaisically.)

RENNÈ *(Yawns again)*: Yes, yes, he's rather nice. Has delusions of grandeur and is sort of childlike all the same. He belongs to the group of intelligent parvenus. And he's supposed to really know something as well. Mertens told me that the stocks of the three hotels he directs here are rising rapidly. The dividends are supposed to be enormous. Might add some to my portfolio myself. Hm, and to think he was a waiter once.

ELLY: I think he's first class. His smoking jacket fits him perfectly. You should find out who his tailor is.

IVAN: Do you know his wife, a real beauty.

ELLY: Only superficially. They say she's rather reserved.

IVAN: She used to be a bareback rider, from a good family that lost its money somehow. It's said he loved her very much until now *(Looks toward Elly)*.

ELLY *(Agitated)*: You're an absolutely horrid man, Ivan.

IVAN: My God, why shouldn't I be, your grace?

RENNÈ: Now please, boys and girls, don't fight. You know I can't stand it. Do whatever you like, but please let's have peace in my presence. I'm already bothered enough by my diabetes. But here comes your hero. Hello, Director, good morning.

(Zwerch enters. They greet each other.)

RENNÈ: Sit down for a while. *(Zwerch sits down.)* Have much to do?

ZWERCH: One does what one can, Baron. *(To Elly)* Did you enjoy your boat ride, Your Grace?

ELLY: Thank you, my dear Director, it was charming. We are very much in your debt. The Rigi was wonderful at sunset.[4]

IVAN: Yes, it was very nice and I didn't have to walk.

ELLY: You old tub of blubber you. Lazy bones, sluggard. You'll choke from your own idleness if you keep it up. Don't you agree, Director?

ZWERCH: I cannot deny that a little business activity appeals to me more.

ELLY: People say you'll stop at nothing, Herr Zwerch.

ZWERCH: Well, my dear madam, it was certainly not always easy,

although I'm not happy with the expression you used. I only did
what anyone would do. Climbed the ladder one rung at a time. If
sometimes one wasn't empty yet, I might have helped along a little.
But I didn't enjoy that. It's just that one has to live. And then some-
times, it's enjoyable too.

IVAN: What drives you to do it? Can't you break the habit? It's fatal,
this tendency. I myself live only because I'm too lazy to kill myself.
Not even a duel is tempting anymore since—sad to say—I am a very
good shot and the other guys are all so scared that they miss me.

ELLY: My dear Ivan, you're such a drag! You have absolutely no fan-
tasy. "—life is no more than what one makes of it and what one is
oneself—" my friend Oskar said recently. You know, the one who
wrote that wonderful book. You think my new feather boa is beauti-
ful, don't you Herr Zwerch, come and look.

ZWERCH: I believe, madam, that there are few things that would not
be beautiful when worn by you.

ELLY: Oh, a compliment! That was truly charming. It is hardly to be
expected from you, such a serious man!

RENNÈ: Maybe Herr Zwerch looks more serious than he himself re-
alizes sometimes. Nonetheless, my dear fellow, you work too hard!
You should be satisfied with your three hotels, and instead you now
want to acquire one in Zurich as well. Leave it alone, my friend.

(Zwerch shrugs his shoulders.)

IVAN: I could almost be envious of your naive entrepreneurial drive,
Director. I find it very comical that I was able to get so much gold
through my own miserable little factory. Before that, I longed to be
a first-class confidence man, although I fear I am too lazy to really
succeed. All that I now do is buy paintings, and sometimes I spend
time with Frau Elly *(Bows ironically toward her)*. She amuses me
just as much as you do with your ambition. I do not understand ei-
ther one of you, although I find you personally relatively amusing
still. For me the world is boring to the point of despair. People crawl
out of their eggs, bark like young dogs, and hurl themselves onto the
fodder that is more or less available. To make the meal somewhat
more palatable, they decorate it with ideals that are threadbare and
full of holes. When I go along the streets and see that sickly, sad
vermin senselessly rushing about in the harsh light of that exploding
mass of gas that is so close to us and that they call the sun, and when
I see the comical seriousness and ridiculous sense of self-worth with

which they pursue the same game generation after generation for the millionth and billionth time without ever having the idea of doing it differently. When I but look at this herd of slaves, in which everyone always thinks only of himself instead of finally being smarter for once and thinking about everyone out of pure intelligent egotism, then my morning coffee rises in my throat and my urge to throw up becomes so strong that I enter the next bar and buy myself a drink, which is what I intend to do now as well. Hey, waiter, some cognac.

RENNÈ: My dear Ivan, I think you must be suffering from constipation once again, considering how ill-humored you are. My God, if I were only as relatively healthy as you are, I would have something else to do than to preach such a constipated philosophy as you are doing.

ELLY: Oh, let him be. Once in a while he has to spew out his poison or else he gets sick from it. He's still interested in patent-leather shoes with high heels. Aren't you, you old rogue? *(Shows him her legs that are shod in high-heeled French patent-leather shoes)* And he's drinking again too.

ZWERCH: Why don't you do something to make people smarter?

IVAN: Haha, only childishly pure souls such as you can ask that question. I have only to look at you.

ZWERCH: Me? Why?

IVAN: That would be difficult to explain, my dear sir. At any rate, please believe me when I say that any malicious or insulting idea is furthest from my mind, but sometimes I can see something like the future and I feel sorry for you.

ELLY: Oh, how interesting, our little Ivan a clairvoyant. That's a part of you I do not know yet. You'll have to explain it to me sometime. But now I am of the firm opinion that we should talk about something else. Whenever things start to get personal, I begin to feel faint and uncomfortable.

ZWERCH: I at any rate marvel at your honestly admitted talents, Herr Ludmann. I can reassure you, however, that for the time being I still feel quite comfortable in my own skin. Feelings of being constipated and overstuffed do not beset me.

RENNÈ: Bravo Zwerch. Good response. This Zwerch, heehee, this Zwerch. Still water runs deep, heehee. Well, Ivan, what d'you say to 'nother drink? Besides, my dear fellow, women continue to exist too, despite your talk of squirming vermin and nausea. Ah yes, women. Pardon, Elly, I mean of course "the woman." They are the morphine of life. You're right, Ivan, they give us a hangover, but what would

we do without this invention. They are such a marvelous luxury. Do you know what a woman smells like? And the ankles, this prelude to the thighs. I'll always be their student. They are my garden, my paradise. My eternal dream. I need no other meaning in life, no philosophy, no further proof that God exists when I think of Elly's legs.

ELLY: My, but you're getting poetic, you old fool. But it's nice of you anyway. Come here and I'll give you a kiss.

IVAN: Certainly he's right. The only problem is if one's mind is burdened with a few other points of view.

ZWERCH: I wish I too could speak about "women" so carelessly. For me there is never anything but "the woman" *(Gazes at* Elly).

ELLY: Bravo, Herr Zwerch, that's right, that's what we like to hear. *(Ivan and Rennè smile at each other silently.)*

IVAN *(To Zwerch)*: Do you love your wife that much?

ZWERCH: Yes, I do love my wife *(Looks at Elly)*.

ELLY: There you see, Ivan, he's a good boy after all, despite his Napoleonic airs. Didn't I always tell you so?

IVAN *(Laughs)*: Yes indeed, and I'm almost prepared to believe it. Such family bliss may even be enviable. At this rate, I'm going to have to get married after all *(Laughs out loud)*.

ZWERCH: Since you seem to be a collector of the absurdities of life, Herr Ivan, I would advise you to come this afternoon to our culinary exhibition and the awarding of prizes and join us in the feast afterward. I believe it would offer you another opportunity to see "true joy in life." At the same time, you'll be able to admire or pity me as one of the judges, depending on your inclination.

ELLY: A culinary exhibition, wonderful! We'll have to see it, Rennè, we'll have to join in. Ludmann has to come too, my kind chubby Ivan.

ZWERCH: So I shall have places set at the tables for all of you.

ELLY: So that's settled. Oh, isn't life beautiful, children! Just look at the sailboats in the sun and all the automobile traffic. That Opel over there, it's wonderful. Look at it, Rennè, the long black one over there. I have to have one just like it too, but a little longer. Do you hear, honey? Our old crate is repulsive by now. You old sinner. In two weeks it's my birthday. If I don't have one by then, I warn you, you'll see what happens.

RENNÈ: You'll be the ruin of me, my dear child. I won't even consider it. Our old crate is still in excellent condition.

ELLY: There you have it. There you see, that's how you are, hard and

cold and petty and stingy. A pitiful worm not worthy of possessing even my little finger. If I don't get the car, I'll poison myself. I swear it. It'd be so easy, just child's play for you, you old cheat *(Cries)*.

RENNÈ: Well, now we've done it. Sweetest kitten. Ly, Ly, Ly . . . Elly, my little Elly, please, don't cry. You can have anything you want, just don't cry. I can't stand tears *(Crawls around on his knees before her)*. Please, please, don't be mad.

(Ivan laughs loudly while Zwerch looks on angrily.)

ELLY: You're just an old miser, come here *(Kisses him on his bald head. Wipes away her tears and laughs loudly)*. So, gentlemen, are you coming along? I've rented a motor boat and want to ride out to the island. Who'll come along?

IVAN: Since you're not talking about a walk, I'll come.

ZWERCH: You will have to excuse me, madam. Business, you know.

ELLY: You're an absolute slave to your business, my dear Zwerch. Ugh, you should be ashamed!

(Zwerch shrugs his shoulders again, says nothing, and looks at her.)

ELLY: So, let's get going, guys. Rennè and Ivan, off with you and get the boat into the water. The director will bring me to the beach. *(Ivan and Rennè leave; Elly softly to Zwerch)* How much I love you, Fried.

ZWERCH: No one else but me??

ELLY: Oh, you fool. Haven't I told you a thousand times?

ZWERCH *(Dull and tortured)*: Do I have to love you then?

ELLY *(Laughs)*: Yes, you do! Dearest lamb! *(Both leave.)*

PAUL *(Rushes in, addresses the porter)*: Where's the director?

PORTER: He left with Baron Mânosch for the beach.

PAUL: When he gets back, remind him that his wife urgently asks that he not forget about Dr. Kalla. Her friend, the ventriloquist, seems finally to be nearing his end. Ah, isn't that Anna over there? *(Turns to the baroness's maid, who is coming down the stairs, dressed to go out)* PAUL: How do you do, my beautiful child?? *(Both move off to the side slightly.)* Now, dearest! I'm dying of loneliness for you. Will you be coming this evening?

ANNA: Yes, Paul. I'll be there. I hope Friedrich comes early, then she always sends me away.

PAUL: Was he there again?

ANNA: But of course, her ladyship won't leave him alone. She's as horny for him as some mare from our stables who's in heat. But he's damned dull. He just whinnies for her every so often. It's not easy for her. He resists furiously. I wasn't able to hear much. But this evening she'll get him. *(Softly)* Because this evening she had me lay out her finest underthings and her new Polish lacquered shoes along with her yellow stockings. Oh, these people always think we don't notice anything. He seems to be ready too. Just a little while ago I read a note her ladyship had in her purse. "This evening after the celebration I'll come to you, dearest Elly." The stupid goose, and she . . .

PAUL: Can you get the note for me? I'm interested in it.

ANNA: Gladly, my dearest friend. What wouldn't I do for you. She won't even notice it, in all of her mess. These dolts, always they think we don't notice anything. She seems to have Ludmann worked up too.

PAUL: Haha, yeah, they always think we won't notice anything. *(Both leave through a side door.)*

Curtain

ACT 2

A common hotel ballroom, front right the judges. In the background, the public, including Rennè, Ivan, Elly, and Clara Zwerch.

HOTEL DIRECTOR CRAMER: And here, my dear colleagues, I propose we offer the greatest honor to this truffle ragout. I know the house where it originated for a long time, and I know it is worthy of receiving the first prize.

DIRECTOR PORTEN *(Tastes again)*: Well yes, my friend, quite good. But I ask the gentlemen once again to test this mayonnaise seriously. It was made by my friend Kraus. I know that the man works with his heart, and that business is bad right now and he has four children. Think about it.

CRAMER: Are you serious? Children, heart? Nonsense. Excuse me, dear colleague, but art is what is at issue here. What do most of those jerks know about the love that is necessary to make a ragout such as this. What do they know of how our country will be served when we are in a position of making such things once again. Just register the

aroma one more time. You'll not find it any better at Riche's. In the name of our fatherland, I support this ragout.

HOTEL DIRECTOR SCHULZ *(An old gentleman)*: To be honest, my friends, I've tasted all of this, tasted, then tasted again and again. But I find that our times are regrettably depraved. Nothing of any real value. Not even your mayonnaise, my dear colleague Porten, and also not your ragout, my dear Cramer. My God, when I think of how my regrettably long departed Jean Louis created his compositions. He'd work eight days at the recipe for a sauce. Time and again he let it be conceived and then tasted and tasted. How often did I not have to give him double antacids in the evenings because his stomach simply couldn't go on. There simply is no love for the job anymore. Everything is surface, surface, and surface again. I cannot convince myself to agree on the award of even a single prize. I just find everything despicable.

CRAMER: My dear colleague Schulz, you're certainly right about a lot of things. But nonetheless you shouldn't forget that time marches on and some things that seem like nothing more than artifice to you in terms of form are actual artistic form. But that is something that escaped the notice of your generation. You were too much concerned with content. In some things that's fine, but just look at how this ragout is constructed, its crown of four powerful truffles; anybody will realize what's important here. Don't you realize the man thought it all through? I have to admit that on me this absolutely powerful presentation, this pyramidal structure leaves an almost mystical impression. I see how the abdominal nerves of the eaters already transform themselves into pleasurable convulsions, and that is the essence, my dear sir, fantasy is the determining factor, not the content. Just place the public under the appropriate suggestion, and it will eat kidney beans with more pleasure than oysters, but you just don't understand that, do you? You simply won't allow it.

SCHULZ: Now you've gone too far. You're a young brat. And you want to make me seem ridiculous and antiquated here? Me, Hotel Director Schulz, who won three gold medals in Berlin, Brussels, and Hamburg, who dedicated his entire life to such things with love and devotion, with ambition and hard work. To me you say I understand nothing of my art, you, you young brat. Do you think you can impress me with your own work? Fraud is what I call the stuff you make. It's that simple.

CRAMER: Only your age, my dear colleague Schulz, prevents me

from giving this insult the form of satisfaction that it deserves . . .
But one has to respect age *(Turns away disrespectfully).*

DIRECTOR HASENBÜTTEL *(Very fat)*: But my dear, honored col-
leagues, I really don't think you should get so worked up. More com-
posure, my friends. Just remember that life is a precious opportunity
and that any irritation shortens your life expectancy. Let's relax and
drink this good Bordeaux; that's the right thing to calm everyone
down again. I find that only in Bordeaux is the final wisdom. *(The
contest judges sit down again, Hasenbüttel pours and continues to
speak)* Only here is true gentleness of soul to be found, gentlemen.
The peace of heart necessary to come to terms with the things life
exposes us to. Why bother with all this disagreement and anger when
in the end we all croak anyway, why constantly make life miserable
for yourself by talking about your bitterness? Fletcherize, gentle-
men, you have to learn to fletcherize more, whether during the judg-
ing of contests or while eating and drinking. That godlike American
really did discover the meaning of life for us.[5] Just chew the cud
slowly, let everything swish around in your mouth and mind and
stomach fifty or sixty times. Then, it's best to regurgitate everything
again and then slowly, slowly finally swallow it all. You see, gentle-
men, this is what peace and quiet gave me; it helped me to achieve
this sizable reserve that I now carry around with me patiently. Pa-
tience and calm and chew everything several times. That's how you
store up treasure for the bad times *(Pats himself on his sizable
stomach).*

SCHULZ *(Still angry, makes a fist at Cramer)*: But he called me an
idiot, a senile dusty old fool, this, this . . .

ALL: Quiet, boys, quiet, we have work to do. Therefore: prost *(All
drink to each others' health).*

*(At this moment, a man-sized carp, an almost mythological creation
with a lemon in its mouth and surrounded by parsley, is carried in
and is placed slowly on two chairs in the center of the stage. A short
man, unremarkable in his appearance, walks next to it, stands beside
the carp and calls out, while turning toward the judges.)*

GRATZEWOHL: Gentlemen, I ask that you excuse me a thousand
times, my name is Paul Gratzewohl, director of the Tutzlingen Con-
cordia Hotel, representative of the Tutzlingen Hotel Owners and
Restaurateurs. We regret greatly that we were only able in the last

minute to bring over our entry into the contest. I hope that the honored jury will be kind enough to judge our contest entry nonetheless.

(All the guests, Elly, Rennè, Ivan, Clara, and the jury members rush up with great interest and arrange themselves around the fish, exchanging their opinions with great excitation.)

CRAMER: Damn, that's some fish.

SCHULZ *(Admiringly)*: Indeed, that still shows solid workmanship.

ELLY *(Clapping her hands)*: Oh, isn't that a charming creature, just look at this big mouth and the whiskers and the moss on its head. That must have been a really old one. My God, look at the melancholy bugged-out eyes. And the lemon in the mouth is fabulous too. What do you think, Herr Zwerch, surely this has to get the first prize. *(They move a little to one side.)* Fried, sweetie, why do you make such a sour face? All this is so wonderfully comical, all this business.

ZWERCH: Comical? Comical, yes certainly, naturally it's comical. I too am, I believe, comical, terribly comical. I'm pulled to right and left. It would be best if I let myself be cut in two and present my two halves to you all on a shiny silver platter *(Tugs at his mustache)*.

ELLY: What's the matter with you, Fried, why do you say such weird things? Come on, be nice, don't make such a face, didn't I make myself beautiful in your honor? *(Twirls coquettishly in front of him)* Look at this crêpe de Chine dress; I'm wearing it for the first time in your honor, and my pailette hat, how do you like that? Come on, don't be so moody, you sweet puppy, don't make me sad when I'm so happy. Or would you like to ruin my mood? Tell me, whisper to me quick that you love me. And that my hat looks great on me. Or else I'm going to leave.

ZWERCH: But of course, Your Grace, I do know that I have to love you. I'm not allowed to do anything else. You will allow nothing else. And . . . *(Sighs)*. I have no choice either, but I'm not happy about it. This ludicrous situation, in which I am still forced to participate, depresses me and I find it upsetting that my wife is here. Isn't she watching us?

ELLY: Of course not. She's too busy talking to Ivan and my husband. You know, Fried, I'm really jealous of your wife. I think you love her more than me, you know? . . . I won't stand for that. Be married as much as you like, but it's me you have to love most, or else God help you.

ZWERCH *(Brutally)*: I think actually I can't stand you. Sometimes I'm afraid of you. What do you really want from me? Why can't you leave me in peace? I want to stop. I can't go on.

ELLY: Oh, really . . . Really? That's really something. But please forgive me, most honorable Herr Director, if I have been a burden to you. Please forgive me, please forgive me *(Leaves in a rage to join the others)*.

(Zwerch remains standing a while longer in the public. He stares straight ahead. Then he heads boldly toward the excited discussion of the judges. Rennè comes forward with Ivan and Clara.)

RENNÈ: That won't be easy, coming to a decision. Don't you want to have yourself named to the panel of judges quick, Ivan. You are, after all, a first-class gourmet.

IVAN: No thanks. Takes too much effort to appeal to me.

RENNÈ *(To Clara)*: I just feel sorry for your husband, Frau Zwerch, that he has to be part of this rather ridiculous theater.

CLARA: My God, but that's hardly the worst of it.

RENNÈ: Look over there. Now the two fat guys are going at each other again. I have to find out what they're saying *(Off to right, stage rear)*.

IVAN *(To Clara)*: Do you not feel well, my dear lady? You seem rather pale this evening. Hotel life must not seem like the most desirable to you sometimes. Actually you looked happier in the circus sometimes.

CLARA: My Lord, ha, Herr Ludmann, it was nice sometimes, back then. God, the worry now about the business just doesn't ever stop. Did you hear anything from Correlli recently, by the way? I really am totally out of the loop. But I do miss it sometimes.

IVAN: I thought your old friend Ernesto was living with you now.

CLARA: That on top of everything else. The poor guy has been seriously ill for the past four weeks. And we are almost afraid that the end will come today. And this horrible farce has to go on meantime.

IVAN: Is he actually that sick? That would really be a shame. I have never heard another ventriloquist who was so unusual and clever. Sometimes he came across as downright spooky. And the dummy he had was more lifelike than most of the human beings I got to know. You really do owe him a lot, Clara, I know, he saved your life back then when the horse bolted with you.

CLARA: He was always my friend, a person who truly did love me

selflessly. I'll never find anyone else like him . . . Oh . . . *(Looks around her)*. I hate all this business, if it weren't for Friedrich. I long so for the country, for peace and to be alone, for chicken, cows, goats, for the smell of a barn and for making butter. I want to get away from these people, from these women.

IVAN: It's not possible to be alone in the country either. The toilets are bad and people exist there too. The mob is everywhere.

CLARA: And they don't love each other either. I know that.

IVAN: Idiocy, poor material, bad theater. But the carp over there, it's beautiful.

RENNÈ *(Comes stage front with Elly again)*: How exciting! The honorable directors have a hard choice to make.

ELLY *(To Clara)*: Ah, Frau Zwerch, what do you think of the animal? Your husband will vote for the carp, won't he?

CLARA *(Sharply, almost impolitely)*: I do not meddle in my husband's affairs and . . . can only advise you to do likewise *(Turns and leaves Elly standing)*.

ELLY *(To Ivan)*: That's certainly an arrogant bitch.

IVAN *(Laughs)*: But she's got breeding, Elly.

ELLY *(Maliciously)*: That beast.

RENNÈ: Well, well, what brought that on, what's the matter with her all at once? Did you step on her corns, darling? Oh, just don't make a scene. Let her go. She seems to be having a hard time of it. *(To Ivan)* One shouldn't take something like that too seriously between women. I think, heehee, that she's jealous of our dear little Elly. These people suffer delusions of grandeur just a little.

ELLY: You're right, Rennè. It's impossible to offend so subaltern a creature. Hm, the dumb beast *(Quietly to herself)* . . . but just wait. *(Goes directly to Zwerch, who has returned from the tumult and is alone stage right)* Fried, love, come and be good again. *(Whines)* Look, you should feel sorry for me. Your wife just now snubbed me in the most shameful way before everyone. And I only wanted to be nice to her. Will you put up with that?

ZWERCH *(Flares up)*: What?! Clara? She shouldn't have done that. What of it, Elly. Come, don't let it bother you, my darling. No, she shouldn't do that.

ELLY: Well, she tore into me like a crazed panther. See, and you're not treating me very nicely either. Everybody's rude to me. There's nobody who's good to me. You said that you can't stand me, too. And I love you so, Fried, oh, I love you much too much *(Dabs eyes and nose with her handkerchief)*.

ZWERCH: How can you possibly believe seriously that I wouldn't love you? I love you much too much already. But I don't want to. I can't hurt Clara either. She's always been a faithful wife. You have to understand that. You're just playing with me, after all. Are you crying? Is that possible? You're captivating, charming, like sweet poison, but I don't care. Tell me, you really do love me. Will you be mine alone then? Tell me. I can only love you the way you want if I can have absolute faith in your love . . . I can't help but feel something in you that is incapable of loving. Amusement, yes, that's possible. I can't trust you, you bad, sweet little creature.

ELLY *(Excited and intense)*: Come to me this evening around 10, the way you promised, and you'll see if I don't love you a thousand times more than your horrid Clara. Come, Fried. Will you come, darling? I beg you, come.

ZWERCH *(Firmly)*: It's OK, I'll come.

HASENBÜTTEL: Ladies and gentlemen, I implore you to return to your seats at your tables. The jury must continue to fulfill the duties of its office.

(The guests return to their seats again; the judges take their positions stage right.)

PORTEN: Well, gentlemen, I think now that—in consideration of the extraordinary nature and the monumentality of the whole—we will have to award first prize to the Tutzlingen entry now.

SCHULZ: Yes, I fully agree, that is a solid piece of work. I must say that I am grateful that at the end such a remarkable achievement appeared amid all these miserable concoctions.

HASENBÜTTEL: Before we take the cudgels up again, I beg you, gentlemen, to strengthen yourselves once more with a little sip. Your health, gentlemen, prosit. *(They drink to each other's health.)* . . . So, now I advise you all to take ten deep breaths first. That will calm the nerves and give us the necessary patience to enable us to carry out our office with all the care and objectivity required by something of such significance.

(Slowly they all take ten deep breaths, then Cramer immediately bursts out in anger.)

CRAMER: I simply cannot understand how anybody could ever doubt for a single moment that this huge beast over there, this ludicrous

monstrosity *(Points toward the carp)* should *not* be given the first prize. That would be a direct blow at the eye of culture. A regrettable triumph of matter over artistic form. What in this animal is art, gentlemen? Nothing, absolutely nothing. Other than that it was simply overcooked with salt and pepper as seasoning. It's effect is only in its mass. Where is there the fantasy of an artist who has re-created the material by first giving it form . . . Here in this ragout, which does not seek to impress by means of quantity but through discursion and elegance, here the possibility of future development for our art is to be found. What it tastes like is insignificant. What is important is how it looks.

PORTEN: Nonetheless I am of the opinion that we should not disappoint the good people who put so much effort into it. I am of the opinion of our colleague Schulz.

SCHULZ: Oh, oh, so this is how today's youth is. A horrible diabolical mirage. Oh, my people, my poor Swiss people, what will become of you? That I should have to hear such damnable points of view expressed at my age. Things look bleak to me, gentlemen, my heart is saddened. When I see this younger generation that our colleague, Herr Cramer, represents for us. Has your stomach actually slipped into your head, Herr Cramer? Do you not realize what you do when you say such things, with what a terrible responsibility you burden yourself. I beg of you, I beseech you.

CRAMER *(Laughs mockingly)*: Hahaha.

HASENBÜTTEL: But gentlemen, dear colleagues, please let's not get personal again. Look here, Schulz, I concede that you are right about much of what you say, but I also find that much of what our colleague Herr Cramer says is not to be disdained. I'm sure it's because we all just thought too much of the stomach and not enough of the spirit, something that's simply a characteristic of our times. At least, that's what everybody says. And I find that we have to go with the times. Otherwise they'll pass us by. Yes, it's true, gentlemen, I have come to the conclusion that time marches on. What can we do? We simply have to adjust our stomachs accordingly. The good old times when content mattered most to us have passed . . . And I want my peace too. It is the most important part of life for me and ultimately we can fletcherize too when the form has become more spiritual. Therefore I have to conclude that I must support the position of our colleague Cramer.

PORTEN: Since my honored colleague Hasenbüttel, whom I admire very much as a wise and experienced critic in the noble art of cook-

ing, is so much in favor of the ragout of our colleague Herr Cramer, I have to say that there is much that seems better to me than it did before. Yes indeed, my dear Schulz, it's necessary to go with the times. I too vote for the ragout.

SCHULZ: I can already tell that I shall lose. Good, there's nothing I can do about it. Oh, my dear Jean Louis, be glad that you did not live to see this. I know, I can sense it, that you are turning in your grave *(Weeps and wipes the drops from his nose).*

CRAMER *(Stands up)*: Now, I believe, gentlemen, that we are here in order to fulfill the duties of our office and not to engage in useless sentimentality. Therefore I now call the question. Colleague Zwerch, so far you have not found it necessary to join in our discussion. Where do you stand?

ZWERCH *(Tired)*: I am with the majority, gentlemen, please take the vote.

(The vote is taken, and it turns out that the ragout receives first prize, the fish the second, and the mayonnaise the third. The gentlemen of the jury rise from their places.)

HASENBÜTTEL *(Steps forward)*: I beg the gentlemen competitors to step forward.

(The gentlemen step forward.)

HASENBÜTTEL: In the name of the contest jury I allow myself to inform the gentlemen competitors that the jury has made its decision to present the first prize to the grand truffles ragout, the second to the carp, and the third to the excellent mayonnaise. I hope that the honored competitors are convinced of the seriousness and loyalty of our attempt to do justice to their art. My congratulations, gentlemen. *(He goes toward the prize winners and shakes their hand one after the other. Paul Gratzewohl pulls his hand away with a loud cry of indignation.)*

GRATZEWOHL: That's for us? The second prize, the second prize? . . . Gentlemen, I implore you, reconsider. Do you realize that you have destroyed the flower, the hope of Tutzlingen? Everyone there scrimped and saved, each member of our club contributed his penny. When the giant animal was discovered in a dark hollow at the bottom of the lake. Then, yes, then it was clear to us all that it had to get the

first prize. That's why we had to win it, because all Tutzlingen was at stake. Tutzlingen should finally win first prize, that much we knew. What could possibly happen to us if we had this carp. Our board was certain that Scherl would catch it for this week. Our women have even had their festival dresses renewed in order to celebrate the honor of their men properly. I beg of you, gentlemen, you cannot disappoint us this way. Reconvene and reconsider your decision. Change your judgment.

HASENBÜTTEL *(Very solemnly)*: My dear colleague Gratzewohl, that is just not possible. We arrived at this decision after serious and careful consideration. Believe me, it was far from easy, but you too have to learn that form is simply more important than content. And you just had too much content, yes indeed, too much content.

GRATZEWOHL *(Shouts)*: What, that's pure gibberish you speak. I make the motion that this entire jury be declared insane. Yes, you're every single one of you insane.

SCHULZ *(Whining)*: Not me, my dear Gratzewohl, I was in favor of you.

GRATZEWOHL: See, this noble gentleman understood us. The others are all insane, insane, insane.

HASENBÜTTEL *(To the waiters)*: Take him outside.

GRATZEWOHL: What, throw me out? *(Tears himself loose)* Now nothing matters to me anymore *(Grabs the truffles ragout and throws it at Cramer's head)*. Here you can have your first prize and here *(Finally throws everything together and behaves like a madman)* and here, and here is the rest of your garbage . . .

PEOPLE *(Scream and run amok)*: A madman, a madman. He's gone mad.

(The waiters try to grab him. He tears himself loose again and begins to throw things again. Everyone runs toward the exit. Finally he is dragged out.)

HASENBÜTTEL *(To Zwerch and Clara, who remained behind)*: That certainly brought our celebration to a most unpleasant end. Yes, I say, yes, we have to fletcherize much more, the whole world has to learn to do it still. Too bad, too bad. Good night, my dear Zwerches. *(Leaves. The waiters clear up the dishes lying around and leave the room laughing and joking.)*

CLARA *(To Zwerch)*: Thank God that this ridiculous comedy is finally over.

ZWERCH: Thank God. It ended up being a real madhouse.

CLARA: Did you tell the doctor about Ernesto?

ZWERCH: Yes *(Deep silence between the two, both walk back and forth for a time without looking at each other)*.

CLARA *(Finally)*: Are you angry with me, Friedrich? *(Goes slowly toward him and reaches for his arm)*

ZWERCH *(Angrily, pushes her away from him)*: Leave me alone.

CLARA: I beg of you, Friedrich, don't be so hard toward me. What did I do to you anyway?

ZWERCH *(Laughs loudly)*: Done—? Are you mad? You insult our guests here in our own house, insult them, brutalize them with your stupid jealousy.

CLARA *(Mockingly)*: So, this little toad had nothing more urgent to do than to repeat everything to you. Well, the two of you seem to be pretty intimate already. Is it too soon to offer congratulations?

ZWERCH: You're a witch, a scorpion. You choking the life out of me.

CLARA: And you? . . . What are you doing? . . . You ignore me in public before everyone. Everybody sees how you are around this woman. If at least you had enough of a sense of shame to do it secretly. But no, before everyone's eyes you let yourself be courted by this coquette and make sweet googoo eyes at her like some old rooster.

ZWERCH: What are you telling me? Hm, that's rich, that's really rich. Yes, of course, I'm chasing her. There's nothing that's more urgent for me than to enjoy her love. Your great selfless love is seen for what it really is. Just go on this way. Just go on this way. I have only one thing to say to you: if you continue to restrict me in this way, if you go on watching every step I take and spy on what I say, then you really will experience what you only imagine now.

CLARA *(Begins to cry)*: Yes, I know that's the way things will be. I already know you'll kill me. I see it clearly now, you want to kill me. Just do it, do it soon, life's been hell to me a long time already. What am I supposed to do without you? *(Weeps uncontrollably)*

ZWERCH *(Sighs horribly and tears at his hair)*: Clara, for God's sake, Clara, don't make me lose my mind. You know that I can't bear it when you cry. Don't you know that you can't think up a more effective torture than these eternal tears of yours.

(Again an extended silence. Clara cries the entire time. She sits on a sofa with her head on the pillow.)

ZWERCH *(Walks back and forth extremely agitated)*: You simply don't know what all I have done for your sake. You have no idea of how I have to do violence to my own nature all the time. Yes, I do love you. You can believe me when I tell you that. There is simply no one else who is as close to me as you, but you mustn't imprison me, you mustn't deprive me of all air. After all, it isn't my fault if I have eyes in my head and can see that there are other women than you who are beautiful. I beg of you for all I'm worth, my dear sweet Clara, don't be so petty with me. I'm sorry I'm a man. I'm sorry, God knows. Please don't make life so terribly hard for me. You do have to be my friend, must help me, must make some things easier for me, and, when all else fails, allow me some things. How I will love you for it. Maybe then I won't even need another woman anymore. But leave me my freedom, I beg of you, or I'll suffocate and I become afraid of myself, because then I no longer know what I might do. It's even possible that I'd be like poor Gratzewohl a little while ago *(Laughs bitterly)*.

CLARA: That's the way you men are. You want all freedoms and we should bear all the bitterness and, if possible, be thankful for it as well.

ZWERCH *(Screams loudly)*: Oh, it's horrible. There's a wall between us, an iron wall. Oh, how I hate it, this love of which you women always speak in such gentle tones. I can't stand even the word anymore. It's the most deceptive word there is. Love, you women say, and be selfless. Haha. You all just want to devour me, devour me like a spider a fly. Suck out my blood slowly and passionately, and you close your eyes all the while and play your damned songs about selfless, divine love. Even on your death bed you'll prefer poisoning me over leaving me to another.

CLARA: You have absolutely no idea what love is. You love only yourself, know only yourself, you are a boundless, self-indulgent egoist who happens to know how to twist everything skillfully so that you'll look good.

ZWERCH *(Suddenly cool toward her)*: All right, Clara, let it go, let's stop this constant torture, we won't come to an agreement anyway— *(Becomes gentler)*. Come, my darling, I do know that it's hard for you, but it is for me too. Come on, be good again. Try to understand me just a little.

CLARA: Oh, I want nothing more than that we should understand each other, Fried. You have no idea how much I love you. Come, tell me that you really do love me and not anyone else.

ZWERCH: Clara, I swear to you that I love you, as deeply and passion-
ately as I possibly can, but I beg of you, don't speak to me about other
women. Leave me these flirtations. Leave me with my thoughts.
Don't always drag everything out of me.
CLARA *(Laughs bitterly again)*: There you see, there you go again,
you can't say anything without qualifications. *(Wildly)* Say that you
love me . . . !
ZWERCH *(Darkly)*: Yes, I love you . . .

(Both clasp hands and go out slowly.)

Curtain

ACT 3
*The stage is divided into two relatively shallow halves. In the left
section, Clara is with the doctor in the foreground, toward the back,
the sick Ernesto. Later the second section is illuminated to reveal Elly
and Zwerch.*

DR. KALLA: I have already told you, my dear Frau Zwerch, that I do
not believe he will survive the night.
CLARA: Isn't there any hope anymore?
DR. KALLA *(Shrugs his shoulders)*: There is not much more that can
be done. It is already too late. Send for me, if it becomes necessary.
You know already that I am always at your service. *(Leaves.)*
CLARA *(At the bed)*: Are you still not feeling better, Ernst? . . . *(Props
the pillow higher for him. The sick man moans.)*
ERNESTO: Are you still here, am I still here? . . .
CLARA: My poor, good Ernst.
ERNESTO: A while ago our old director was here, but the door up
there wasn't locked and the white worms in his mouth tickled his
nose constantly. I'd like to know if he intends to hire that Ludolf
woman again.
CLARA: You shouldn't get so worked up all the time, Ernst. Oh God,
come, I'll turn the lights off and stay with you *(Turns off the electric
light, only nocturnal illumination remains)*.

*(Meantime, the other side becomes illuminated and Elly enters,
dressed in white silk and pearls. Standing in front of the mirror she
takes off her coat and gloves.)*

ELLY: I wonder if he will actually come? Oh, I'm . . . *(sings "Sa-lome":[6] " . . .")*

(Her maid Anna enters.)

ELLY: Here, child, are the gloves. They have to be washed by tomorrow. Did the hat come from Babier?
ANNA: Yes, madam.
ELLY: Good. After you're finished you can go walking with your friend Paul. Adieu.

(Anna leaves.)

ELLY: This man appeals to me over and over again. There's nothing more amusing than a respectable man and his shoulders really are handsome *(Powders herself)*. I wonder if Rennè bought me the car. Steier cars are the best now. Too bad Rennè doesn't have Fried's shoulders and legs. His constant worries about morality have almost become boring, and his fussing about his Clara is simply ridiculous. I hate that woman. Such insolence. Haha, she is as dumb as she is tall. But he's so sweet when his eyes are flashing the way they do. I have to have him—*(Resumes singing "Salome" quietly to herself.)*

(The other side)

ERNESTO: Where is Friedrich?
CLARA: He probably still has work to do.
ERNESTO: Something has come between you two.
CLARA: Don't start now, Ernst, I don't want to talk about it and you shouldn't get upset.
ERNESTO: You shouldn't be so strict—Oh, the pain—Clara, he's not a bad man and he does love you.
CLARA: Stop it. I can't be any different, so help me God. Stay with me, Ernst, my dearest brother, don't leave me, don't leave me all alone.
ERNESTO: I want to stay so much, but they're coming back again, can you hear them? . . .
CLARA: Forget your old pranks, Ernst. This is no circus.
ERNESTO: Of course it is. Here he is. Don't you see the people down there, how they are staring and gaping again and how their tongues hang out with curiosity and boredom? *(Sadly, gestures as if holding*

his ventriloquist's dummy) It's true, my child, isn't it? We don't care
for them at all. *(In his delirium he begins to throw his voice.)*
THE FIRST VOICE: Hehehehehe, you, keep quiet.
THE SECOND VOICE: You are such a stupid fool, can't even see that
I'm sitting here.
CLARA: Ernst! Ernst! Get hold of yourself, Ernst!

*(Gives him tranquilizing drops, then puts her head down on the bed
and falls asleep too after turning the light off. Only a night-light
continues to burn.*
The other side. Knocking at the door. Zwerch enters.)

ELLY: Ah, the director. It's so nice of you actually to come. Just now
I powdered myself with my best powder for you. How do you like
my lace handkerchief? Rennè just brought it back from Brussels for
me. No, why so solemn and sad, Maestro. Our chambermaid from
Berlin sang it the other day. Do you know the little song *(Sings)*: "die
Lampe brennt so trübe, ihr fehlt es wohl an Fett!—den Jüngling, wo
ick liebe,—der liegt wohl längst inns Bett . . . [The lamp, it burns so
dimly, surely it's fuel it needs.—The boy I love so dearly—he's
surely fast asleep.]⁷
ZWERCH: You certainly must realize that you are beautiful, dear ma-
dam, and sadly I cannot avoid realizing it as well.
ELLY: Sadly?! Well, you certainly are a true gentleman.
ZWERCH: Yes, damn it, damn it. And I'm not supposed to love you,
but I can't help it, I have to anyway.
ELLY: Do you actually think I am beautiful? *(She draws him down
next to her on the sofa.)* All this trouble just because you have a wife.
I always heard that men didn't take that so seriously.
ZWERCH: But I love my wife and it pains me to think that I could
love someone else as well, and on top of all that, a woman who
mocks me.
ELLY: Who could mock you, you Hercules? Don't you know that
I actually admire you, Friedrich? Finally I meet a real man, and I
haven't known very many like you. What you have been able to
make of yourself, the way you run this huge business without it be-
ing noticeable, oh, I do love men who know how to be boss. *(She
leans against him and shows her feet and stockings by artful gath-
ering of her dress.)*
ZWERCH: Are you trying to torture me to death? It's not possible

for you to love me. I'm so far removed from your usual circles. Could you be my wife, be totally mine, Elly? Totally?

ELLY: But, my dear dummy, aren't you married already? *(Runs her fingers through his hair)*

ZWERCH: There has to be an end *(Kisses her)*. I love Clara, but you drive me crazy. The whole world turns blood-red when you put your arms around me. I can no longer stand the heaving of your breasts and your sweet hips, if I have to think of your husband touching them . . . Will you be mine totally?

ELLY: Yes, yes, yes, anything you want, my darling! Kiss me!

(They embrace.)

. . .

(After some time)

ZWERCH: It's true after all, you really do love me, you're not cold the way people say you are. You want to be mine, to abandon everything and follow me—My horrible loneliness, the terrible desire for you I've had the past days has to end. Instead of a vision of fish heads, life must gain a face again. In your eyes I see the same boundless yearning that possesses me, that is never satisfied. And Clara?— What can I do. The hell with it.—Listen! *(Immensely agitated)* Listen! Do you hear eternity knocking with its dried bones? How it grins at us from billions of faces. All my hotels are filled with them and my waiters are spying. They grin mischievously and shamelessly like the others and want to listen in on us. To watch us like the fat visitors in zoological gardens watch the tiger and his mate in their cage when they feel the drive to love.[8] But we will hide ourselves, we will disappear. Nobody should see us. Now you are my mate. You're mine totally—Do you see the night with its endless golden lanterns and the undulating black waters? Howling cats sing us our love song, my beloved. Come . . .

ELLY: Yeah, yeah, hold your horses, I'm coming already *(Leaves for the neighboring room)*.

(The other side. Knocking is heard several times.)

CLARA: What is it? Oh, I've been sleeping, Ernst! Who's there?

PAUL *(Outside)*: Frau Zwerch!

CLARA: Müller? *(Turns on the light and opens the door)*

PAUL: I would like to speak with your husband. Two waiters are sick and we need replacements for them.

CLARA: He's not here yet.

PAUL: Oh, not here yet? What do you know!

CLARA: Not so loud. You know that Ernst is very ill *(Points toward the bed)*.

PAUL: Are you very sad? Hm, yes, I do believe he loved you very much. It's always a shame to lose an admirer.

CLARA: Ugh, you should be ashamed for saying things like that.

PAUL: Don't I love you too, Clara, and even if you are always so harsh and mean to me?

CLARA: I have often told you, Paul, that I love only my husband, and that's the end of it.

PAUL: Heehee, Friedrich the tall one. Oh well, there's no denying you're nuts about him because he was more successful than I was. He doesn't deserve your love, though, believe me.

CLARA: Get out. You have no right to speak in that manner to me about my husband. I do not love you. I can't stand you. I despise you. Get out!

PAUL: So, I can't even say that I love you anymore, and all that just because of this ludicrous guy Friedrich who deceives you every chance he gets.—You don't believe me. Well, you'll just have to learn to believe *(Pulls the note from his pocket, trembling and very agitated)*. Now I just don't give a damn, even if he kills me. I can't put up with your constantly rejecting me any longer. You'll just have to see that I didn't lie. If you'd only cared for me a little, I wouldn't have done this to you.—But now you don't want it any other way *(Gives her the note Zwerch wrote to Elly)*. Do you recognize the handwriting? So, my darling little Clara, now I'll finally leave you alone. *(Leaves.)*

CLARA *(Slowly takes the note and reads out loud)*: "This evening after the celebration I'll come to you, dearest Elly" *(She becomes deathly pale and puts a hand on her chest)*. Friedrich's handwriting. So, it's Elly after all . . . *(Stares blankly ahead)*

ERNESTO *(His voice gets loud again, with a truly choking tone.)*: Ha, ha, why don't you shut up!

THE OTHER VOICE *(Coming from the left corner of the room)*: Quiet, you'll be with us soon.

HIS TRUE VOICE: Sto-o-o-p making so much noise!

THE OTHER VOICE *(Left corner)*: We're waiting for you, our dear little one.

His true voice: How can you torture me so. I can't breathe. My heart is in my mou-ou-outh . . .

The third voice *(Very high falsetto voice, from the right)*: We look forward to your company, that is why you must suffer so much.

The other *(Darkly)*: Torture him, stab him, prick him, in his belly, don't you see his breast tremble. Wasps are emerging, wasps in his foul mouth, gadflies in his eyes, sweat flies and bugs, how sweet, how sugary he is . . .

His true voice: My mother does not want you to kill me. I did not kill him. He was just a ventriloquist's dummy, after all, h-h-h-he had to get a n-n-n-new h-h-head, you know. His old one was totally worn out. The stuffing was coming out of his mouth.

Clara *(Turns quickly and rushes to the bed and cries out)*: Ernst, Ernst, save me.

The other voice *(Darkly)*: Nothing will help anymore. You're going to croak. We've already laid out black mourning suits. The various sections are already fluttering in the wind behind one another. Now we'll reach your heart next, then it's all over, all over. Can you feel it already? The sweet wine is rising. It's fruit wine, it's fruit wine. People are laughing and shouting, a joyful dance in the rain that weeps and cries like small children. And the moon, the good moon is here too.

The falsetto voice: You wanted to live, but now it's no longer allowed. Now we'll tickle you to death, friend. Soon you'll stink us a joyous song. Can't you smell it already? Ugh, how you stink. Your belly is already turning pink and violet. Those are our standard's colors. A sweet sweat is softly making your body sticky and happy spittle bubbles out of your mouth. Oh, come to us, oh, come to us, our dear sweet friend.

Ernesto *(Rises up in his bed and stares into the audience)*: Oh, o-oh, you damned pigs, shut up. Where are you Clara, Clara, I'm vomiting myself to death, they're choking me, I don't want to yet, don't want to, don't want to . . . *(Dies)*.

Clara *(After some time, presses his eyes shut and arranges his body)*: He's dead. It's good this way and makes things easy for me— *(Pauses, whimpers and sobs quietly)* I see the ocean. Many, many thousands of white crests want to rush toward me. *(Louder)* They all of them thunder and hiss and writhe and slither toward me, these white snakes. Oh, how good you smell, my good old sea air, how beautiful you are, whirling infinity, in your lace-covered dress. My

soul has been away from you a long time, much too long . . . —There is the shore, the white island, the gulls screech and it is quiet. The hot sun is silent, far far in the distance the ocean sounds now, the horizon's black stripe is tiny and the small dark steamers move along it into the distant lands, to the other people and to the grand trees with the huge flowers. I hear a sweet song, oh what wonderful birds, silken wings hover above me, diamond and ruby-colored and great rainbows shine around their heads. The great white chalice-shaped flower kisses my head. Oh, the scent of it, the heavy yearning of my heart. Where was I, where am I still? There is the ocean again. Icy gray now and cold and evil. An ice-cold wind blows around me, my heart, my poor heart is so cold. *(Looks around her. Awake now)* Oh, that's right, I'm here, I almost forgot. I'm still here, still here. Ernst, my friend, did you leave me something to drink? *(Goes to the night stand and looks at the bottles there)* There it is. What did the doctor say? "Fifteen drops suffice" *(Drinks and slowly collapses onto the bed of the dead man.)*

(The other side. Zwerch enters and turns on the light, behind him is Elly in nightgown.)

ELLY: Do you have to go already, it's not even midnight. Rennè won't be back before 2:00. Besides, Anna is watching for him. Aren't you even a little bit happy?

ZWERCH: Yes, I love you and you are horribly beautiful in your sweet nakedness *(Pulls her to him and kisses her)*. But you must belong totally to me. I don't want another man to see you like this. Tomorrow, maybe even today still, I'll tell my wife everything and then you'll come with me. We'll leave for a while until everything has been worked out. Will you come?

ELLY: My dearest darling, sweetest, we'll be able to talk about all that more calmly tomorrow. Oh, you were so wonderful, my old Hercules. Tomorrow, OK? Don't bother me with it tonight, when all I'm thinking about is you *(Kisses him)*.

ZWERCH: Well then, tomorrow *(Kiss)*. Now I have to run, Clara will be waiting. But I want to repeat one more time: you *have to* belong to me. *(Again a passionate embrace. Zwerch leaves.)*

ELLY *(Alone; arranges her hair before the mirror)*: The poor boy, he'll have to wait a long time *(Whistles happily, then throws herself onto the sofa and dreams with her arms thrown over her head)*.

(Meantime, knocking on the door of the left side. When no one opens, Zwerch pulls the door open violently. Semidarkness with night-light.)

ZWERCH *(Calls out)*: Clara, Ernesto! *(Silence. Continues to call out)* Clara *(Louder)* Clara, my God . . . *(Advances toward the bed).* Oh, she must have fallen asleep. *(Touches Ernesto)* Ugh, he's cold already. *(Walks back and turns on the light)* Well, it's for the best. I only wonder how Clara can sleep so soundly. *(Suddenly sees his note on the table)* What, what is this? *(Picks it up)* My handwriting?! "This evening after the celebration I'll come . . ." My God! *(Runs toward the bed and calls out)* Clara! *(Shakes her, then slowly turns her head toward him)* Clara, beloved *(Sees the empty medicine bottle).* So, hm, so this is the end *(Stands stiffly and immobile for a time while staring at the audience, then walks toward the telephone).* 8816, please. Dr. Kalla? Yes, Zwerch here. Please come as quickly as possible up here. I think my wife has poisoned herself. *(Then slowly he goes to Clara again, kneels next to the bed and cries.)*

(On the other side, Elly softly sings a foxtrot. Both stages are now brightly lit.)

ZWERCH: Hm, Clara, so you've left me. What will happen to me now, I don't know. My poor sister, my heart is heavy . . . But woe to the bastard that did this to you, I'll break his neck *(Breaks into a laugh).* But that's you yourself, mon ami, . . . no, this isn't what I wanted at all *(Picks up the medicine bottle).* She drank all of it. A tenth of it would have been enough already. Hm, so I'm alone . . . Well, it'll just have to be this way, just have to be this way.

DR. KALLA *(Knocks, examines the two corpses)*: Your wife's been dead half an hour. Digitalis poisoning. Can't do anything for her. Ernesto over there's been dead over an hour *(Comes over to Zwerch).* Get hold of yourself! Whatever got into your wife that she took his death so hard? What, . . . Zwerch *(Shakes him).* You've got to be a man.

ZWERCH *(Stares at him)*: It's all right, fine. I have to go out now. Excuse me, please, Doctor. Inform the police. I'll be right back.

DR. KALLA *(Shakes his head)*: The grief has gone directly to his head. *(Picks up the phone)* Police station, please. Dr. Kalla here, want to report a suicide by poisoning at Hotel Director Zwerch's. Frau Zwerch has been dead half an hour. Yes, certainly, I'll wait for you

here *(Looks at Clara again)*. That's some amusement, killing your-
self. The woman must have been absolutely hysterical. It's a shame,
she was such a stunning woman, after all. What's the meaning of all
this nonsense. Every day people are killing themselves now as if it
were some sort of foxtrot. Oh well, it doesn't matter, nothing's im-
portant except eating and drinking, and maybe a dog too and . . . my
cigar.

*(Lights one for himself slowly and with obvious enjoyment, then
turns off the light and enters the neighboring room, where he turns
on a light again so that now the darkened left stage and the two
corpses are illuminated solely by this harsh light from the neighbor-
ing room.
The other side)*

ELLY: So, now we'll go to sleep. Good night, my sweet Zwerch. I'll
dream about you, love, you big, dumb guy. Once I get my car, we'll
take you along for a ride. It should be fun, sitting next to Rennè and
Ivan, haha, now I've got three men, wonder if I'll like it . . . Oh, how
strong that fellow is. My whole body hurts. *(Laughs sensually while
she touches her shoulders and arms. Knocking at the door)* Now
what, can that be Rennè already? But he's early for once this evening,
must have lost too much at the club, whenever he does, he comes
home earlier. Good thing Fried left so early *(Opens the door)*.
ZWERCH: It's me, Elly.
ELLY: What, wha-at, Fried, you again? Did you start to miss me al-
ready? *(Wants to kiss him. Zwerch stiffly pushes her away.)*
ZWERCH: My wife killed herself a little while ago.
ELLY: Your wife? Jesus and Mary! *(Pause)*
ZWERCH: I loved her, Elly.
ELLY: But that's horrible.
ZWERCH: Do you know why she did it?
ELLY: Did she . . . ?
ZWERCH *(Nods his head)*: The note I sent to you today.
ELLY: You don't say, the note? *(Quickly walks over to her purse and
searches roughly through it, then looks everywhere in the room)* It's
gone . . .
ZWERCH *(Nods)*: You can search forever. I just saw it over there.
ELLY: It must have been Anna. Oh, damn that creature and her Paul.
They're always so nosy, these servants. But just you wait. She must
have stolen it to show off.

ZWERCH *(Nods again)*: And to think my wife wanted to hire her.

ELLY: Oh, now I understand. Are you too sad, Fried dear? Come on, be nice. Look, you didn't really like her anymore. But this guy Paul we'll get him, that rascal, that informer . . .

ZWERCH: Forget it for now, Elly, and listen to me. I am . . . alone now. Clara is dead. I don't know, it feels as if something in me has been torn in two. I thought I didn't love her anymore, and now I feel as if I am slowly bleeding to death *(Looks at Elly with distaste)*. Now you're coming with me!

ELLY: With you? Now? What do you mean?

ZWERCH: Get dressed. Get ready. Right away. You're going to leave this room and are coming with me. Wherever I want to go. Now you're mine.

ELLY: But, Friedrich dear, don't talk such nonsense. You can't be serious. Where can we go at this time? Please, Fried dear, don't be so strange.

ZWERCH: I'm not joking. *(Louder)* I'm not telling you another time, get dressed and come with me.

ELLY: I wouldn't even think about it.

ZWERCH: You don't want to?!

ELLY: No, lover, you're too unpleasant for me.

ZWERCH: Don't want to at all? You won't be my wife?

ELLY: But, loverboy, don't talk such nonsense. I never really wanted to. Do you really think I could leave my dear Rennè? No, dearest, as a lover I rather like you, sweetie, but to leave with you, that's more than you can ask for.

ZWERCH: So you lied to me the whole time.

ELLY *(Yawns)*: Oh well, call it what you want. You're a little nuts, after all, and so I thought some encouragement would help. Besides, my love, you should get out of here now. Rennè could come soon. Oh, I'm so tired *(Yawns again)*.

ZWERCH: So that's what you're actually like.

ELLY: What of it? Don't throw a tantrum. I'm tired. Get out of here, why don't you? I certainly would never marry a waiter *(Stamps her foot)*.

ZWERCH *(Extremely angry)*: Do you realize what you are doing, Elly? Over there my wife lies dead because of you and you stand here and yawn. My wife, my Clara, is dead. Dead because of you. I'm telling you the last time now, you're coming with me. Get dressed. *(Slowly advances toward her. Elly screams loudly.)*

ELLY: Get away from me, you. You've lost your mind. Help. No, I don't want to. I won't . . .

ZWERCH *(Throws himself on her)*: Shut up, you toad. *(Throws her on the sofa and chokes her)* Shut up, you murderer, horrid snake, you, you beast. Give me my Clara back . . .

ELLY: Someone help, help m-e, hel— . . .

ZWERCH: Give my wife back to me, you whore.

(Elly gasps for air, throws her arms back and slowly becomes quiet . . .)

ZWERCH *(Picks her up)*: Ah, that helped, so, now you're quiet. *(Paces back and forth)* Is she truly dead? *(Goes to her and examines her)* God knows, she's dead *(Looks at her)*. Too bad for that beautiful creature. But it's good this way. Have I not offered a beautiful sacrifice up to you, Clara? Are you satisfied now? . . . But now what? What's going to happen to me? *(Paces back and forth again)* . . . Didn't she always have one of those little Brownings with which she did all sorts of foolish stuff. Where can it be now? *(Searches in drawers and on shelves)* Ah, here the thing is. Pretty. Very pretty. Hm. So now we've reached the end. Definitely the right thing. Why should I stay here? *(Knocking at the door)* Oh, the baron. *(Laughs out loud. Goes and opens the door.)* Good evening, Baron. You arrived just in time. I just now killed your wife.

RENNÈ: Have you lost your mind, Director? What are you doing here at this time anyway? Where is . . . *(Sees Elly on the sofa, rushes to her)*. Elly! *(Shakes her)* Elly! Elly! Help, murder!

ZWERCH *(Aims the pistol at him)*: Don't make so much unnecessary noise, Baron, otherwise I'll transfer you to eternity immediately. Be glad that I knocked off that animal there . . . I don't feel well, my friend. I don't know. I think I'll have to go to our little villa outside the city. I have such desire for women this evening. *(Rennè begins to cry for help again. Zwerch aims at him again. Rennè is quiet, stuttering.)* So, my friend, don't be angry. Oh, there are my coat and hat. They must still be here from before *(Puts on his coat)*. So, now you can scream as much as you like, for all I care. So long! *(Leaves.)*

RENNÈ: Help, help . . .

Curtain

ACT 4

Scene 1

An empty road with barren trees, parallel to the stage. Along side of a vast, empty, absolutely flat field. One o'clock in the morning. In the background, right, a brightly illuminated house is painted onto the sky. Zwerch enters wearing his coat and top hat.

ZWERCH: Where am I now? Someplace around here that damned shack has to be.

(Trips and falls. When he gets up again, Zwerch II gets up with him as well, dressed identically. His face made up absolutely white, masklike, with blood-red rings around his eyes and with black gloves. Both of them are now illuminated as if by the headlights of a car.)

ZWERCH II: Oh, pardon me.
ZWERCH I: What's this, what do I want here. You're mistaken, I'm already here.

(Zwerch II raises his top hat, to which his head remains attached. Silent bow.)

ZWERCH: Ah, now I know, my double. Hm. Oh well. Had to come now, didn't he? . . . So, you can go away. I already know.

(Zwerch II puts hat and head on again.)

ZWERCH: I suppose you're trying to ridicule me, most honored sir. A mistake. I know precisely that you're nothing but my imagination . . . Although not very enjoyable. So, go away. Adieu.

(Zwerch II shakes his head.)

ZWERCH: What? . . . You won't? . . . Oh well, I killed her, so a ghost has to appear right away afterward. But she was nothing but a goddamned whore. I'd kill her ten more times, even if there were a hundred dwarfs like you running around. Hey! You! *(Involuntarily he makes a half-questioning gesture, as if about to slit his throat. Zwerch II makes the identical gesture.)*

ZWERCH: Get away from me, fellow. I'll kill you *(Screams madly)*.

(Zwerch II shakes his head.)

ZWERCH *(Somewhat calmer)*: So, you want to go on irritating me.
Oh well, go ahead. But I'm telling you right away that I have to get
to the brothel over there. I have to see living flesh again. Let me pass.
Let me pass, you miserable dwarf.
ZWERCH II *(repeats like an echo)*: . . . miserable dwarf . . .
ZWERCH: Well, at least you gave an answer this time. That's progress
of a sort. Come along to the brothel. It's more pleasant there than
here. Here it's cold. Don't you find as well that staying here is
uncomfortable? . . .
ZWERCH II: You must realize by now that you're a murderer.
ZWERCH: What? A murderer? Me? I'm the well-known Herr Direc-
tor Zwerch, general director of the three largest hotels in Geneva,
my friend. You are absolutely mistaken.
ZWERCH II: I know all that too, dearest brother. But I also know that
now you're a poor swine. You have fallen between the wheels of the
machine. You should have been more careful. Now you're finished.
Soon they'll come and devour you. Then it's all over with you.
ZWERCH: What should I do. Help me, save me. Wasn't I human once
too? What am I now? The streets circle around my head. Horrid ani-
mals stare at me out of the darkness. Something is sneaking around
me with soft, sticky paws. Ugh, I feel a chill running down my
spine . . . The world is empty, horribly empty. Once it was stable.
Clara was there. The hotel was there. My position, the money. I
think, even God . . . Why are you grinning at me with such stupid
compassion? If you would at least be the devil, but as it is you're only
me all over again. Always me all over again . . . There, I'll stomp you
to death, I'll step all over you, you repulsive me *(Beats him to the
ground)*. Ah, that felt good. Now I'm rid of him, this Herr Zwerch.
He really did become quite repulsive for me. I must admit, I never
met a more egotistical and proud patron.
ZWERCH II *(Now lying on the ground)*: You won't get rid of me, my
sweet friend, you can't kill me, I love you much too much for that, so
tenderly! You see, here, let me give you my head. It got chopped off.
Come on, kiss it, this poor dear head. See, how faithfully it gazes at
you, slightly melancholy. But it does love you so much, after all.
With or without a neck. Look, that's the great aorta, look, here at the
neck. A pretty red bracelet. A snake necklace. Do you remember how

Lucy always does it? The one you liked to sleep with so much? Especially when she wore black silk stockings. By the way, the object she also loved so much also does not play a particularly pretty role on a corpse. It's always somehow ridiculous. The flaccid little man.

ZWERCH: Phooey, stop it, I beg of you, stop it.

ZWERCH II: Thank you. Now what do you intend to do, my friend?

ZWERCH: I already told you . . . what did I tell you already, you ugly creep, I didn't tell you anything. It's not any of your business.

ZWERCH II: Did you already forget that you gave your girlfriend a blue neck tonight?

ZWERCH: It's not true, it can't be true, why am I here, why are you here Friedrich, I'm the one who's Zwerch after all. Friedrich Georg Walter Zwerch. What. I'm supposed to have killed somebody, but that's . . . *(Screams loudly)* but that just can't be possible . . . *(Stammering)* no, no, no. I won't, won't, I want to be good again, really. I promise not to do it again. Good Lord, please, dear God, I promise I won't do it again *(Cries helplessly)*.

ZWERCH II: Ah, so that's it, the good Lord, sure, of course, right, we almost forgot all about him. It's a good thing that we found him again at last. What luck. Thank God, that we invented him. Yes, my dear Lord, I've been waiting for you all this time. Besides, you're the one whose fault it all is, you old rascal. Weren't you the one who fabricated us because things got too boring for you? So, please, . . . it's high time now. I can't live with the responsibility any longer. Please take care of my affairs now. I've gone bankrupt. That's pretty much what you want to say, my good Zwerch, if I'm not mistaken.

ZWERCH: You are a truly disgusting creature and the lowest swine that I ever knew.

ZWERCH II: But how can you say that, my good fellow? I only want to speak with the Old Man to your best advantage. After all, you really do need it. He's your last chance. Maybe he'll arrange for a passport out of the country for you. You'll allow me, by the way, to put my head on again. My neck's starting to get cold.

ZWERCH *(Preoccupied)*: By now the baron will probably be there with the police. They turn on the lights. And then they see her. Ugh, how horribly pale she was and how blue her tongue was, her sweet tongue, that poisonous snake. The doctor unbuttons her blouse. And rests his dirty head on her breast, these two breasts that dragged my soul from my body. Her black hair waves in the night air and her white arms drag on the floor . . . Those poor, deprived policemen will stare at those treasures that they otherwise could only lust for at a

distance. Their eyes'll be glued to the buckles on her garters, the ones on her legs, the ones that border between her murderous legs and the soft white silk above them. They'll be panting, they will, because that flesh they'll stare at is still almost alive, after all.

ZWERCH II: Well, well, a pretty portrait of Elly.

ZWERCH: Are you still here, you monster *(Turns toward him)*.

ZWERCH II: At your service. I won't abandon you anymore, my boy. So, what are we going to do now?

ZWERCH: I'm going into the house over there *(Points toward the lighted windows)*.

ZWERCH II: So long, we'll meet again.

(He vanishes behind the trees. Zwerch slowly walks toward the house.)

Curtain

Scene 2

Entrance hall to a larger room with numerous large mirrors. In the background, music and pleasurable cries. Zwerch enters slowly through the door, takes off his coat and sees himself reflected in the mirrors.

ZWERCH: Oh, so you're here already. Hm, but you've multiplied yourself a lot in that short time. Do you intend to go on ridiculing me? Oh, I don't care, just do what you want.

(From another entrance the real double now enters.)

ZWERCH II: You're mistaken, my friend, here is the real me.

ZWERCH: Thank God that you came. I was beginning to miss you already.

ZWERCH II *(Sentimentally)*: Oh, my dear fellow, I had such a hard time separating myself from the night out there. I feel so sorry for you, and outside it's so quiet. The fields are asleep and the trees stand with their long black hair straight up in the air as if they were afraid of me. And that impresses me. Well now, don't we want to go in? Things seem rather exciting in there. And that's something we could use right now.

ZWERCH: Oh, my brother, I feel miserable. I could cry, cry, howl. The world is out of control. My soul is dark and filled with pus. Filled

with all sorts of awful growths. Clara is dead. My dear, faithful, good Clara. I loved her without being able to feel it. That is why I had to kill her, why I had to kill her. I don't regret at all that I killed Elly, not yet anyway, but that I slowly drained the life from my Clara, my own flesh and blood, that I can't accept, my brother . . . *(Weeps)*. Go away, you disgust me with your repulsive mug and your insincere compassion. I know you, you're the first one who betrayed me. And sics the bloodhounds on me. Oh, everything disgusts me. My entire disgusting life filled with greed and pride. I find it disgusting that I could still have an appetite and that I'm supposed to go on eating, regurgitating, and digesting food. I hate the slavery of this existence. I hate the monster that invented it. I laugh at all those who try to find some sense, some ludicrous sense in this shit house. Hahaha, when I just think of justice, of some sort of justice here below or up there . . . If I could imagine some sort of justice, it would be to have the inventor of all this nonsense before me, to be able to grab him by the throat or whatever it is he has, and to throttle him so long until he finally lets out an answer through his ugly mouth. You grinning monster, why did you think of all these martyrs to your invention? Why did you provide me with so little strength that I could not love Clara alone . . . Why do you think up horrible, inventive bacteria and bacilli in order to destroy carefully and slowly the machines you yourself produced? Haha, I know how to get at you, my friend, I know the errors in your machinery. You're in luck; I remember all of them. I'm not your only one. You repulsive pimp and most merciless of all executioners. Do you think I didn't see you as you slowly tortured sweet, innocent women to death with horrible illnesses, how you sent them mocking and thoughtless priests who recited insufficient and noncomforting stuff to them about your goodness and your mercy. Haha, do you think I didn't see them, your rotten jokes, that these eunuchlike slaves call history. Yes, of course, I bowed down too and crept around before you. After all, you inserted into my flesh that sweet poisonous thorn with which you always entice us, you scoundrel, you lecher, the one with which you always force us to go on, to take up the bit of slavery into our mouths over and over again. Women. *(In the background, the music becomes ever louder.)* Do you hear, there they are, your miserable apparatus. Do you want to hear still more?

ZWERCH II: But my dear brother, what horrible speeches you make. I'll admit I thought things like that once in a while too and egged you on with it back there a while ago. But I feel that now you should put

yourself in a more diplomatic posture toward this gentleman. You know very well that no poet appreciates it if you don't praise his poems. I do think that now you should try to get on his better side. Remember, he gave you the chance to be good and selfless too.

ZWERCH: Hahaha, yes, of course, I'm aware of that. It's the same song that the Salvation Army always sings too: Castrate yourselves so that you will inherit the kingdom of God, haha, ridiculous. With the entire power of my heart I wanted to love just one woman that I respected and wasn't able to do it anymore. The woman I loved was a whore and that's why I had to kill them both. Oh, how right the Salvation Army is. *(Sings loudly)* Castrate yourselves, castrate yourselves so that you can inherit the kingdom of God.

(The band, a gypsy band, slowly approaches. Cries of women and laughter of men. First to enter is a large woman, a tall blonde. At the same time, Zwerch II disappears.)

THE BLONDE: Now, now, what's all the shouting about out here? What, Chubs, tipsy already? But that don't matter, come on here to me.

(Zwerch stares at her but says nothing. Meantime other women enter, all of them wearing heavy makeup, powdered, deep décolletage. Ivan Ludmann, Director Cramer, Director Porten, the latter two on the arms of one of the women. Four or five other, unknown men.)

THE BLONDE *(To Ivan)*: Here's a new one. He wasn't here yet before. Seems to be pretty drunk already.

IVAN: Ah, it's Herr Zwerch.

THE BLONDE AND THE OTHERS *(in chorus)*: How are you, Herr Zwerch.

PORTEN AND CRAMER *(shake Zwerch's hand)*: Wonderful, wonderful that you could come still. It's comfortable here. Wonderful women here. Come on in.

THE BLONDE: Chubby there doesn't want to. I suggest we all stay here. And I adore the mirrors so much. *(To Porten)* Right, Chubs, now the fun'll begin. Oh, I really need a drink.

THE OTHER WOMEN *(In unison)*: Yes, we're still thirsty too. Really need a drink.

PORTEN AND CRAMER: So, let's go. Waitress, over here, four more bottles of champagne.

(The band starts to play a foxtrot. The blonde dances with Porten. The others join in. Zwerch looks around desperately, half crazed.)

ZWERCH: Brother, where are you?

IVAN: Who is it you're looking for?

ZWERCH: Myself.

IVAN *(Confidentially)*: Tell me, Director, where were you before you came here? You seem to be in a rather strange mood. You certainly don't seem to feel good. I approve of that, since I don't feel good either.

ZWERCH *(Still preoccupied)*: Who are you?

IVAN: Now, now, Zwerch, let's not joke around. Don't you recognize Ivan Ludmann anymore? Come on now, tell us what happened to you. It must be quite amusing *(Sits down and makes himself comfortable in an armchair)*.

ZWERCH: Of course, of course, now I remember. Ivan Ludmann. Right. The man who once felt sorry for me *(Looks at him silently for some time . . .)*. Tell me, Ludmann, do you too have such wild desire for happiness, desire like a child has for a bun . . . Well, ha. For lard to smear onto your pus-filled brain. My own is constantly bumping against my skull up there. The skin is sore . . . For happiness, you know. I mean something like this: the tallying of the receipts every evening, meetings, real orderly meetings after a good lunch, where some good woman is sitting with you and smiles pleasantly, where there are rising dividends and a report about the general assembly, where you held a speech and it's in the evening paper, and your wife and your mother read it and laugh and are amused. And after the theater you go slowly to bed with your beloved wife and yawn and you're justifiably tired . . . Of course not too tired to . . . and when you fall asleep you think with satisfaction that it's just going to keep on like this, that it's just going to go on and on and on . . . *(Mumbles something unintelligible to himself)*.

IVAN *(Laughs uncomfortably)*: What's bothering you, Zwerch? What've you done now? Speculated? Your beautiful picture is really quite charming, but it doesn't quite suit you. Actually, you seem more like someone who's killed somebody.

ZWERCH *(Suddenly with his attention restored)*: That's a good idea. Hey, you there, the band, stop the music. Attention everybody. Listen to me, listen. *(Shouts)* Listen! *(The band stops playing, everybody stands still and looks at Zwerch.)* Here, my honorable listeners, here you see Friedrich, Georg, Walter Zwerch "the director of the

Continental-Monopoly and Astoria Hotel," a fine man, isn't he?

THE CHORUS *(Shouts out)*: Oh what a fine man! Certainly a fine man! *(Isolated voices)* Just so he pays for the champagne.

ZWERCH: Honored colleagues, Director Porten and Director Cramer, I greet you. Too bad that you didn't bring the big carp from this afternoon along. I miss it, actually. My compliments, Herr Ivan. Hired and charming ladies, noble gentlemen, all of you I greet as well. It's a wonderful evening and the world is marvelous. I am happy to see you all. Because you are the world. The sweet, wonderful world. My heart beats for you. My dear and gentle fellow human beings. Treasured and honorable creations of God, our all-glorious master. I am happy to be able to smell your flesh and to hear the melodious sounds of your voices. What would I be without you, my dear sisters and brothers. I know you love me as well. What else could drive you together to stand before me like a herd of cows and oxen and to stare at me the way you are. Therefore I am going to tell you my secret, my sweetest and heaviest secret. Listen, listen, toot, toot *(Toots through his hands into the air)*. This evening, around midnight, I killed both my women.

PORTEN: He's lost his mind.

CRAMER: Oh well, that's it. Leave him alone to sleep it off.

THE BLONDE: I don't know, I think anything's possible.

IVAN: What women were they, Director?

ZWERCH: My wife, who poisoned herself because of me and Frau Elly, whom I killed because of that *(Bows to the others)*. Yes sir, my friends.

THE BLONDE: Who in the world is this Frau Elly?

IVAN *(Coolly)*: That is the Baroness Manôsch, Elly Manôsch, and besides, what he says is probably true.

PORTEN: What do you mean, Herr Ivan? Do you think he's serious? What? *(He raises his arms and stares at Zwerch.)*

CRAMER: But that's not possible, dear colleague, please tell us you're joking.

THE BLONDE: Did ya really rub 'er out, sweetie? I c'n almost find that in'eresting. What d'ya know!

IVAN: If you actually managed to do that, I could almost be impressed, Zwerch.

ZWERCH: You old fat slob, I despise you *(Turns his back to him and stares into the audience)*.

PORTEN *(Suddenly yells loudly)*: Help, murder, the man has to be arrested. Police. Somebody call the police.

CRAMER: Such a scandal for our profession. Director Zwerch, Director Zwerch. Unheard of. Yes, get the police. They should arrest the man.

(The two of them, along with others who are excitedly calling for the police, get ready to run out of the room. Zwerch turns suddenly and has the pistol in his hand.)

ZWERCH: Stop, stop now, whoever leaves the room is a dead man. So, my friends, now your love for me has come to an end. Now you shout for the police. That's just like you, you're pitiful. Haha, now you despise me. Because I'm a murderer. You yellow dogs. Because you behaved yourself and didn't kill anybody. *(Screams)* Shut up, you bums. Do you think I don't know how often you all have wanted to do it and how often you want to do it every day but don't do it because you're such cowards, you dim-witted fakes?! *(Screams)* Shut up, I tell you. Here I have power and you have to do what I want. Now I want you to dance. *(Aims the pistol at the band)* Play "Salome."

(The band begins to play the melody with suddenly horribly pale faces.)

ZWERCH: Herr Ivan, please, choose one of the ladies and dance with her. Dear colleagues, Porten and Cramer, take one of the fat carps over there. I want to see your excellencies twist and turn in time to the music. *(Several still hesitate.)* Come on, get going, or I'll shoot. Pay attention. This time, I'll shoot in the air, a warning shot. Watch! *(Shoots at the ceiling at a skylight that falls to the ground in a crash of glass)* You see, the thing really is loaded. Now, dance! But la-la, de-dum.

(All begin to dance to the music of "Salome." They turn their heads toward Zwerch in fright.)

ZWERCH *(To the blonde)*: Come here, Blondie, you may dance with me.

THE BLONDE: You're crazy, Director, but I love you *(Leans tenderly on him)*.

ZWERCH *(Slowly begins to dance, watching the others, holding the pistol in his hand. Speaks approximately according to the rhythm of the music)*: I want to dance, dance, dance. Poor, sad humanity, dear brothers, turn to the music, glide with it, hump away at each other, the dumpling of our globe does no better, never stop turning, turning, turning . . . Dance and sing the melody, noses will get pointier and white teeth will glisten, eyes glaze over and stare toward the ceiling. Up there, yes up there, that's where the great man sits. He smiles gently and kindly when we go to stink now and probably will enjoy it when we're resurrected . . . *(Calls out passionately)* Will you dance, you swine! *(Raises the pistol threateningly. Continues singing to the music)* Oh, . . . oh, . . . oh . . . if you can, you fat Moloch, come down and dance with me, we'll follow your lead gladly, after all you've got the stars on your nose, in your eyes, and up your ass.

THE BLONDE: You're divine, Zwerch, wherever did you learn these curses?

ZWERCH: Shut up. *(Suddenly stops dancing. All others do as well and scream.)* Jehovah, Moloch, or God, whatever your name is, appear to me *(Falls to his knees).*[9] Lord, Lord, my God. Come down from above. Come to me and deliver me from evil, heavenly God and Father, have mercy on me. I can't go on.

PORTEN *(Whispers to Cramer)*: Aha, he's wearing down finally.

(Zwerch suddenly stares at the dark hallway from which slowly Zwerch II approaches again.)

ALL: What's he staring at? What is it?

ZWERCH II *(Invisible to all but Zwerch, comes slowly to him and slaps him on the shoulder)*: The game's over now, my friend. They're on their way. *(Slaps Zwerch on the shoulder again and leaves slowly. Zwerch laughs loudly, bitterly.)*

ZWERCH: So, of course, I understand . . . The dear Lord excuses himself and sends the police instead.

(Outside, loud knocking at the door and the command: "Open up in the name of the law." Someone goes out and opens the door.)

RENNÈ *(Storms in, accompanied by the police)*: There he is!

ALL *(Shout out)*: There he is, but be careful, he's got a pistol.

ZWERCH *(Lifts the pistol to his head as if he were going to shoot*

himself, thinks a moment, then lowers his arm and throws the pistol away, stands tall and straight): No, not yet, maybe this is just the beginning of life now.

POLICEMAN: In the name of the law, Zwerch, you're under arrest.

Curtain

20

LETTER FOR THE PIPER *ALMANACH*

(WRITTEN MARCH 1923; PUBLISHED NOVEMBER 1923)

BECKMANN first met Reinhard Piper when the latter admired Beckmann's *Battle of the Amazons* in the Berlin Secession exhibition of 1912. In 1911 Piper published the *Answer to the "Protest of German Artists"* to which Beckmann contributed; in the following year he published some of the key documents of the new art that Beckmann had decried, including Kandinsky's *Über das Geistige in der Kunst* (Concerning the spiritual in art) and the *Blauer Reiter Almanac.* Piper's own artistic tastes were rather conservative, however, and he clearly felt more comfortable with works by Beckmann and Alfred Kubin than with works by Marc and Kandinsky.

When Beckmann and Piper first met, Piper was publishing the monumental new German translation of Dostoevsky, edited by the political and cultural writer Arthur Moeller van den Bruck. After seeing the lithographic illustrations Beckmann had already published for *The House of the Dead*,[1] Piper asked Beckmann to illustrate some more episodes of Dostoevsky. Though Beckmann subsequently produced one illustration to *The Idiot*,[2] Piper's proposal did not lead to any further publications.

During World War I the two resumed their correspondence. The record of their subsequent exchange is one of the richest sources of documentation of Beckmann in these years.[3] They were kindred spirits and regularly enjoyed discussing both literature and art. Piper routinely sent Beckmann copies of his publications; Beckmann frequently commented upon them and spoke more familiarly and freely with Piper than he did with many of his correspondents. The two were especially fond of Jean Paul and Christian Dietrich Grabbe (1801–36) and were fascinated with Buddha and Eastern religions and philosophy.[4]

Though Piper had limited means for collecting in the postwar period, he did his best to assemble collections of Beckmann's

graphics and drawings. He regularly sent Beckmann art supplies and for a while managed the printing and distribution of several of his prints. As his business flourished in 1922–23, Piper also purchased two Beckmann paintings.[5]

As he himself wrote to Beckmann, Piper felt the greatest service he could do for Beckmann was to publish a book on him,[6] and in 1921 Piper started planning the monumental Beckmann monograph by Glaser, Meier-Graefe, Hausenstein, and Fraenger that would be published at the end of 1923. The four authors seem to have submitted their articles to Piper by the winter of 1923. Beckmann had probably read all of them shortly before he wrote the following letter to Piper.

Like most publishers, Piper routinely published occasional volumes celebrating his company's anniversaries. Beckmann was asked to write this letter for one of the annual Piper almanacs, on this occasion, to mark the firm's twentieth anniversary.[7] In the foreword to the volume Piper spoke not only of the anniversary but also of how the war had made him determine to direct his readers' attention toward their specifically German spiritual and cultural heritage.[8] In the postwar period Piper published several conservative nationalistic tracts.

Beckmann wrote the following letter, then, after Piper had done a great deal for him and was about to bring his lavish Beckmann monograph into print. Appropriately for this tribute to his friend, Beckmann adopted the familiar, jocular tone he regularly took in their correspondence and willingly shared this informality with a larger public as he told something of his past and his whims. His ironic tone, as well as his attention to many mundane and humorous things, is thoroughly typical of this period.

Dear Editorial Board,

You have asked that I present you with a written self-portrait.

My God, I feel downright faint, what should I say? And above all else, what should I not say? I find that much more significant than what I should say.

So the result will be music that consists of nothing but pauses.

That I was born on February 12, 1884, near the Schwansee in Leipzig is something I cannot suppress.[9] However, I do not consider this birthplace to be my essential one, since both my anonymous parents came from Braunschweig (well known especially for its sau-

sage and canned foods), since my siblings were born there, and since we also returned there shortly after my birth.[10]

At any rate there are certain dark alleys and a few odors of fur goods from the Brühl that remain in my memory.[11]

In general I find it embarrassing to be reminded of one's birth. It's somehow too naturalistic for me, besides which it also always conjures up something like an encyclopedia and other such things. And here we are just beginning.

So, right now I live in Frankfurt am Main, at Schweizer Straße 3, in my studio, and am annoyed because I am not out taking a walk since it is spring outside.[12]

Besides, I have to get myself shaved because this evening I am invited to the home of my friend [Heinrich] Simon, who has just returned refreshed from Weidner's sanatorium.[13] And yet here I sit writing my autobiography. I have made the observation, by the way, that a personality's effect is significantly and unfavorably influenced by an unshaven chin. One is oneself embarrassed and so are others, too.

It was much nicer when, before having to shave myself or getting a shave, I waited in ambush at night with a huge butterfly net in order finally to catch the longed-for death's-head moth; to attract it, I carefully attached apple slices dipped in beer to a tree. With this passion I passed the time that I should have spent sleeping or working while I stayed eight years with my sister in Pomerania.[14] Sadly, I never caught it, which continues to bother me even today, although I searched many an afternoon in the potato fields for its majestic caterpillar.

In Braunschweig I especially attracted attention to myself at school by constructing a small picture factory during the lesson, and my products went from hand to hand and gave many a poor fellow slave a few minutes' escape from his sad fate.

At this time I also had my "grand passion." Yes, I was very much in love with my cousin, who was eighteen years old, and seriously proposed to her. She should wait until I was ready. Oh well. In the second grade you still have the world ahead of you.

But my talents were not appreciated.

In terms of colors, I like vermilion and violet a lot and also tobacco brown. Probably because I appreciate cigars so. Is there anything more beautiful than a good cigar?

Perhaps a woman? Only it's not possible to put her down again as easily. Nonetheless. I also like women. I got married too, in the

year 1906. To Minna Tube, opera singer at the municipal theater in Graz.[15] In 1908 Peter Beckmann was born. A youth filled with hope. From time to time I take random samples of his development since it interests me very much.

Around 1912 I got to know the publisher Reinhard Piper, somewhat later I. B. Neumann as well, both of them men of experience who later would contribute a bit to the problematic continuation of my life.

My first debut took place in 1906 at the Berlin Secession.[16] Now it's called the Free or Liberated Secession.[17] I also came into contact with the art trade for the first time then as well. But I was successful in throwing off the fetters that suppressed my dainty genius. Besides, money is a truly embarrassing business.

I also write dramas and comedies and there are good people who also want to perform them.

And I would like to play music!

Since I don't know a single note, however, I first would have to study for five years.

That's a bit much. Or maybe not?

Oh, it would be so nice!

But there's still time for sculpture!![18]

I love jazz so much. Especially because of the cowbells and the automobile horns. At least that's decent music. It could really be turned into something!

In addition, for an entire year I made drawings "after the Antique." With Professor Frithjof Smith,[19] once I arrived in Weimar in the year 1900 following intense family disputes. At the art school. Yes, that's something I'm very proud of. You can always tell: there's a foundation, there's a solid foundation.

As a determined German youth I went to Paris in 1903. Rented myself a studio in the rue Notre Dame des Champs and painted huge pictures, twice as big as those with which I later aroused admiration and disdain among my respected peers. That was a good beginning.

But the spring of 1904 caused me problems there. I left the giant painting unfinished,[20] had my shoes resoled, and set out for the south of France on foot. By the time I got to Geneva, I'd had enough of the wonders of nature and took the express train to Berlin, and stayed there, with only a few breaks, until 1914.

That was my real academy period. I learned what could be learned. Art, love, and politics occupied me sufficiently. I was, I

think, somewhat more ambitious than I was at school in Braun-schweig. Finally, I was earnestly engaged in learning the tango when intense shouts of "hurrah" and various patriotic songs made me realize that I was about to experience a role change in my life.

When I came to my senses again, I found myself occupied with making a fire in a recalcitrant stove in an Augustinian monastery in Belgium, and noticed that I was wearing the uniform of a medical orderly.[21] As I'm sure you agree, it was certainly a significant role change. I always had to pour a lot of petroleum onto the wet wood before it would burn. Despite this, the entire examination room re-mained filled with a horribly stinking smoke for almost two more hours, which caused my dear chief medical officer, Dr. Spinola, to frown severely.[22] Patients with eye problems didn't appreciate it very much either. But, after all, it's not possible to do everything well right away. Despite this, it was almost comfortable there, espe-cially in comparison to the typhus hospital where I was earlier. Now, that was a bad fever.

And yet I also found decent people there. One of them was al-most in his death throes and read a short story by Poe all the time. He found that it relaxed him.[23]

Now would be a not inappropriate time to provide some war-time sketches. But I have occupied myself with this material with sufficient generosity to no longer have the time to lose words over it. I have been concerned with other kinds of wars for a long time already.

By chance I landed in Frankfurt am Main. Here I found a stream that I liked, a few friends, and a studio as well.

Now I decided to become self-sufficient.[24] At first the business was quite small. Slowly it expanded. What will become of it now?— We live from one day to another.

Sincerely,
Your Beckmann

21

AUTOBIOGRAPHY

(WRITTEN MAY 19, 1924)

THIS TEXT was written for a volume published in commemoration of the twentieth anniversary of the Piper publishing company and, like the preceding text, is personal, informal, and jocular. The autobiography was written just a few months after the appearance of Piper's Beckmann monograph and Beckmann's January 1924 retrospective at Paul Cassirer's.

After their period of intense collaboration Piper and Beckmann corresponded less frequently, but their relationship never seemed to dim.[1] Piper's business had flourished in the last years of the inflation but took a turn for the worse after the stabilization of the economy. In 1926 he even had to part with much of his Beckmann collection and ceased marketing Beckmann graphics.[2]

Beckmann's cryptic comment about the earth's being surrounded by a "massive shell of frozen nitrogen" reflects his eclectic reading in a variety of accounts that dealt with cosmology and the beginnings of culture. In this case he seems to refer to the popular but largely discredited "world ice theory" of Hanns Hörbiger (1860–1931) and Philipp Fauth (1867–1941), which held that the universe was made chiefly of ice.[3] His tone, on the other hand, suggests some skepticism toward that theory.

1. Beckmann is not a very nice man.
2. Beckmann had the bad luck not to have been endowed by nature with a moneymaking talent, but rather with a talent for painting.
3. Beckmann is hardworking.
4. Beckmann went through his basic training as a proper middle-class European in Weimar, Florence, Paris, and Berlin.

5. Beckmann loves Bach, Pelikan, Piper, and two or three other Germans.[4]

6. Beckmann is a Berliner and lives in Frankfurt am Main.[5]

7. Beckmann got married in Graz.[6]

8. Beckmann is wild about Mozart.

9. Beckmann suffers from an unshakable weakness for that faulty invention "life." The new theory that the earth's atmosphere is surrounded by a massive shell of frozen nitrogen gives him cause for concern.

10. Nevertheless, Beckmann has recently discovered the beneficent effects of southern exposure.[7] Even the theory of meteors puts his heart at rest.[8]

11. Beckmann still sleeps very well.

22

"THE SOCIAL STANCE OF THE ARTIST BY THE BLACK TIGHTROPE WALKER"

(JANUARY 1, 1927)

PETER Beckmann first published this essay in 1984 after he found it in an envelope with "The Artist in the State." Both were written in 1927 and typed on the same typewriter. Beckmann's correspondence suggests that he wrote this essay first and sent it to Prince Karl Anton von Rohan (1898– 1972) on January 1, 1927. Rohan had asked Beckmann to write on the social position of the artist, presumably as a contribution for Rohan's journal, *Europäische Revue*. In the letter sent with this statement Beckmann wrote that he had tried to consider Rohan's question "seriously and positively" but had arrived only at this bitter and ironic conclusion.[1] Rohan did not print this statement. As Beckmann undoubtedly would have known, its tone would have been totally inappropriate in Rohan's journal. Perhaps he hoped that this—a short piece that contained some of the biting irony of this plays—would nonetheless be published. He wrote the more formal reply Rohan wanted in "The Artist in the State."

In 1924 and 1925 Beckmann's life changed greatly. His personal, social, and economic situation improved dramatically with the stabilization of the German economy. He was appointed to a teaching job in the new Frankfurt art school—an institution that joined the former arts and crafts and Städel Institute schools on the model of the Bauhaus, and he came into more frequent contact with members of German and Austrian high society.[2] He gained entry into that society with introductions through Frankfurt friends such as Irma Simon, who had been born into an aristocratic Viennese Jewish family as the Baroness Schey von Koromea, and Lilly von Schnitzler, a Rhenish Catholic aristocrat who had married the aristocrat Georg von Schnitzler (1884– 1962), a top executive at the I. G. Farbenindustrie AG in Frankfurt. At the end of 1924 Beckmann also met Mathilde von

Kaulbach (1904–86), one of four daughters of the distinguished Munich artist Friedrich August von Kaulbach (1850–1920) and Frida Schytte von Kaulbach (d. 1948). Beckmann promptly nick-named this twenty-year-younger woman Quappi, became en-gaged to her, and married her in September 1925.

Beckmann first mentioned meeting Rohan at a June 1925 party at the Frankfurt home of Lilly von Schnitzler.[3] The follow-ing day he wrote Mathilde von Kaulbach that Rohan had been extremely impressed by him; in fact, Rohan told Schnitzler that he found Beckmann one of the most extraordinary people he had met in years. This could be "quite useful," Beckmann concluded, "because this man gets around quite a bit."[4]

An Austrian aristocrat from Vienna, Rohan founded the *Europäische Revue*, a respected organ for discussions of Euro-pean questions, in 1925.[5] Three years earlier, in 1922, Rohan had founded his own Austrian cultural league, the Kulturbund, one of many postwar groups formed to consider issues of Euro-pean cultural, economic, and social unity. Rohan was strongly conservative; he was a great admirer of Benito Mussolini and would eventually become a National Socialist.[6] Although his own right-wing position was clear, Rohan presented a variety of views in his journal and was able to win contributions from such well-known liberals and liberal conservatives as Beckmann, Ka-simir Edschmid, André Gide, Hermann Hesse, Hugo von Hof-mannsthal, Annette Kolb, Carl Jung, Thomas Mann, Henry van de Velde, Alfred Weber (1868–1958), and Richard Wilhelm (1873–1930).[7]

Beckmann traveled to Vienna to attend the third annual meeting of Rohan's international group, the Verband für kul-turelle Zusammenarbeit (League for cultural cooperation) from October 18 to 20, 1926. Rohan had organized this group as an outgrowth of his Austrian Kulturbund in 1924.[8] Rohan's inter-national league had first met in Paris; in the fall of 1925 it met in Milan to recognize the achievements of fascist Italy. This group's 1926 meeting in Vienna attracted several distinguished artists, intellectuals, and politicians, including Beckmann, Rudolf Binding (1867–1938), Kolb, Hofmannsthal, and Alfred Weber.[9] Most likely at the suggestion of Lilly von Schnitzler, who be-came a warm champion of Rohan's European causes, Beckmann joined Binding, Kolb, and Weber as an elected member of the German delegation to this meeting.

Beckmann wrote his new wife of attending receptions, lunching with the German ambassador, and meeting Kolb and others, but in his letters said little more of the conference than that it was interesting but also a bit of a farce ("Affentheater").[10] In a letter to his new Munich dealer Günther Franke (1900–1976), Beckmann also noted that Rohan and his "clique" "might be useful to us."[11]

It seems possible that Rohan asked Beckmann to write an essay for him already in Vienna and that Beckmann's experiences on that occasion might have partly inspired this ironic reply. Neither in this nor in "The Artist in the State" did Beckmann show any specific concern with the questions of European unity that interested Rohan. In the second essay, on the other hand, Beckmann did respond to several of the ideas put forth at the conference and in subsequent articles in *Europäische Revue*. Following his initial supposition, Beckmann seems to have courted Rohan because he thought the latter could be useful to him. Beckmann was intrigued by the workings of high society, welcomed its benefits and support, and thought that it would prove indispensable to his success.

From the postwar period on Beckmann repeatedly represented himself and his friends in costumes of the circus and other popular entertainments and on many occasions depicted himself in the costume or role of an acrobat or tightrope walker. Since youth he had been familiar with the passage of the tightrope walker in Nietzsche's *Also sprach Zarathustra*, a book to which he often returned, and he seems deliberately to have recalled Nietzsche by casting himself as the tightrope walker in the title of this essay.[12] In the Nietzsche passage, Zarathustra celebrated the actors, tightrope walkers, and supermen who took dares and distinguished themselves from the meek herd. After the tightrope walker died from a fall, Zarathustra recognized how much work it would take to make his message understood by common men.[13]

Beckmann's sardonic essay, especially his complaints about the artist's need for self-promotion, reflects his continued frustration not only at what he saw as the artist's lack of status in society but also at how much he had to be his own best supporter and promoter. Beckmann's comments on critics and the artist's "bothersome personality" also reflect his own position. He was strongly respected and admired by some and strongly criticized

by others, often, he felt, for reasons that had little to do with his art. The irony, humor, and complaints of this essay are fully characteristic of the author of *Ebbi* and *The Hotel*. This was a side and a pose that Beckmann plainly wanted to make known to a wider public.

 1. The talent for self-promotion is a prerequisite for those inclined to pursue the artistic calling.

 2. The budding genius must learn above all else to respect money and power.

 3. A reverence for critical authority must dominate his life. He must strictly adhere to his subservient standing, and never forget that art is merely an object the purpose of which is to facilitate the critic's realization of his critical potential.[14]

 4. The riskiest thing an artist can have is too strong a backbone. Woe betide that miserable creatively inclined creature not able to subdue his obdurate spinal column in the course of daily bowing and scraping.

 5. Let him therefore take cognizance of the fact that he is a subservient member of society, nothing more in essence than a slightly better employee. His demands can, of course, be taken under consideration only when society's more essential needs for a family car and a vacation trip to the Pyramids have been satisfied.

 6. The artist may take quiet pleasure in his craft. Let him not, however, forget that fashion changes every five years. He would therefore do well not to indulge in all that much "quiet pleasure," and stay well informed of every new set of marching orders.

 7. Aside from the talent for self-promotion, the most important asset an artist can have is a girlfriend or a beautiful wife. Her utility can be imagined in a variety of ways. Who other than the artist's beloved could better soothe the transaction-riddled, multinational-takeover-scheme-saturated, cosmic thunder-stricken brain of the champagne manufacturer or leather dealer?[15] With her gentle hand she can stroke the mighty one's chaotic brow and, resting him against her soft body, induct him into the mysteries of dreaming and art.

 8. The artist can know nothing of religion, politics, and life. He must not forget that sylphlike presence that he is, his only purpose consisting in sprinkling the world with brightly colored pollen. He must serve the amusement and the delight of the mighty. The

"merry little artist folk" had best keep in mind their humble limitations. It is therefore advised that, should the unfortunate artist have been endowed by nature with a little sense and a modicum of critical faculty, he keep these qualities to himself. Only insofar as he maintains an aura of artlessness can the artist expect to be recognized by the public.

9. The best thing an artist can do, of course, is to die. Only when the last living vestige of this bothersome personality has disintegrated in his grave can his fellow men take pleasure in his work. Only then does the artist's work truly belong to his contemporaries, for if they buy it at the right time it is as good as if they had made it. The artist is therefore strongly advised to die at the right time. Only thereby can he put the finishing touches on his work.

10. The artist who follows these fundamental precepts will have a good life. His fellow men will gladly accord this well-respected and untroublesome element in the fabric of the state all the love and recognition he deserves.

23

"THE ARTIST IN THE STATE"

(JULY 1927)

PRINCE KARL Anton von Rohan published Beckmann's "Artist in the State" in the July issue of *Europäische Revue*, which contained contributions from several other distinguished contemporaries.[1] This essay has long been seen as a counterpart to Beckmann's celebrated *Self-Portrait in Tuxedo* (1927) and like the portrait seems to have been at least partly inspired by his participation in Rohan's meeting of the Verband für kulturelle Zusammenarbeit in Vienna the preceding October. Like "The Social Stance of the Artist" this essay makes no specific reference to issues of European unity, but it does address broader issues raised by Rohan, the conference, and articles in Rohan's *Europäische Revue* about the position of the individual, intellectual, and artist in effecting change.

Although Rohan and most of his followers were right wing, many different positions were presented at the conference.[2] Hugo von Hofmannsthal, the celebrated Austrian-German author and spokesman who increasingly represented a conservative cultural view, served as the conference president; the liberal sociologist Alfred Weber and the French poet Paul Valéry (1871–1945) joined Hofmannsthal and Rohan as key speakers.[3] All noted the importance of the league as a free spiritual movement that could accomplish things unattended by the more practical concerns of other groups and politicians.

Many presented themselves as deliberately and proudly unpolitical or apolitical and interested chiefly in questions of the intellect and spirit. Most considered the role of the spiritual elite or "aristocrats of the spirit" in guiding the creation of a new Europe. Observing the "great turn" that had come with the war, the liquidation of the old Europe, and the new thinking about the world and natural history, they commonly saw the need for new ideas, politics, and metaphysics. Referring to Os-

wald Spengler's (1880–1936) *Der Untergang des Abendlandes* (Decline of the West, 1918–22), several Germans said that they felt they had now moved beyond Spengler's pessimism and the gloom of the war and immediate postwar period to see a new future. Moreover, since politicians had just ushered Germany into the League of Nations, the spiritual workers felt free to redirect the European spirit. Several continued to cite Nietzsche, saying that the new man of the new age would be informed by Nietzschean idealism. The liberal Albert Weber, on the other hand, voiced the hope that the new man would not be a "blond beast."[4]

Subsequent to the meeting, Rohan stressed the importance of the work of the *Europäische Revue* and announced a series titled "Der Europäer" (The European). Authors would deal with such fundamental European institutions, types, and concepts as priests, heroism, duty, knowledge, charity, artists, and researchers.[5] Beckmann's "Artist in the State" was included in that series.

During the Weimar Republic many artists and intellectuals considered the artist's position within the state, especially as they won unprecedented recognition and status. In his essay Beckmann dealt with an issue central to the conference and the league, namely, how spiritual workers might contribute to the formation of a new culture. His essay is both abstract and metaphysical, so much so, in fact, that Rohan added a disclaimer, saying that though he was proud to publish Beckmann's ideas he could not accept "certain extreme metaphysical conclusions."[6]

Beckmann wrote in a more formal, metaphysical, and grand manner, in keeping with the tone of the conference and the journal. He developed many of the ideas he had first presented in his "Creative Credo" of 1918; indeed, one could even say that he had moved from the Sturm und Drang of the "Creative Credo" to a more balanced, statesmanlike view. In this and in many of his statements about the workings of the artist in the state, he seemed not unconsciously to recall those pillars of Weimar's first golden age—Goethe and Schiller—who were in fact often presented as the liberal predecessors of the new Weimar.[7] In his ideas of artistic transcendence, he again repeatedly recalled Schopenhauer. Throughout the essay Beckmann reminded his readers that he continued to see the age as threatened.

As in the "Creative Credo" Beckmann again cited Bolshe-

vism as a possible model. Probably knowing little about con-
temporary Bolshevism or Soviet art, Beckmann argued that
Bolshevism lacked a new center, art, and dogmatic centraliza-
tion of faith. As he spoke of the need for a new cultural center,
new discipline, and new priests to implement a transcendent
idea, however, he also seemed to respond to another article that
had appeared in Rohan's series "Der Europäer," an article on
the priest in Europe by the renowned Sinologist Richard Wil-
helm, a Frankfurt scholar to whom Beckmann had also recently
been introduced.[8]

Wilhelm's article traced both the history and the function-
ing of the priest in Western cultures and considered what new
forms the modern priest might take. He variously considered a
doctor, a psychotherapist, or a new order of monks, persons who
would be fully aware of life, yet separated from life and part of
an esoteric circle. Such priests could thus stand back to illumi-
nate life for those who needed help.

Just as Wilhelm had argued that the new priests would have
to allow moderns their autonomy, Beckmann also celebrated
autonomy and self-reliance. The "first revolutionaries" or Pro-
metheans had struggled against God, just as had Zwerch in Beck-
mann's *Hotel* or Beckmann himself in his "Creative Credo." In
his 1927 statement, however, Beckmann did not want to reject,
kill, or throttle God: he saw the business of new world, artists,
art, and education as teaching humans that they and their work
are themselves God.[9] In this he directly echoes Gnostic, Hindu,
and theosophical beliefs that the deity or God is to be found in
humans themselves. He might have been introduced to theoso-
phy through his new wife—an ardent follower of theosophy—
or through his own wide-ranging reading.[10]

When Beckmann said he thought Rohan might be useful to
him in 1925 and 1926, he might have already contemplated pub-
lishing an essay in Rohan's journal. The two seem to have had
little to do with one another in subsequent years until March
1931, when Rohan joined Lilly von Schnitzler and a new inter-
national cultural league in supporting Beckmann's exhibition at
the Galerie de la Renaissance in Paris. Rohan, the exhibition,
and its opening reception at the German embassy in Paris—an
event that involved the German ambassador, Leopold von
Hoesch (1881–1936); the veteran French government minister
Anatole de Monzie (1876–1947); and the art critic Waldemar

George (1893–1970)—would be recalled in Beckmann's *Paris Society* (1925, 1931, and 1947, G. 346).[11]

EDITOR'S NOTE: We are proud to publish the great artist's moving confession, although we do not want in any way to associate ourselves with certain extreme metaphysical conclusions detached from their deeply human meaning.[12]

The artist in the contemporary sense is the conscious shaper of the transcendent idea. He is at one and the same time the shaper and the vessel. His activity is of vital significance to the state, since it is he who establishes the boundaries of a new culture. Without a universal new transcendent idea the very notion of a new state is incomplete. The concept of a state must first be derived from this transcendent idea, and the contemporary artist is the true creator of a world that did not exist before he gave shape to it. Self-reliance is the new idea that the artist, and with him, humanity, must grasp and shape. Autonomy in the face of eternity. The goal must be the resolution of the mystic riddle of balance, the final deification of man.

Should this goal be achieved in a work of art, then the work itself becomes a symbol and an energy-engendering medium for the development of the partially still-slumbering forces in the responsible man. Appraisal of the finished product is an aesthetic question to be measured according to the highest degree of the collective vitality of the engendered balance. In this sense, artist and statesman are both components of the overall process, since like the artist, the statesman seeks the realization of the transcendent idea in the concrete expressive product of the effected balance, that is, in the organization of the state.

Law on the one hand and the complete achievement of balance on the other are the essence of humanity's goal. Should this goal ever be achieved, the cosmic game in which we are now engaged will come to an end and a new one will begin, in the face of which deified humanity will once again disguise its true role.

Humanity's first revolutionaries perceived their primary purpose as a struggle against God. They adopted more or less the role of Prometheans or other delinquent angels. We fought against God, we swore at him, we hated him, or we ridiculed him—depending on our inclination or talent. Let us realize at last that we were always fighting only against ourselves. We no longer have anything

to expect from without, only still from within. For we are God—by
Jove, perhaps an altogether inadequate and pathetic God, but God all
the same.

The collective intellectual products of humanity constitute God.
This is and always has been the case. God is the collective conscious-
ness of the world conceived in eternal evolution—or as I would
rather put it, in its eternal unraveling. Its thermometer, the gauge of
its achieved balance or its accomplishment, is embodied in art, and
thereafter in all the other products of the human brain.

What we have here is a picture of ourselves. Art is the mirror of
God embodied by man. The fact cannot be denied that this mirror
has in the past been greater and more rousing than it is today. Yet
we know that even childhood in its innocent fashion sometimes en-
genders things that are often more beautiful than all the works of
grown-ups. I view the period of humanity in which we live today as
the transitional age from humanity's youth to its manhood. We are
just beginning to be grown-up, and in the process permit some
beautiful dreams of our youth to fall by the wayside. But no one can
deny the fact that even the adult has it in his power to apply his
consciousness to the creation of things that may yet surpass the
shimmer of the muffled magnificence of our childhood achieve-
ments (in India, China, Egypt, and Europe's Middle Ages). We have
arrived at this transitional juncture. The old gods lie in smithereens
at our feet, and the old churches in their twilight perpetuate a dark,
unreal, deceptive sham existence.

Chastened and devoid of all faith, matured into its adulthood,
humanity stares into the empty void, not yet aware of its strength.

What we're missing is a new cultural center, a new center of
faith. We need new buildings where we can practice this new faith
and this new cult of man's balance, buildings in which to collect and
present all that has become whole as a consequence of our newly
acquired balance. What we are after is an elegant mastery of the
metaphysical, so as to live a stalwart, clear, disciplined romanticism
of our own profoundly unreal existence. The new priests of this
new cultural center must be dressed in dark suits or on state occa-
sions appear in tuxedo, unless we succeed in developing a more pre-
cise and elegant piece of manly attire. Workers, moreover, should
likewise appear in tuxedo or tails. Which is to say: We seek a kind of
aristocratic Bolshevism. A social equalization, the fundamental
principle of which, however, is not the satisfaction of pure mater-
ialism, but rather the conscious and organized drive to become God

ourselves. The external sign of success in this state system would no longer or only secondarily consist in money; the collective approbation would go to the individual who had achieved the greatest sum of balance and who would merit the greatest degree of power and influence. Power and influence are to be assigned on the basis of self-reliance. I am well aware that all this is a utopian vision. But someone has to make the first step, if only in the realm of ideas.

If we are not willing to adopt the faith that one day in the course of human development we ourselves will become God, that we will be free, that we will finally and clearly recognize or see through that incomprehensible, weak, and impossible charade that we still call life, see it in all its hidden expediency—then the entire flux of humanity will from the very beginning have been nothing but a foolish farce. To focus this transcendent wish, we must join together. To strengthen this faith and transform it into reality, we must create the new art form, the new state form. This shared hope, this common faith will be the new core of what in olden times was filled by the longing for redemption through God's intercession. What we want today is to believe in ourselves. To be God, each one of us must share responsibility for the development of the whole. We can no longer depend on anything other than ourselves.

Children must already learn in school that they themselves are God. The purpose of such instruction is to free every creature from its metaphysical dependence and to make it reliant upon itself. Only in this way can the essential and new strengths of humanity be unleashed, the strengths that will bring the eternally fluctuating generations of man, which we embody, to a final standstill, allowing for a free state of being.

If the practically impossible were possible again, if we could build a new center of faith, then surely it would be this one. And it is imperative that we establish that new center, lest humanity sink into the foulest morass it has ever known. In accordance with this new faith, it is essential that the aesthetic education of humanity be far more strenuously pursued in childhood. The recognition of the law of balance in art, whether in painting, poetry, music, or sculpture, is an essential complement to the moral lesson of self-reliance and self-deification. Here is the basis for the transcendent positive potential perceived through the balance achieved in the work of art. This is a replacement for prayer. Our purpose is the last and final focus of the new and ultimate religion of mankind. Oh, our goal is still far off—how well I know it!—but let us harbor the thought,

even if the center of which we speak is today still a utopia. We ourselves are the future generations and all those to come. We will reencounter this resolve in the next life, and it will help us—indeed, it will continue to help us emerge from this pathetic slave's existence we now call life. Locked up like children in a dark room, we sit, beholden to God, waiting for the door to be opened, waiting to be led off to our execution, our death. Only when the faith becomes firmly established that we ourselves have a say in the outcome of our lives, only then will our self-reliance grow stronger. Only by combating the weak, the egoistic, and so-called evil in ourselves for the sake of universal love will we succeed together as one humanity in achieving those great and decisive works; only then will we find the strength in ourselves to become God—that is, to be free, to decide for ourselves whether to live or to die. Only then will we become the conscious masters of eternity—free from time and space.

This is humanity's goal. Humanity's new faith, new hope, new religion. Bolshevism took the first steps toward the fulfillment of this vision by the state. Yet what Bolshevism lacks is art and a new faith. It lacks centralization—the dogmatic centralization of this faith, as well as a centralization of art in this faith.

24

STATEMENT IN THE CATALOGUE OF THE
MANNHEIM KUNSTHALLE RETROSPECTIVE
(SUBMITTED ON FEBRUARY 7, 1928)

FROM February 19 to April 10, 1928, the Mannheim Kunsthalle showed a comprehensive retrospective of Beckmann's work to date, the first and last major museum exhibition of his art shown while he still lived in Germany. The museum's director, Gustav Hartlaub, had long been an admirer of Beckmann and had attempted to acquire his works for the museum and for exhibitions since 1917.[1]

After Hartlaub became director of the Kunsthalle in 1923, he mounted a remarkable and varied series of modern exhibitions, an especially impressive achievement in view of the city's provincialism. Hartlaub had strongly personal views about the art he liked and catholic, rather than strictly avant-garde, tastes. Convinced of the need to cover a wide range of modern developments, he regularly alternated shows of figural and abstract art even though he himself was more inclined toward the figural. Throughout the 1920s the museum was increasingly criticized for its championing of modern art. After Hitler's accession to power Hartlaub was promptly fired (on March 20, 1933), and the museum's modern works were defamed in the exhibition *Kulturbolschewistische Bilder* (Images of cultural Bolshevism, April–May 1933).[2] In 1937 a large number of them would be seized and sold in one of the largest "degenerate art" actions.[3] Hartlaub devoted the rest of his life to scholarly research on the Renaissance and esoteric subjects such as magic and alchemy, and published a distinguished body of scholarship.[4]

From April 1 to May 12, 1918, the Mannheim Kunsthalle showed part of the 1917 exhibition of Beckmann graphics that Neumann had shown in Berlin. In mid-September Hartlaub visited Beckmann in his studio and subsequently urged the museum's current director, Fritz Wichert (1878–1951), to acquire

Beckmann's *Christ and the Woman Taken in Adultery* (1917, G. 197) as soon as possible.[5] Even before he was officially named director of the museum in 1923, Hartlaub attempted to purchase Beckmann's unfinished wartime *Resurrection,* but was unable to find the funds amid the hyperinflation crisis.[6]

In their 1923 correspondence Hartlaub also approached Beckmann concerning his ideas for a show that eventually became the famed *Neue Sachlichkeit* (New objectivity) exhibition of 1925. In fact, Beckmann was the only artist Hartlaub directly approached about this show. Hartlaub found Beckmann central to his conception of "new objectivity"—which both seemed to derive from Schopenhauer—and gave Beckmann a key place in the exhibition.[7]

This statement is the first in which Beckmann chiefly addressed the subject of constructing a picture. Like that in "The Artist in the State," his language was formal and didactic, and he frequently employed the passive voice to articulate his dicta, which sometimes read almost like magical formulas. His way of speaking differs markedly from his direct, passionate description of his process in his 1918 "Creative Credo."

This text does not even seem to be in the language he used with his students, which was reportedly more direct and personal.[8] Beckmann's idea of making such a statement might have been partly influenced by his increased activity as a teacher, although his involvement as a teacher was not extensive. Given the improvement in international relations and his own improved personal situation, from the fall of 1925 through 1932 he spent most of each winter in Paris, returning to Frankfurt only once a month for critiques.[9]

Beckmann's Mannheim statement was probably more directly inspired by contemporary theoretical and didactic statements of other artists, many of whom had similarly come to enjoy public teaching positions and had frequently articulated their theories and teachings. He certainly would have known of writings such as Kandinsky's *Punkt und Linie zur Flache* (From point and line to plane) and Klee's *Wege des Naturstudiums* (Ways of nature study), both of which had been published by the Bauhaus, or Klee's earlier didactic statement published in Kasimir Edschmid's *Schöpferische Konfession.*[10] Both because he was much less involved in teaching and because he was not theoretically

inclined, Beckmann never wrote or articulated his ideas on art as extensively as did Kandinsky or Klee. He might even have felt called upon to present his own theory as a response; Hartlaub, for instance, had just featured both of those artists in his Mannheim exhibition *Wege und Richtungen der abstraken Malerei in Europa* (January 30–March 13, 1927).[11] Like those abstract masters, Beckmann was concerned not just to state the basics of pictorial structure but also to relate his artistic practice to his larger philosophical and spiritual concerns. Like Klee's "Schöpferische Konfession" (Creative credo, which was similarly printed in separate, numbered sections) and Kandinsky's *Punkt und Linie zur Flache*, Beckmann's Mannheim statement shows a fascination with the spiritual content of his art and continues the preoccupation with aesthetics and metaphysics more fully articulated in "The Artist in the State." His desire to achieve transformation through "the transcendental mathematics of the soul of the subject," for instance, suggests some acquaintance with tenets of Pythagorean philosophy and its relation of numbers and measure to the harmony of the soul and spheres.[12] In these interests, and especially in his emphasis on the magical, transformative properties of art, Beckmann was also expressing interests he shared with Hartlaub.

Beckmann's language again reflected the influence of Kant, Schopenhauer, and the nineteenth-century realist aesthetic in which he had found his artistic orientation. He stressed that transformation is achieved through regular, critical scrutiny and observation of the subject or nature, and he emphasized the physical actuality of objects and the active nature of painting. He often echoes his prewar statements, frequently contrary to his subsequent assimilation of many abstract formal inflections. Even though he was increasingly influenced by cubism, Matisse, and Picasso during his extended stays in Paris, Beckmann again criticized practices he associated with cubism and abstract art as approaching "applied art and ornament."[13] Whereas his own treatment of space had become strongly two-dimensional in emphasis, he continued to insist on art's need to deal with three-dimensional space. Beckmann would subsequently incorporate much of this statement in his 1938 "On My Painting."

I

The construction of a picture is determined by the transformation
of the optical impression of the world of objects by means of a tran-
scendental mathematics of the soul of the subject.

Thus, in principle, any transformation of the object is permitted
that demonstrates a sufficient strength of generating form.

In this transformation the determining factor is the uniform
application of a single formal principle.

II

A comprehensive construction attempts the translation of the three-
dimensional space of the world of objects into the two dimensions of
the picture plane.

The picture surface filled only with a two-dimensional spatial
experience becomes applied art and ornament.

III

The dissolution or breaking up of corporeal volume in a three-
dimensional handling of space is inadmissible because artificially in-
vented interpretation of the two-dimensional nature of space, or a
purely decorative property, must be employed in order to unite the
broken and broken-off elements of a three-dimensional handling of
space. A mixture of different formal elements with an impurity of
artistic principle results in a product that should proceed from only
one element of form.

IV

The individualization of the object through sentiment contributes to
the enrichment of form.[14]

The individual formal transformations of all details of the ob-
ject [are] the indispensable means for the representation of concen-
trated volumes.

Sentiment intensifies individuality into type.

V

Light as articulation of the picture surface and deeper penetration of
the object's form.

Its employment in the formation of a picture comes about
through the a priori apparatus of the soul of the subject, which pro-
duces the architecture of the picture.

VI

Color as expression of the fundamental spiritual mood of the subject.

It is to be subordinated to the handling of light and form. A predominance of the coloristic element at the expense of form and space leads to two-dimensional development of the picture plane and thus applied art. Broken tones and pure local colors should be used.

25

ANSWER TO *FRANKFURTER ZEITUNG* QUESTIONNAIRE ABOUT POLITICS

(DECEMBER 25, 1928)

DURING the Weimar Republic newspapers frequently published questionnaires on key cultural and political issues of the day. Beckmann had been closely associated with the *Frankfurter Zeitung*'s editor, Heinrich Simon, since his move to Frankfurt in 1915, and regularly joined other artists, intellectuals, political figures, and journalists at Simon's "Friday tables." Simon had already done much to help Beckmann and was writing a Beckmann monograph that would appear the following year.[1]

Beckmann was thus conversant with many of the chief issues of the day and especially with the questions raised by this questionnaire. The editor's introduction noted that Germans had become increasingly involved with politics in the war and postwar period but also that in 1928 many people seemed to turn away from an involvement in politics.[2] As the editors noted, the "Gretchen-Frage" (Gretchen question) of the title asked several contemporaries how they felt about the issue of politics at large.[3] Several of the other respondents—who represented a variety of political views—might have been known to Beckmann through Simon's Friday lunches and other occasions.[4]

Most of the respondents acknowledged that they had indeed become more involved with politics during and since the war. Beckmann readily admitted that he felt displaced in politics, perhaps remembering the awkwardness he felt in the company of Rohan and the members of the Verband für kulturelle Zusammenarbeit in 1926. Recalling ideas that he had expressed in his "Artist in the State" of eighteen months earlier, Beckmann again stressed that he was more preoccupied by the metaphysical than by the political.

The Painter Max Beckmann

I am a painter, or—to use a highly unsympathetic collective term—
an artist. In any case, rather out of place. Out of place in politics, too.

This business is not going to interest me again until it has
passed through its *materialistic epoch* and shifted its attention to
metaphysical or transcendental—that is, religious—things, in a
new form.

There would be no value in debating the nature of that future
form; I live in it already and await its fulfillment.

26

"ON MY PAINTING"

(FIRST READ IN LONDON, JULY 21, 1938)

BECKMANN read this speech in German in the rooms of the *Exhibition of 20th Century German Art* in London's New Burlington Galleries; afterward, Brian Howard of the *New Statesman* read his own English translation of the text.[1] Beckmann had traveled to London from Amsterdam the preceding day with his friend, the young German collector Stephan Lackner, and both would remain there until August 2.

Beckmann had made only one prior trip to London during a short, scarcely week-long visit to England in 1936.[2] At that time he had visited Heinrich and Irma Simon, who had been forced to resign their control in the *Frankfurter Zeitung* because they were Jewish; had fled Germany for England by way of Paris in 1934; and finally emigrated to the United States in 1938. It seems likely that Beckmann's first trip to London was an occasion on which he discussed the possibilities of his own emigration.

By the time of Beckmann's second trip to London in July 1938, both he and Lackner were also living in exile. Lackner, a wealthy Jew whose family name was Morgenroth, had begun to look at Beckmann's works with an eye toward collecting after he saw paintings from a show planned but canceled for Erfurt in the museum's basement in the spring of 1933.[3] Lackner, who was then studying in Berlin, subsequently met Beckmann at the Beckmanns' new apartment and began to purchase works from him. In 1935 Lackner moved to Paris, where he published several pieces in the *Pariser Tageszeitung* and *Das neue Tage-Buch*, and in 1939 he left Europe for the United States.

After long considering his options both inside and outside Germany, Beckmann finally left Germany on July 19, 1937, the day following the opening of the *Entartete Kunst* (Degenerate art) exhibition in Munich. He and Mathilde Beckmann initially traveled to Amsterdam, where her sister Hedda von Kaulbach

(1900–1992) had lived since the late 1920s. All of their belongings were sent after them the following day, and Beckmann's Berlin dealer, Karl Buchholz, brought their dog with him to Amsterdam the following month; by autumn they had set up home in an apartment and studio at Rokin 85.[4] Beckmann visited Paris in September 1937, and the couple returned to Paris for the winter of 1938–39, at which time they applied for and were granted permanent identity cards to stay there. They planned to move to Paris in September but were caught in the Netherlands at the outbreak of the war and forced to stay there.

Beckmann's and Lackner's meetings in Paris were of great importance to both and are extensively recorded in Lackner's memoirs.[5] By the time Lackner finally emigrated to the United States, he had purchased a large number of Beckmann's paintings, many of which he left in storage in Paris. The two also set up a contract whereby Lackner continued to buy works from Beckmann sight unseen during their separation. Along with Käthe von Porada, a Frankfurt friend and Jew who lived in Paris and wrote for German newspapers, and the Berlin critic Paul Westheim, a Jewish journalist who had fled to Paris,[6] Lackner was also instrumental in urging Beckmann to participate in the *Exhibition of 20th Century German Art* in London.

Several groups—in London, in Switzerland, and in Paris—were planning exhibitions of the art of contemporary German artists, some before and some in response to the opening of the *Entartete Kunst* exhibition in 1937. Eventually Herbert Read (1893–1968), Kenneth Clark (1903–83), and Irmgard Burchard (1908–64) organized the London show. Though many of those working on the London exhibition were opposed to appeasement of the Nazis, in the climate of 1938 England—soon after the German *Anschluß* of Austria and shortly before the Munich Accord—they thought they should avoid mounting a strongly political show. In justification, they said they feared they would lose interest and support in England and perhaps even harm artists who still lived in Germany.

Several of the German émigré artists in Paris united in the Deutscher Künstlerbund and re-formed as the Freie Künstlerbund (Free artists' league) in April 1938 after the *Anschluß*. Many were outspoken anti-Fascists or Communists and increasingly opposed the London exhibition when it refused to take an openly political stance. One of the group's founders, Paul

Westheim, was highly critical of the London show and planned a show for Paris the following November, *Freie deutsche Kunst* (Free German art), that would be outspokenly anti-Fascist. In the end, Westheim encouraged Beckmann to exhibit in London and exercised caution in arranging the Freie Künstlerbund show in Paris as well. The Paris show also avoided taking a strong political stance in the face of the difficulty of Germans' finding support and sympathy in the aftermath of the Munich Accord.[7]

Beckmann's "On My Painting" must be understood within the context of those debates as well as of the debates about the politicization of the artist that he had heard for years in the Weimar Republic and Third Reich. Since he and so many other modern artists had repeatedly been attacked as radicals or Bolshevists since the 1930s, and with renewed strength since the *Entartete Kunst* show had opened the previous summer, Beckmann felt it necessary to stress that he had not been politically active in Germany.

In his move to Berlin and in his decision—at the time of his fiftieth birthday in February 1934—to refrain from exhibiting, Beckmann said he had willingly adopted the life of a hermit.[8] Yet he was hardly the nonpolitical hermit he asserted himself to be in his London talk. He had longed moved in relatively conservative circles of German high society and had several friends and acquaintances of different classes who were nationalists, conservatives, neoconservatives, and even supporters of the National Socialists.[9]

Lackner said it was not easy to convince Beckmann to participate in the London show. A Beckmann letter of January 29, 1938, indicates that Beckmann clearly wanted to maintain his distance from the strongly politicized, anti-Fascist, and/or Communist émigré artists—such as Erwin Piscator (1893–1966)— he characterized as making journalistic or "tendentious" political art.[10] Through Lackner's participation in the initial stages of organizing the London exhibition and his interaction with Irmgard Burchard and Paul Westheim, Beckmann would have been well aware of the political implications of the London show.[11] Though he had told Lackner he would stop exhibiting with the London show, he contributed a work to Westheim's Paris show in November; at that time, too, however, he sought to distance

himself from the other artists in the Freie Künstlerbund. He did not lend paintings from the large group of his works then in Paris: Lackner told the Künstlerbund that Beckmann was reserving those for viewing by an American visitor, and he submitted only a single work, a painting executed in 1925 that had long been in the collection of a German who lived in Paris.

In "On My Painting," even as he maintained his purposefully nonpolitical stance and stressed the need for artistic transcendence, Beckmann made frequent references to the times and conditions that he felt required him to remain nonpolitical. His assertion that he suddenly awoke in Holland to find himself in the midst of a world in turmoil thus belies his acute awareness of his situation.

By July 1938 Beckmann thought that his future depended entirely on his continued access to an international market. Through the efforts of I. B. Neumann, Karl Nierendorf, and Curt Valentin (1902–54) in New York, he had begun to win major recognition in the United States. Through his move to Paris in the fall of 1938—which he wanted to make permanent in the fall of 1939—he hoped to continue to find recognition in the European markets still open to him. He thus would have placed great stake in his London talk—his first to an international audience—and he put much effort into crafting it, combining parts of earlier statements with new observations.

"On My Painting" is one of the richest and most philosophical public statements of Beckmann's career. The many strands of the talk find a common basis in his concern with the state of the world, his musings on the rise and fall of various cultures, and his ideas on how the individual could assert force in the process of artistic creation. Several sections come from earlier writings. Most of his comments on the making of art, beginning with his discussion about transforming objects "by a transcendental arithmetic progression of the inner being," are only slightly changed versions of sections of his Mannheim essay of 1928, a text that he correctly assumed would have limited circulation. Beckmann drew the song he attributed to one of the figures in his second large triptych *Temptation* from his own uncompleted play of 1923–24, *The Ladies' Man*. In deference to his audience in London, Beckmann also made several British allusions—to the Hebrides, David Hume, Herbert Spencer, and Wil-

liam Blake—all subjects with which he had generally been familiar.

Before I begin to give you an explanation, an explanation that it is nearly impossible to give, I would like to emphasize that I have never been politically active in any way. I have tried only to realize my conception of the world as intensely as possible.

Painting is a very difficult thing. It absorbs the whole man, body and soul—thus I have passed blindly many things that belong to real and political life.

I assume, though, that there are two worlds: the world of spiritual life and the world of political reality. Both are manifestations of life that may sometimes coincide but are very different in principle. I must leave it to you to decide which is the more important.

What I want to show in my work is the idea that hides itself behind so-called reality. I am seeking the bridge that leads from the visible to the invisible, like the famous kabbalist who once said: "If you wish to get hold of the invisible you must penetrate as deeply as possible into the visible." [12]

My aim is always to get hold of the magic of reality and to transfer this reality into painting—to make the invisible visible through reality. It may sound paradoxical, but it is, in fact, reality which forms the mystery of our existence.

What helps me most in this task is the penetration of space. Height, width, and depth are the three phenomena that I must transfer into one plane to form the abstract surface of the picture, and thus to protect myself from the infinity of space. My figures come and go, suggested by fortune or misfortune. I try to fix them divested of their apparent accidental quality.

One of my problems is to find the self, which has only one form and is immortal—to find it in animals and men, in the heaven and in the hell which together form the world in which we live.

Space, and space again, is the infinite deity which surrounds us and in which we are ourselves contained.

That is what I try to express through painting, a function different from poetry and music but, for me, predestined necessity.

When spiritual, metaphysical, material, or immaterial events come into my life, I can fix them only by way of painting. It is not the subject that matters but the translation of the subject into the abstraction of the surface by means of painting. Therefore I hardly

need to abstract things, for each object is unreal enough already, so unreal that I can make it real only by means of painting.

Often, very often, I am alone. My studio in Amsterdam, an enormous old tobacco storeroom, is again filled in my imagination with figures from the old days and from the new, like an ocean moved by storm and sun and always present in my thoughts.[13]

Then shapes become beings and seem comprehensible to me in the great void and uncertainty of the space that I call God.

Sometimes I am helped by the constructive rhythm of the kabbalah, when my thoughts wander over Oannes Dagon to the last days of drowned continents.[14] Of the same substance are the streets with their men, women, and children; great ladies and whores; servant girls and duchesses. I seem to meet them, like doubly significant dreams, in Samothrace and Piccadilly and Wall Street. They are Eros and the longing for oblivion.[15]

All these things come to me in black and white like virtue and crime. Yes, black and white are the two elements that concern me. It is my fortune, or misfortune, that I can see neither all in black nor all in white. One vision alone would be much simpler and clearer, but then it would not exist. It is the dream of many to see only the white and truly beautiful, or the black, ugly and destructive. But I cannot help realizing both, for only in the two, only in black and in white, can I see God as a unity creating again and again a great and eternally changing terrestrial drama.[16]

Thus without wanting it, I have advanced from principle to form, to transcendental ideas, a field that is not at all mine, but in spite of this I am not ashamed.

In my opinion all important things in art since Ur of the Chaldees, since Tell Halaf and Crete have always originated from the deepest feeling about the mystery of Being.[17] Self-realization is the urge of all objective spirits. It is this self that I am searching in my life and in my art.

Art is creative for the sake of realization, not for amusement; for transfiguration, not for the sake of play. It is the quest of our self that drives us along the eternal and never-ending journey we must all make.

My form of expression is painting; there are, of course, other means to this end, such as literature, philosophy, or music; but as a painter, cursed or blessed with a terrible and vital sensuousness, I must look for wisdom with my eyes. I repeat, with my eyes, for nothing could be more ridiculous or irrelevant than a "philosophical

conception" painted purely intellectually without the terrible fury
of the senses grasping each visible form of beauty and ugliness. If
from those forms that I have found in the visible, literary subjects
result—such as portraits, landscapes, or recognizable composi-
tions—they have all originated from the senses, in this case from
the eyes, and each intellectual subject has been transformed again
into form, color, and space.

Everything intellectual and transcendent is joined together in
painting by the uninterrupted labor of the eyes. Each shade of a
flower, a face, a tree, a fruit, a sea, a mountain is noted eagerly by
the intensity of the senses, to which is added, in a way of which we
are not conscious, the work of the mind, and in the end the strength
or weakness of the soul. It is this genuine, eternally unchanging
center of strength that makes mind and senses capable of expressing
personal things. It is the strength of the soul that forces the mind to
constant exercise to widen its conception of space.

Something of this is perhaps contained in my pictures.

Life is difficult, as perhaps everyone knows by now. It is to es-
cape from these difficulties that I practice the pleasant profession of
a painter. I admit that there are more lucrative ways of escaping the
so-called difficulties of life, but I allow myself my own particular
luxury, painting.

It is, of course, a luxury to create art and, on top of this, to in-
sist on expressing one's own artistic opinion. Nothing is more luxu-
rious than this. It is a game and a good game, at least for me; one of
the few games that make life, difficult and depressing as it is some-
times, a little more interesting.

Love in an animal sense is an illness, but a necessity which one
has to overcome. Politics is an odd game, not without danger I have
been told, but certainly sometimes amusing. To eat and to drink are
habits not to be despised, but often connected with unfortunate con-
sequences. To sail around the earth in ninety-one hours must be
very strenuous, like racing in cars or splitting the atom.[18] But the
most exhausting thing of all—is boredom.

So let me take part in your boredom and in your dreams while
you take part in mine, which may be yours as well.

To begin with, there has been enough talk about art. After all, it
must always be unsatisfactory to try to express one's deeds in
words. Still we shall go on and on, talking and painting and making
music, boring ourselves, exciting ourselves, making war and peace
as long as our strength of imagination lasts. Imagination is perhaps

the most decisive characteristic of humanity. My dream is the imagination of space—to change the optical impression of the world of objects by a transcendental arithmetic progression of the inner being. That is the precept. In principle any alteration of the object is allowed that has a sufficiently strong creative power behind it. Whether such alteration causes excitement or boredom in the spectator is for you to decide.

The uniform application of a principle of form is what rules me in the imaginative alteration of an object. One thing is sure—we have to transform the three-dimensional world of objects into the two-dimensional world of the canvas.

If the canvas is filled only with a two-dimensional conception of space, we shall have applied art, or ornament. Certainly this may give us pleasure, though I myself find it boring, as it does not give me enough visual sensation. To transform three into two dimensions is for me an experience full of magic in which I glimpse for a moment that fourth dimension that my whole being is seeking.[19]

I have always on principle been against the artist's speaking about himself or his work. Today neither vanity nor ambition causes me to talk about matters that generally are not to be expressed even to oneself. But the world is in such a catastrophic state and art is so bewildered that I, who have lived the last thirty years almost as a hermit, am forced to leave my snail's shell to express these few ideas which, with much labor, I have come to understand in the course of the years.

The greatest danger that threatens humanity is collectivism. Everywhere attempts are being made to lower the happiness and the way of living of mankind to the level of termites. I am against these attempts with all the strength of my being.[20]

The individual representation of the object, treated sympathetically or antipathetically, is highly necessary and is an enrichment to the world of form. The elimination of the human relationship in artistic representation causes the vacuum that makes all of us suffer in various degrees—an individual alteration of the details of the object represented is necessary in order to display on the canvas the whole physical reality.[21]

Human sympathy and understanding must be reinstated. There are many ways and means to achieve this. Light serves me to a considerable extent on the one hand to divide the surface of the canvas, on the other to penetrate the object deeply.

As we still do not know what this self really is, this self in

which you and I in our various ways are expressed, we must peer
deeper and deeper into its discovery. For the self is the great veiled
mystery of the world. Hume and Herbert Spencer studied its vari-
ous conceptions but were not able in the end to discover the truth.[22]
I believe in it and in its eternal, immutable form. Its path is, in some
strange and peculiar manner, our path. And for this reason I am im-
mersed in the phenomenon of the Individual, the so-called whole
Individual, and I try in every way to explain and present it. What
are you? What am I? Those are the questions that constantly perse-
cute and torment me and perhaps also play some part in my art.

Color, as the strange and magnificent expression of the inscru-
table spectrum of Eternity, is beautiful and important to me as a
painter; I use it to enrich the canvas and to probe more deeply into
the object. Color also decided, to a certain extent, my spiritual out-
look, but it is subordinated to light and, above all, to the treatment
of form. Too much emphasis on color at the expense of form and
space would make a double manifestation of itself on the canvas,
and this would verge on craft work. Pure colors and broken tones
must be used together, because they are the complements of each
other.[23]

These, however, are all theories, and words are too insignificant
to define the problems of art. My first unformed impression, and
what I would like to achieve, I can perhaps realize only when I am
impelled as in a vision.

One of my figures, perhaps one from *Temptation*, sang this
strange song to me one night—

> Fill up your mugs again with alcohol, and hand up the larg-
> est of them to me . . . In ecstasy I'll light the great candles
> for you now in the night, in the deep black night.

> We are playing hide-and-seek, we are playing hide-and-
> seek across a thousand seas, we gods . . . when the skies are
> red in the middle of the day, when the skies are red at
> night. You cannot see us, no you cannot see us but you are
> ourselves . . . That is what makes us laugh so gaily when
> the skies are red in the middle of the night, red in the
> blackest night.

> Stars are our eyes and the nebulae our beards . . . We have
> people's souls for our hearts. We hide ourselves and you

cannot see us, which is just what we want when the skies are red at midday, red in the blackest night.

Our torches stretch away without end . . . silver, glowing purple, violet, green-blue, and black. We bear them in our dance over the seas and the mountains, across the boredom of life.

We sleep and our brains circle in dull dreams . . . We wake and the planets assemble for the dance across bankers and fools, whores and duchesses.[24]

Thus the figure from my *Temptation* sang to me for a long time, trying to escape from the square on the hypotenuse in order to achieve a particular constellation of the Hebrides, to the red giants and the central sun.[25]

And then I awoke and yet continued to dream . . . Painting constantly appeared to me as the one and only possible achievement. I thought of my grand old friend Henri Rousseau, that Homer in the porter's lodge whose prehistoric dreams have sometimes brought me near the gods.[26] I saluted him in my dream. Near him I saw William Blake, noble emanation of English genius.[27] He waved friendly greetings to me like a super-terrestrial patriarch. "Have confidence in objects," he said. "Do not let yourself be intimidated by the horror of the world. Everything is ordered and right and must fulfill its destiny in order to attain perfection. Seek this path and you will attain from your own self ever deeper perception of the eternal beauty of creation; you will attain increasing release from all that which now seems to you sad or terrible."[28]

I awoke and found myself in Holland in the midst of a boundless world turmoil. But my belief in the final release and absolution of all things, whether they please or torment, was newly strengthened. Peacefully I laid my head among the pillows . . . to sleep, and dream, again.

27

SPEECH GIVEN TO HIS FIRST CLASS
IN THE UNITED STATES,
WASHINGTON UNIVERSITY, ST. LOUIS
(READ BY MATHILDE BECKMANN
ON SEPTEMBER 23, 1947)

IN THE immediate aftermath of the war the Beckmanns were not free to travel from Amsterdam, but they were also uncertain if they could stay there; indeed, Beckmann did not receive "nonenemy" clearance until August 21, 1946.[1] In the last few days of the war he determined not to return to Germany and assumed that he would soon be able to find a position in the United States. He telegraphed Curt Valentin as soon as connections were restored but did not hear from Valentin for some time and had to wait much longer until his papers, and an appointment, could be arranged.

After receiving a first invitation from the Indiana University Department of Fine Arts, to which he tentatively agreed, and several invitations from institutions in Germany, Beckmann finally accepted an offer from the School of Fine Arts at Washington University in St. Louis on June 6, 1947. This appointment had been arranged in part by Valentin and Perry Rathbone (b. 1911), director of the City Art Museum, who was already planning the large Beckmann retrospective that originated in St. Louis in 1948;[2] in fact, Rathbone met Beckmann in Amsterdam less than a month later. Dean Kenneth E. Hudson (1903–88) hired Beckmann to take the place of the American artist Philip Guston (1913–80), who had just won a Fulbright Grant to study in Italy. Whereas the fine arts faculty at Washington University were delighted to hire Beckmann, they also remained devoted to Guston and were ready to take him back when he decided to return. The school could thus hire Beckmann only on

a semester-by-semester basis, and the Beckmanns traveled to the United States on temporary visas without attempting a final move. Guston did not return to Washington University, and Beckmann taught and lived in St. Louis from September 1947 through June 1949. Since he was never assured a permanent position, he continued to look for another teaching opportunity, and on January 6, 1949, readily accepted an appointment to teach at the Brooklyn Academy Museum School beginning the following autumn.

The Beckmanns returned to Amsterdam in the summer of 1948 to change their visa status and move their belongings. After his second year at St. Louis Beckmann taught at the University of Colorado in Boulder during the summer of 1949; after a first year in New York he taught at Mills College in Oakland, California, in the summer of 1950.[3]

Aside from his Mannheim statement of 1928, the four public statements from Beckmann's three years in the United States provide the only written records of his attempts to articulate the practice and philosophy of his art as a teacher. In the United States Beckmann came into contact with many more students than he had known in Germany. Through teaching in St. Louis, Boulder, Oakland, and Brooklyn and delivering his 1948 talk, "Letters to a Woman Painter," at several colleges and art schools, he came into contact with a large number of American students and educators, including Walter Barker (b. 1921), Warren Brandt (b. 1918), Pierre (1907–73) and Tracy (1911–92) Montminy, Nathan Olivera, and George (b. 1907) and Edith (b. 1924) Rickey. Even with the considerable barriers of language—Beckmann never spoke English well and constantly relied on Mathilde Beckmann as his interpreter—and his generally silent nature, he made a tremendous impression on those with whom he came in contact, often less through what he said than by his presence. Many students seem to have simply been awed by the presence of an imposing, internationally recognized figure. Many others, on the other hand, were grateful to find in Beckmann and his works a powerful alternative to the abstraction already dominant in American art and art schools.[4] Beckmann's presence, teaching, and talks in America had a great and lasting impact even if they reached a relatively limited audience in a relatively short period of time. Together with the large number of Beckmann's paintings

that increasingly came into American museums, private collections, and exhibitions from the 1940s on, his stay and talks came to constitute a major contribution to the American scene.

This talk was read by Mathilde Beckmann after the Beckmanns were introduced by Dean Hudson, in a classroom in Washington University's Bixby Hall.[5]

Thank you, ladies and gentlemen, for showing me your work. It was very interesting for me, and now we can begin.

I hope that you won't expect me to instill in your minds at once—like a mighty magician—the spirit of fiery genius. In my opinion you ought to learn very much, in order to forget most of it later on. That means that I wish you to discover your *own selves,* and to that end many ways and many detours are necessary.

One can hardly expect this to happen at an early age; you must bide your time by forming as many conceptions of reality as you possibly can, conceptions that later on you will be able to use with your own free will. You must remain self-reliant and free, but forever bound within your own law, indeed, presuming that there exists such a law in every one of you. However, you already have started this adventure of seeking your own self. In doing so, everyone is on his own.

I shall try to assist you with all my means. But do not forget that the main work will be yours—and do not expect too much of me, who himself is still in search of his own true self.

The most important things everyone must teach himself, yet, of course, suggestions can be helpful.

I do not have to tell you there can be no question of thoughtless imitation of nature.

Please do remember this maxim, the most important I can give you. If you want to reproduce an object, two elements are required: first, the identification with the object must be perfect; and second, it should contain, in addition, something quite different. This second element is difficult to explain. Almost as difficult as to discover one's self. In fact, it is just this element of your own self that we are all in search of.

In order to start and to develop this game, after becoming familiar with your work, I shall confront you from time to time with problems, or I shall ask you to seek such problems yourselves.

I may spend a lot of time with you; however, there may be

times when I shall find it better to leave you alone with your work.

According to my conviction as an artist, I do not want to give you an academic training in the strict sense of the word, as it is my most sincere wish and intention to show and make easy your way toward *independent!* work of your own.

Now let us begin:

First problem: Still life with fruit, which everyone may execute to his own liking—on condition that all given objects will be represented on the canvas.

Second: Composition and interpretation have to be identical from the very beginning. Even in sketches from nature, you must at the same time observe the distribution of space.

Third: Difference between painting and drawing. In painting, the composition, by means of space and distribution of surface, has to be executed up to the last part of the picture. In drawing, space may be improvised, sometimes by omission and sometimes by suggestion.

28

"LETTERS TO A WOMAN PAINTER"

(FIRST READ FEBRUARY 3, 1948)

BECKMANN was asked to speak at Stephens College in Columbia, Missouri, by Pierre and Tracy Montminy, both of whom were distinguished artists and teachers in Columbia. Pierre Montminy, born in Lowell, Massachusetts, and educated at the Lowell Technological Institute and the Massachusetts College of Art, began teaching art at Stephens College in 1946. Tracy Montminy, born Elizabeth Tracy in Boston, was educated at Radcliffe College and the Art Students' League in New York. Between 1935 and 1945 she received six mural commissions for public buildings on the East Coast and in Mexico City, and in 1940 she was awarded a Guggenheim Fellowship. In 1948 Tracy Montminy joined the faculty of the art department at the University of Missouri in Columbia.[1]

In his diaries Beckmann described his three-day visit to Columbia (February 3–5, 1948), where he met with students, the Montminys, and other members of the faculty and community.[2] In 1948 Stephens College had an enrollment of about three thousand students and was considered one of the preeminent American junior (two-year) colleges for women.[3] Beckmann wrote that German émigrés—prominent in a small Missouri college town in the 1940s—almost devoured him during one of the receptions.[4]

Beckmann's talk was well received, and he and Mathilde Beckmann were asked to present the letters at other locations as well, including Mills College, the School of the Museum of Fine Arts in Boston, the University of Colorado in Boulder, and Vassar College in Poughkeepsie. The letters were first published in English in the *College Art Journal,* a chief organ of the College Art Association, in the autumn of 1949. Mathilde Beckmann also read them on radio in St. Louis, an event that was recorded on tape.

I

To be sure it is an imperfect, not to say a foolish, undertaking to try to put into words ideas about art in general, because, whether you like it or not, every man is bound to speak for himself and for his own soul. Consequently, objectivity or fairness in discussing art is impossible. Moreover, there are certain definite ideas that may be expressed only by art. Otherwise, what would be the need for painting, poetry, or music? So in the last analysis, there remains only a faith, that belief in the individual personality which, with more or less energy or intelligence, puts forward its own convictions.

Now you maintain that you have this faith and you want to concentrate it upon my personality and you want to partake of my wisdom. Well, I must admit that at times you are really interested in painting and I cannot suppress a sort of feeling of contentment that you have this faith, even though I am convinced that your really deep interest in art is not yet too much developed. For, sadly, I have often observed that fashion shows, bridge teas, tennis parties, and football games absorb a great deal of your interest and lead your attentions into idle ways. Be that as it may. You are pretty and attractive, which in a way is regrettable, for I am forced to say a few things to you that, frankly, make me a bit uncomfortable.

In the development of your taste you have already left behind certain things: those fall landscapes in brown and wine red, and those especially beautiful and edible still lifes of the old Dutch school no longer tempt you as they did before. Yes, as you have assured me, even those prismatic constructions, pictures of recent years, give you that sad feeling of boredom that you so much want to get rid of. And yet formerly you were so proud of understanding these things alone.

And now. What now? There you stand not knowing your way in or out. Abstract things bore you just as much as academic perfections, and ruefully you let your eyes fall on the violet red of your nail polish as if it were the last reality that remained to you! But in spite of it all, don't despair. There are still possibilities, even though they are at the moment somewhat hidden. I know very well that in the realm of pure concentration your greatest enemies are the evils of the big wide world: motor cars, photographs, movies—all those things that more or less consciously take away from people the belief in their own individuality and their transcendent possibilities and turn them into stereotyped humans.[5]

However, as I have said, we need not give up the hope of search-

ing and finding the way out of the dark circle of machine phantoms in order to arrive at a higher reality. You can see that what you need is difficult to express in words, for what you need are just the things that, in a sense, constitute the grace and gift for art. The important thing is first of all to have a real love for the visible world that lies outside ourselves as well as to know the deep secret of what goes on within ourselves. For the visible world in combination with our inner selves provides the realm where we may seek infinitely for the individuality of our own souls. In the best art this search has always existed. It has been, strictly speaking, a search for something abstract. And today it remains urgently necessary to express even more strongly one's own individuality. Every form of significant art from Bellini to Henri Rousseau has ultimately been abstract.

Remember that depth in space in a work of art (in sculpture, too, although the sculptor must work in a different medium) is always decisive. The essential meaning of space or volume is identical with individuality, or that which humanity calls God. For in the beginning there was space, that frightening and unthinkable invention of the Force of the Universe. Time is the invention of humanity; space or volume, the palace of the gods.

But we must not digress into metaphysics or philosophy. Only do not forget that the appearance of things in space is the gift of God, and if this is disregarded in composing new forms, then there is the danger of your work's being damned by weakness or foolishness, or at best it will result in mere ostentation or virtuosity. One must have the deepest respect for what the eye sees and for its representation on the area of the picture in height, width, and depth. We must observe what may be called the law of surface, and this law must never be broken by using the false technique of illusion. Perhaps then we can find ourselves, see ourselves in the work of art. Because ultimately, all seeking and aspiration end in finding yourself, your real self, of which your present self is only a weak reflection. There is no doubt that this is the ultimate, the most difficult exertion that we poor men can perform. So with all this work before you, your beauty culture and your devotion to the external pleasures of life must suffer. But take consolation in this: you still will have ample opportunity to experience agreeable and beautiful things, but these experiences will be more intense and alive if you yourself remain apart from the senseless tumult and bitter laughter of stereotyped humanity.

Some time ago we talked about intoxication with life. Certainly

art is also an intoxication. Yet it is a disciplined intoxication. We also love the great oceans of lobsters and oysters, virgin forests of champagne, and the poisonous splendor of the lascivious orchid.

But more of that in the next letter.

II

It is necessary for you, you who now draw near to the motley and tempting realm of art, it is very necessary that you also comprehend how close to danger you are. If you devote yourself to the ascetic life, if you renounce all worldly pleasures, all human things, you may, I suppose, attain a certain concentration: but for the same reason you may also dry up.[6] Now on the other hand, if you plunge headlong into the arms of passion, you may just as easily burn yourself up! Art, love, and passion are very closely related because everything revolves more or less around knowledge and the enjoyment of beauty in one form or another. And intoxication is beautiful, is it not, my friend?

Have you not sometimes been with me in the deep hollow of the champagne glass where red lobsters crawl around and black waiters serve red rumbas that make the blood course through your veins as if to a wild dance? Where white dresses and black silk stockings nestle themselves close to the forms of young gods amid orchid blossoms and the clatter of tambourines? Have you never thought that in the hellish heat of intoxication amongst princes, harlots, and gangsters, *there* is the glamour of life? Or have not the wide seas on hot nights let you dream that we were glowing sparks on flying fish far above the sea and the stars? Splendid was your mask of black fire in which your long hair was burning—and you believed, at last, at last, that you held the young god in your arms who would deliver you from poverty and ardent desire?

Then came the other thing—the cold fire, the glory.

Never again, you said, never again shall my will be slave to another. Now I want to be alone, alone with myself and my will to power and to glory.

You have built yourself a house of ice crystals and you have wanted to forge three corners or four corners into a circle. But you cannot get rid of that little "point" that gnaws in your brain, that little "point" that means "the other one." Under the cold ice the passion still gnaws, that longing to be loved by another, even if it should be on a different plane from the hell of animal desire. The cold ice burns exactly like the hot fire. And uneasy you walk alone

through your palace of ice. Because you still do not want to give up the world of delusion, that little "point" still burns within you—the other one! And for that reason you are an artist, my poor child! And on you go, walking in dreams like myself. But through all this we must also persevere, my friend. You dream of my own self in you, you mirror of my soul.

Perhaps we shall awake one day, alone or together. This we are forbidden to know. A cool wind beyond the other world will awake us in the dreamless universe, and then we shall see ourselves freed from the danger of the dark world, the glowing fields of sorrow at midnight. Then we are awake in the realm of atmospheres, and self-will and passion, art and delusion are sinking down like a curtain of gray fog . . . and light is shining behind an unknown gigantic gleam.

There, yes there, we shall perceive all, my friends, alone or together . . . who can know?

III

I must refer you to Cézanne again and again. He succeeded in creating an exalted Courbet, a mysterious Pissarro, and finally a powerful new pictorial architecture in which he really became the last old master, or I might better say he became the first "new master" who stands synonymous with Piero della Francesca, Uccello, Grünewald, Orcagna, Titian, El Greco, Goya, and van Gogh.[7] Or, looking at quite a different side, take the old magicians Hieronymus Bosch, Rembrandt, and as a fantastic blossom from dry old England, William Blake, and you have quite a nice group of friends who can accompany you on your thorny way, the way of escape from human passion into the fantasy palace of art.

Don't forget nature, through which Cézanne, as he said, wanted to achieve the classical. Take long walks and take them often, and try your utmost to avoid the stultifying motor car, which robs you of your vision, just as the movies do, or the numerous motley newspapers. Learn the forms of nature by heart so you can use them like the musical notes of a composition. That's what these forms are for. Nature is a wonderful chaos to be put into order and completed. Let others wander about, entangled and color-blind, in old geometry books or in problems of higher mathematics. We will enjoy ourselves with the forms that are given us: a human face, a hand, the breast of a woman or the body of a man, a glad or sorrowful expression, the infinite seas, the wild rocks, the melancholy language of the black trees in the snow, the wild strength of spring

flowers, and the heavy lethargy of a hot summer day when Pan, our old friend, sleeps and the ghosts of midday whisper. This alone is enough to make us forget the grief of the world, or to give it form. In any case, the will to form carries in itself one part of the salvation you are seeking. The way is hard and the goal is unattainable; but it is a way.

Nothing is further from my mind than to suggest to you that you thoughtlessly imitate nature. The impression nature makes upon you in its every form must always become an expression of your own joy or grief, and consequently in your formation of it, it must contain that transformation that only then makes art a real abstraction.

But don't overstep the mark. Just as soon as you fail to be careful you get tired, and though you still want to create, you will slip off either into thoughtless imitation of nature, or into sterile abstractions that will hardly reach the level of decent decorative art.

Enough for today, my dear friend. I think much of you and your work and from my heart wish you power and strength to find and follow the good way. It is very hard with its pitfalls left and right. I know that. We are all tightrope walkers. With them it is the same as with artists, and so with all humanity. As the Chinese philosopher Lao-tse says, we have "the desire to achieve balance, and to *keep* it."[8]

29

Speech for Friends and Faculty during Commencement Week Activities, Washington University, St. Louis

(read on June 5, 1950)

IN 1950 Beckmann learned that he would receive an honorary degree from Washington University, and in early May 1950 he was asked to give a lecture during the commencement week activities. Dean Kenneth Hudson of the School of Fine Arts wrote Beckmann that the school would be pleased to have him talk "on any subject relating to painting that is close to your heart at this time, leaving the subject entirely up to you."[1] Max and Mathilde traveled to St. Louis for the ceremonies on their way to spend the summer at Mills College, and she read the English text to an audience at the university's Women's Building on June 5.[2] The audience of about one hundred people comprised the general public and many invited friends, former students, and faculty associates, including Mr. and Mrs. Perry Rathbone, Mr. and Mrs. Joseph Pulitzer, Jr., Curt Valentin, Mr. and Mrs. Morton D. May, and Mr. and Mrs. Walter Barker.

By all accounts the Beckmanns enjoyed their stay in St. Louis immensely—even with the continued uncertainties about his job, their immigration status, and his poor state of health—and found many friends and champions there. The St. Louis businessman Morton D. May (1914–83), who would ultimately acquire a huge collection of expressionists and Beckmann, had already begun to collect Beckmann before he learned that Beckmann had come to teach at Washington University.[3] Joseph Pulitzer, Jr. (1913–93) also became a good friend who purchased works and offered the Beckmanns much help and good company, and Perry Rathbone joined Curt Valentin in promoting Beckmann throughout the country.[4]

In his commencement-week address Beckmann reiterated many of the themes of his last talks but also added several comments about his memories of St. Louis and the new surround-

ings to which he was beginning to accommodate himself in New York. He received his honorary degree at the commencement exercises the following day.[5] The other recipients of honorary degrees were Bernard M. Baruch (1870–1965), who gave the major address at the commencement ceremonies on June 6; Alexander Langsdorf (b. 1912); Vijaya Lakshmi Pandit (1900–1990), India's ambassador to the United States; and Eugene P. Wigner (b. 1902), professor of physics at Princeton University and a leader in the development of the atomic bomb.[6]

It is a great pleasure for me to meet again the circle of friends who shared with me my first impressions of America. While my Pullman car called the Silver Cascade thundered over the Mississippi, the memories of my first arrival in St. Louis came vividly to my mind.[7] I thought of the beautiful river paintings of George Catlin[8] as I saw the big yellow river again, downtown St. Louis, and later, in rapid succession, all the other landmarks: the lovely park, the Jefferson Memorial, the art school, the university and the City Art Museum with its beautiful treasures.[9] And many thoughts that I had pondered then came back to me. As always and as in everything, the eternal link is the arts—music, painting, poetry, and architecture. When I now walk under the blossoming trees of Central Park,[10] so carefully guarded by Manhattan's towering skyscrapers, I often think of those first, unforgettable days here. You cannot imagine the complete change the arrival in this peaceful country produced within me after having witnessed the terrible destruction wrought in Europe. As everything in life of necessity undergoes a change, the pleasant time here had to end, but for all the more reason it has impressed itself so strongly on me.

Friends have asked me to say something about art during this reunion. Should one embark again on the discussion of this old theme, which never arrives at a satisfactory conclusion because everyone can speak only for himself? Particularly the artist who, after all, can never escape his calling. Isn't it much nicer to go for a walk and experience the new, young dream of spring instead of getting entangled in dry theories or arriving at inconclusive results?

Indulge in your subconscious, or intoxicate yourself with wine (for all I care, love the dance, love joy and melancholy, and even death!). Yes, also death—as the final transition to the Great Un-

known. But above all you should love, love, and love! Do not forget that every man, every tree, and every flower is an individual worth thorough study and portrayal.

And when you ask me again *how* should I make this study and portrayal, I can tell you again only that in art everything is a matter of discrimination, address, and sensibility, regardless of whether it is modern or not. Ever important are keen awareness and uncompromising self-criticism. The work must emanate truth. Truth through love of nature and iron self-discipline.

If you really have something to say, it will always be evident; therefore do not shy away from tears, from despair and the torment of hard work, for in spite of it all, there is no deeper satisfaction than to have accomplished something good, and therefore it is worth your while to sweat a bit.

This is all that might be said about painting. I do believe, however, that this very problem applies to all the arts and sciences. Purposely I have avoided commenting on the various art theories, as I am a sworn enemy of putting art in categories. Personally, I think it is high time to put an end to all isms, and to leave to the individual the decision whether a picture is beautiful, bad, or boring. Not with your ears shall you see, but with your eyes.

Greatness can be achieved in every form of art; it depends alone on the fertile imagination of the individual to discover this. Therefore I say not only to the artist but also to the beholder: If you love nature with all your heart, new and unimaginable things in art will occur to you. Because art is nothing but the transfiguration of Nature.

Manhattan's skyscrapers nodded reflectively to my thoughts— some of them reared themselves even prouder than before. Right, they said, right—we too have become nature. Manmade—but grown above man—and slowly they vanished in the warm gray mist of a spring evening.

Art, with religion and the sciences, has always supported and liberated man on his path. Art resolves through form the many paradoxes of life, and sometimes permits us to glimpse behind the dark curtain that hides those unknown spaces where one day we shall be unified.

30

"CAN PAINTING BE TAUGHT?
1. BECKMANN'S ANSWER"

(INTERVIEW WITH DOROTHY SECKLER, 1950;
PUBLISHED MARCH 1951)

ON MAY 20, 1950, as he lived in New York and taught at the Brooklyn Academy Museum School, Beckmann was interviewed by Dorothy Gees Seckler (1910–94) about his teaching.[1] Seckler, an associate editor of *Art News* (1945–50), the renowned American art monthly founded in 1902, is especially remembered for her contributions of series such as "Can Painting Be Taught?"[2] An exhibiting artist who postponed that career while she worked as a critic, Seckler was educated at the Maryland Institute of Art, Teachers College of Columbia University, and the Institute of Fine Arts of New York University.[3] Aside from her extensive criticism and editing for *Art News*, Seckler also served as consulting editor for *Art in America* (1955–67), interviewed many American and European artists for the Archives of American Art, and wrote for the McGraw-Hill *Encyclopedia of World Art*. In 1977 she published a monograph on the Provincetown painters.[4]

Seckler's interview captured not only the way Beckmann worked with his American students—almost always with Mathilde Beckmann working as translator—but also the taciturn advice he gave, always assuming that students ultimately had to make their own choices. Beckmann died before the interview appeared. Suffering from heart trouble and chest pains since Amsterdam, he was formally diagnosed with angina pectoris on June 1, 1950. Mathilde Beckmann and the doctor apparently did not tell him of this diagnosis and were prepared for him to die at any time.[5] He went on to teach and exercise extensively in California that summer and taught another semester in New York in the fall. He died on the cold afternoon of December 27, 1950, as he walked toward Central Park.

"Art cannot be taught," Beckmann said positively, "but," he added, "the way to art can be taught." The German-born and internationally famous expressionist painter, who died suddenly of a heart attack in January of this year, had also become a well-known teacher since his arrival here in 1947. With Mrs. Beckmann constantly at his side acting as interpreter, the artist had, first at the Washington University in St. Louis and later at the Brooklyn Museum Art School, sufficiently overcome his language problems to inspire in his serious students some notably vigorous and varied work.

The first impression of Beckmann was that he was different from his self-portraits, appearing unexpectedly blond, rugged in frame and even rather mild mannered in contrast to the severity with which he had presented himself in paintings. Later acquaintance proved, however, that some of the bluntness and intensity of his portraits was indeed a striking element in his character.

"Method?" the painter shook his head. "No, I have no method. There is no recipe. What I say and direct is different for every individual student. Each one is a special case." With typical expressionist contempt for system and rationale, Beckmann seemed to have disposed of the whole question of teaching procedure; nevertheless, he responded with ready good humor when asked to describe what actually happens in a first class-meeting. "It's very simple," he explained. "To one student I suggest a still life, to another a self-portrait. I advise working from the model for some and there may be a few who are ready to begin more advanced compositions." After an exchange in German with Mrs. Beckmann, he added, "Of course, each student must bring in examples of what he has done the first time and from this I judge."

It is doubtful if even without the barrier of language Beckmann would have attempted to express any generalized body of ideas or elaborate any program. He was at his best, apparently, in a vis-à-vis relationship with individuals, especially if they were vigorous, prolific and, above all, hardworking. Those who worked less intensively, or whose approach was either extremely abstract or extremely academic, were simply ignored. Even to favored students, Beckmann spoke very little. His advice was constantly to: "work a lot . . . simplify . . . use color, lots of color . . . make the painting more personal." Lucky was the student whose picture elicited a "ja, ja, good" and unhappy the one who was dismissed with a cryptic "very amusing." He was not a teacher to encourage the faltering beginner, but

his advanced and serious students, for whom the classes were always intended, felt that the association was a profitable, inspiring one.

When Beckmann wanted to make a correction in drawing or composition, and in his classes they were almost the same thing, he would often work directly over the student's painting. Taking the largest-size brush (he hated small brushes) and dipping it alternately into dirty turpentine and black paint, he would outline a shape in sweeping rhythmic curves. A timid student he would send to "see the paintings of my friend Rousseau."

"At the beginning," Beckmann concluded, "Some students go with the teacher and try to paint in his manner, but later on most will develop their own way." Asked if imitation included his own cryptic symbolism or if it were ever discussed, the artist waved the idea aside. "Certainly not. No, we do not talk of symbolism at all. I am concerned only with the architecture of the painting; the subject is absolutely personal. Where I can help is in bringing the image to the surface." Beckmann described with his hand the vertical lattices that are so marked in the structure of his own painting. "There must be an architecture, you understand, not illusion."

Beckmann did not feel that his students here were very different from those he had taught at the Frankfurt school in Germany. But as we parted Beckmann said earnestly: "My students in Brooklyn and also in St. Louis have a good spirit. There is something very vital here in America."

Table of Monetary Equivalents in 1995 U.S. Dollars

YEAR	VALUE OF A DOLLAR PRICE INDEX (1860 = $1)	DOLLARS	VALUE OF A GERMAN MARK	VALUE OF A FRENCH FRANC	VALUE OF A BELGIAN FRANC
1903	0.764	49.67	11.83	9.59	9.55
1904	0.750	50.60	12.05	9.77	9.73
1905	0.753	50.40	12.01	9.73	9.69
1906	0.773	49.10	11.69	9.48	9.44
1907	0.785	48.34	11.52	9.33	9.30
1908	0.794	47.80	11.39	9.23	9.19
1909	0.805	47.14	11.23	9.10	9.07
1910	0.756	50.20	11.96	9.69	9.65
1911	0.749	50.67	12.07	9.78	9.74
1912	0.760	49.94	11.89	9.64	9.60
1913	0.777	48.84	11.63	9.43	9.39
1914	0.873	43.47	10.36	8.39	8.36
1915	1.002	37.87	9.02	7.31	7.28
1925	1.300	29.19	6.92	1.36	1.46

Sources: Calculations by Andrew Reschovsky using Scott Derks, ed., *The Value of a Dollar: Prices and Incomes in the United States, 1860–1989* (Detroit: Gale Research, 1994), updated to 1995 using the consumer price index; and R. L. Bidwell, *Currency Conversion Tables: A Hundred Years of Change* (London: Rex Collings, 1970).

NOTES

INTRODUCTION

1. Beckmann to Caesar Kunwald in Uwe M. Schneede, ed., *Max Beckmann Briefe. Band I: 1899-1925* (Munich: R. Piper & Co., 1993), 1:38–39 (August 14, 1905).

2. See Minna Beckmann-Tube, "Erinnerungen an Max Beckmann," in Doris Schmidt, ed., *Max Beckmann. Frühe Tagebücher* (Munich: Piper, 1985), pp. 179–80. Lilly von Schnitzler told Christian Lenz that Beckmann's three conditions for his marriage to Mathilde von Kaulbach were the following: (1) that she would have no career; (2) that they would have no children; and 3) that Beckmann could see Beckmann-Tube as often as wanted. Beckmann continued to have trysts with Beckmann-Tube after his marriage to Kaulbach.

3. Beckmann to Julius Meier-Graefe (mid-March 1919), *Briefe* 1:176–77.

4. Christoph Bernoulli on Simon's Friday luncheons around 1922–23, quoted in Wolfgang Schivelbusch, *Intellektuellendämmerung. Zur Lage der Frankfurter Intelligenz in den zwanziger Jahren* (Frankfurt a.M.: Insel, 1982), pp. 47–48.

5. On the print, identifications, and *Hell* at large see Barbara Copeland Buenger, "Max Beckmann's 'Ideologues': Some Forgotten Faces," *Art Bulletin* 71, no. 3 (September 1989): 453–79.

6. Beckmann to Günther Franke (January 30 and February 3, 1934) in Stephan von Wiese, ed., *Max Beckmann Briefe. Band II: 1925-37* (Munich: Piper, 1994), 2:239–40.

7. Lothar-Günther Buchheim, *Max Beckmann* (Feldafing: Buchheim, 1959), p. 114.

DIARY, AUGUST 14–SEPTEMBER 20, 1903

This translation by Barbara Copeland Buenger and notes are based on the German edition, *Max Beckmann: Frühe Tagebücher, 1903–1904 und 1912–1913, mit Erinnerungen von Minna Beckmann-Tube,* with notes and commentary by Doris Schmidt (Munich: Piper, 1985), pp. 9–50, 131, 141–44, © R. Piper GmbH & Co. KG, München 1985, and on the original manuscript in the possession of the Beckmann estate. In this volume the placement of bullets corresponds to the Schmidt edition, which used this system to mark Beckmann's starts and stops and changes of writing utensils.

1. The sketches are catalogued in *Frühe Tagebücher*, p. 131. See also the diary pages reproduced in facsimile on pp. 11, 47.

2. In this volume many of the basic facts of Beckmann's life are taken from the chronology in Erhard Göpel and Barbara Göpel, *Max Beckmann:*

Katalog der Gemälde (Bern: Kornfeld and Cie, 1976; hereafter referred to as *Katalog*), 1:13–32. The fullest account of Beckmann's earliest years and background is found in Rudolf Pillep, "Die Leipziger Jahre Max Beckmanns und seiner Familie: Eine Quellenstudie mit Dokumenten-Anhang und Briefen," *Leipzig: Aus Vergangenheit und Gegenwart. Beiträge zur Stadtgeschichte*, vol. 5 (Leipzig: Museum für Geschichte der Stadt Leipzig Fachbuchverlag Leipzig, 1988), pp. 94–113. Beckmann's parents and ancestors of several generations came from areas near Helmstedt and Königslutter in Lower Saxony. His mother, Antoinette Henriette Bertha Düber Beckmann (1846–1906), came from a family of brewers and millers in Königslutter. His father, Carl Heinrich Christian Beckmann (1839–95), had owned a mill in Helmstedt and was a saloon-keeper, produce dealer, salesman, and mill- and house-owner. The couple moved to Leipzig with their two older children, Margarethe Friederike Auguste Johanne (Grethe, 1869–1940) and Richard (1874–1926) in 1878; Beckmann himself was born in Leipzig in 1884. As Pillep notes (pp. 113–14), in the seventeen years in Leipzig the Beckmann family lived in fourteen different apartments, which would seem to reflect their rising prosperity in a period of boom growth, the need to improve their station by changing addresses, and the rapid growth and change of that city.

3. On Beckmann's early background and training in Weimar, see Barbara Copeland Buenger, "Beckmann's Beginnings: *Junge Männer am Meer*," *Pantheon* 61 (April–June 1983): 134–44.

4. On Minna Beckmann-Tube's background see the extensive memoir in her "Erinnerungen an Max Beckmann," in *Frühe Tagebücher*, pp. 157–86.

5. That is, in the Reclam Universal-Bibliothek (Leipzig) and the Hendel Bibliothek der Gesamt-Litteratur des In- und Auslandes (Library of the complete world literature, Halle, hereafter abbreviated as BGL). In his early diaries Beckmann frequently referred to books he read or purchased by author, title, price, publisher, or number in a publisher's series. Many times, though, he gave only one or two of these indications, so that it is impossible to determine the precise volume he had in hand. Several of the Reclam volumes Beckmann acquired were first identified by Doris Schmidt.

6. Beckmann owned many other books not mentioned in his diaries. The fullest list of the state of his library at his death is found in Peter Beckmann and Joachim Schaffer, eds., *Die Bibliothek Max Beckmanns* (Worms: Werner, 1992) (hereafter referred to as *Bibliothek*). Almost none of the books mentioned in this diary, however, are on that list.

7. Beckmann-Tube, "Erinnerungen an Max Beckmann," p. 157. Beckmann-Tube's mother, Ida Concordia Römpler Tube (1843–1922), was a lively, intelligent, and artistically talented woman who had been married to Dr. D. Paul Tube (d. 1889), a senior military pastor and theologian. After living in Metz, Posen, and Danzig, Ida Tube had moved to Altenburg after the death of her husband.

8. Beckmann-Tube, "Erinnerungen an Max Beckmann," p. 159. This examination was for the one-year volunteer (*Einjährig-Freiwilliger*) exemption from compulsory military training. Beckmann-Tube said Beckmann had failed the exam when he initially took it in 1902. In a letter of March 1904 to his friend Caesar Kunwald, Beckmann indicated that he had finally

passed it, presumably before he left Braunschweig in the summer of 1903. See Beckmann to Caesar Kunwald, March 16, 1904, in *Briefe*, 1:19.

9. A cousin later remembered that Beckmann was already reading Nietzsche at the age of thirteen (noted in Otto Stelzer, "Max Beckmann: Ein Braunschweiger Kind," *Salve Hospes* 3 [June 1953]: 39).

10. Ernst-Gerhard Güse, *Das Frühwerk Max Beckmanns* (Frankfurt and Bern: Lang, 1977), was the first study to establish the fundamental importance of Nietzsche for Beckmann. On Nietzsche and the Nietzsche cult and influence, see Steven E. Aschheim, *The Nietzsche Legacy in Germany, 1890–1900* (Berkeley: University of California Press, 1992).

11. Kessler, a progressive advocate of cultural change and one of the most influential figures of the contemporary German artistic scene, directed Weimar's museums until the summer of 1906. Dubbed "the red count" because he championed George Grosz and other radical artists during the Weimar Republic, Kessler remained a leading spokesman for German artistic, literary, and political affairs until his death.

The Belgian van de Velde—like Kessler, a progressive advocate of social reform—moved to Germany in 1900 because the large supply of excellent craftsworkers in Thüringen enabled him to execute his numerous commissions more quickly and efficiently than he could in Belgium. After an initial stay in Berlin, van de Velde moved to Weimar, where he initiated a seminar on arts and crafts in 1902 and opened his celebrated school of arts and crafts in 1904. From 1910 to 1914 he joined Kessler and Förster-Nietzsche in the development of plans for a grand Nietzsche monument in Weimar, but the monument had to be abandoned because of the Weimar Nietzsche circle's nationalistic opposition to a Belgian architect and because of the onset of World War I. At the beginning of the war van de Velde left Weimar for Switzerland. See Günther Stamm, "Monumental Architecture and Ideology: Henry van de Velde's and Harry Graf Kessler's Project for a Nietzsche Monument at Weimar, 1910–1914," *Gentse Bijdragen* 23 (1973–75): 303–42.

Förster-Nietzsche, the highly conservative widow of a man who had attempted to found an Aryan colony in Paraguay, had brought her insane brother to Weimar in 1897. She thereafter managed the Nietzsche Archives and supervised the publishing and editing of Nietzsche's literary estate, often to the discredit of Nietzsche's actual achievement. She established the archives in her home in the Villa Silberblick on the southwest outskirts of the city, across the cemetery from the Weimar academy.

12. Paul Verlaine (1844–96). An inexpensive German edition of Verlaine's poems, *Gedichte*, translated by H. Kirchner, was in the Hendel BGL. This line, which sounds as if it might come from one of Verlaine's early poems, has not been identified.

13. Ludwig Bechstein (1801–60) was renowned for publishing collections of fairy tales.

14. On the recto of the following page Beckmann drew a landscape (W. 6, reproduced in *Frühe Tagebücher*, p. 11). On the verso he drew a map of Paris that highlighted the Latin Quarter, perhaps after his arrival. He showed the Luxembourg, his own apartment at 117, rue Notre Dame des

Champs, the nearby Atelier Colarossi (10, rue de la Grande-Chaumière), where he often drew models, and the boulevard du Montparnasse and boulevard St. Michel. He also gave the more distant coordinates of the boulevard de Strasbourg, Gare du Nord, Gare de l'Est, Louvre, and Tuileries. The two following pages were torn from the diary.

15. Nietzsche's *Jenseits von Gut und Böse* (Beyond good and evil).

16. A postcard sent by Beckmann to his mother on May 20, 1902, gave her address as Theaterpromenade 6/II, the last Braunschweig address at which she is known to have lived. The street directly adjoined the Herzoglicher Park (now Theater and Museum Parks), which is perhaps the park to which Beckmann referred in this diary.

17. Beckmann was referring to Weimar and his many walks with Minna Tube. The castle was either the Schloß (built 1790–1803 on much earlier foundations) or the more distant Schloß Belvedere (1724–32) or Schloß Tiefurt (begun 1760, redesigned after 1781).

18. Tiefurt is two miles east of Weimar on the Ilm.

19. The Ilm River, a tributary of the Saale, runs from Tiefurt to Weimar and through the Weimar Park.

20. The four following pages were torn out.

21. As noted by Schmidt in *Frühe Tagebücher*, p. 141 n. 8, these were probably what Beckmann considered to be the dates of his relationship with Minna Tube.

22. Ralph Waldo Emerson, a leading figure of American transcendentalism, published *Representative Men* (essays on Goethe, Montaigne, Napoleon, Plato, Shakespeare, and Swedenborg) in 1850. The volume appeared as a second volume of Emerson's essays.

23. The numbers and title refer to Emerson's *Essays*, trans. Oskar Dähnert (Leipzig: Reclam, 1897).

24. Beckmann crossed out *stark* (strong) and wrote *gut* (good).

25. Beckmann had studied art books since childhood and received instruction in art history at the Weimar academy. Ramses II lived in the period of Egypt's New Kingdom and was associated with many monuments, including the temple at Karnak, the Rameseum, the temple at Luxor, and the temple at Abu Simbel. Many different portraits of him exist, in several different styles.

26. Deliberate misspellings of Nietzsche's, Schopenhauer's, and other authors' names appear throughout Beckmann's diaries.

27. Direct quote from Nietzsche's *Jenseits von Gut und Böse*. This translation is by Walter Kaufmann, from *Beyond Good and Evil: Prelude to a Philosophy of the Future* (New York: Vintage Books, 1966), p. 15 (part 1, sec. 8).

28. Ibid., p. 43 (2:30).

29. Beckmann's "Notes on the Philosophy of Beauty" are Schopenhauerian, especially in their stress on aesthetic transcendence and on how "life is happiest when it most reflects the eternal repose and beauty of the universe" (cf. Schopenhauer's emphasis on the escape from the will into tranquility). The mention of the "gradation and subordination" also recalls

Schopenhauer's discussion of the platonic forms. Beckmann could already have been reading *Die Welt als Wille und Vorstellung* (The world as will and representation) or the *Handschriftlicher Nachlaß*.

30. The fragmentary religious writings of the French physicist and philosopher Blaise Pascal were first published as *Pensées* in 1670 and continued to attract attention in the early twentieth century, especially because of Pascal's emphasis on the inadequacy of reason in the face of metaphysics. Heinrich Hesse's German translation of an edition annotated by Voltaire was published by Reclam.

31. Reclam published Eduard Griesebach's edition of the collected works of Schopenhauer, including the *Handschriftlicher Nachlaß*, between 1891 and 1894.

32. The Dutch philosopher Baruch Spinoza strongly influenced German idealist philosophy and was discussed by many of the writers Beckmann read.

33. The abbreviation is left untranslated; Beckmann's meaning is unknown.

34. The Elm mountains rise to the southeast of Braunschweig.

35. Nietzsche, *Beyond Good and Evil,* p. 36 (2:25).

36. The numbers 1043, 1313, and 1317 do not logically correspond to related volumes in the Reclam or BGL lists.

37. Johann Karl August Musäus (1735–87) published a vast collection of German folk tales, the *Volksmärchen der Deutschen* (1782–86).

38. The Scotch writer James Macpherson (1736–96) invented the name and person of Ossian, a legendary Gaelic warrior and author of tomes of ancient Celtic legend that were actually written by Macpherson himself. Though Macpherson's fabrication of Ossian was firmly established in the early nineteenth century, Ossian continued to be read widely throughout the nineteenth and early twentieth centuries.

39. Beckmann was charting the times of trains to travel to Leipzig-Rosenthal for a farewell meeting with Minna Tube.

40. Beckmann used the dialect "Ne, also det jeht nicht."

41. Beckmann anticipated that his meeting with Minna Tube would be somber and awkward.

42. The Swiss writer Gottfried Keller (1819–90) was a poetic realist known for his passionate and vital characterization of human nature. He is best known for his autobiographical *Bildungsroman* about the life of an artist, *Der grüne Heinrich* (Green Henry, 1854–55), and for the short stories about Swiss small-town life in *Die Leute von Seldwyla* (The people of Seldwyla, 1856–74).

43. The French novelist and short-story writer Guy de Maupassant. Maupassant's psychological realism was influenced by Gustave Flaubert: he depicted unhappy characters who were victims of their own selfishness and sensuality. His best-known novel, *Bel-Ami* (1885), is about an ambitious journalist.

44. The French novelist, journalist, and cleric Antoine-François Prévost d'Exiles (1697–1763) remains best known for *Manon Lescaut* (1731), the

seventh volume of his *Mémoires d'un homme de qualité,* which represents a young man's passionate fall for an amoral woman and his eventual redemption through suffering and religion.

45. Beckmann would have read widely in the works of Germany's most celebrated author and genius, Johann Wolfgang von Goethe, since childhood. He probably read and learned more of Goethe during his sojourn in Weimar, the city in which Goethe spent most of his adult life. In his comment, though, Beckmann suggested that Goethe's ideas of love no longer seemed relevant.

46. The Belgian writer Maurice Maeterlinck (1862–1949) was a key figure in the Belgian and French symbolist movements and was strongly influenced by the mysticism of the German romantic writer Novalis (1772–1801) and Emerson. Maeterlinck became extremely popular in the decade before World War I for his emphasis on ennui, death, and universal mystery.

47. Beckmann often affected some dismissal of Nietzsche, probably because of the latter's tremendous contemporary popularity and cult status. He belied this, however, with the tremendous engagement and humor of his responses to Nietzsche throughout this diary.

48. Beckmann makes no other specific reference to his readings in Kant, but his previous "Notes on the Philosophy of Beauty" (August 23, 1903) indicate that he was thinking about ideas of metaphysics and aesthetics that Schopenhauer had developed from Kant. As noted in Beckmann and Schaffer, *Bibliothek,* p. 488, a 1908 edition of Kant's *Kritik der reinen Vernunft* (Critique of pure reason, 1781) was in Beckmann's library at the time of his death.

49. In this as well as in his "Notes on the Philosophy of Beauty," Beckmann's celebration of the natural unfurling of nature also directly reflects the pantheism of Goethe.

50. Beckmann's mother died of cancer in Braunschweig in August 1906.

51. Beckmann was baptized in the Lutheran Church of St. Nikolai in Leipzig. As was customary, he probably received Lutheran instruction and learned the catechism in both the church and the north German schools he attended. Otherwise, neither he nor his family seems to have had much formal affiliation with the church.

52. Beckmann and Minna Tube met in the Leipzig suburb of Rosenthal, one of the many different locations at which his family had lived during their years in that city.

53. Direct quote from poem 74 of Heinrich Heine's *Die Heimkehr* (The homecoming, 1823–24).

54. Nietzsche, *Beyond Good and Evil,* p. 91 (4:161): "Poets treat their experiences shamelessly: they exploit them." The celebrated German lyric poet Heinrich Heine had strong roots in romanticism but left Germany for exile in Paris in 1831 because of his revolutionary political views as a member of the Young German Movement. A witty cosmopolitan and outspoken critic and stinging satirist, Heine nonetheless always remained passionate about Germany and its countryside. His works show great energy, spirit, poignancy, lyricism, irony, and humor, and it is not surprising that Beckmann admired him.

55. *Die Fledermaus* (The bat), an operetta by Johann Strauss, was first performed in 1874. The song Beckmann quotes is from act 3, in which Adele, the Eisensteins' maid, asks Frank, the governor of the prison, to help her start a stage career. She sings of her versatility as an artist and says there is nothing she cannot do.

56. Minna Tube was slightly cross-eyed.

57. As Schmidt (in *Frühe Tagebücher*, p. 143 n. 25) notes, Beckmann was referring to Hans Holbein the Younger's (1497/98–1543) *Lady Parker* (Windsor Collection, London).

58. From the time they first met, Beckmann and Minna Beckmann-Tube had strongly differing ideas about whether she should pursue a career. As noted in Beckmann-Tube, "Erinnerungen an Max Beckmann," p. 162, before they met at the Großherzogliche Kunstschule in Weimar, she had studied from 1900 to 1903 in the Munich Künstlerinnenverein and in the Damenakademie der Akademie der bildenden Künste, where she would have encountered much talk about women pursuing their own careers. Many of the couple's friends were also trying to make similar career decisions. Although both left Weimar with top prizes and Beckmann-Tube briefly continued art study in Amsterdam and Berlin, she would ultimately abandon her career as a painter to devote herself to Beckmann and their son Peter (1908–90). As Beckmann-Tube noted in "Leben an der Seite eines Genies," *Der Regenbogen* (Baden-Baden) (1962): 5, her decision to take on a career as an opera singer in 1915 was probably a major reason for their separation and eventual divorce. In an elided passage of "Erinnerungen an Max Beckmann" (pp. 179–80), however, she noted that when Beckmann returned from the Eastern Front in 1914, she first learned that women were pursuing him, suggesting that his philandering might also have been a cause.

59. Although many have assumed Heine, born a Jew and converted to Christianity to further his career, to be an atheist, he was in fact a deist.

60. Beckmann's comments about morality, especially about the dogmatism of morality and the need for morality to change constantly, suggest that he had been reading Nietzsche's "Natural History of Morals" in *Beyond Good and Evil*, pp. 97–118 (part 5).

61. Quotation from Arthur Schopenhauer, *Handschriftlicher Nachlaß: Anmerkungen zu Platon, Locke, Kant, und nachkantischen Philosophen*, vol. 3, ed. Eduard Griesebach (Leipzig: Reclam, 1892), p. 82. This passage, from the Berlin manuscript of 1813, was in a footnote to Schopenhauer's commentary on Kant's *Kritik der Urtheilskraft* (Critique of judgment). This is published in the first volume of the current edition of the *Manuscript Remains*, ed. Arthur Hübscher, trans. E. F. J. Payne (Oxford: Berg, 1988), p. 51n. The section that precedes Beckmann's quote reads: "The *magic of the past* comes from the same source. When we picture to ourselves past days and distant places, we recall merely the objects, not the subject with all its woe and misery, which it then had just as it now has and which (just because it was vain and empty) is forgotten and, like useless dregs, is abandoned by us. We remember merely the objective, and then the objective in our recollection, its consideration filling our consciousness, acts on us like the present objective when we prevail upon ourselves to give ourselves up to its contem-

plation. It frees us from the subject that is wretched, always in need and limited to a narrow sphere, and the better consciousness becomes free. And so it comes that, especially when we are in trouble and afraid, the sudden recollection of a time when there was not this trouble flies past us like a lost paradise, because now only the objective and not the subjective returns, and we imagine that at that time we were as free for that objective as we now are; yet even then the subjective had its troubles."

62. The Koran was number 1501–7 in the BGL series.

63. BGL 72 was Heinrich Heine's *Atta Troll* (1847), a satirical epic.

64. BGL 66 was the Danish author Hans Christian Andersen's *Picture Book without Pictures* (1840), a collection of fairy tales.

65. BGL 1620–21 was the British novelist George Eliot's *Silas Marner: The Wool Weaver from Ravenloe* (1861), trans. K. Wuest.

66. BGL 1261 was a volume of Maupassant poems, trans. F. Steinitz.

67. BGL 548 was Ovid's *Liebesbüchlein: Ein Cyclus altrömisches Lebens in modernem Gewande* (probably a standard edition of the erotic poems, *The Amores, The Art of Love, Cures for Love,* and *On Facial Treatment for Ladies* [ca. B.C. 20]), trans. F. Herz.

68. BGL 276 was Sophocles' *Oedipus Rex* (ca. 429 B.C.), trans. R. Körner.

69. BGL 364 was the German author Johann Fischart's (1546–90) moral satire on the problems of marriage, *Ehzuchtbüchlein* (Primer on marital decorum, 1572), ed. G. Holten-Weber.

70. Beckmann was speaking of his French teacher.

71. Beckmann's brother, Richard, had just returned from his first trip to America. Richard had long been a student and seemed perpetually unable to decide on which direction he would pursue, a source of continual irritation to Max. See Pillep, "Die Leipziger Jahre Max Beckmanns," pp. 105–9.

72. Maximillian Delphinus Berlitz founded his first school of language instruction in 1878.

73. How Beckmann arrived at this insight—from reading the fairy tales or from a factual report—is unknown. Andersen once posed for a photograph with a pipe in his hand and in at least one letter spoke of enjoying a good smoke.

74. The German composer Giacomo Meyerbeer (1791–1864), a chief creator and exploiter of French grand opera, was well-known for spectacular, popular, and obvious dramatic effects. Queen Louise of Prussia (1776–1810) was one of the most beloved female figures of German history, renowned for her unpretentiousness, charm, symbolic resistance to the French during the Napoleonic occupation, and early death. From the Biedermeier period on she was commemorated in an abundance of popular images such as the one that found its way into the Beckmann home.

75. That is, Beckmann's mother predicted that he, too, would go mad (Nietzsche had gone insane in 1889).

76. BGL 73 and 74 were Heine's *Reisebilder* (Travel pictures, 1826–31); BGL 75 was Heine's *Neue Gedichte* (New poems, 1844) and *Zeitgedichte* (Poems for the times, 1850s).

77. The *Meditations* presented the Stoic philosophy of the Roman emperor and philosopher Marcus Aurelius; a German edition, trans. Hans Stich, was available from Hendel (BGL 1549–50).

78. The *Enzyklopädie der philosophischen Wissenschaften im Grundrisse* (Encyclopedia of the philosophical sciences) (1817) was Georg Wilhelm Friedrich Hegel's outline of his idealist philosophy.

79. A German translation of the Danish writer Jens Peter Jacobsen's (1847–85) historical romance, *Marie Grubbe: A Lady of the Seventeenth Century* (1876), was available in the BGL series. The novel was a tale of spiritual degeneration in seventeenth-century Denmark.

80. At the end of this passage is a first drawing of figures in a landscape that anticipates the figural ideas Beckmann finally developed in his first major painting, *Young Men by the Sea* (1904–5, G. 18) (reproduced in *Frühe Tagebücher*, pp. 43, 136).

81. Four pages were ripped out at this point.

82. The Durand-Ruel Galerie was located at 16, rue Laffitte, Paris.

83. As noted by Schmidt in *Frühe Tagebücher*, p. 144 n. 41, this passage of Thekla's lines is from Friedrich von Schiller's *Die Piccolomini* (1757–66), the second drama in the *Wallenstein* trilogy (1797–99). In this play, the youthful and pure young lovers, Max Piccolomini and Thekla, were figures invented by Schiller. Just as Beckmann would have read much Goethe, he would have been well-versed in the works of Schiller and would have known Weimar, too, as the city in which Goethe and Schiller had enjoyed their close association.

84. This translation from *Die Piccolomini* (act 3) is from *Wallenstein: A Historical Drama in Three Parts*, trans. Charles E. Passage (New York: Frederick Ungar, 1958), p. 102.

85. Beckmann is again thinking of Weimar. The artists' home (then apparently in the Poseck Haus) was a place designated for meetings, parties, and exhibitions. He was probably referring to the large, flat black hat in which he portrayed himself in a drawing now in the Staatliche Graphische Sammlung in Munich (1902, pen and ink, watercolor, and chalk, 23.6 cm × 20.6 cm).

86. The Norwegian Carl Frithjof Smith (1859–1917) taught both Beckmann and Minna Tube in Weimar. Smith was primarily a painter of realist genre, and Beckmann remained grateful for his instruction throughout his life. Mili Plump (1879–1947) was a fellow student at Weimar who later married the sculptor Wilhelm Gerstel (1879–1963). The Hungarian Caesar Kunwald (1870–1946), one of Beckmann's closest friends in the pre–World War I period, was also a fellow student at Weimar.

87. On the reverse side of the page are five sketches of the clothes, hair, and poses of a woman (Minna Tube?) (reproduced in *Frühe Tagebücher*, p. 47).

88. Beckmann was listing the schedule of his travel to Paris.

89. Börsum was at the junction of the Magdeburg-Cologne line, where Beckmann would have transferred for a train to the west.

90. Beckmann chose a popular tourist route and traveled on one of the Rhine's most attractive stretches. Andernach, a port on the Rhine that became part of Prussia in 1815, is a charming old medieval town known for its Romanesque church and sixteenth-century town hall. Beckmann seems to have stayed there two nights, Monday and Tuesday, September 21–22, 1903.

91. The Drachenfels is a popular tourist spot, the peak of the Sieben-

gebirge overlooking the Rhine near Königswinter. The Drachenfels is sur-
mounted by the ruins of Schloß Drachenfels, abandoned since the Thirty
Years' War, and located near the Drachenhöhle, the legendary home of the
dragon slain by Siegfried.

92. According to this schedule Beckmann would have arrived in Paris
on the evening of September 23, 1903.

93. A facsimile of the diary page with this entry is reproduced in *Frühe
Tagebücher,* p. 137.

94. This was one in a series of similar large buildings near the Jardin du
Luxembourg, not far from the intersection of boulevard du Montparnasse
and boulevard St. Michel.

DIARY, DECEMBER 6, 1903–JANUARY 6, 1904

This translation by Barbara Copeland Buenger and notes are based on
Schmidt's edition of *Frühe Tagebücher,* pp. 51–76, 131–33, 144–45, © R.
Piper GmbH & Co. KG, München 1985, and on the original manuscript in
the possession of the Beckmann estate.

1. See the illustrations, facsimiles, and catalogue of the drawings in
Frühe Tagebücher, pp. 60–73, 138–39, 131–33. On *Young Men by the Sea*
see Buenger, "Beckmann's Beginnings."

2. See *Briefe,* 1:16–20, 27–33.

3. The Académie Julian was at 31, rue du Dragon, southwest of St. Ger-
main des Prés. The Académie Colarossi was at 10, rue de la Grande-
Chaumière, southwest of rue Notre Dame des Champs.

4. The famed Closerie des Lilas was at the intersection of the bou-
levard du Montparnasse and boulevard St. Michel at 171, boulevard du
Montparnasse.

5. The Weimar Park is a long park that runs on both sides of the Ilm
behind the Schloß.

6. Beckmann added this phrase in 1905.

7. The festival scene is near the end of act 3 of Richard Wagner's *Die
Meistersinger von Nürnberg* (The mastersingers of Nuremberg, 1867).

8. Facsimiles of the last entry of December 6 to here are reproduced in
Frühe Tagebücher, pp. 138–39.

9. Jean Paul, the pseudonym of Johann Paul Friedrich Richter, renowned
for his rambling, humorous, eccentric, and sentimental novels, remained a
lifetime favorite of Beckmann. As noted in Beckmann and Schaffer, *Bib-
liothek,* pp. 416–21, 485–87, at least twenty-one volumes of Jean Paul were
in Beckmann's library at his death. Jean Paul's wonderfully meandering and
fantastic discussions and descriptions demand the absolute and undivided at-
tention of readers; they are not to everyone's taste, but reward devotees with
their exceptional liveliness.

10. The Concerts Rouges was a café-concert at 6, rue de Tournon, just
north of the Jardin du Luxembourg. Café-concerts featured a variety
of popular musical entertainment from vaudeville, operettas, and other
shows.

11. As Schmidt has noted in *Frühe Tagebücher,* p. 144 n. 3, place Saint-
Sulpice 6 is the address of a building with a distinguished facade by Jean-

Nicolas Servandoni (1695–1766)—originally planned as part of a semicircle of buildings that was never realized—two blocks north of the Jardin du Luxembourg.

12. The text of an express letter Beckmann prepared to send to his concierge in Paris, Madam Fusther.

13. Beckmann was trying to think of the right name, presumably of the people with whom Minna Tube was staying.

14. Beckmann was probably in the Baulig beer hall (Zum Franziskaner), Warmoesstraat 182, in the harbor and inner town area. A 1910 Baedeker's says that the "Warmoes-Straat and the Zeedyk, running to the south and southeast, respectively, from the square in front of the church of St. Nicholas, are apt, in the evening, to be the scene of somewhat rowdy manifestations of popular amusement" (Karl Baedeker, *Belgium and Holland* [Leipzig: Karl Baedeker, 1910], p. 370).

15. *Winterreise* (1827) is a cycle of twenty-four poems set for solo voice and piano accompaniment by Franz Schubert. Minna Beckmann-Tube, "Erinnerungen an Max Beckmann," p. 166, remembered this as a concert sung by the baritone Johannes Martinus Messchaert (1857–1922).

16. This passage was next to a single small drawing of a standing clothed (female?) figure against a dark ground.

17. Beckmann was writing his impressions from his first visits to the Rijksmuseum.

18. Rembrandt's *Night Watch* (1642, Rijksmuseum, Amsterdam); *Family Portrait* (before 1737, Herzog-Anton-Ulrich Museum, Braunschweig).

19. Frans Hals, Gerard Terborch or Ter Borch, and Jan Vermeer. All are represented by numerous works in the Rijksmuseum.

20. Following this entry are a drawing of a man playing the guitar (reproduced in *Frühe Tagebücher*, p. 60) and drawings of a woman's dress, which Beckmann later annotated (on March 13, 1905) with "My God, how can anything really show so little taste as these reform clothes" (noted in *Frühe Tagebücher*, p. 145 n. 8).

21. The following pages (22 verso through 36 recto) are mostly filled with sketches, partially reproduced in *Frühe Tagebücher*, pp. 61–69. These included many sketches of women, some presumably of Minna Tube, others of musicians in a chamber concert. Among the unpublished drawings are several quick sketches of a nude, an almost Munch-like profile of a woman, and a sketch of Jugendstil-like designs.

22. The passage is followed by the profile sketch of a young girl and then by several other drawings, including further sketches of nudes out of doors that anticipate *Young Men by the Sea*. See *Frühe Tagebücher*, pp. 70–73.

23. The Closerie des Lilas.

24. Beckmann wrote this passage in a large script.

25. This passage was followed by an address, "Naciver, 18 Bd De la Tour Maubourg," and a page with two portrait sketches. See *Frühe Tagebücher*, p. 133.

26. Beckmann wrote this last passage vertically across the last page in stylized Jugendstil block letters.

DIARY, JANUARY 6 OR AFTERWARD—MARCH 9, 1904

This translation by Barbara Copeland Buenger and notes are based on Schmidt's edition of *Frühe Tagebücher*, pp. 77–94, 146–47, © R. Piper GmbH & Co. KG, München 1985, and on the original manuscript in the possession of the Beckmann estate.

1. See illustrations, facsimile pages, and the catalogue of drawings in *Frühe Tagebücher*, pp. 81, 86, 88–89, 94, 133.

2. Jean Paul characteristically broke up his narratives, moving back and forth from positions as both narrator and participant and imposing seemingly arbitary restrictions on the duration of each section. The novel's subtitle, for instance, refers to the forty-five chapters that were supposedly carried individually to the author's friend by a Pomeranian dog.

3. A partial listing of the works exhibited in the Salon des Indépendants is found in Donald E. Gordon, *Modern Art Exhibitions, 1900–1916*, vol. 2 (Munich: Prestel, 1974), pp. 86–89.

4. The German word seems to be *wund*.

5. That is, Beckmann skeptically asks if Minna Tube's and Mili Plump's suffering will have any creative results.

6. The sentence is transcribed "dann wird er dich Sch[w]arz [?] machen" in *Frühe Tagebücher*, p. 78, but *schwarz* does not make sense.

7. An aside of Victor, a court surgeon who loves all beautiful girls and is closely modeled on Jean Paul himself, from Jean Paul's *Hesperus*. The passage was slightly changed by Beckmann but retains the meaning of the original. The German text of Jean Paul reads: "ein Poet sitzt wie die Nachtigall (der er an Gefieder, Kehle und Einfalt ähnelt) oben auf dem Baume und sieht die Falle stellen und hüpft hinunter und—hinein" (*Hesperus, oder 45 Hundposttage: Eine Lebensbeschreibung*, in *Jean Paul Werke*, vol. 1, ed. Norbert Miller [Munich: Carl Hanser, 1960], p. 837). An older English translation of a larger section of this passage by Charles T. Brooks, *Hesperus, or Forty-Five Dog-Post-Days: A Biography*, vol. 1 (Boston: Ticknor and Fields, 1865), p. 449, reads as follows: "The second lesson which is to be learned from this (this, however, to be sure, presupposes Joachime's being a coquette) is, that a hero may scent coquetry, and yet run into the trap; a poet, like the nightingale (which he resembles in plumage, throat, and simplicity) sits up on the tree, and sees the snare set, and skips down and—into it."

8. Another passage from Victor's musings in *Hesperus* (p. 841): "Seine Meinung war: 'die Dichter wären nichts als betrunkene Philosophen—wer aber aus ihnen nicht philosophieren lerne, lern' es aus Systematikern ebensowenig." From the Brooks translation (1:454): "His opinion was, that the poets were nothing but intoxicated philosophers,—but whoever could not learn philosophizing from them, would learn it quite as little from the systematicians."

9. The narrator's (Jean Paul's) aside, mocking the formalities of court life as Victor—also a critic of court life—arrives at court in *Hesperus* (p. 847): "Dieses Gastwirtleben am Hofe, täglich Leute zu sehen, die nicht einmal Ich sagen, deren Verhältnisse man so gleichgültig unkennt wie deren Talente, wenn sie nicht ein Bedürfnis sucht." A longer passage from the Brooks translation (1:462) reads: "Nothing chills the noblest parts of the inner man more than intercourse with persons in whom one cannot take any interest."

This hotel-life at court, this daily seeing people who never even say 'I,' whose relations one ignores as indifferently as their talents, unless some necessity seeks them."

10. Matthieu to Victor in *Hesperus* (p. 862): "Nimm zwei junge große Herzen—wasche sie sauber ab in Taufwasser oder Druckerschwärze von deutschen Romanen—gieße heißes Blut und Tränen darüber—setze sie ans Feuer und an den Vollmond und lasse sie aufwallen—rühre sie fleißig um mit einem Dolche—nimm sie heraus und garniere sie wie Krebse mit Vergißmeinnicht oder andern Feldblumen und trage sie warm auf: so hast du einen schmackhaften bürgerlichen Herzenskoch." The same passage from the Brooks translation (1 : 482 – 83): "I will make you a cookery-book receipt for a good citizenly love: take two young and large hearts,—wash them clean in baptismal water or printer's ink of German romances,—pour on them warm blood and tears,—set them on the fire and under the full moon, and let them boil,—stir them briskly with a dagger,—take them out and garnish them, like crabs, with forget-me-not or other wild-flowers, and serve them up warm: in that way you have a savory citizenly heart-soup."

11. Victor to Joachime in *Hesperus* (p. 863): "ihre Rolle ist die einer Hörschwester; denn die bürgerliche Mädchen wissen nicht zu reden, wenigstens mehr in Haß als in der Liebe." A longer passage from the Brooks translation (1 : 483) reads: "I am in love with the second daughter of the *pastor primarius;* her part is that of a listening-sister; for maidens in citizenly life know not how to talk, at least they can do it better in hatred than in love." As noted, Minna Tube's father was a pastor.

12. On the page opposite are a sketch of a woman in profile and the inscription "Ester Victoir Queine d'Angleterre." The written reference is presumably to Queen Victoria.

13. In a letter to Caesar Kunwald (February 1, 1904, *Briefe*, 1:17) Beckmann said he was painting "pictures" measuring 5.5 m × 4.0 m, which was far larger than his later *Young Men by the Sea* (148 cm × 235 cm). Minna Beckmann-Tube, "Erinnerungen an Max Beckmann," p. 165, recalled that one of these paintings was planned to represent a horseback rider.

14. Schubert's Piano Quintet in A, op. 114, "The Trout" (1819).

15. On the bottom of the page (15 recto) is a profile portrait of a bearded man, noted in *Frühe Tagebücher*, p. 133.

16. The page (15 verso) begins with a sketch of the architecture in the court of the Concerts Rouges (the garden now belongs to the Institut Français d'Architecture) with a woman standing before it (reproduced in *Frühe Tagebücher*, p. 81).

17. The painter Feigerl had also studied in Weimar and was living in Paris at this time.

18. Description of Victor looking at Clotilda, with whom he is deeply in love, in *Hesperus* (p. 1051): "Aber er hatte dabei die noch edlere Absicht, seine anbetende Aufmerksamkeit, sein zuweilen in Gestalt einer Träne ins Auge tretendes Herz von seiner geliebten Klotilde wegzurufen, um ihr eine ganz andere Aufmerksamkeit zu ersparen als die seinige." The same passage in the Brooks translation (2:220) reads: "But he had in this the still nobler design to draw off his adoring attention, his heart that sometimes started in

the shape of a tear to his eye, from his beloved Clotilda, in order to spare her a wholly different attention from his own."

19. Description from the dramatic love scene of Victor and Clotilda in *Hesperus* (p. 1059): "dann quollen endlich, wie Lebensblut aus dem geschwollnen Herzen, große Wonnetränen aus den liebenden Augen in die geliebten über." In the Brooks translation (2:229) this passage reads: "then at last gushed forth, like life-blood out of the swollen heart, great tears of bliss out of the loving eyes over into the loved ones."

20. Immediately following the previous passage between Victor and Clotilda in *Hesperus* (p. 1059): "Plötzlich stand er, wie von einer unermeßlichen Begeisterung gehoben, auf und sagte leiser, sie anschauend: 'Klotilde! dich, Gott und die Tugend lieb' ich ewig.'" The Brooks translation (2:229) reads: "Suddenly he rose, as if lifted by an immeasurable inspiration, and said in a lower tone, looking upon her: 'Clotilda, I love thee, God, and virtue forever.'"

21. Description of Victor as he prepares to leave Clotilda in *Hesperus* (p. 1077): "desto drückender waren seine Augen gespannt, und er ging lieber mit einem sich selber vollblutenden Herzen hinaus ins Freie und führte den Blinden mit." The Brooks translation (2:252) reads: "so much the more painful was the straining of his eyes, and he preferred to go out, with a heart bleeding itself full, into the open air, and led the blind one with him."

22. Description of Victor kissing Clotilda in *Hesperus* (p. 1086): "Wie ein Verklärter an eine Verklärte neigte er sich zurückgezogen an ihren heiligen Mund und nahm in einem leisen andächtigen Kusse." The Brooks translation of a slightly longer passage (2:263) reads: "Like a transfigured one to a transfigured he inclined himself modestly to her holy lip, and in a gentle, devoted kiss, in which the hovering souls only glide tremulously from afar to meet each other with fluttering wings, with a light touch he took from the yielding, dissolving lips the seal of her pure love, the repetition of his late Eden, and her heart and his all—."

23. The Moulin de la Galette, the famous public dancing hall at 77, rue Lepic in Montmartre.

24. The upper half of the following page was ripped out.

25. The other side of the page ripped out above.

26. The Norwegian Munch, who regularly moved between Berlin, Paris, Oslo, Hamburg, and Weimar, was in Paris to exhibit six paintings in the Indépendants exhibition, *Société des Artistes Indépendants: Grandes Serres de la Ville de Paris: 20e Exposition* (February 21–March 24, 1904). According to Beckmann-Tube, "Erinnerungen an Max Beckmann," p. 165, when Beckmann was later introduced to Munch in Berlin, he told Munch he had seen him at the Closerie.

27. In spite of his protests, Beckmann would continue to read more of Schopenhauer than of any other philosopher.

28. A framed sketch of standing figures follows on the next page, reproduced in *Frühe Tagebücher*, p. 86.

29. Reference to the exhibition and address of the Salon des Indépendants exhibition, which officially opened on February 21.

30. This address was in Montmartre, close to the Moulin de la Galette.

31. On the following pages Beckmann drew women in long dresses dancing a round dance, seemingly on a shore by trees (reproduced in *Frühe Tagebücher,* pp. 88–89).

32. Beckmann's reference to "Dehmelsche Gedichte" suggests he was reading a specific edition, *Zwanzig Dehmelsche Gedichte* (Berlin: Schuster and Loeffler, 1897), of the famous German poet, Richard Dehmel. Dehmel, one of the most popular writers at the turn of the century, was an important and exuberant conveyor of Nietzschean ideas of life affirmation who dealt continually with problems of life and sex. On Beckmann, Dehmel, and Nietzsche see Buenger, "Beckmann's Beginnings," p. 138.

33. Wilhelm Bölsche was a naturalist writer known for his popular, Darwinist writings, among them a famous account of the sexual life of animals, *Das Liebesleben in der Natur* (Love life in nature, 1898–1902), which argued for the naturalness of sex.

34. The recital of four Beethoven quartets was by the Capet Quartet at the Salle Erard, 13, rue de Mail, near the place des Victoires.

35. The Café Riche was at boulevard des Italiens 16, not far from the Opéra.

36. From 1889 to 1898 Beckmann's sister, Grethe, was married to Carl Julius Erich Ewald Lüdecke, by whom she had two children; Beckmann lived with them in Falkenburg, Pomerania, from 1892 to 1894. In 1898 the Lüdeckes moved to Berlin and were divorced. Grethe subsequently married Paul Zech, who was the brother-in-law Beckmann met in Paris.

37. The Théatre du Châtelet at the place du Châtelet was a large theater for spectacular pieces and ballet. *L'Oncle d'Amérique* (1826) was a *comédie-vaudeville,* a simple play that joined comic and serious scenes with satirical or jovial songs, by Eugène Scribe (1791–1861) and Édouard Mazères (1796–1866).

38. The transcription reads "daß [das] wollen."

39. The bottom of the page has been cut out, and drawings follow on the next pages: the top of a head (cut by removal of paper), a dancing man and woman, and another compositional sketch of naked young men by the sea that anticipates *Young Men by the Sea* (reproduced in *Frühe Tagebücher,* p. 94; see also p. 133).

40. The Salle Erard was the concert room where Beckmann often heard chamber music concerts.

DIARY, APRIL 1–MAY 7, 1904

This translation by Barbara Copeland Buenger and notes are based on Schmidt's edition of *Frühe Tagebücher,* pp. 95–108, 134, 148–49, © R. Piper GmbH & Co. KG, München 1985, and on the original manuscript in the possession of the Beckmann estate.

1. See the illustrations, facsimiles, and catalogue of drawings in *Frühe Tagebücher,* pp. 101, 102, 104–6, 134.

2. Beckmann to Caesar Kunwald, April 17, 1904, *Briefe,* 1:22.

3. Beckmann to Caesar Kunwald, June 9, 1906, *Briefe,* 1:44, suggests that he had seen the altar on his 1904 trip.

4. Beckmann mentioned the following stops on a route he traversed mostly by train, partly by foot, in slightly over two weeks: Paris, Fontainebleau, Avallon, Chastellux, Lormes, Château-Chinon, La Selle en Morvan, Autun, St. Emiland, Chalon-sur-Saône, Bletterans, Geneva (arriving April 12), Frankfurt am Main, Berlin. He presumably made other stops but did not cite them in his diary.

5. Fontainebleau is thirty-six and a half miles from Paris.

6. Beckmann was traveling in the direction of Avallon, about eighty-four miles southeast of Fontainebleau. From Avallon he moved toward the southwest to Chastellux and Lormes.

7. Nietzsche spoke repeatedly of actors, artists, and entertainers and of role-playing and artists of life. In *Jenseits von Gut und Böse* and other writings he often stressed the need to act or wear a mask. Here Beckmann might have been thinking of the passage in which Nietzsche spoke of the tortured behavior of youth before they had learned how to become "actors of life" (*Beyond Good and Evil*, p. 43 [2:31]).

8. Auxerre, a stop on the way to Avallon, is about sixty miles from Fontainebleau.

9. As noted by Schmidt in *Frühe Tagebücher*, p. 148 n. 2, St. Gervais is the name of the train station in Auxerre.

10. Chastellux is a village seven and a half miles southwest of Avallon on the way to Lormes. The village is on a hill on the left bank of the Cure, dominated by a castle of the thirteenth century.

11. The village's hotel was the Hôtel du Maréchal.

12. Lormes is a small town nine miles beyond Chastellux.

13. The table near the end of this volume gives 1995 values of foreign currencies.

14. Château-Chinon, a small town on the slope of a hill near the left bank of the Yonne, has the ruins of the château and fortifications. This is about twenty-two miles south of Lormes and twenty-three and a half miles from Autun.

15. La Selle en Morvan is fifteen and a half miles from Château-Chinon and eight miles from Autun.

16. Autun is eight miles from La Selle.

17. Beckmann probably meant *tartelettes*.

18. La Selle en Morvan.

19. The Baedeker guide described the hike from La Selle toward Château-Chinon (i.e., the direction opposite to that taken by Beckmann) as follows: "For some distance beyond La Selle the road ascends the picturesque valley of the Canche, at the end of which rises the Pic du Bois-du-Roi (2960 ft.), the highest summit of the Morvan Mountains. It takes about 4 hrs. to make the ascent and descent, starting from the tavern, about 3 ½ M. from La Selle, near which the road leaves the river" (Karl Baedeker, *Northern France* [Leipzig: Karl Baedeker, 1905], p. 392).

20. St. Emiland is about ten miles southeast of Autun on the way to Chalon-sur-Saône.

21. Bletterans is much farther from St. Emiland and about thirty miles southeast of Chalon-sur-Saône, the next stop mentioned in the diary.

22. Chalon-sur-Saône is an old manufacturing town on the right bank of the Saône and was once the residence of the kings of Burgundy.

23. The bridge was the old pont St. Laurent.

24. This is followed by pages with two more of the figural sketches related to *Young Men by the Sea:* see *Frühe Tagebücher,* pp. 101, 134.

25. Geneva is about seventy-three miles from Chalon-sur-Saône.

26. The little dashes of red were Baedeker guidebooks.

27. Beckmann would make a painting of a similar subject, representing half-naked giants (though without snow on their heads) standing around the bed of a person who has just awakened. See *Nightmare* (ca. 1903, G. 14).

28. The text begins at the top of the page after an empty page. Opposite is another drawing related to *Young Men by the Sea* (reproduced in *Frühe Tagebücher,* p. 102).

29. Veyrier is directly south of Geneva and Annecy on Lake Annecy. Two pages of drawings for *Young Men by the Sea* follow this entry (reproduced in *Frühe Tagebücher,* pp. 104–5).

30. On the same day Beckmann wrote a letter to Kunwald in which he said that he had seen works of Ferdinand Hodler, presumably at Hodler's atelier at 29, rue du Rhône. Beckmann commented specifically that Hodler had developed the same painterly style he himself had attempted to achieve. As Uwe Schneede has noted, this visit would have had immediate relevance for *Young Men by the Sea,* which Beckmann had been envisioning for months. See Beckmann to Caesar Kunwald, April 17, 1904, *Briefe,* 1:22, 398–99.

31. On the following page is another drawing for *Young Men by the Sea,* noted in *Frühe Tagebücher,* p. 134.

32. Beckmann left Geneva on April 19. In the subsequent nine days he decided to forgo Italy and traveled to Frankfurt—presumably via such cities as Basel, Colmar, and Strasburg—before he reached Berlin on April 28.

33. In the first part of the century trains coming from long distances regularly stopped at the Charlottenburg station in Berlin.

34. Beckmann skipped two pages between this and the next entry, and subsequently placed the entry of May 4 between them. On the page preceding this entry is another sketch related to *Young Men by the Sea* (reproduced in *Frühe Tagebücher,* p. 106).

35. This might have been the exhibition *Royal Painter-Etchers* that originated in the Arnold Art-Salon in Dresden, included Frank Brangwyn (1867–1956) and approximately thirty other artists, and possibly traveled to Berlin. See Hans W. Singer, "Dresdener Brief," *Kunst und Künstler* 2 (April 1904): 297–98.

36. The English painter and graphic artist Frank Brangwyn has been appreciated chiefly for his graphic work.

37. Beckmann crossed out the word *meet* several times.

38. Minna Tube's mother had moved to Pariserstraße 2 in Berlin-Wilmersdorf in January 1904, but Tube seems to have lived on her own. See Beckmann-Tube, "Erinnerungen an Max Beckmann," p. 167.

39. Two empty pages follow.

DIARY, DECEMBER 26, 1908–APRIL 4, 1909

This translation by Barbara Copeland Buenger and notes are based on Hans Kinkel's two different German editions of *Max Beckmann: Leben in Berlin: Tagebuch, 1908–9* (Munich: Piper, 1966, 1984) and on the original manuscript in the possession of the Beckmann estate. Unless otherwise noted, all references to *Leben in Berlin* are to the 1984 edition, © R. Piper & Co. Verlag, München 1983.

1. Beckmann-Tube, "Erinnerungen an Max Beckmann," pp. 167–69. Beckmann-Tube had four siblings, Elisabeth (Else) (1872–1914), Magdalene, Annemarie (Anni) (d. 1917), and Martin (1878–1914).

2. Grethe is thought to have lived in Berlin since she divorced her first husband in 1898. She had moved with her second husband, Paul Zech, to Berlin-Marienfelde, Emilienstraße 10, by May 1907. Beckmann's mother and brother moved to Berlin in 1905.

3. Founded in 1898, the Berlin Secession had long been the city's chief group and exhibition space for modern art. From 1905 on, it was housed in a building at Kurfürstendamm 208–9, just east of Knesebeckstraße. The fullest account of its history is found in Peter Paret, *The Berlin Secession: Modernism and Its Enemies in Imperial Berlin* (Cambridge, MA: Harvard University Press, 1980).

4. On Meier-Graefe see Robert Jensen, *Marketing Modernism in Fin-de-Siècle Europe* (Princeton: Princeton University Press, 1994), pp. 235–63; Kenworth Moffett, *Meier-Graefe as Art Critic* (Munich: Prestel, 1973); Paret, *Berlin Secession.*

5. In Willy Pastor, Stanislaw Przybyszewski, Franz Servaes, and Julius Meier-Graefe, *Edvard Munch: Vier Beiträge* (Berlin: S. Fischer Verlag, 1894).

6. Julius Meier-Graefe, *Die Entwicklungsgeschichte der modernen Kunst: Ein Beitrag zur modernen Ästhetik,* 3 vols. (Stuttgart: Julius Hoffmann, 1904); the standard English translation is *History of Modern Art,* 2 vols., trans. Florence Simmonds and George W. Chrystal (New York: G. P. Putnam's Sons, 1908).

7. *Ausstellung deutscher Kunst aus der Zeit von 1775–1875* (Nationalgalerie, Berlin, 1906).

8. These lectures were published in Julius Meier-Graefe, *Wohin treiben wir? Zwei Reden zur Kunst und Kultur* (Berlin: S. Fischer, 1913).

9. Paul Cassirer, whose influential gallery was at Viktoriastraße 35 (near Kemperplatz), had a major, controlling voice in the Berlin Secession as he acted in various roles of business director, voting member of the board, and president. In 1908 Cassirer was a member of the board, as he had been every year since the Secession's founding. Many found Cassirer, who suffered considerably from depression, difficult and abrasive; but many criticisms of Cassirer, such as Beckmann's, also reflected anti-Semitic sentiments. On Cassirer see Paret, *Berlin Secession;* Georg Brühl, *Die Cassirers* (Leipzig: Edition Leipzig, 1991); Barbara Copeland Buenger, "Max Beckmann's 'Ideologues': Some Forgotten Faces," *Art Bulletin* 71 (1989): 453–79.

10. *Secession: 16. Ausstellung: Zeichende Künste* (December–January 10, 1909).

11. Few of Beckmann's early prices and sales are specifically recorded, and we have no prices for 1908–9: the information quoted here comes from catalogue entries in *Katalog,* vol. 1. Already in August 1906 Beckmann had received an honorarium of M 1,000 for a portrait of Kurt von Mutzenbecher (1866–1938), the director of the Wiesbaden Theater, a commission that had been arranged by Count Harry Kessler. By 1908 some of his works had been bought by Cassirer and several had been acquired by members of his family and several by artist friends, the latter most likely in exchange. By 1912, after he had been on the board of the Secession and had received a few more major exhibitions, he was asking high prices, much lower than those received by the highly esteemed and established Corinth, Liebermann, and Max Slevogt (1868–1932), but considerably higher than those of most of his expressionist contemporaries. As noted in Gordon, *Modern Art Exhibitions,* 2:398, 513, in the Berlin New Secession show of 1910 a work by Erich Heckel (1883–1970) was priced at M 500, Ernst Ludwig Kirchner's (1880–1938) works went from M 400 to M 800, and Max Pechstein's (1881–1955) from M 600 to M 2,000; in the New Secession show of 1911 Kirchner asked from M 1,000 to M 2,000, Franz Marc (1880–1916) M 800 to M 900, Pechstein M 500 to M 2,000. In a 1912 show at the Bremen Kunsthalle Beckmann asked M 4,500 for one of his large group portraits, *Party* (1911, G. 140); in 1914, after a major retrospective of his early work at Cassirer's, he finally sold the painting for M 5,000 to Max Sauerlandt (1880–1934) of the Halle Museum, saying that this was a special price in deference to Sauerlandt. Throughout and after the prewar period, however, Beckmann found few buyers for the dramatic figural works to which he attributed so much importance.

12. See the facsimile page published in *Leben in Berlin,* p. 19.

13. The Beckmanns rented an apartment at Nollendorfplatz 6 from 1910 to 1914.

14. See, for instance, Beckmann's enthusiastic appraisal of Berlin's artistic life in his letter to Caesar Kunwald, August 14, 1905, *Briefe,* 1:38–40.

15. See Beckmann's extensive discussion of the art he saw and admired in Paris and subsequently in Berlin in several letters to Caesar Kunwald, October 27, 1904; August 8 and 14, 1905; and June 9, 1906; in *Briefe,* 1:27–33, 35–40, 43–45.

16. On this debate see Paret, *Berlin Secession,* pp. 170–82; Elizabeth Tumasonis, "Böcklin's Reputation: Its Rise and Fall," *Art Criticism* 6, no. 2 (1990): 48–71.

17. Julius Meier-Graefe, *Der Fall Böcklin und die Lehre von den Einheiten* (Stuttgart and Munich: Julius Hoffmann and Piper, 1905). Thode responded in a series of lectures held in Heidelberg in the summer of 1905 and in an ensuing exchange of letters about the lectures published in the *Frankfurter Zeitung:* see Henry Thode, *Böcklin und Thoma: Acht Vorträge über neudeutsche Malerei für ein Gesamtpublikum an der Universität* (Heidelberg: Carl Winter, 1905).

18. Rudolf Klein-Diepold, "Beckmann," *Sozialistische Monatshefte* 11, no. 1 (1907): 337–38; idem, "Berliner Sezession," *Sozialistische Monatshefte* 11, no. 2 (1907): 809–12. Rudolf Klein or Klein-Diepold was a critic

and essayist who in the prewar period published books about Aubrey Beards-
ley, Böcklin, Corinth, Hodler, Klinger, Liebermann, Adolph von Menzel, and
Félicien Rops and frequently wrote about the Berlin Secession.

19. On Beckmann's early views see also Dietrich Schubert, "Die
Beckmann-Marc-Kontroverse von 1912: 'Sachlichkeit' versus 'Innerer
Klang,'" in Bernd Hüppauf, ed., *Expressionismus und Kulturkrise* (Heidel-
berg: Carl Winter, 1983), pp. 207–44.

20. The show was *Paul Cassirer: 11. Jahrgang: Winter 1908–1909: 5.
Ausstellung: Henri Matisse.*

21. The Matisse exhibition was neither a critical nor a commercial suc-
cess and unleashed a great wave of disapproval of Matisse and his painting.
See Alfred H. Barr, Jr., *Matisse: His Art and His Public* (New York: Museum
of Modern Art, 1951), pp. 108–9; Jack Flam, *Matisse: The Man and His Art*
(Ithaca: Cornell University Press, 1986), pp. 244–45.

22. Oskar Moll, a painter, and Greta Moll, a sculptor, had studied with
Matisse in Paris the previous year. They warmly received Matisse in their
home at Christmas 1908, and Greta Moll subsequently translated Matisse's
Notes d'un peintre (Notes of a painter, 1908) into German; the latter was
published as "Notizen eines Malers," *Kunst und Künstler* 7 (May 1909):
335–47.

Kirchner, one of the leaders of Die Brücke, found the exhibition crucial
for his style and subsequently misdated his works so that it would seem that
he had developed his free manner prior to the interaction with Matisse.

23. Perhaps the unfinished self-portrait Beckmann had begun in the
summer (1908, G. 99).

24. *Double Portrait with Minna* (1909, G. 109). In 1911 Beckmann sold
this portrait to the Staatliche Galerie Moritzburg in Halle for M 1,700.

25. The Café Mandl was at Kantstraße 165–66 in Charlottenburg, not
far from the train station at the Zoologischer Garten.

26. That is, Oskar and Greta Moll, who had entertained Matisse at their
home the previous day.

27. Edited by Achim von Arnim (1781–1831) and Clemens Brentano
(1778–1842), *Des Knaben Wunderhorn* (The boy's magic horn, 1805–8), a
collection of more than seven hundred German folk songs, was regarded as
one of the most important documents of the German romantic movement.

28. Oda Hardt Rösler (1880–1965) and Waldemar Rösler (1882–1916)
had both been trained as painters; she temporarily abandoned her career
upon marriage, but resumed painting after her husband's death. In 1908–9
the Röslers lived in Berlin-Wilmersdorf at Durlacherstraße 3, near the park
on the Wilmersdorf Lake (today Volkspark) and Kaiserallee (today Bundes-
allee). They had just come to know the Beckmanns in 1908.

Rösler was one of the most celebrated Berlin Secessionists in the period
before World War I and was often compared with Beckmann. During this
period, some considered Rösler the riper talent. See Rupert Schreiner and
Reiner R. Schmidt, *Waldemar Rösler, 1882–1916* (Regensburg: Ostdeutsche
Galerie, 1982).

29. Presumably in Hermsdorf or one of the many new suburbs devel-

oping in neighboring areas; the Röslers ultimately moved to the southern Berlin suburb of Groß-Lichterfelde a few years later.

30. Sophie Meyer Schocken (1871–1921) and Wilhelm Schocken (1874–1948) were also painters who first came to know the Beckmanns in 1908. In this period Wilhelm Schocken worked in a postimpressionist manner influenced by Cézanne, the pointillists, and the fauves; he exhibited in the Secession but never achieved the acclaim of Rösler or Beckmann. He dramatically changed his style during and after World War I and left Germany after Hitler came to power in 1933, ultimately emigrating to Palestine. A retrospective of his work was held in the United States in 1984, *Wilhelm Schocken: Paintings, Drawings, Woodcuts* (Goethe Institute, Boston, November 6–December 7).

The Schockens had just had a second son, Wolfgang, and were presumably contemplating a move, but they did not in fact move to the suburbs until March 1911.

Tegel is a village far to the north of Berlin, beautifully located at the top of Tegel Lake. It was and remains a popular starting point for walks in the northern suburbs and for steamboat trips.

31. Max was referring to Minna's mother, whom he nicknamed Buschen or Buschchen, and to Minna's siblings, Anne-Marie and Martin, with whom they met regularly, often several times daily. Gertrud "Tutti" Jackstein (1879–1960) was a friend of the Beckmanns from Weimar and, like Minna, one of the first women admitted to the academy.

32. *Resurrection* (1909, G. 104); *Deluge* (1908, G. 97).

33. One of the most celebrated artists—along with Böcklin and Anselm Feuerbach (1829–80)—of the so-called *Gründerzeit* (Founders' age), Marées was a current preoccupation of Meier-Graefe, many young German artists, and the German art world in general. Meier-Graefe would soon publish his monumental three-volume study of the artist, *Hans von Marées* (Munich: Piper, 1909–10), and had arranged the major retrospective of Marées that would open in the Berlin Secession (February 28–early April 1909) as Beckmann wrote this diary. The Marées show had first opened in Munich and received highly favorable criticism, for instance, in Wilhelm Worringer, "Die Marées-Ausstellung der Münchner Secession," *Kunst und Künstler* 7 (February 1909): 231–32.

Marées was perhaps best known for his ambitious figural conceptions, including several triptychs, and generally arcadian and idyllic subjects. The marked surface tautness and simplification in his works have long seemed abstract and often caused them to be compared to those of Cézanne.

Böcklin's subjects were generally more moody, stormy, fleshy, and grotesque than those of Marées.

34. Beckmann deeply admired both the Flemish artist Peter Paul Rubens and Rembrandt, who had continued to be major influences on German art throughout the nineteenth century. In the same period, the subjective and moody aspect of Rembrandt's late works had come to be newly appreciated, especially under the influence of Julius Langbehn's (1851–1907) best-selling *Rembrandt als Erzieher* (Rembrandt as educator; Leipzig: C. L.

Hirschfeld, 1890), which celebrated Rembrandt as a preeminently Germanic figure.

35. Stefan George (1868–1933), one of the most influential German poets at the turn of the century, saw himself as a leader and formulator of Germany's new culture and inspired an influential and long-lived cult following among a large circle of aesthetes. He championed a highly sensual, stylized, art-for-art's-sake aesthetic and employed a frequently obscure symbolism. In 1892 he founded *Blätter für die Kunst,* a journal that voiced the ideas of his aesthetic movement.

36. Rösler had exhibited four paintings in the fifteenth exhibition of the Berlin Secession, for which he received a favorable, if short, notice from Karl Scheffler in "Berliner Sezession," *Kunst und Künstler* 6 (June 1908): 372–73. Rösler also had six drawings and pastels in the Secession's winter show of prints and drawings that had opened in December.

37. The exhibition hall at the Zoologischer Garten was at the southwest corner of the park at the intersection of Hardenbergstraße and Kantstraße.

38. The Schockens lived at the center of west Berlin-Tiergarten in a house at Kurfürstenstraße 71, at the corner of Schill-Straße just below the Lützowplatz.

39. Sophie Schocken's mother was the widow of Alexander Meyer (1832–1908), who had been a National Liberal member of the Berlin Parliament and Prussian Landtag.

40. Dora Hitz was one of the leading German impressionists and a founding member of the Gruppe 11, Berlin Secession, and Verein der Berliner Künstlerinnen (League of Berlin women artists), who had lived in Berlin since 1892. An eminent and highly regarded figure in the Berlin art world, she was the instructor of Sophie Meyer Schocken and had been friendly with Minna and Max Beckmann for some time; she was supposed but unable to be a fellow at the Villa Romana in Florence at the same time the Beckmanns were there in 1906–7. Hitz lived in an apartment close to the Schockens's at Lützowplatz 12. On her life and art see Karl Scheffler, "Dora Hitz," *Kunst und Künstler* 14 (May 1915): 383–88; Margrit Bröhan, "Dora Hitz," in *Profession ohne Tradition: 125 Jahre Verein der Berliner Künstlerinnen* (Berlin: Berlinische Galerie, 1992), pp. 49–57.

41. *Landscape in May* (1907).

42. Probably Mario Spiro (b. 1883), a writer and translator of French literature who later wrote for films. Two years earlier Beckmann had painted his portrait (1906, G. 60).

43. Beckmann's brother.

44. Beckmann's sister.

45. Tilly Erlenmeyer (b. 1875) was Beckmann-Tube's singing teacher.

46. The bohemian, writer, and anarcho-socialist Gustav Landauer (1870–1919) and his wife, the poet and translator Hedwig Lachmann Landauer (1865–1918), had lived in Hermsdorf since 1903. In 1908–9 they lived at Kaiserstraße 26. When Beckmann met them, Landauer had already served a term in prison for his politics and was busy organizing his Sozialistischer Bund. On Landauer see Eugene Lunn, *Prophet of Community: The Romantic Socialism of Gustav Landauer* (Berkeley: University of California Press,

1973); Charles B. Mauer, *Call to Revolution: The Mystical Anarchism of Gustav Landauer* (Detroit: Wayne State University Press, 1971).

47. In 1906 Hedwig Lachmann Landauer published a German translation of Oscar Wilde's *Salome*. She and Hedda Moeller-Bruck were the translators of a German edition of the complete works of Edgar Allan Poe that Beckmann acquired; see Beckmann and Schaffer, *Bibliothek*, p. 496.

48. The Rhenish painter Heinrich Nauen (1880–1940) was active in Berlin from 1906 to 1911.

49. Lump, a boxer, was the Beckmanns' dog.

50. Gustav Landauer, *Die Revolution* (Frankfurt: Rütten and Loening, 1907). Alfred Mombert (1872–1942) was a German writer strongly influenced by Nietzsche and Dehmel. At that time Mombert was concerned with metaphysical and obscure cosmic myths dealing with the entire history of humanity, as exemplified by his dramatic trilogy *Äon* (1907–11).

51. Kurt Tuch (1877–1945), a Berlin painter. Beckmann possessed one of his works, *Edge of the City* (1904, reproduced in *Leben in Berlin*, fig. 29), and Tuch owned Beckmann's *In the Moving Dunes* (1907, G. 81).

52. Beckmann would already have known many works of Gauguin, chiefly through his two visits to Paris and the writings of Meier-Graefe. He could have seen the major Gauguin retrospective at the Salon d'Automne, for instance, just after he arrived in Paris in the fall of 1903. Gauguin's works were much less frequently shown in Germany, but Beckmann could have seen several additional examples by 1908.

53. Gudula Landauer was born in 1902 and Brigitte Landauer in 1905.

54. Waidmannslust is a suburb directly south of Hermsdorf, and Tegel is southwest of both.

55. On December 28, 1908, an extensive earthquake in Messina, Sicily, destroyed most of the city's buildings and killed about eighty thousand people.

56. In *Leben in Berlin*, p. 54 n. 21, Kinkel identified and quoted this passage from the *Berliner Lokal-Anzeiger*, December 31, 1908. The picture would be Beckmann's *Scene from the Destruction of Messina* (1909, G. 106).

57. W. 27 (1908) is the only identified composition sketch for the painting.

58. Julius Meier-Graefe, "Aus einem spanischen Tagebuch," *Die neue Rundschau* 20 (January 1909): 52–72. Subsequent sections were published in the following months, and the whole was finally published as *Spanische Reise* (Berlin: S. Fischer, 1910). These writings were instrumental in the widespread reawakening of interest in El Greco in Germany and elsewhere.

59. The Beckmanns and the Landauers had presumably been talking about Landauer's ideal of socialized community living. Minna suggested the alternative example of the evangelical Christian communion of the Moravians (*Herrenhuter*), who in the modern period were engaged primarily in missionary work.

60. Georg Kolbe (1877–1947) was a German sculptor who had lived in Berlin since 1903 and would gain considerable acclaim for his modern classicist style both in Secession circles and, in the 1930s, among National Socialists.

61. Meier-Graefe lived in Berlin-Tiergarten at Genthiner Straße 13, two blocks east of the Lützowplatz.

62. Probably Otto Grautoff (1876–1937), sometime editor and critic for such journals as *Jugend, Münchener neueste Nachrichten, Monatshefte für Kunstwissenschaft, Zeitschrift für Bücherfreunde, Die Kunst für Alle,* and *Kunst und Künstler.*

63. Beckmann had come to admire the works of Tintoretto in Italy.

64. Meier-Graefe had been an enthusiastic champion of Delacroix in his *History of Modern Art* and in his catalogue of the exhibition of the Chéramy collection in 1907 (*Eugène Delacroix* [Paul Cassirer, Berlin, 4 November– 4 December 1907]). Beckmann probably saw that exhibition as well as the many works of Delacroix in Paris.

65. The 57 was an electric tram that ran through Wilmersdorf near the home of Frau Tube. Aunt Mariechen might have been Beckmann's mother's sister, who was married to his guardian.

66. The Countess Augusta "Ära" vom Hagen (1872–1949) came from an old family of Prussian aristocrats. As an eldest daughter denied full inheritance of her family's estate by primogeniture, she always lived somewhat simply, but she lived a rich life surrounded by artists and writers and herself studied art with the Berlin artist Sabine Lepsius (1864–1942). By this time Beckmann had painted her portrait (1908, G. 94) and included her with a few other friends and family members in his *Resurrection.* See Buenger, "Max Beckmann's 'Ideologues.'"

The neoromanticist Bernhard Kellermann (1879–1951) was a journalist and foreign correspondent who wrote five novels between 1904 and 1913. Arthur Hollitscher (1869–1941) was a writer who had moved from Munich to Berlin in 1907 and was employed as a reader for the publishing firm of Bruno Cassirer. Joachim von Bülow (1877–1949) was an artist known to Beckmann from the Weimar days who exhibited in the Berlin Secession in 1908 and in the Paris Salon d'Automne from 1907 to 1927. Agnes von Bülow (b. 1884), who painted landscapes and figural subjects and was an engraver, also exhibited at the Salon d'Automne from 1910 to 1913.

67. Presumably Bruno Cassirer (1872–1941). Bruno and Paul Cassirer were first cousins and further related by Bruno's marriage to Paul's sister. The two united to form a gallery and publishing house in 1898 but ended their partnership in 1901 after a personal falling out (Bruno is said to have fathered the child of Paul's first wife). Bruno retained sole control over their publishing house and inaugurated *Kunst und Künstler,* the great Berlin journal of realism, impressionism, and other modern trends, in 1902. Paul agreed not to enter publishing for seven years and subsequently started both a press and a journal (*Pan*) of his own. For more on Bruno Cassirer see Paret, *Berlin Secession;* Brühl, *Die Cassirers.*

68. Benno Berneis (1889–1916) showed fifteen works, both paintings and graphics, contemporaneously with the Matisse show. The works by Matisse were listed in the Cassirer catalogue as follows:

1. Still Life, owned by Herr F.; 2. Landscape, owned by Herr C. H. [probably Curt Herrmann]; 3. The Gardener [*Gärtnerin*]; 4. Guitar Player; 5. Geranium; 6. Le petit pont; 7. The Gardener [*Gärtner*];

8. Le pont St. Michel; 9. Girl's Head; 10. Bathers; 11. Green Landscape; 12. Interior; 13. Bacchante; 14. Bouquet of Flowers; 15. Landscape (13–15, owned by Herr L. S.); 17. Study; 18. Still Life; 19. Rose; 20. Le Madras; 21. Bathers, Study; 22. Study (18–22, collection of Herr M.); 23. Head; 24. The Friseuse; 25. Still Life (23–25, collection of Herr M. S.); 26. Flower Bouquet, collection of Herr T. T.; 27. Place des Lices, St. Tropez; 28. Still Life; 29. Vegetables and Fruits; 30. Still Life, collection of Herr S.; 31. Decorative Painting for a Dining Room, collection of Herr S.; 32–55. drawings, lithographs, and woodcuts; 56–60. drawings; 61. woodcut (56–61, collection of Herr M.); 62–71. bronzes (ten numbered examples have been cast of each): 62. The Slave; 63. Standing Girl; 64. Child's Head; 65. Child's Head; 66. Woman, Supporting Herself on Her Hands; 67. Squatting Girl; 68. Small Head of a Woman; 69. Study (Sitting Girl); 70. Group of Girls; 71. Reclining Girl.

The identifiable works might have included the following, indicated by the page on which they are reproduced in Flam, *Matisse*: 4. *Guitar Player*, ca. 1903, p. 94; 5. *Still Life with Geranium* (?), 1906, p. 178; 10. *Bathers with a Turtle* (?), 1908, p. 225; 14. *Bouquet on a Bamboo Table* (?), 1902, p. 81; 20. *The Red Madras Hat*, 1907, p. 214; 24. *La Coiffure* (?), p. 206; 27. *Place des Lices, St. Tropez*, 1904, p. 111; 31. *Harmony in Red* (?), 1908, p. 229; 62. *The Serf*, 1900–ca. 1906, p. 86; 63. *Standing Nude*, 1906, p. 182; 66. *Woman Leaning on Her Hands*, 1905, p. 180; 68. *Small Head of a Woman*, 1906, p. 183; 71. *Reclining Nude I*, 1907, p. 192.

The identifiable works also included the following work, indicated by the page on which it is reproduced in Barr, *Matisse*: 19. *The Rose*, 1906–7, p. 330.

69. Beckmann would have seen many works of van Gogh not only in France but also in Berlin, where the Dutch artist's work had been regularly featured in the Cassirer and other galleries since 1904.

70. That is, Berneis's work just seemed to imitate the works of Corinth and Slevogt, in 1909 considered the leading Berlin impressionists after Max Liebermann.

71. Hans Baluschek was a Berlin painter of the working class and member of the Social Democratic Party who depicted working-class subjects, joined the Berlin Secession in 1898, and became a member of its board of directors in 1908. The exhibition Beckmann saw took place in the Bellevue Straße, probably at the Künstlerhaus at Bellevue Straße 3. Both it and the exhibitions of Matisse and Berneis were reviewed by Karl Scheffler in *Kunst und Künstler* 6 (February 1909): 236.

72. Probably Baluschek's *Blind* (1900, Märkisches Museum, Berlin).

73. The café was in the Hotel Fürstenhof at Potsdamer Platz.

74. Walther Lampe (1872–1964), a pianist, composer, and pedagogue who had studied piano with Clara Schumann.

75. That is, to the winter exhibition of prints and drawings in which Beckmann showed, which closed on January 10.

76. Probably the exhibition of Chinese paintings from the collection of

Olga-Julia Wegener held in the Königliche Akademie der Künste at Pariser Platz. Karl Scheffler's enthusiastic review of the exhibition appeared alongside his reviews of the shows of Matisse, Berneis, and Baluschek in *Kunst und Künstler* 6 (February 1909): 232–35.

77. The Eduard Schulte Galerie was at Unter den Linden 75–76, just down the street from the Chinese exhibition at the academy.

78. On October 6, 1908, Austria-Hungary had proclaimed its annexation of Bosnia and Herzegovina, then part of the Ottoman Empire. The Balkans became a dangerous area of conflict in which the great powers became involved. The Turks were infuriated and made preparations for war; the Russian government opposed the move and supported the Serbians; the Germans decided to support the Austrians; and the French and British called for an international conference. On March 2, 1909, the European powers would intervene to prevent a war between Austria and Serbia, but the issues remained far from settled.

79. Hofmann was one of the leading older members of the Berlin Secession and a founding member of the Gruppe 11, the group that preceded the Secession. He was on the jury that awarded Beckmann's *Young Men by the Sea* the prize in Weimar and began to teach at Weimar just after Beckmann left. In 1899 Hofmann had married his cousin, Eleonore Kekulé, the daughter of the archaeologist Reinhard von Kekulé.

80. The concert, at the Kammerspiele of the Deutsches Theater at Schumann-Straße 14, began with Ludwig van Beethoven and continued with pieces by older masters, such as Carl Philipp Emanuel Bach (1714–88), arranged for violin and piano.

81. Johannes Brahms's Piano Quintet in F Minor, op. 34 (1865).

82. Reference to an unknown and lost painting (1909, G. 123). The Friedrichstraße is the longest street in the inner town, running two miles from the Oranienburger Tor to the Hallesches Tor. At most parts it was flanked by shops, hotels, restaurants, and businesses and filled with people until late at night. The northern part, running by the Friedrichstraße station, was an amusement quarter.

83. A photograph of Beckmann had appeared alongside those of many other artists who had received stipends to the Villa Romana in F. H., "Das deutsche Künstlerheim in Florenz," *Die Woche*, November 7, 1908, pp. 1958–62.

84. One drawing (1906, W. 15) was published in a review of the Secession show written by Hans Bethge in *Deutsche Kunst und Dekoration* 24 (June 1909): 146.

85. *Three Women in the Studio* (1908–9, G. 101).

86. Perhaps the *Crucifixion of Christ* (1909, G. 119), although Beckmann entered the work into his list of paintings only in the summer. He might well have been referring to *Drama* (1906, G. 57), which he initially called *Crucifixion*, exhibited under that title at Cassirer's in 1913, and seems still to have had in his atelier in 1909.

87. Opened in 1904, the Kaiser-Friedrich Museum (now called the Bodemuseum), built by Ernst von Ihne (1848–1917) and Max Hasak (1856–1934), is situated at the northwest end of the Museum Island on Am Kup-

fergraben, northwest of the royal castle, cathedral, Altes Museum, Neues Museum, and Nationalgalerie. It was the major home of Berlin's collection of western European art until World War II.

88. Rembrandt's *Rape of Proserpina* (ca. 1630) had arrived in Berlin in 1720 as part of the bequest of the House of Orange.

89. The Kaiser-Friedrich Museum possessed several paintings by the Dutch genre specialist Jan Steen (1625 or 1626–79), most of which were executed in the 1660s: *The Inn Garden, The Quarrel during Play, Merry Company,* and *The Christening: "The Young Ones Chirrup as the Old Ones Used to Sing."*

90. The museum owns a large number of paintings by Rubens.

91. Beckmann was describing a walk toward the southeast, as he viewed some of Berlin's most elegant older buildings and some of the most notorious recent Wilhelmine additions. He went past the cathedral, which had been newly built in a Roman Renaissance style by Julius Raschdorff (1823–1914) and his son Otto Raschdorff (1854–1915) between 1894 and 1905 (destroying the older church and nineteenth-century additions by Karl Friedrich Schinkel [1781–1841]); the royal castle, begun in the fifteenth century and subsequently elaborated upon by Andreas Schlüter (1664–1714), Johann Friedrich Eosander (1670–1729), Schinkel, and August Stüler (1800–1865), among others; and onto the grand avenue of Unter den Linden. Opposite the southwest corner of the royal palace, on a raised platform overlooking the Kupfergraben along Schloß Freiheit, was the huge national monument to Kaiser Wilhelm I, completed by the sculptor Reinhold Begas (1831–1911) in 1897. The elaborate monument included a thirty-foot-high equestrian figure of Kaiser Wilhelm. It was finished in bronze and stone with elaborate allegorical personifications of Prussia, Bavaria, Saxony, Württemberg, Commerce and Navigation, Art, Science, and Agriculture and Industry. A bronze quadriga was mounted on each of the corner pavilions.

92. Probably the sculptor and painter Fritz Rhein (1873–1948) and his wife.

93. The painter Charlotte Berend-Corinth (1880–1967) was married to Lovis Corinth and continued to paint and exhibit after their marriage. She gave birth to a second child, their daughter Wilhelmine, on June 13, 1909.

94. Leipziger Platz is southwest of the old center, adjacent to Potsdamer Platz and just south of the Tiergarten.

95. The exhibition was accompanied by a catalogue, *Max Klinger: Katalog der siebzehnten Ausstellung der Berliner Secession vom 16. Januar bis zum 15. Februar 1909* (Berlin: Paul Cassirer, 1909).

96. A woman named Frida worked for the Beckmanns; the stamps were probably a form of rebate stamp.

97. Beckmann used the German word *Bombe,* and this meaning of the word was first suggested in *Katalog,* 1:98. Without any record of the painting it is impossible to tell what Beckmann really meant.

98. *Langbein* means long leg or long legged.

99. Probably Rudolf Alexander Schröder, the poet, artist, and interior designer who had long been a close associate of Meier-Graefe, and Curt Herrmann (1854–1929), a founding member of the Berlin Secession.

100. Emil Pottner (1872–after 1931) was also a member of the Secession.
101. Beckmann is again speaking of the Secession's winter drawing and graphics exhibition. Gordon, *Modern Art Exhibitions*, 2:288, lists eleven Beckmann drawings in the show. Karl Scheffler's review appeared in "Kunstausstellungen," *Kunst und Künstler* 7 (January 1909): 185–86. This is Beckmann's first extant written reference to Scheffler (1869–1951), the influential and outspoken editor of *Kunst und Künstler* who would become one of his strongest supporters in the prewar period.

102. Ernö Dohnányi (1877–1960), the famed Hungarian pianist who taught piano at the Hochschule für Musik in Berlin from 1906 to 1916. The German composer and conductor Oskar Fried (1871–1941) had set texts of both Nietzsche and Dehmel to music and was a noted conductor of the works of Gustav Mahler. On January 18 Beckmann attended a concert of the Berlin Philharmonic Orchestra conducted by Fried at the Philharmonie. The soloist was the royal chamber singer, Frieda Hempel (1885–1955).

103. The Dutch Benjamine van der Meer de Walcheren had married Kolbe in 1902.

104. Aleksandr Scriabin's Symphony no. 3, op. 43, "Divine Poem" (1905); an aria from Mozart's *Il re pastore* (K. 208, 1775); overture to Wagner's *Die Meistersinger von Nürnburg*.

105. Eve Sprick Meid (1880–1970), who had known the Beckmanns since Weimar and was married to the painter Hans Meid (1883–1957).

106. The piano concert by Dohnányi at the Mozart-Saal in the Neue Schauspielhaus at the Nollendorfplatz included Robert Schumann's sonata op. 11 (1832–35); the Beethoven sonatas opp. 110 (1821) and 111 (1822); and Chopin.

107. The Café Josty was at several locations; one was near the Zoologischer Garten at Joachimstaler Straße 44.

108. Beckmann-Tube's sister Anni lived in Hohen Neuendorf, a suburb farther north of Hermsdorf and reached by the same train.

109. Beckmann's sister and her husband lived in Marienfelde, a suburb at the far southern end of Berlin.

110. *Feldblumen* (Wild flowers, 1840) is a collection of stories by the Austrian writer Adalbert Stifter (1805–68).

111. The photos have been identified in *Leben in Berlin*, p. 64 n. 44; and Güse, *Das Frühwerk Max Beckmanns*, pp. 33–35, 94.

112. The exhibition *Die Dame* was held in the Hohenzollern-Kunstgewerbehaus at Leipzigerstraße 13, the interior of which had been redesigned by van de Velde in 1899 when the firm's owner, Wilhelm Hirschwald, invited van de Velde to open his atelier and show his products there. The store, which continued to feature an atelier for interior decoration and furnishings, mounted regular exhibitions and sold arts and crafts of many different countries and cultures.

113. *Der Weltspiegel* 6 (January 21, 1909). The announcement featured illustrations of portraits executed by four artists, Schuster-Woldan (perhaps Raffael Schuster-Woldan [1870–1951]), Adolf Heller (1874–1914), Ernst Oppler (1867–1929), and Beckmann, including the latter's *Portrait of Minna in Gray Fur* (1907, G. 84).

114. Julie Wolfthorn (born Julie Wolf in Thorn, 1868–1944) was a painter and printmaker who studied in Paris and exhibited in the Berlin Secession and the Verein der Berliner Künstlerinnen, frequently published in *Die Jugend* and made posters and illustrations for socialist organizations and publications. A Jew, she was deported to Theresienstadt, where she died in 1944. See Berlinische Galerie, *Profession ohne Tradition*.

115. The marble version of Klinger's *Brahms Monument* (1909), designed for the new music hall in Hamburg, was exhibited in the Klinger exhibition that had just opened in the Secession.

116. Beckmann again invokes Rembrandt, Hals, and the Spaniard Francesco de Goya as masters of a vitally human art.

117. Schulzendorf was almost directly opposite the Beckmanns' home, 1.85 miles on the other side of the Hermsdorf forest.

118. As was true earlier in this diary, Beckmann was probably referring to *Drama* rather than to *Crucifixion*, which he would first add to his painting list in the following summer of 1909. *Battle* (1907, G. 85) was one of his most criticized early paintings. *Nudes* probably refers to *Adam and Eve* (1907, G. 67), a work completed in Florence, which he exhibited in the 1907 Berlin Secession.

119. The library that would have been most accessible to Beckmann as an artist was that of the Kunstgewerbemuseum (Museum of arts and crafts), built by Martin Gropius (1824–80) between 1877 and 1881 at Prinz Albrecht Straße 7a near the Potsdam station (now known as the Martin-Gropius-Bau). The museum possessed a reading room, graphic collections, and a costume library.

120. Because Beckmann used the word *selten* or "rare" and called this a new work, he was probably referring to the recent publication by Valerian von Loga, *Goyas seltene Radierungen und Lithographien: 44 getreue Nachbildungen der Reichsdruckerei* (Berlin: G. Grote, 1907).

121. Beckmann was referring to Goya's four large lithographs, measuring 31.8 cm × 41.3 cm, popularly called *The Bulls of Bordeaux* (1824), produced when Goya was seventy-eight. One of these is reproduced in *Leben in Berlin*, fig. 25.

122. The *Tauromaquia* (1815–16).

123. Gustave Courbet's *Hunt Breakfast* (1858–59, Wallraf-Richartz Museum, Cologne) was shown in Cassirer's *6. Ausstellung: 11. Jahrgang: Winter 1908–1909* (January–February 1909). The painting is reproduced in *Leben in Berlin*, fig. 26.

124. That is, *Scene from the Destruction of Messina*.

125. Martin Brandenburg (1870–1919), a Secession artist with whom Beckmann was frequently compared, was a close friend of Hans Baluschek.

126. The Stettin station, considerably north of both the old and new western sections of Berlin, was where the Beckmanns caught the train to Hermsdorf.

127. Emil Nolde (1867–1956), the much older German artist from Schleswig-Holstein, had begun to enjoy considerable success in Berlin from 1906 on. Emil Rudolf Weiß (1875–1942) was a Berlin painter and printmaker associated with the arts and crafts movement. The Berlin painter Karl

Hofer (1878–1955) early established himself as a major figure and would continue to have a distinguished career for decades. In 1923 Hofer and Beckmann were the only German artists Meier-Graefe singled out for praise in a new edition of his *History of Modern Art*. Haller probably refers to the Swiss sculptor Hermann Haller (1880–1950).

128. Beckmann and Nolde had exhibited with others in a group show at Cassirer's in 1908 (*Paul Cassirer: 5. Ausstellung: 10. Jahrgang, 1907–1908* [January 8–February 2, 1908]) and presumably met then and on other occasions through the Secession. Nolde later recalled a more friendly, bantering exchange, sometime after the summer of 1909: Beckmann told Nolde he had made good progress, and Nolde called Beckmann an arrogant youth: see Emil Nolde, *Mein Leben* (Cologne: DuMont, 1976), p. 168.

129. Johannes Guthmann's (1876–1956) *Eurydikes Wiederkehr* (Euridice's return), which Beckmann illustrated (H. 7–16) for publication by Cassirer (Berlin: Paul Cassirer, 1909). Paul Cassirer had just established a new series of bibliophile editions for his *Pan*-Presse: the first volumes were illustrated by Max Slevogt (James Fennimore Cooper, *Tales from Leatherstocking*, 1909) and Lovis Corinth (Martin Luther's translation of the Book of Judith, 1910).

130. Part of this page is missing.

RESPONSE TO *IN BATTLE FOR ART: THE ANSWER TO THE "PROTEST OF GERMAN ARTISTS"*

This translation by Barbara Copeland Buenger is based on *Im Kampf um die Kunst: Die Antwort auf den "Protest deutscher Künstler,"* ed. Franz Marc (Munich: Piper, 1911), p. 37. This contains only slight changes of spelling, address, and punctuation from the original in the Piper Archives, which was published and annotated in *Briefe*, 1:66–67.

According to Schneede, *Briefe*, 1:417–18, Piper or someone else wrote "spring 1911" at the top of Beckmann's undated letter. On June 2, 1911, Piper wrote Alfred Walter Heymel (1878–1914), a chief editor of *Im Kampf um die Kunst*, that he had already received many letters in response to the *Protest deutscher Künstler*, among them Beckmann's. Vinnen's *Protest* appeared at the beginning of April 1911; *Im Kampf um die Kunst* appeared in June or the summer of 1911.

1. See Paret, *Berlin Secession*, pp. 209–10. Cassirer took a six months' leave from his position as business manager and thus did not help select the 1910 show, but he had returned to the Secession's board by the summer. On the New Secession see *Berlin Secession*, pp. 210–12; Peter Selz, *German Expressionist Painting* (Berkeley: University of California Press, 1957), pp. 113–14.

2. Beckmann to Waldemar Rösler, [November 1910], *Briefe*, 1:64–65. There the letter is incorrectly dated 1911.

3. *Ein Protest deutscher Künstler, mit Vorwort von Carl Vinnen.* (Jena: Diedrichs, 1911). A full study of the Vinnen protest and the "answer" produced by Alfred Walter Heymel, Franz Marc, and Reinhard Piper is found in Ron Manheim, *"Im Kampf um die Kunst": De discussie van 1911 over*

contemporaine kunst in Duitsland: Die Diskussion von 1911 über zeitgenössische Kunst in Deutschland (Hamburg: Verlag der Buchhandlung Sautter und Lackmann, 1987). See also Paret, *Berlin Secession*, pp. 182–99.

4. The great Roman Marcus Tullius Cicero delivered his first oration against Catiline on November 8, 63 B.C., accusing Catiline of conspiracy to murder the consuls: "Quo usque tandem abutere, Catilina, patientia nostra? Quam diu etiam furor iste tuus nos eludet? Quem ad finem sese effrenata iactabit audacia?" (In heaven's name, Catiline, how long will you abuse our patience? How long will that madness of yours mock us? To what limit will your unbridled audacity vaunt itself?), from *The Speeches of Cicero*, trans. Louis E. Lord, Loeb Classical Library (Cambridge, MA: Harvard University Press, 1964), pp. 14–15.

5. Indeed, though Julius Meier-Graefe was specifically attacked by Vinnen and many other contributors to the *Protest*, the title of his 1912–13 critique of modern German art, "Wohin treiben wir?" (Where are we drifting?), also seemed to revive Vinnen's battling question, "Quo usque tandem?"

6. A second edition of *Die Antwort* published in 1913 was titled *Deutsche und französische Kunst: Eine Auseinandersetzung deutscher Künstler, Galerieleiter, Sammler, und Schriftsteller* (German and French art: an argument of German artists, dealers, collectors, and writers).

7. For a complete list of contributors to each tract, see Manheim, "*Im Kampf um die Kunst*," pp. 227–30.

8. In addition to Delacroix, Courbet, and van Gogh, the French Théodore Géricault (1791–1824), Honoré Daumier (1808–79), and Auguste Renoir (1841–1919) were all artists whom Beckmann knew in numerous examples from both Berlin and Paris.

9. Beckmann had already mentioned several of those artists in earlier writings. He would have known works by the Italian Luca Signorelli (1445–50–1523) from his academy studies, from Paris, and from *The School of Pan* (ca. 1490) in the Kaiser-Friedrich Museum, long acknowledged as a source for Beckmann's *Young Men by the Sea*. He would have known the German Lucas Cranach the Elder (1472–1553) from Weimar, Berlin, and many other collections. As an admirer of the great painterly tradition, he had also studied Titian and Diego Velázquez.

10. The French artist Othon Friesz (1879–1949) was closely associated with the fauves and had shown works in the Berlin Secession exhibition of 1909, though Beckmann could also have known his works from Paris. Jean Puy (1876–1960) was a French artist associated with the fauves and the Salon des Indépendants. His works had been exhibited in the Berlin Secession show of 1907 and would also have been known to Beckmann from Paris.

11. Jules Bastien-Lepage (1848–1884) was a highly popular and influential French realist painter known especially for his representations of peasants. He was widely exhibited throughout Europe and had a vast following.

By "Scots" Beckmann was referring to the large number of Scottish artists, including the Glasgow Boys and members of the School of Cockburnspath, who had frequently showed in Munich exhibitions in the late nineteenth century and were much imitated by German artists. The Glasgow

Boys, too, were influenced by Bastien-Lepage and known for their repre-
sentations of figures in rural landscapes. See Maria Makela, *The Munich
Secession: Art and Artists in Turn-of-the-Century Munich* (Princeton:
Princeton University Press, 1990), pp. 39–42; Barbara Copeland Buenger,
Max Beckmann's Artistic Sources (Ann Arbor: University Microfilms,
1981), p. 29.

12. The renowned realist Adolph von Menzel was unquestionably one
of the most respected Berlin artistic figures when Beckmann arrived in the
city. As a serious realist and impressionist, Beckmann would have closely
studied Menzel's works. Wilhelm Leibl was the leading realist in southern
Germany and a highly respected figure in Beckmann's youth. Leibl's works
were repeatedly exhibited in Berlin, and many of Beckmann's early works,
particularly his portraits, reflect Leibl's influence.

"THOUGHTS ON TIMELY AND UNTIMELY ART"
 This translation by Barbara Copeland Buenger is based on the original
German edition, "Gedanken über zeitgemässe und unzeitgemässe Kunst,"
Pan 2 (March 14, 1912): 499–502, and from the first English translation, in
Buenger, *Max Beckmann's Artistic Sources*, pp. 353–56. The original manu-
script has not been found.

1. Cassirer founded *Pan* (1910–15) in tribute to the first *Pan* magazine
(1895–1900); the journal was edited by Wilhelm Herzog (1884–1960). Cas-
sirer also ran the *Pan*-Presse and attempted to create a *Pan* theater. See
Roy F. Allen, *Literary Life in German Expressionism and the Berlin Circles*
(Ann Arbor: University of Michigan Research Press, 1972), pp. 173–204;
Paret, *Berlin Secession*.

2. *Der Blaue Reiter* (Moderne Galerie Thannhauser, Munich, December
18, 1911–January 1, 1912). On the exhibition see Mario-Andreas von Lüt-
tichau, "Der Blaue Reiter, München 1911," in Berlinische Galerie, *Stationen
der Moderne* (Berlin: Berlinische Galerie, 1989), pp. 109–29.

3. Wassily Kandinsky, *Über das Geistige in der Kunst* (Munich: Piper,
1912). The book first appeared in December 1911.

4. Paul Ferdinand Schmidt, "Die Expressionisten," *Der Sturm* 3 (1911):
734–36. On Schmidt's essay and the first uses of the term *Expressionism* in
Germany, see Ron Manheim, "Expressionismus: Zur Entstehung eines
kunsthistorischen Stil- und Periodenbegriffes," *Zeitschrift für Kunstge-
schichte* 49, no. 1 (1986): 73–91; Donald E. Gordon, "On the Origin of the
Word 'Expressionism,'" *Journal of the Warburg and Courtauld Institutes* 29
(1966): 368–85.

5. *Erste Ausstellung: Der Blaue Reiter, Franz Flaum, Oskar Kokoschka,
Expressionisten* (Der Sturm, Berlin, March 12–before April 12, 1912). A list
of works in the exhibition is found in Gordon, *Modern Art Exhibitions*, 2:
557–58.

6. Wassily Kandinsky and Franz Marc, eds., *Der Blaue Reiter* (Munich:
Piper, 1912).

7. *Max Beckmann (Gemälde)* (Kunstverein, Magdeburg, April 1912)
and *Gemälde von Max Beckmann in Berlin* (Grossherzogliches Museum für
Kunst und Kunstgewerbe, Weimar, August 1912).

8. These connections were first made in Güse, *Das Frühwerk Max Beck-*

manns, pp. 11–16. See also Buenger, *Max Beckmann's Artistic Sources*, pp. 32–37; idem, "Beckmann's Beginnings."

9. In 1919 Beckmann stressed that in 1903 Cézanne had already been of great importance to him (Beckmann to Julius Meier-Graefe, May 10, 1919, *Briefe*, 1:178). His first extensive discussion of Cézanne, in which he said he found Cézanne both deeper and more intense than van Gogh, is found in a letter to Caesar Kunwald (August 4, 1905, *Briefe*, 1:35–38).

10. The first major discussion of the controversy is found in Selz, *German Expressionist Painting*, pp. 238–40.

11. Beckmann's essay provoked an angry response from Marc, who said there was so little to which he could respond that he preferred readers to examine an essay he had subsequently published on the new constructive ideas in painting (Marc, "Anti-Beckmann," *Pan* 2 [March 28, 1912]: 555–56; idem, "Die konstruktiven Ideen der neuen Malerei," *Pan* 2 [March 21, 1912]: 527–31). Although a few writers alluded to the Beckmann-Marc controversy in contemporary criticism, the debate received little major notice. One writer, Alfred Schnaar, responded to *Pan* in favor of Beckmann ("Marc-Beckmann," *Pan* 2 [April 18, 1912]: 635–36). Marc and Kandinsky, on the other hand, fumed about and made fun of Beckmann's reply (*Wassily Kandinsky/Franz Marc: Briefwechsel*, ed. Klaus Lankheit [Munich: Piper, 1983], pp. 141, 143, 149).

12. See Schubert, "Die Beckmann-Marc-Kontroverse von 1912," pp. 207–44.

13. Portions of the French painter Émile Bernard's (1868–1941) reminiscences were published in three successive issues of the magazine; the portion quoted by Beckmann appeared in the first installment, "Erinnerungen an Paul Cézanne," *Kunst und Künstler* 6 (July 1908): 426. See also *Kunst und Künstler* 6 (July 1908): 421–29; 6 (August 1908): 475–80; 6 (September 1908): 521–27.

14. Beckmann is referring to one of the chief emphases of Marc's essay.

DIARY, DECEMBER 30, 1912–APRIL 17, 1913

This translation by Barbara Copeland Buenger and notes are based on Schmidt's edition of *Frühe Tagebücher*, pp. 109–24, 134, 149–54, © R. Piper GmbH & Co. KG, München 1985, and on the original manuscript in the possession of the Beckmann estate.

1. See the facsimile pages and catalogue of drawings in ibid., pp. 118–19, 122–24, 134, 140.

2. *Portrait of the Simms Family* (1913, G. 164). Beckmann might have been brought to the Simmses' attention by their good friend Alfred Lichtwark, the influential director of the Hamburg Kunsthalle, who had admired several of Beckmann's works in Berlin Secession shows of 1910 and 1911 and had even spoken of finding a commission for him. See Alfred Lichtwark, *Briefe an die Kommission für die Verwaltung der Kunsthalle*, vol. 18 (Hamburg: Lütcke und Wulff, 1918), p. 121; vol. 19 (1919), p. 87.

3. The home was built in 1905–6 by the architect Georg Radel (b. 1860).

4. In November 1912 Beckmann had traveled to Davos, Switzerland, to complete a portrait study of Karl Frederic Simms (1912, G. 160) that he could

incorporate into the group portrait. Karl Frederic most likely went to Davos, an important center for the treatment of tuberculosis, for his health: he died three years later at the age of nineteen.

5. The Simmses acquired about fifteen of Beckmann's paintings in addition to large numbers of works by Lovis Corinth, the Hamburg artists Arthur Illies (1870–1952) and Friedrich Schaper (1869–1956), and the Munich painter Albert Weisgerber (1878–1915). In 1930 when ten of the Beckmann paintings in the Simmses' collection were auctioned, Beckmann wrote a friend that they were among his best prewar works (Beckmann to Baron Rudolf von Simolin, October 18, 1930, in *Briefe*, 2:77).

6. Beckmann's single print of seminaked prostitutes in *The Ulrikus Street in Hamburg* (1912, H. 39) predated this diary. Lili von Braunbehrens (1894–1982), in *Gestalten und Gedichte um Max Beckmann* (Dortmund: Crüwell/Schropp, 1969), p. 26, recalled Fridel Battenberg (1880–1965) saying that during World War I Beckmann frequently returned to Hamburg to capture the Hamburg night life in connection with his painting *Night* (1918–19, G. 200), a subject that had interested him since 1912 (see also W. 101 and 102 and H. 77).

7. Hans Kaiser, *Max Beckmann* (Berlin: Paul Cassirer, 1913).

8. 1912, G. 159, shown in *26. Ausstellung der Berliner Secession* (Secession, Berlin, April 1913).

9. According to Peter Beckmann, this sentence was written in ink by Minna Beckmann-Tube (*Frühe Tagebücher*, p. 149).

10. At this point a piece of paper was torn away.

11. The subjunctive *würde* is proposed in the German edition.

12. As previously noted, Beckmann frequently read, and ultimately gave, his diaries to Minna Beckmann-Tube.

13. Beckmann enjoyed considerable success in 1912 with his published exchange with Marc, his first one-man shows in Magdeburg and Weimar, and his participation in exhibitions in Berlin, Amsterdam, and Vienna.

14. The German transcription suggests this word could be *reiten* (ride on horseback) or *reisen* (travel).

15. Wilhelm Giese (1883–1945) was a Magdeburg painter and friend who studied at Weimar when Beckmann and Tube were there. He was the godfather of their son, Peter, and was portrayed in Beckmann's *Resurrection* and in a portrait presumably lost during World War II (1910, G. 134); Giese and Beckmann had also painted together at Nenndorf, outside Hannover, in 1910. Beckmann thus seems to have been traveling to Magdeburg, a seventy-five-minutes' train ride to the southwest of Berlin.

16. In a later diary entry (between January 7 and 16) Beckmann noted that Simms was considering buying *Bearing of the Cross* (1911, G. 139), which he called "the smallest of my big pictures, thus the most saleable." Otherwise, it is unclear to which picture Beckmann was referring here.

17. Hans Kaiser (1884–1954), the son of a Protestant pastor in Constance, was the journalist who had just completed the Beckmann monograph in conjunction with the exhibition that was to be shown at Paul Cassirer's. Julius Aufsesser, a collector of Beckmann's works, lived at Sigmundshof 21, Berlin.

18. Hilde Lüdecke (1894–1959) and Richard Lüdecke were the children of Beckmann's sister, Grethe, from her first marriage.

19. This is Beckmann's first extant quote from the Scriptures, which inspired many of his current works. The passage comes from Luke 10:38–42: "Now as they went on their way, he entered a village; and a woman named Martha received him into her house. And she had a sister called Mary, who sat at the Lord's feet and listened to his teaching. But Martha was distracted with much serving; and she went to him and said, 'Lord, do you not care that my sister has left me to serve alone? Tell her then to help me.' But the Lord answered her, 'Martha, Martha, you are anxious and troubled about many things; one thing is needful. Mary has chosen the good portion, which shall not be taken away from her.'"

20. Reinickendorf-Rosenthal was a stop on the Nordbahn line, not far from Hermsdorf, which led to both of those suburbs to the southeast.

21. Minna Beckmann's.

22. That is, his brother.

23. That is, the Paul Cassirer firm.

24. Since the previous diary entry of December 31, Cassirer had apparently examined paintings in Beckmann's studio and finalized the exhibition, the major, month-long show that would run from the end of January (January 24 or after) through February, *Paul Cassirer: 15. Jahrgang 1912–13: Vierte Ausstellung: Max Beckmann* (Paul Cassirer, Berlin, January–February 1913.) A list of the paintings in the show is found in Gordon, *Modern Art Exhibitions*, 2:651.

Since Beckmann received a copy of Hans Kaiser's text on this same day (January 7), Kaiser had no knowledge of Cassirer's final choices for the show. The following list in the diary includes most paintings that were in the show but also many that were not.

25. 1909, G. 104.

26. 1909/10, G. 124.

27. 1911, G. 146.

28. *Falling Motorcyclist: Death Fall* (1913, G. 170).

29. *Flower Still Life* (1912, G. 158), which was owned by the collector Karl Steinbarth.

30. Steinbarth owned two self-portraits by Beckmann, both of which were probably in this show: *Self-Portrait with Green Background* (1912, G. 154) and *Self-Portrait with Large Background* (1913, G. 163).

31. *Rabbit Thieves in Hermsdorf Forest* (1912, G. 161).

32. *Scene from the Destruction of Messina* (1909, G. 106). Beckmann crossed this title out, and the work was not exhibited in the Cassirer show.

33. 1908, G. 88.

34. 1911, G. 140.

35. *Portrait of Countess Augusta vom Hagen* (1908, G. 94).

36. *Portrait of Hanns Rabe* (1911, G. 148). Beckmann crossed the title out, and the painting was not included in the exhibition. Hanns Rabe (1880–1959) was a distant relation of Beckmann. Aside from this portrait, he acquired four other early Beckmann paintings.

37. 1906, G. 56.

38. 1905, G. 44.

39. 1909/10, G. 125.

40. Beckmann's "3" is confusing; he painted only two known portraits of members of the Simms family and lists only two (17 and 18) here, although he did omit the next number (19) from his list. He presumably exhibited the *Portrait Study of Karl Simms* at Cassirer's in 1913. His *Portrait of the Simms Family* was not exhibited in the Cassirer exhibition, but was shown in the 1913 spring exhibition of the Berlin Secession.

In a letter to Simms on May 6, 1913 (*Briefe*, 1:81), Beckmann indicated that he was also planning to paint a portrait of Simms himself and tried to set a date for a sitting, but he never seems to have executed this work. Perhaps that was the third Simms portrait Beckmann referred to (but did not number) in this list.

41. 1912, G. 152.

42. *Construction of the Hermsdorf Water Tower* (1909, G. 108).

43. 1909, G. 105. Beckmann crossed this title out, and the painting was not included in the Cassirer exhibition.

44. 1910, G. 127.

45. *Three Women in the Studio* (1908, G. 101).

46. 1910, G. 136.

47. Probably *Crucifixion of Christ* (1909, G. 119).

48. Probably *Dark Nenndorf Landscape* (1910, G. 133).

49. Beckmann did several landscapes at Wangerooge in 1909 and 1910. Those not previously identified as being in the Cassirer exhibition include *People after Work by the Sea* (1909, G. 110), *Clearing Weather* (1909, G. 112), *Lonely Beach* (1909, G. 114), *The Beach* (1909, G. 115), *Gloomy Evening by the Sea* (1909, G. 116), *Beach Landscape with Blue Sky* (1910, G. 130), and *Large Waves* (1910, G. 131). The Cassirer business books indicated that Beckmann sent *Large Waves* to the gallery in January 1913, where it remained until October 1920, so this was probably the work included in the 1913 show.

50. *Head of the Shepherd* (1909, G. 113).

51. *The Beach* (1909, G. 115). According to Göpel (*Katalog*), this painting was not exhibited in the Cassirer show.

52. *View of Lankwitz and Marienfelde* (1907, G. 70) was owned by a Director Stern; the title was crossed out, and the work was not included in the Cassirer exhibition.

53. 1908, G. 97. The title was crossed out, and the painting was not included in the Cassirer exhibition.

54. 1911, G. 139.

55. 1909, G. 109.

56. 1908, G. 91.

57. 1909, G. 112. According to Göpel, this painting was not exhibited in the Cassirer show.

58. 1909, G. 111.

59. *Self-Portrait with Hat* (1910, G. 135). According to Göpel, this painting was not exhibited in the Cassirer show.

60. *Christ Announces His Last Departure for Jerusalem* (1910, G. 129).

61. Perhaps *Forest Path near Hermsdorf* (1912, G. 156).

62. 1911, G. 142.

63. 1912, G. 153. Beckmann crossed out the title, and the painting was not included in the Cassirer exhibition.

64. 1908, G. 89.

65. 1908, G. 92.

66. *Dance Hall* (1909, G. 117).

67. *Light Nenndorf Landscape* (1910, G. 132) was listed as belonging to the collection of Dr. Schaper. Beckmann crossed this title out, and the painting was not included in the Cassirer exhibition.

68. *Portrait of Herr Pagel* (1907, G. 73) was owned by Waldemar Rösler. The painting was exhibited under the title of *Pomeranian Farmer* in the Cassirer show.

69. 1911, G. 144. The title was crossed out, and the painting was not included in the Cassirer exhibition.

70. 1911, G. 143.

71. 1911, G. 150.

72. 1911, G. 149. *Katalog* lists this as the *Portrait Study* shown in the Cassirer exhibition (cat. no. 13).

73. *Still Life with View from the Atelier into the Snow* (1909, G. 107).

74. 1906, G. 51. Beckmann crossed the title out, and the painting was not included in the Cassirer show.

75. *Lonely Beach* (1909, G. 114). Beckmann crossed the title out, and the painting was not included in the Cassirer exhibition.

76. This work cannot be identified. Other works in the Cassirer exhibition that cannot be identified with certainty are cat. no. 3 (*Portrait: Frau B.*, probably a portrait of Minna Beckmann-Tube); 10 (*Self-Portrait*); 13 (*Portrait Study*, perhaps G. 149 or G. 160); 14 (*Portrait of a Woman*, perhaps G. 84); 21 (*Beach near Wangerooge*); 30 (*Still Life*); 32 (*Wife of the Painter*). Identifiable works in the Cassirer show that do not seem to have been on Beckmann's diary list were cat. no. 23 (*Woman with a Fan* or *Portrait of Minna Beckmann-Tube in Décolleté*, 1909, G. 120); 24 (*The Beach* or *Summer Day by the Sea*, 1907, G. 77); 36 (*Shipwreck*, 1908, G. 96); 40 (*Balloon Competition*, or *Ascent of the Balloons at the Gordon Bennett Race*, 1908, G. 100); 41 (*Portrait of Dr. B.*, or *Portrait of Dr. Bender*, 1911, G. 141); and 42 (*Interior*, or *Atelier Interior*, 1912, G. 157).

77. Kaiser's monograph.

78. The town of Wittenberge is less than halfway from Berlin to Hamburg.

79. The numbers might refer to a third group sitting for the Simmses' portrait.

80. Theodor Brodersen was on the board of directors of the Hamburg Kunstverein after World War I. He might have been the Brodersen with whom Beckmann spoke on this occasion, perhaps in connection with Beckmann's exhibition in the Kunstverein, which would take place in February 1914.

81. Beckmann was possibly referring to one of Hamburg's oldest and best-known cafés, the Alster Pavilion at Jungfernstieg 54, at the southwest corner of the Inner Alster. The café was in the old center of the city, located below the basin of the Inner Alster; the Simmses' home on Heilwigstraße, where Beckmann worked, was far to the north, above the Outer Alster.

82. Beckmann's niece.

83. An agency near the Stettin station in Berlin.

84. *Construction of the Hermsdorf Water Tower, Portrait of Minna Beckmann-Tube in Décolleté, Portrait of Minna Beckmann-Tube with a Violet Shawl* (1909/10, G. 125), *Dark Nenndorf Landscape, Self-Portrait with Hat* (1910, G. 135), *Judith and Holofernes* (1912, G. 152); *Portrait Study of Karl Simms* (1912, G. 160).

85. Given the Simmses' interest in placing their collection within the decorative ensemble of their home, Beckmann feared that his paintings would never again be exhibited; several of the works they owned, however, were sent to the Cassirer exhibition. For illustrations of the interior of their home see Carsten Meyer-Tönnesmann, *Der Hamburgische Künstlerclub von 1897* (Hamburg: Hans Christians, 1985), pp. 146–47 and plate 173.

86. The Simmses did not acquire *Bearing of the Cross*. In his 1912 exhibition at Weimar Beckmann had asked M 6,750 for *Bearing of the Cross* (noted in Gordon, *Modern Art Exhibitions*, 2:610).

87. Given the Simmses' general tastes and the decorative Jugendstil of their home, Beckmann seems to have wondered whether they would find *Bearing of the Cross* fitting for that milieu.

88. According to Göpel in *Katalog*, 1:116, 118, the Simmses liked neither the portrait study of Karl Frederic nor the finished family portrait.

89. Perhaps the sixth group sitting or sixth day of work for the Simms portrait.

90. As noted by Schmidt in *Frühe Tagebücher*, p. 151 n. 29, Gerhart Hauptmann's *Gabriel Schilling's Flight* (1912) was performed that night at the Deutsches Schauspielhaus (German theater) at Kirchen-Allee 38–41. In Hauptmann's play, Gabriel Schilling was an unsuccessful artist who tried to escape from his mistress and wife and ended by drowning himself off the shore of an island in the Baltic Sea.

91. The Deutsches Schauspielhaus is just east of the main train station, Kunsthalle, and Alster basins, about three blocks from the river. The Neva flows from Lake Ladoga through Leningrad into the Gulf of Finland.

92. Mittelweg is a major street a few blocks west of the Outer Alster, moving north from the city at the Dammtor station toward the Heilwigstraße where the Simmses lived.

93. Tuesday was January 21, 1913.

94. Eduard Wilhelm Tieffenbach (1883–1948) was a natural scientist who suddenly abandoned that career to print graphics in 1911 on his own handpress at Officina Serpentis. Some of the first artists he worked with were Waldemar Rösler and Beckmann; he published Beckmann's *Six Lithographs to the New Testament* (1911, H. 18–23) and several subsequent prints.

95. Karl Scheffler wrote a major piece on Beckmann's show at Cassirer's—one of the most glowing reviews Beckmann received in the prewar

period (*Kunst und Künstler* 11 [March 1913]: 297–305)—and the two presumably met to discuss Beckmann's works and ideas.

96. As noted by Schmidt in *Frühe Tagebücher*, p. 152 n. 34, advertisements in catalogues of the Berlin Secession indicate that Beckmann and other artists, including Wilhelm Giese, taught at the Atelier Clara E. Fisher, Potsdamer Straße 121a in Zehlendorf, southwest of Berlin.

97. Beckmann was planning an excursion to the countryside west of Hamburg, probably by train and by steamer. Blankenese, on the shores of the Elbe, is a suburb nine miles west from the center of Hamburg.

98. Lühe was the end station of the Elbe steamer, one and a half hours from Hamburg-Altona on the south bank of the Elbe at the mouth of the Lühe River.

99. Beckmann probably was referring to the Altes Land, a broad strip of marshy land extending from Hamburg along the south bank of the Elbe to Stade. Traveling west from Blankenese, he could have disembarked at Lühe and traversed the Altes Land on the Lühe Dyke. This is a scenic district crossed by canals and rivers, the northernmost area in the world devoted entirely to fruit growing and ideally suited for walking.

100. Baurs Park is on the heights of the Elbe between Mühlenberg and Old Blankenese, next to the Katharinenhof in Blankenese. It was created by the Altona merchant Georg Friedrich Baur (1768–1809) between 1802 and 1815.

101. The German transcription reads: "Der Mensch ist und bleibt doch ein R. Schw.[ein?] erster Klasse."

102. Beckmann drew a portrait at this point.

103. The German transcription is "m[an]."

104. That is, Beckmann feels he'll never win.

105. Jungfernheide, a moorland south of Hermsdorf and Tegel, east of Tegel Lake (the Berlin-Tegel airport was subsequently built on part of this land). Beckmann had thus barely left Berlin.

106. The following page was removed.

107. Forty-six days had passed since the previous entry, in which Beckmann announced the opening of the Cassirer exhibition. Beckmann made no further reference to the show in this diary.

108. The Simmses were presumably visiting their son.

109. The firm of Velhagen and Klasing published a series of popular art monographs and a yearly almanac and might have considered publishing one of Beckmann's works in the latter. As noted in Beckmann and Schaffer, *Bibliothek*, p. 502, at the time of his death Beckmann had a copy of the almanac for 1913 (Berlin: Velhagen and Klasing, 1913), but neither that nor the following almanac contained an illustration by Beckmann.

110. Beckmann's first mention of his *Sinking of the Titanic*, a huge painting on which he worked intensively after the ship's sinking on April 15, 1912, and first exhibited in the spring Secession show of 1913. In a sketchbook of the same period (1912–13) Beckmann made several preparatory sketches for his painting: see *Frühe Tagebücher*, pp. 126–28, 135.

111. On the following page was a drawing of water with ships, perhaps the Hamburg harbor, reproduced in *Frühe Tagebücher*, p. 118. On the next

two pages Beckmann wrote some addresses and numbers. On the following page he drew a sketch of several people gathered in conversation, reproduced in *Frühe Tagebücher*, p. 119.

112. The sum seems to be of prices of paintings and/or prints. As Schmidt notes in *Frühe Tagebücher*, pp. 152–53 n. 44, a later list gave three of the same numbers: M 1,200 for one of the Simmses' portraits of Minna Beckmann-Tube (G. 120 or G. 125) and M 700 for the portrait study of Karl Frederic, and an amount of M 1,500 assigned to Reinhard Piper, who had first met Beckmann and begun to collect his works in the summer of 1912. In the catalogue of his 1912 Weimar exhibition, Beckmann asked prices from M 700 to M 13,500, the latter for his huge *Resurrection*, but no prices of M 10,000, M 4,200, or M 4,000 (see Gordon, *Modern Art Exhibitions*, 2:610).

113. Perhaps a nickname for Beckmann's nephew, Richard Lüdecke, for whom he also seems to have acted as guardian.

114. Beckmann was preparing the *Sinking of the Titanic* for the spring show of the Berlin Secession.

115. The passage cannot be read.

116. Beckmann scratched out several numbers in the date and finally seemed to have written the wrong number for the month; he presumably meant April.

117. H. Birkholz printed the following two lithographs for the publisher, I. B. Neumann of Berlin.

118. 1911, H. 34. The Admirals Café was part of the grand new Admirals Palace, a shopping and entertainment complex across from the Friedrichstraße station that had just opened in 1911.

119. *Boats on Lake Tegel* (1911, H. 36). Tegel Lake, a few stops from Hermsdorf to the southeast, would have been the Beckmanns' major place for boating outings.

120. Tieffenbach published the following prints, all of 1911: H. 26, 27, 29, 28, and 25.

121. Several empty pages, some with addresses, follow.

122. Several empty pages follow.

123. Several pages with drawings and short notices and addresses follow. See *Frühe Tagebücher*, pp. 122–23, 134.

124. Beckmann had spoken critically of Picasso's "chessboards" and cubism in his March 1912 exchange with Marc. By the spring of 1913 he could have seen Picasso's works on several other occasions in Berlin, as well as in illustrations. See, for instance, Gordon, *Modern Art Exhibitions*, 1:350.

The phrase "with a shot of Gothic" seems to have been added later.

125. Several pages, empty or with addresses or sketches, follow to the end of the book. See *Frühe Tagebücher*, pp. 124, 134.

STATEMENT FOR EXHIBITION AT HAMBURG KUNSTVEREIN

Founded in 1817, the Hamburg Kunstverein sponsored exhibitions of international contemporary art every two years. In 1914 the Kunstverein was located at Neuerwall 14, south of the Inner Alster.

The Bulgarian Jules Pascin (1885–1930), a key figure of the circle of Montparnasse, did much prewar work in Germany; the Hanburg-born Walter Geffcken (1872–1950) was active in Munich.

This translation by Barbara Copeland Buenger is based on a handout that accompanied the show; the original text has not been found. The statement was inadvertently excluded from the list of Beckmann statements in *Katalog* and is reprinted here in German for the first time since 1914: "Mein Programm ist kurz. Ich habe nämlich keines. Höchstens, daß mir alle Theorie und jegliches Prinzipielle in der Malerei verhaßt ist. Ich liebe das Erhabene und das Lächerliche. Das Normale und das Groteske. Jede Form des Lebens, denn meine Sehnsucht ist, etwas Lebendiges zu machen. Also vielleicht doch ein Programm."

1. 5. *Graphische Ausstellung des Deutschen Künstlerbundes* (Commeter Galerie, Hamburg, 1913).

"THE NEW PROGRAM"

This text was one of several published in response to a request from Karl Scheffler and first appeared in "Das neue Program," *Kunst und Künstler* 12 (March 1914): 301. The original manuscript has not been found. This translation is taken from Victor H. Miesel, trans. and ed., *Voices of German Expressionism* (Englewood Cliffs, NJ: Prentice Hall, 1970), pp. 106–7.

1. On Scheffler see Paret, *Berlin Secession;* Karl Scheffler, *Die Fetten und die Mageren Jahre* (Munich: Paul List, 1948).

2. See, for instance, Karl Scheffler, "Der Krieg," *Kunst und Künstler* 13 (October 1914): 4.

3. In "Chronik: Ein Protest deutscher Künstler," *Kunst und Künstler* 9 (July 1911): 557–59, Scheffler sharply attacked Vinnen and the "Worpsweder," although only two other Worpswede artists signed the protest.

4. Meier-Graefe first presented these ideas in lectures and published them in *Die neue Rundschau* in 1913. They are republished in Julius Meier-Graefe, *Die doppelte Kurve* (Berlin: Paul Zsolnay, 1924), pp. 19–94.

5. Karl Scheffler, "Die Jüngsten," *Kunst und Künstler* 11 (May 1913): 391–409.

6. Scheffler, "Das neue Program," *Kunst und Künstler* 12 (March 1914): 299–314.

7. Since the journal's archives were destroyed, we have no idea whom Scheffler initially asked or whether everyone who was asked responded.

8. See Paret, *Berlin Secession,* pp. 230–32.

9. The organizers of the Cologne Sonderbund exhibition of 1912 had included many of Cézanne's works.

WARTIME LETTERS: EAST PRUSSIA

This translation by Reinhold Heller is based on the German edition of Max Beckmann, *Briefe im Kriege,* collected by Minna Beckmann-Tube, with an afterword by Peter Beckmann (Munich: Piper, 1984). © R. Piper GmbH & Co. KG, München 1984. The 1984 edition was based on the original 1916 publication of the collected letters. These letters were first published as

"Feldpostbriefe aus Ostpreussen," *Kunst und Künstler* 13 (December 1914): 126–33, and subsequently in the first book edition, *Briefe im Kriege* (Berlin: Bruno Cassirer, 1916). The original letters were probably destroyed: Minna Beckmann-Tube lost many letters after she left Berlin at the end of World War II.

The following annotations were developed from the documentation in Barbara Copeland Buenger, "Max Beckmann in the First World War," in Rainer Rumold and O. K. Werckmeister, eds., *The Ideological Crisis of Expressionism: The Literary and Artistic German War Colony in Belgium, 1914–1918* (Columbia, SC: Camden House, 1990), pp. 237–79; *Briefe*, 1: 92–143, 430–35; and Stephan von Wiese, *Max Beckmanns zeichnerisches Werk, 1903–1925* (Düsseldorf: Droste, 1978), pp. 45–108, 198–206.

1. Beckmann-Tube, "Erinnerungen an Max Beckmann," pp. 177–80.

2. "Die erste Kriegswoche in Berlin nach Mitteilungen Berliner Tageszeitungen, mit sieben Zeichnungen von Max Beckmann," *Kunst und Künstler* 13 (November 1914): 53–60.

3. The lithograph (H. 76) would first be published a few weeks after Martin Tube's death on October 11, in *Kriegszeit: Künstlerflugblätter* 11 (November 4, 1914), p. 4.

4. This group of letters was published first as "Feldpostbriefe aus Ostpreussen," *Kunst und Künstler* 13 (December 1914): 126–33.

5. W. 184.

6. Beckmann and Schaffer, *Bibliothek*, p. 47. Roessel is northeast of Allenstein (Olsztyn).

7. Schneede, in *Briefe*, 1:429, identified the location as Mlawa. Documentation of the events of the war is derived from several accounts, notably Robert B. Asprey, *The German High Command at War* (New York: William Morrow, 1991); Karl Baedeker, *Northern Germany* (Leipzig: Karl Baedeker, 1904, 1925); Martin Gilbert, *Atlas of the First World War* (New York: Oxford University Press, 1994); idem, *The First World War* (New York: Henry Holt, 1994); Randal Gray, *Chronicle of the First World War*, 2 vols. (New York: Facts on File, 1990); Philip J. Haythornthwaite, *The World War I Source Book* (London: Arms and Armour Press, 1994); B. H. Liddell Hart, *History of the First World War* (London: Pan Books, 1972); and Reichsarchiv, *Der Weltkrieg, 1914–1918*, vol. 5 (Berlin: S. Mittler and Son, 1929).

8. No record of Beckmann's status during the war could be found in German military archives. Since Beckmann had passed the exempting *Einjährig-Freiwilliger* (one-year volunteer) examination in 1903, he had received no military training. In a letter to Reinhard Piper on August 15, 1914, Beckmann declared that he was in the "home reserves with weapon" waiting to be called up any day (*Briefe*, 1:91). The only semiofficial definition of his wartime status that survives is his 1916 statement for a census made in a letter to his friends Ugi (1879–1957) and Fridel Battenberg, in which he stated that he was classified as a "volunteer medical orderly . . . fit for limited duty" (November 29, 1916, *Briefe*, 1:149).

9. "Iacta alea est" was a proverb quoted by Julius Caesar as he crossed the Rubicon (49 B.C.).

10. Perhaps Hohenstein (Olstynek).

11. On September 12 the Russians evacuated Tilsit, a town on the Neman River at the mouth of the Tilse beyond Königsberg and far to the northeast of Beckmann's current location. As Beckmann wrote, the Germans continued to advance toward that area and would take Tilsit by September 19.

12. A mounted lancer or cavalryman.

13. Thorn (Torun), an old fortified town on the Vistula, is 238 miles from Berlin and was of great importance in the history of both Poland and Prussia. Thorn was a main place of transfer, about sixty miles from Mlawa.

14. Osterode (Ostróda) is seventy-seven miles northeast of Thorn.

15. Mühlen is near the village of Tannenberg (Stebark), which gave the Battle of Tannenberg its name.

16. Mlawa is about thirty miles from Mühlen.

17. *Lamentation* (1908, G. 89).

18. Deutsch-Eylau (Ilawa) is southwest of Allenstein and was on the train line from Thorn.

19. On September 16 Beckmann did two drawings at Neidenburg (W. 188, 189), which he presumably visited from Mlawa, on the same train line about twenty-one miles away. The Germans had retaken Neidenburg on August 31.

20. Allenstein has many old buildings, including an episcopal palace of 1353–60.

21. The Pour le mérite, created by the Francophile Frederick the Great of Prussia, was the highest German award for bravery, normally given for heroic action in frontline combat.

22. Kaiser Wilhelm II would award the Pour le mérite to Hindenburg himself, chiefly out of political necessity, only after the winter battle of 1915. Hindenburg, who became field marshall after the victory at Lodz in November 1914, remained at the head of the armies throughout the war and subsequently swore allegiance to the new Weimar Republic. He was elected president of the republic in 1925 and in 1933 appointed Adolf Hitler chancellor.

23. In the first post–World War II edition of Beckmann's war letters, *Briefe im Kriege* (Munich: Piper, 1955), edited by Beckmann's son, Peter, this entire passage (from "Allenstein remained untouched" through "caused me to shout hurrah") and all references to Hindenburg were deleted.

24. This paragraph was deleted from the 1955 edition.

25. Lyck (Elk) was close to the Russian border, ninety-eight miles east and slightly north of Allenstein. Located on a lake, Lyck is a major town in Masuria, the area into which masses of Russians had retreated during the Battle of the Masurian Lakes.

26. This famous popular song, "Wenn ein Mädchen einen Mann hat, den sie liebt und den sie gern hat," was written by Walter Kollo (1878–1940), a celebrated writer of cabarets, operettas, and reviews.

27. The Iron Cross, created by Friedrich Wilhelm III in 1813, was the best known of all Prussian war decorations, awarded to both officers and men.

28. The Austrian losses during the Battles of Lemberg (Lvov; August 23–September 12, 1914) had exposed the German flank in the east, and Hin-

denburg was ordered to assist the Austrians and protect Silesia. Hindenburg's new Ninth Army joined the Austrians against much larger Russian forces in late September and October. Their plan to cross the Vistula near Warsaw was ultimately unsuccessful and had to be abandoned, but the move did stop the Russians' advance on Silesia through Poland.

Martin Tube fell in the German-Austrian advance on October 11 at Ivangorod; the action, which caused heavy casualties, reached its limit the following day.

The entire passage from "Now, for a change of pace" was deleted from the 1955 edition.

29. Beckmann did not go to Galicia.

30. The Fortress Boyen, near Lötzen (Gizycko), was northeast of Lyck on one of the Masurian Lakes.

31. Jean Paul's *Hesperus*, which Beckmann quoted so extensively in his 1903 diaries, contains much discussion of a pastor's family and way of life.

32. It is impossible to determine where Beckmann was when he wrote the remaining letters from the Eastern Front. His location in Lyck and Lötzen on September 24 suggests he remained with the Eighth Army in the north as it advanced farther into Russia. His subsequent mention of going to "R.," sounds of battle, and refugees from Lyck seem to reinforce this.

33. Beckmann probably meant that he had suffered chest spasms or perhaps even a throat inflammation; the usual symptoms of angina—chest spasms and pain brought on by exertions such as exercise, walking into the wind, or emotional distress—usually disappear when those exertions cease. Symptoms of angina pectoris or angina (the word derives from words for choking and strangling) had been recognized and described since the eighteenth century; by the end of the nineteenth century it was recognized that people could die from angina. Not until the 1900s was angina associated with coronary disease, and in an American article of 1918 angina was first linked with coronary artery disease. Although Beckmann died of angina pectoris and a heart attack in 1950, he probably would not have lived as long if he had suffered angina pectoris as early as 1914. It is unlikely that either Beckmann or his doctors associated his angina with heart disease in 1914, but without records we will never know.

34. Both as a child and as an artist who studied in Paris, Beckmann would have seen numerous representations of the French heroes Jean Paul Marat and Napoleon Bonaparte, both obvious models for the Polish representations he saw.

35. Perhaps Königsberg.

36. Lyck is 131 miles from Königsberg and was on the train line.

37. Perhaps Gumbinnen (Gusev), which had been at the center of a major drive against the Russians during the Battle of Tannenberg.

38. The Belgian port of Antwerp had finally capitulated to the Germans on October 10.

39. The French engraver Jacques Callot (1592/93–1638) was renowned for representations of popular life and scenes of the Thirty Years' War that emphasized the barren aftermath of war.

40. Perhaps Gumbinnen, although that does not seem to have been the headquarters of the German High Command at this point.

This translation by Reinhold Heller is based on the German edition of Beckmann, *Briefe im Kriege*. © R. Piper GmbH & Co. KG, München 1984. These letters were published first as "Feldpostbriefe aus dem Westen," *Kunst und Künstler* 13 (July 1915): 461–67, and in the first collected edition of the letters in 1916.

1. W. 204 and 205.

2. Beckmann to Waldemar Rösler, November 25, 1914, *Briefe*, 1:101. Max Kaus, "Mit Erich Heckel im ersten Kriege," *Brücke Archiv* 4 (1950): 5, described the training he and Erich Heckel received, which must have been similar, if not identical, to Beckmann's. They met for instruction at the Ordonnanzhaus near the Alexanderplatz in Berlin and were taught little more than military formalities and a great deal about caring for patients.

3. Courtrai is located on the River Lys (Leie) in Flemish-speaking West Flanders, almost directly west from Ypres and about 143 miles from Brussels. The city, whose wartime population was about 30,600, was captured by the Germans on October 17, 1914, and became a main base behind the Ypres front. During World War II much of the city was damaged by aerial bombardment.

4. In his March 1923 letter to Reinhard Piper, published in *Almanach 1904–1924 des Verlages R. Piper and Co.* (Munich: Piper, 1923), p. 86, Beckmann said he worked in an "Augustinian cloister" in Courtrai, but there was no Augustinian monastery in the city, which had ten military hospitals during World War I. Beckmann probably first worked at the cloister of the Picpussen, or the Holy Hearts of Jesus, at Meiweg 1, which was a field hospital for German soldiers with typhus. On Courtrai during the war see E. Van Hoonacker, *Kortrijk, 14–18* (Courtrai: E. Van Hoonacker, 1994).

5. Several of the faces Beckmann drew recall drawings of peasants by van Gogh: see Buenger, *Max Beckmann's Artistic Sources*, pp. 99–101.

6. Ypres is eighteen miles from Courtrai.

7. Beckmann had probably transferred from the cloister of the Picpussen to the Passionistencloster at Wandelingstraat 33, which was mostly for wounded soldiers and occasionally for typhus patients. Unlike the neo-Gothic Picpussen cloister, the Passionistencloster had a colonnade.

8. Woman Beckmann drew in W. 224.

9. A stone windmill was near the Picpussen cloister about a mile southwest of town at the beginning of the Pottelberg; this suggests Beckmann still lived at the Picpussen cloister.

10. The Kriegslazarett-Museum (Field hospital museum) was a collecting place for the sick and wounded close to the Courtrai railway station. After a first examination the slightly wounded remained in this field hospital, and the more badly wounded were sent to Ghent or Germany. The field hospital was on the ground floor of the Grote Hallen (Grand halls); the city museum was on the next floor, hence the building's unusual name.

11. Perhaps the Picpussen cloister in Pottelberg.

12. During one period of his career Giuseppe Verdi was strongly influenced by Wagner, his exact contemporary, and both wrote celebratory music that would have been adapted or imitated by military bands.

13. Beckmann might have already arrived at Roeselare (Roulers), where he wrote many of the following entries. Roeselare, in north Flanders, is about six miles northeast of Courtrai. The Germans took the city on October 18, 1914, and made it the headquarters for German soldiers facing the Ypres salient.

14. Beckmann's reflection on his hopes for his style again expresses his resistance to the type of decorative effects ("arabesques," "calligraphy") he would have associated with expressionism, but his newly urgent, gestural mode of drawing seems related in many ways to expressionist drawing styles.

During the less than two weeks he was in Roeselare, Beckmann came into contact with Erich Heckel, who was a volunteer medical orderly for the Red Cross with the Fourth Army. The two, who knew each other before the war through the Secession, spoke on several occasions, especially about art. Though Beckmann made no mention of their encounters in the published letters, Heckel later recalled their meetings in interviews. See Kaus, "Mit Erich Heckel im ersten Kriege," pp. 5–14.

15. Ostende (Oostende), about thirty-two miles from Roeselare, was a principal seaport and the most fashionable bathing resort in Belgium. The Germans entered the city on October 15 and used it as a submarine base during the war.

16. Torhout is about halfway to Ostende, directly north of Roeselare at the junction of the line from Bruges to Courtrai. Blankenberge is a seaside resort northeast of Ostende, and was reached by changing trains at Bruges.

17. Ludwig Thormaehlen (1889–1956), a sculptor, had become director of the Charlottenburg Kunstgewerbeschule at the war's beginning. The same year he also began a career at the Berlin Nationalgalerie that eventually led to his appointment as curator in the department of prints and drawings.

18. Menin (Meenen) was about twelve miles on a direct train line from Roeselare and about twelve miles from Ypres.

19. Dixmude (Diksmuide) was totally destroyed in fighting between October 10 and November 19, 1914, before Belgian and French troops abandoned it to the Germans. There had been renewed attacks near the city during the second week of March and a Belgian success near the city on March 14.

20. The Ostende casino on the beach promenade was built in 1745.

WARTIME LETTERS: ROESELARE, WERVICQ, BRUSSELS

These letters were first published in *Briefe im Kriege*, pp. 29–75. © R. Piper GmbH & Co. KG, München 1984. This translation by Reinhold Heller is based on that edition.

1. Beckmann conceivably wrote of the first gas attack at Langemark to Minna Beckmann, but no references to it are found in his published letters of April 22, 24, 26, and 27: mention of the attack would still have been censored in publications of 1916. Rudolf Binding (1867–1938), for instance, a writer with whom Beckmann would later become acquainted in Frankfurt,

was an experienced soldier close to the attack at Langemark: in a private letter of April 24 he spoke openly of his disgust with the attack, but that letter was first published only in 1925. See Rudolf Binding, *A Fatalist at War* (London: George Allen and Unwin, 1929), p. 64.

2. Falkenhayn, chief of the German general staff since 1914, would be replaced by Hindenburg in 1916 after Verdun. Falkenhayn subsequently led forces into Romania; he was less successful in Mesopotamia and Palestine and was relieved of that command in February 1918.

3. In addition to the documentary sources listed in the chapter 11 notes, see also Buenger, "Max Beckmann in the First World War"; Rose E. B. Coombs, *Before Endeavours Fade* (London: Battle of Britain Prints International, 1986); J. E. Edmonds and G. C. Wynne, *Military Operations: France and Belgium, 1915*, vol. 1 (London: Macmillan and Co., 1927); Rudolf Hanslian, *Der deutsche Gasangriff bei Ypren am 22. April 1915* (Berlin: Verlag Gasschutz und Luftschutz, 1934); G. W. L. Nicholson, *Canadian Expeditionary Force, 1914–1919* (Ottowa: Roger Duhamel, 1962); Reichsarchiv, *Der Weltkrieg, 1914–1918*, vol. 8; Ulrich Trumpener, "The Road to Ypres: The Beginnings of Gas Warfare in World War I," *Journal of Modern History* 47, no. 3 (1975): 460–80.

4. *Kriegslieder des 15. Korps, 1914–1915: Von den Vogesen bis Ypern* (Berlin: Paul Cassirer, 1915).

5. Wervicq (Werwik), which was taken by the Germans on October 7, 1914, is about seven miles from Ypres, about four miles southeast of Menin on the train line from Roeselare. It was then a town of about 9,900 inhabitants and had a number of tobacco factories and textile mills. The city is divided by the River Lys, so that its northern half is in Belgium, its southern half in France.

6. The bathing establishment, or delousing bath, Beckmann would paint was located in one of the textile buildings, probably that owned by the Cousin brothers, just south of the River Lys in French or South Wervicq. The Germans destroyed this and many of the other buildings they used when they left Belgium in 1918.

7. Philalethes Kuhn (1870–1937).

8. The painting (1915, G. 186) was reproduced and discussed in the same issue of *Kunst und Künstler* that published the second installment of Beckmann's war letters (13 [July 1915]: 478–79).

The Allies made bombardments and attacks in the Dardanelles on February 19 and 25 and March 18. Turkey, which entered the war on the side of the Central Powers at the end of October 1914, prevented British and French supplies from reaching Russia by closing the Dardanelles. The Allies wanted to topple the Turkish government by forcing the Dardanelles, gaining access to the Black Sea, and bombing Constantinople. Since the Germans had strengthened and reorganized the Turkish forces, however, the Allies' attempt to force the narrows on March 18 had been unsuccessful. As Beckmann wrote, then, the German camp must have been celebrating the Turks' success at the Dardanelles.

9. Beckmann was about five miles from the German line and six miles from the Allied line.

10. Comines (Komen) is two miles southwest of Wervicq. The Germans took Comines on October 4, 1914.

11. The land rose slightly with a few hills just south and slightly west of Wervicq in an area that is called La Montagne.

12. Innumerable wartime accounts noted that German soldiers carried the New Testament and Nietzsche's *Also sprach Zarathustra*—both available in special field editions—in their knapsacks. Beckmann was carrying his own edition of *Zarathustra* (Leipzig: Naumann, 1906), in which he continued to make annotations throughout his life. See Beckmann and Schaffer, *Bibliothek*, pp. 46−49.

13. Deutsch-Eylau was the city in East Prussia in which Martin Tube had been stationed: Minna Beckmann had gone there to retrieve his personal effects.

14. The Church of St. Medard in Belgian Wervicq, founded in 1214 and rebuilt in 1380−1430, had been recently restored (Karl Baedeker, *Belgium and Holland* [Leipzig: Karl Baedeker, 1910], p. 53). Beckmann represented the church in the background of his mural.

15. Beckmann is describing what he will represent in his mural. The painting combined vignettes seen or studied from several different points of view. A possible source of his synthetism and arrangement could have been Hodler's *Departure of the German Students during the War of Liberation, 1813* (1907−8), a mural at the Friedrich Schiller University in Jena that he would have known through reproductions. Beckmann's mural showed a view of St. Medard's from the southern side of the Lys (exactly as he would later sketch it in a drawing, W. 320). When he arrived on the front, however, the fighting was well north and away from St. Medard's: he could not have seen fighting soldiers and trenches at the range he depicted from the south of St. Medard's.

16. The German bombardment of the northern French city of Lille on October 11 destroyed eight hundred buildings, and the city surrendered on October 12. Lille is about ten miles directly south of Wervicq; it was normally reached by train via Armentières, but Beckmann had to take another route since the British had retaken Armentières on October 18.

17. This route was not only more pleasant but also necessary because of the British position. Tourcoing is about ten miles from Werwicq and ten miles from Lille.

18. The only recent prints in which Beckmann had depicted a murdered man were the different versions of *Night* (1914, H. 77).

19. The graphic artist and caricaturist Karl Arnold (1883−1953) was one of the key contributors to the famed Munich journals *Simplicissimus* and *Jugend*. In a letter of May 11, 1915, Arnold noted that Beckmann had already visited him twice: see Fritz Arnold, ed., *Karl Arnold: Leben und Werk* (Munich: Bruckmann, 1977), p. 45.

20. Beckmann had probably boarded a train near Quesnoy-sur-Deule, riding northward on the route through Comines and Wervicq.

21. Beckmann was edited here. He was recalling the Grimm Brothers' fairy tale of "The Fisherman and His Wife," a narration that starts by saying the couple lived in a chamber pot (in Plattdeutsch, *Piβputt*). The insatiable

Ilsebill kept asking for and receiving more wishes, but she finally asked for so many that she ended up back in the chamber pot.

22. Minna Beckmann-Tube, who had long studied voice, finally decided to embark on her career as a singer in 1915 and had her first engagements in Elberfeld in the Wuppertal near Düsseldorf. In an interview of 1956, "Leben an der Seite eines Genies," *Der Regenbogen* (1956): 5, she noted that Beckmann had once said he would divorce her if she ever took up a professional career as a singer, but that he had apparently accepted it when she took on the offer in 1915 because they needed the money during the war.

23. Brussels, which the Germans captured on August 20 and made the capital of their occupation government, was sixty-seven miles northeast of Wervicq by train through Courtrai. On Brussels, German policies, and artists in and near the city, see Rumold and Werckmeister, *Ideological Crisis of Expressionism.*

24. Brussels occupies rising ground on the edge of the Senne valley at a point where the hills drop away to the plain of Flanders. In 1915 the city proper was restricted to the pentagonal area formerly formed by fortifications, consisting of the Lower Town and the smaller Upper Town on a ridge to the east (Vera Beck et al., *Baedeker's Belgium* [New York: Prentice Hall, 1993], p. 161).

25. The Grand-Place in the Lower Town acquired its name in 1380 and remains one of the finest medieval squares in existence. The town hall was started in 1402, and its tower was completed in 1455. Aside from St. Mark itself (begun in the eleventh century), the most famous architecture in St. Mark's square stems from the fifteenth century, much of it associated with Jacopo Sansovino (1486–1570). Beckmann had been in Venice on at least two occasions, during his stay at the Villa Romana in Florence in 1906–7 and in 1913.

26. The Flemish policy of the German occupation government attempted to win supporters for Germany by stressing the close affinities of Flemish and German culture.

27. Beckmann had visited the Royal Museum of Fine Arts. As noted in Schneede, *Briefe,* 1:433, works by Pieter Brueghel the Elder (ca. 1525 or 1530–69) in that museum included *Fall of the Rebel Angels, Epiphany, Winter Landscape with Skaters and Falling Birds, Census at Bethlehem, Fall of Icarus,* and *The Yawner,* and paintings by Rogier van der Weyden (1399–1464) included *Pietà, Madonna and Child, Man with Arrow,* and *Portrait of Laurent Froiment.*

28. Lucas Cranach the Elder's (1472–1553) *Portrait of Dr. J. Scheyring* (1529).

29. The Wiertz Museum, which owns the collection of paintings of the eccentric Belgian romantic painter Antoine Wiertz (1806–65), was built in the studio given to the artist by the city.

30. Wiertz, who was decisively influenced by both Rubens and Jean Auguste Dominique Ingres (1780–1867), had traveled to Paris and won the Prix de Rome there in 1832.

31. The mountain was probably La Montagne, south of South Wervicq on the way to Linselles. Many events in the Second Battle of Ypres began

before the official starting date of April 22. On April 14 the Germans began a bombardment of Ypres that continued for almost a month, completely destroying the city. From April 17 to 21 the British and Germans fought for Hill 60, about six miles from Wervicq. Both of these battles could have provided the fireworks Beckmann observed from his mountain.

32. The British had taken Hill 60 on April 17 but had to continue to fight back further attacks.

33. Although Beckmann was amid the early skirmishes of the Second Battle of Ypres at this point, he was chiefly concerned with his mural. Given the ground of brick and conditions under which he was working, it has long been assumed that he worked in casein color, not true fresco. On the other hand, he did refer to "how beautiful the colors appear on the plaster," and fresco presumably would have held up better in a bathing establishment than casein. On the mural see *Katalog*, 1:128; Buenger, "Max Beckmann in the First World War."

34. Beckmann had every reason to feel nervous. The fighting for Hill 60 was fierce, and the Germans bombarded Ypres heavily on April 20. They had long been making preparations to mount their first gas attack and called up soldiers repeatedly throughout March and April until the attack was finally undertaken on April 22.

35. The British fought back attacks on Hill 60 on April 19, 20, and 29.

36. Beckmann was probably hearing the German "hate shoot" on Ypres, which either killed or drove out of the city the remaining citizens.

37. The white villa Beckmann mentioned here was probably the Château Dalle-Dumont or Derville, which was long used as the ninth hospital of the Fifteenth Corps. The villa, which Beckmann sketched in one of his subsequent drawings (W. 316), was just southwest of Hill 60.

38. The Bavarian Second Army was to the left, or southwest, of the Fifteenth Corps on April 22.

39. Beckmann must have written the wrong date: he probably meant April 21 or 22. Since he referred to a letter written the day before, it could have been April 21.

40. A great number of casualties resulted from the fighting for Hill 60 on April 20–21.

41. Heinrich von Kleist's highly popular *Amphytrion* (1807) was distributed to troops in a miniature field edition. Kleist, a career soldier, wrote the comedy, based on Molière's play of the same title (1668), just after Prussia had been defeated by Napoleon.

42. Beckmann was talking about Kleist, who committed double suicide with his friend and companion, the incurably ill Henriette Vogel, in 1811.

43. Kleist was extremely close to his half-sister Ulrike (1774–1849), who supported him for much of their lives out of trust in promises. Kleist had become estranged from Ulrike and his family and was shocked to see that she seemingly rejected him at a lunch a little more than a month before his suicide. He reconciled himself to his family in letters written before his suicide, and the letters were published and widely read.

44. The German attack on Langemark with gas shells began on April 22, the formal start of the Second Battle of Ypres. Langemark is about four miles

northeast of Ypres and about ten miles from Beckmann in Wervicq. On April 23 the Germans made a second gas attack and took Langemark.

45. The Berlin sculptor Wilhelm Gerstel was the husband of the Beckmanns' close friend from Weimar, Mili Plump. Gerstel was imprisoned in France in October 1914 and was released only in February 1920.

46. Beckmann's many wartime drawings (W. 169–328) are extensively discussed in von Wiese, *Max Beckmanns zeichnerisches Werk*, and in Buenger, "Max Beckmann in the First World War."

47. Tenbrielen (Timbriele) is about one and a half miles northwest of Wervicq.

48. The Germans used gas again on April 26 but apparently not on April 28.

49. The Hollebeke château, a position fought over throughout the war, was completely destroyed and never rebuilt. Hollebeke, about five miles from Wervicq, was on the rail line and the Ypres-Comines Canal.

50. On May 1 the Germans made a failed gas attack on Hill 60.

51. Linselles is a small French town below La Montagne, about three miles southeast of Wervicq.

52. M. André Braem, the mayor of French Wervicq in 1989, confirmed that Dr. Bonenfant, a doctor to the poor, was also mayor of Linselles during the war.

Beckmann read extensively in the works of Gustave Flaubert throughout his life, usually in German translations. On the books that remained in his library at the time of his death, see Beckmann and Schaffer, *Bibliothek,* pp. 405–15, 476–77.

53. Beckmann is speaking of the Austro-German offensive at Gorlice and Tarnow in the Carpathian Mountains in western Galicia (May 1–5). The operation immediately killed thousands of Russian soldiers, took more than thirty thousand prisoners, and finally ended the Russians' nine months of advances in that area.

54. Probably the church at Hollebeke. Beckmann made a drawing of a destroyed church (W. 269), presumably the same structure he described here.

55. The Germans had continued their gas attacks on Hill 60, about four and a half miles northeast of Messines, and forced the British to withdraw on May 4. On May 5 the Germans took Hill 60, which they kept until June 17.

56. W. 268.

57. Confirmation of the numbers of the Gorlice-Tarnow offensive.

58. The Germans came closer to Ypres after they took Hill 60 and after the Battle of St. Julien (April 24–May 4) but still failed to take the city.

59. On this day, as the British completed a planned withdrawal, the Germans continued to fight for Hill 60.

60. Beckmann was moving much closer to the front and the battle for Hill 60. Zandvoorde is on a hill about one and a half miles northwest of Tenbrielen; this was about one and a half miles southeast of Sanctuary Wood, through which the trenches ran. With the advance of May 1915 the Germans took the eastern part of Sanctuary Wood.

61. The Germans were continuing to attack Hill 60 with gas. Since they

had first used the gas on April 22, they had experienced considerable trouble in combining gas attacks with advances; if the wind was blowing the wrong way or changed, troops advanced into their own gas clouds.

62. Nothing seems to have come of Beckmann's plan to paint another mural.

63. François Haby had been court hairdresser to Kaiser Wilhelm II since 1892 and worked in a Berlin salon designed by Henry van de Velde in 1901; his stores were at Mittelstraße 7–8 and Unter den Linden 60. According to Henry van de Velde, *Geschichte meines Lebens* (Munich: Piper, 1962), p. 170, Haby designed the kaiser's famous mustache with the two ends going up at right angles, and this became known as the Haby mustache.

64. The Germans began heavy bombardment of the Ypres-Menin Road and Ypres salient on May 11 and May 13.

65. Beckmann is still speaking about the success of the Gorlice-Tarnow offensive in western Galicia. Revised reports of the huge numbers of Russians taken prisoner came in throughout June.

66. Albert Weißgerber, a Munich artist associated with the journal *Jugend* and the Munich Neue Künstlervereinigung and Secession, whose works had also been collected by the Simms family. He was killed in Fromelles, France, on May 10, 1915, about twelve miles south of Ypres.

67. Rösler and Beckmann corresponded throughout the first eighteen months of the war, during which Rösler often fought on the front and was awarded the Iron Service Cross. During the spring and summer of 1915 they met on several occasions in Brussels, where Rösler was stationed with the occupation government. In 1916 Rösler was transferred to East Prussia because of his nervous and physical state; on December 14, 1916, he committed suicide on his family's property there. According to Dietrich Schubert (personal interview, 1994), this was apparently because of an extramarital affair.

68. Although still a part of the Ottoman Empire, Egypt had been under British control since 1882. After Turkey entered the war at the end of October 1914, Egypt was made into a British protectorate.

69. In August 1906.

70. This suggests that Beckmann was again at Sanctuary Wood.

71. The Flemish painter Jakob Jordaens (1593–1678).

72. The Battle of Bellewaarde Ridge, about two and a half miles east of Ypres and one and a half miles north of Hill 60, was fought on May 24 and 25.

73. Pentecost is a major spring holiday in Europe.

74. The formal end of the Second Battle of Ypres was May 25.

75. Beckmann is speaking of the antithetical twins—Walt (for Gottwalt) and Vult (for "Quod deus vult" [Whatever God wants], a phrase uttered by their father when the unexpected twin appeared)—in Jean Paul's unfinished novel, *Die Flegeljahre* (The fledgling years, 1804–5).

76. Perhaps at Hooge-Bellewaarde Ridge.

77. This would be the *Kriegslieder des 15. Korps.*

78. The Germans shelled Ypres again on June 3.

79. Jean Paul's novel, *Titan* (1800–1803).

This translation by Barbara Copeland Buenger is based on page 3 of the catalogue. The original manuscript has not been found.

1. Beckmann to the Mannheim Kunsthalle, September 19, 1915, *Briefe*, 1:145.

2. In 1968 Erich Heckel told von Wiese that "the doctor in charge [of Beckmann's unit] was transferred to Frankfurt and arranged that Beckmann come there with him" (von Wiese, *Max Beckmanns zeichnerisches Werk*, p. 172 n. 126).

3. Upon his arrival in Frankfurt, Beckmann moved into the home of good friends from his Weimar days, Ugi and Fridel Battenberg, at Schweizerstraße 3, and Ugi gave up his studio to provide Beckmann with a place to work.

4. See I. B. Neumann, "Sorrow and Champagne," in "Confessions of an Art Dealer," unpublished transcript, 1958. The original is in the possession of Peter Neumann, Stanford, CA, who has kindly given permission to quote from his father's memoirs. H. 39, 52, and 53, all of 1912, seem to have been the earliest prints published by Neumann.

5. A few months after this exhibition Beckmann wrote Piper, who had also become a major supporter by collecting and distributing his prints, that Neumann was finally making his way out of the "narrow-mindedness" of expressionism, even though—as Beckmann acknowledged—Neumann was currently showing an exhibition of Erich Heckel (Beckmann to Reinhard Piper, February 8, 1918, *Briefe*, 1:164–65). Beckmann and Neumann were particularly close, and their surviving correspondence (comprising mostly Beckmann's letters) and Neumann's memoirs are some of the most important sources of documentation we have for Beckmann in this period. In addition to the letters published in the three volumes of *Briefe*, see the two important volumes of documentation, *Max Beckmann: Frankfurt, 1915–1933* (Frankfurt: Städel, 1983–84); Klaus Gallwitz, ed., *Max Beckmann in Frankfurt* (Frankfurt: Insel, 1984).

6. Paul Westheim, "Von den inneren Gesichten," *Das Kunstblatt* 1 (January 1917): 1–6.

7. Beckmann to Reinhard Piper, [April 1917], *Briefe*, 1:160.

8. See Karoline Hille, *Spuren der Moderne: Die Mannheimer Kunsthalle von 1918 bis 1933* (Berlin: Akademie Verlag, 1994), pp. 231–36.

9. Gustav Hartlaub, "Die Kunst und die neue Gnosis," *Das Kunstblatt* 1 (May 1917): 166–79.

10. See Gustav Friedrich Hartlaub, *Kunst und Religion: Ein Versuch über die Möglichkeit neuer religiöser Kunst* (Leipzig: Kurt Wolff, 1919), pp. 82–86. Hartlaub was the first to note the gnostic character of Beckmann's new religious imagery.

11. See Magdalena Bushart, *Der Geist der Gotik und die expressionistische Kunst* (Munich: Silke Schreiber, 1990), pp. 93–134.

12. Beckmann to Caesar Kunwald, September 9, 1906, *Briefe*, 1:44.

13. The Master of the Tegernsee *Tabula Magna* was active in the first half of the fifteenth century and produced the work for which he was named

in 1445–46. He was previously thought to have been Gabriel Mäleßkircher and continued to be so named in a standard popular study Beckmann owned, Curt Glaser, *Zwei Jahrhunderte deutscher Malerei* (Munich: Bruckmann, 1916).

"CREATIVE CREDO"

This essay originally appeared in Kasimir Edschmid, ed., *Schöpferische Konfession,* vol. 13, *Tribune der Kunst und Zeit* (Berlin: Erich Reiß, 1920), pp. 61–67. This translation is taken from Miesel, *Voices of German Expressionism,* pp. 107–9, with a few slight changes. The original manuscript has not been found. The September 1918 date is assumed both because of the dates other authors are known to have submitted manuscripts and because of Beckmann's reference to the war's still being in progress.

1. Kasimir Edschmid, *Die Fürstin, mit sechs Radierungen von Max Beckmann* (Weimar: Gustav Kiepenheuer, 1918) (H. 111–16).

2. Although the translation "creative confession" might be more appropriate, a credo or creed—an affirmative statement of faith—is also considered a confession of faith. Other contributors included the artists Conrad Felixmüller (1897–1977), Rudolf Großmann, Bernhard Hoetger (1874–1940), Adolf Hölzel (1853–1934), Paul Klee (1879–1940), Franz Marc, Max Pechstein, and Edwin Scharff (1877–1955); the composer and artist Arnold Schönberg (1874–1951); and the writers Johannes Becher (1891–1958), Gottfried Benn (1886–1956), Theodor Däubler (1876–1934), Georg Kaiser (1878–1945), René Schickele (1883–1940), Carl Sternheim (1878–1942), Ernst Toller (1893–1939), and Fritz von Unruh (1885–1970). For further discussion of this volume see Buenger, "Max Beckmann's 'Ideologues.'"

3. On Beckmann, Edschmid, and their relation to contemporary politics, see Buenger, "Max Beckmann's 'Ideologues.'"

4. Kolb, a French-German writer from Munich, devoted her lifetime to French-German conciliation. During the war she was closely associated with *Die weißen Blätter* and René Schickele in Switzerland. Beckmann got to know her after the war through his second wife, Mathilde Beckmann, and met her on several occasions in the 1920s.

The elder brother of Thomas Mann, Heinrich Mann had played a central role as a spokesman of conscience and as an advocate for German writers and intellectuals' greater participation in politics since well before the war. He hated the war and associated with pacifist circles in Switzerland and Munich throughout its duration.

An Alsatian writer of French-German heritage, Schickele was the liberal editor of *Die weißen Blätter* and led it to adopt a pacifist stance after it was forced to move to Switzerland in 1915.

Sternheim, the German playwright who authored a series of savagely critical plays about the German bourgeoisie, had allied himself with pacifist circles during the war. Resident in Belgium from 1916 to 1918, Sternheim modeled his outrageous expressionist novella *Ulrike* (1917) on the wartime relationship of Beckmann's friend the Countess vom Hagen with the German art historian and writer Carl Einstein (1885–1940).

5. A complete listing of the series titles is found in Paul Raabe, *Die Zeitschriften und Sammlungen des literarischen Expressionismus* (Stuttgart: J. B. Metzler, 1964), pp. 185–86.

6. Edschmid, editorial statement in *Schöpferische Konfession*.

7. The selections by Marc were from letters written at the front before his death in 1916; the selections by Toller were from letters written during his wartime and postwar imprisonments.

8. Paul Klee, for instance, wrote of having just completed a first version of his essay in a letter of September 19: see Christian Geelhaar, *Paul Klee: Schriften: Rezensionen und Aufsätze* (Cologne: DuMont, 1976), p. 171 n. 1.

9. See Beckmann and Schaffer, *Bibliothek*, pp. 91–97.

10. Kasimir Edschmid, *Tagebuch, 1958–1960* (Vienna: Kurt Desch, 1960), p. 92; idem, "Beckmann," typescript of paper delivered to the Max Beckmann Gesellschaft, Munich, revised October 23, 1969, pp. 13–14.

11. See Iain Boyd Whyte, *Bruno Taut and the Architecture of Activism* (Cambridge: Cambridge University Press, 1982), p. 7; Manfred Schlösser, *Bruno Taut, 1880–1938* (Berlin: Akademie der Künste, 1980), pp. 152–53.

12. Miesel eliminated the reference to Orion in his translation, reading the passage as "fallen from a star." Beckmann, who had a good general familiarity with both mythology and astronomy, most likely knew that the constellation of Orion is seen to form the figure of a warrior or hunter.

13. In this passage Beckmann might have been responding to some of the modern movements—such as the Garden City movement—that urged a return to the country. Though similar sentiments had led him, Minna Beckmann, and their neighbors, the Landauers, to live in the forested suburb of Hermsdorf, they rejected the more radical solution of the Garden City, which called for working together on shared land.

14. This is also a variation of Miesel's translation, which reads "Communism."

15. A reprint of this text—with the word *communistic* changed to *communal*—was published in *Der Kreis: Zeitschrift für künstlerische Kultur* 10 (February 1933): 80–82, on the occasion of Beckmann's 1933 exhibition at the Hamburg Kunstverein. Whether Beckmann, one of his supporters, the Kunstverein, or the magazine decided to reissue this statement is unknown. Richard Tüngel (1893–1970), an acquaintance from Berlin who frequently met with Beckmann and the young Hanns Swarzenski (1903–85), gave the opening speech, also published in *Der Kreis* 10 (March 1933): 148–52.

The Hamburg Kunstverein opened the show in its gallery at Neue Rabenstraße 25 on February 5, 1933. The Kunstverein's director, Hildebrand Gurlitt (1895–1956), who had been fired from his directorship of the Zwickau Museum by Nazis in 1930, had initially planned this exhibition for May 1932 but was forced to delay it. As fate would have it, the exhibition finally opened just six days after Hitler became chancellor.

Der Kreis, a distinguished Hamburg journal dealing with theater and the other arts known far beyond Hamburg, had published articles of many different political views, including those of a German populist tendency, but in 1933 was abruptly forced to conform with National Socialist standards.

Like most cultural journals, *Der Kreis* ceased publication almost immediately thereafter, with the May 1933 issue. (See Roland Jaeger, *"Der Kreis": Zeitschrift für künstlerische Kultur: Hamburg, 1924–1933* [Hamburg: Staatsarchiv Hamburg, 1984], pp. 3–14.)

The essay read the same as the 1918 version of "Creative Credo" except for a sentence in the penultimate paragraph: "Perhaps with the decline of business, perhaps (something I hardly dare hope) with the development of the communal principle, the love of objects for their own sake will become stronger. I believe this is the only possibility open to us for achieving a great universal style."

TEXT FOR *HELL* PORTFOLIO

This translation by Barbara Copeland Buenger is based on the text initially reproduced below Beckmann's self-portrait on the cover of his *Hell* portfolio, published by the C. Naumann Printing Company for I. B. Neumann (Berlin, November 1919). The portfolio (H. 139–49) was published in an edition of seventy-five, twenty-five sets of which were sold as single prints. The portfolio was simultaneously reproduced in smaller format in an inexpensive photolithographic edition of one thousand. On the portfolio and its history see Buenger, "Max Beckmann's 'Ideologues.'"

1. See Buenger, "Max Beckmann's 'Ideologues.'" The expressionist poet and critic Herrmann-Neiße had opposed the war from its outset and supported the Communists in 1919.

2. Wedekind often used similar characters, but Beckmann's inscription directly recalls the prologue of the animal trainer who introduced *Erdgeist* (Earth spirit, 1895), the first of the two Lulu tragedies.

CONTRIBUTION TO "ON THE VALUE OF CRITICISM: AN INQUIRY OF ARTISTS"

This translation by Barbara Copeland Buenger is based on the response first published in *Der Ararat* 2 (April 1921): 132. The original manuscript has not been found.

1. On Goltz and his attitude toward the revolutionary developments, see Joan Weinstein, *The End of Expressionism* (Chicago: University of Chicago Press, 1990); O. K. Werckmeister, *The Making of Paul Klee's Career, 1914–1920* (Chicago: University of Chicago Press), 1989.

2. See Werckmeister, *Making of Paul Klee's Career*, pp. 232–36.

3. The contemporary artists asked included Beckmann, Fritz Behn (1878–1970), Georg Ehrlich (1897–1966), Hermann Geibel (1889–1972), Otto Gleichmann (1887–1963), Rolf Hoerschelmann (1885–1947), Alexander Kanoldt (1881–1939), Paul Klee, Alfred Kubin (1877–1959), Max Pechstein, Karl Schmidt-Rottluff, and Georg Tappert.

4. "Über, für, und wider die Kritik," *Der Ararat* 2 (April 1921): 125–32.

5. Goltz had asked: "Do you recognize the competence of the lay critic at all? Which critics do you value more: lay critics or artist critics? Does the critic have influence on the public? Do you believe that criticism has an educational impact? Are you indebted to criticism for providing valuable illu-

mination about yourself? Which critics have said correct things about your work?" (*Der Ararat* 2 [April 1921]: 130).

EBBI: A COMEDY

Ebbi was first published in a limited-subscription deluxe edition of thirty-three for the Gesellschaft der 33, with Beckmann's six drypoint illustrations for the play (H. 306–8) (*Ebbi: Komödie von Max Beckmann* [Vienna: Johannes Presse, 1924]). This translation by Reinhold Heller is based on a facsimile of that edition (Frankfurt: Ullstein, 1973) and on a copy of the original typescript in the Beckmann Archives.

1. Beckmann, "Ein Brief," in *Almanach 1904–1924*, p. 84. A translation of that letter is included in this collection.

2. Stephan Lackner, "Max Beckmann als Dichter" (1975), in Siegfried Gohr, ed., *Max Beckmann* (Cologne: Josef-Haubrich-Kunsthalle, 1984), p. 135.

3. Dagmar Grimm is preparing a dissertation on *The Ladies' Man* at the University of California at Los Angeles. Since Beckmann spoke of three plays (two of which were still being typed) in his letters to Piper in the spring of 1923, *The Ladies' Man* might well have been one of them, even if it was not yet finished. In any case, the play was written no later than the summer of 1924. In a 1925 letter to his fiancée, Mathilde von Kaulbach, Beckmann said he wrote the play in the summer of 1924 (May 23, 1925, *Briefe*, 1:271). Beckmann's entry in Piper's album of July 2, 1924, which quoted from the third act of *The Ladies' Man*, firmly establishes that date as a *terminus ante quem* for the play: see Piper, *Mein Leben als Verleger: Nachmittag* (Munich: Piper, 1964), p. 339.

4. Peter Beckmann dated the plays "around 1920" but gave no reasons for this dating; Gerd Udo Feller, who edited and performed *Ebbi* and *The Hotel* in 1984, concluded 1923–24. Full accounts and analyses of the plays are found in Thomas Schober, *Das Theater der Maler: Studien zur Theatermoderne anhand dramatischer Werke von Kokoschka, Kandinsky, Barlach, Beckmann, Schwitters, und Schlemmer* (Stuttgart: M and P, 1994).

5. Curt Glaser et al., *Max Beckmann* (Munich: Piper, 1924). Glaser, an eminent art historian and critic, was one of Berlin's most important writers on modern art in that period. Fraenger, a young art historian at the beginning of his career, wrote widely on modern art and the theater. The socialist critic Hausenstein had been a champion of expressionism, cubism, and futurism before the war but drastically changed his attitude toward the new art during the war and revolutionary period. A resident of Munich, Hausenstein became an ardent admirer of Beckmann in the postwar period and frequently wrote on him for the *Frankfurter Zeitung*.

6. Meier-Graefe's *Heinrich der Beglücker* (1917), which deals with a wealthy factory owner, was premiered by the Frankfurt Städtische Bühne on November 27, 1918.

7. See Beckmann to Reinhard Piper, April 8, 1923; n.d.; April 21, 1923; July 12, 1923, in *Briefe*, 1:235, 236, 240.

8. Beckmann to Otto Nirenstein, April 23, 1924, *Briefe*, 1:248. On the

publication see also James Hofmaier, *Max Beckmann: Catalogue Raisonné of His Prints* (Bern: Gallery Kornfeld, 1990), 2:750–57. Beckmann regularly traveled to Vienna in the early 1920s and made many personal and professional contacts through his friends Käthe Rapoport von Porada (1891–1983), Lilly Mallinkcrodt von Schnitzler (1893–1983), and Irma Simon and through his Frankfurt dealer Peter Zingler (1892–1978). Beckmann seems to have first met Nirenstein in Frankfurt. In 1938, after he had emigrated to the United States, Nirenstein reclaimed his family name of Kallir to become known as Otto Kallir, the founder of the Galerie St. Etienne in New York.

9. Beckmann to Reinhard Piper, February 8, 1918, *Briefe*, 1:164–65.

10. On Simon, the *Frankfurter Zeitung*, and the newspaper's cultural tastes, see Schivelbusch, *Intellektuellendämmerung*, pp. 42–61.

11. As noted in Schober, *Das Theater der Maler*, p. 256 n. 5, at that time Simon was also writing plays (under the pseudonym of Heinrich Anton) that were performed in Frankfurt and Darmstadt.

12. Beckmann to Julius Meier-Graefe, August 7, 1918, *Briefe*, 1:173.

13. At this time Beckmann also observed that his own star was rising as Kokoschka's seemed to fall (Schober, *Das Theater der Maler*, p. 240–41); see Beckmann to Reinhard Piper, November 4, 1924, *Briefe*, 1:260.

14. Beckmann and Schaffer, *Bibliothek*, p. 503, indicate that Beckmann's library contained five volumes by Wedekind, all published by 1912: *Feuerwerk* (Firework), *Erdgeist* (Earth spirit), *Die Büchse der Pandora* (Pandora's box), *Frühlings Erwachen* (Spring's awakening), and *Der Marquis von Keith* (The marquis of Keith). Aside from prewar encounters with Wedekind and his plays in Berlin, Beckmann could also have seen productions of Wedekind's plays at the Städtische Bühne in Frankfurt, including *Der Marquis von Keith* (opening November 5, 1918) and *König Nicolo* (opening February 4, 1920).

15. Between 1917 and 1923 the Städtische Bühne presented five Sternheim plays.

16. Both Kokoschka's *Sphinx und Strohmann: Ein Curiosum* (Sphinx and strawman: a curiosity, 1913) and its successor *Hiob: Ein Drama* (Job, 1917) included a Mr. Rubberman. Beckmann could have known of this character both through the performance of *Hiob* directed by Heinrich George in Frankfurt in 1920 and through Kokoschka's illustrations for *Sphinx und Strohmann*, which were published by Paul Cassirer in 1917. The postwar dadas had also been attracted to the rubber man: the Zurich dadas performed the second, revised version of Kokoschka's *Sphinx und Strohmann* in 1917; the same year George Grosz contributed an anonymous article to *Neue Jugend* titled "Mann muss Kautschuk-Mann sein!"

17. In this, Beckmann might even have been recalling his own parents' frequent changes of residence in Leipzig. In Frankfurt, for instance, the Ostpark adjoined factories and the railroad tracks and was depicted in Beckmann's *Landscape with Lake and Poplars* (1924, G. 232).

18. Johanna Löffel also recalls and parodies the strong-woman type made popular in late-nineteenth-century plays, such as Anna Mahr in Gerhart Hauptmann's *Einsame Menschen* (1891).

19. As Schober, *Das Theater der Maler*, p. 252, notes, Nipsel is also an anagram for *Pinsel*, or brush, the tool used by the painter.

20. Beckmann diary entry, August 14, 1903.

21. *Ebbi: Komödie von Max Beckmann*, introduction by Gerd Udo Feller (Gerlingen: Theater der Veröffentlichung, 1984).

22. "Komm in meine Liebeslaube" was a popular hit and is frequently included on German nostalgia records.

23. Tegel was the major Berlin prison, just south of Beckmann's home in Hermsdorf.

24. As Schofer, *Das Theater der Maler*, p. 260 notes, Kasimir Edschmid had used a similar title for a publication of short stories in 1915, *Das rasende Leben* (Raging life).

25. Beckmann used the German phrase *Danaergeschenk*, which means a Greek or treacherous and unwelcome gift, such as the Trojan horse.

26. Augustus Straße in Berlin is in the central (Mitte) area, northwest of Alexanderplatz; it was one of the oldest streets in one of Berlin's poorest districts.

27. Nipsel, speaking in the Berlin dialect, quotes the Lutheran hymn "Jesu, geh voran auf der Lebensbahn, und wir wollen nicht verweilen, dir getreulich nachzueilen; führ uns an der Hand bis ins Vaterland" ("Jesus, Lead Thou on, till Our Rest Is Won"). The hymn was written by Nikolaus Ludwig von Zinzendorf in 1725.

28. The text and music of "Johnny, wenn Du Geburtstag hast" were written by Friedrich Holländer (1896–1976); the song was first performed in 1920 in the Berlin cabaret *Grössenwahn* (Megalomania) by Blandine Ebinger. Although the song describes Johnny, it says much more about the unbridled sexual appetites of the female singer. The song became famous only after Marlene Dietrich recorded it with Peter Kreuder and his jazz band in 1931. It has been sung and recorded in different versions; in one Johnny is depicted as a black man, and in the other no references are made to his color.

29. In 1920 the former states of Saxe-Weimar-Eisenach, Saxe-Coburg-Gotha, Saxe-Meiningen, Saxe-Altenburg, Schwarzburg-Rudolstadt, Schwarzburg-Sondershausen, Reuss jüngere Linie, and Reuss ältere Linie were united in the Free State of Thüringen. In using this imagery Beckmann might have wanted to refer to the Weimar Republic or to the period at large. The address he cited—14 Erfurt Street—was close to the Deutsches Nationaltheater, the famed theater of Goethe and Schiller where the Weimar Constitutional Assembly met in 1919.

30. In this Beckmann is mocking not only Nietzsche and the "O Mensch" pathos of the expressionists, but also his own statement about wanting to get close to humanity in the cities in "Creative Credo."

THE HOTEL: DRAMA IN FOUR ACTS

This translation by Reinhold Heller is based on a copy of the original typescript in the Beckmann Archives and on a published edition, Max Beckmann, *Das Hotel: Drama in vier Akten,* ed. Gerd Udo Feller (Gerlingen: Theater der Veröffentlichung, 1984).

1. Beckmann's first-hand experience of Switzerland at this point was limited. His only recorded visit was his 1912 stay in the resort city of Davos to paint the portrait of Karl Frederic Simms.

2. Although some have identified the man who is being hung in *Night* as Beckmann, he might also have depicted himself as the largely obscured figure of the hangman, in the purple pants and white shoes of an acrobat at the left side.

3. Schober (*Das Theater der Maler*, p. 237) discusses some similarities and differences of Beckmann's and Brecht's plays. Brecht's *Baal* (written 1918, published 1922) was first performed in Leipzig and Berlin (1923); *Trommeln in der Nacht* (1918−20, published 1923) was first performed in Frankfurt on April 23, 1923.

4. The Rigi is the most famous mountain viewpoint in Switzerland, rising above Lake Lucerne, Lake Zug, and Lake Lauerz. This would place the action of the play somewhere between Lucerne and Zurich, although Zwerch later says he is the director of the three largest hotels in Geneva.

5. The American sociologist and nutritionist Horace Fletcher (1849−1919) was an advocate of thorough mastication of food. His ideas became so popular that "fletcherize" became part of the American language; as Beckmann's mention indicates, Fletcherism also caught on in Europe. Fletcher's works include *Fletcherism: What It Is; or, How I Became Young at Sixty* (2d ed., 1913) and *The New Glutton or Epicure* (1903).

6. "Salome: Oriental Song and Foxtrot, Op. 355" was written by Robert Stolz (1880−1975) to a text by Arthur Rebner on December 25, 1919 (Vienna: Boheme Verlag, 1920).

7. These words are not from "Salome," which Elly sang previously.

8. In 1921 Beckmann had made an etching of lions copulating in the Frankfurt zoo (H. 184).

9. Friedhelm Fischer (*Max Beckmann: Symbol und Weltbild: Grundriß zu einer Deutung des Gesamtwerkes* [Munich: Fink, 1972], pp. 17−21), the first scholar to designate Beckmann's outlook as gnostic, noted the three passages of *The Hotel* in which Zwerch imprecated God as a silly monster as further evidence of Beckmann's interest in Gnosis. As Fischer and subsequent scholars have suggested, Zwerch's coupling of God, Jehovah, and Moloch recalls gnostic blame of the cruel Demiurge, who was not God but the chief of the lowest order of spirits or aeons. The Demiurge interacted with man and was responsible for both creation and the presence of evil in the world. The Gnostics also identified the Demiurge with the Jehovah of the Hebrews, who was often used to take the brunt of resentment. Moloch was the cruel Canaanite and/or Assyrian god of fire to whom children were offered in sacrifice, a ritual denounced by Hebrew law.

LETTER FOR THE PIPER *ALMANACH*

This letter was first published in *Almanach 1904–1924*, pp. 79–86. This translation by Reinhold Heller and the annotations are based on that and the version published in *Briefe*, 1:469–70. The original manuscript is in the Piper Archives.

1. 1913, H. 40–48, in *Kunst und Künstler* 11 (March 1913): 289–98.

2. 1913, H. 55.

3. Many of Piper's letters are published in Reinhard Piper, *Briefwechsel mit Autoren und Künstlern, 1903–1953*, ed. Ulrike Buergel-Goodwin and Wolfram Göbel (Munich: Piper, 1979), pp. 158–74, 494–98.

4. According to Beckmann and Schaffer, *Bibliothek*, p. 486, Beckmann's library had a copy of one of Grabbe's best-known comedies, *Scherz, Satire, Ironie, und tiefere Bedeutung* (Jest, satire, irony, and deeper meaning, 1822), a work of sharp satire and grotesquerie that mocked many of Grabbe's romantic contemporaries. Grabbe was largely forgotten until the late nineteenth century, and this play was first performed only in 1907. From that time on, it attracted much interest in modernist circles.

5. *Before the Masked Ball* (1922, G. 216) and *Self-Portrait in front of a Red Curtain* (1923, G. 218).

6. Reinhard Piper to Beckmann, March 6, 1923, typewritten transcript in the Beckmann Archives.

7. On the cover Piper used a lithographic self-portrait Beckmann had produced in 1912, H. 49.

8. Reinhard Piper in *Almanach 1904–1924*, pp. 7–8. Among many other items, the volume also contained submissions requested from René Beeh (1886–1922), Moeller van den Bruck, Max Dvorak (1874–1921), Oskar Hagen (1888–1957), Wilhelm Hausenstein, Alfred Kubin, Julius Meier-Graefe, Hans Naumann (1886–1956), Heinrich Wölfflin (1864–1945), and Wilhelm Worringer. Beckmann, Beeh, and Kubin were the only artists asked to write specifically for this volume.

9. According to Pillep, "Die Leipziger Jahre Max Beckmanns," p. 119, Beckmann was born in a house at Bahnhofstraße 7 in Leipzig. As Pillep notes, pp. 126–27, "Schwannsee" is now known as the Swan Pond, which extended between the opera house and the main train station and was surrounded by green areas.

10. The family did not return to Braunschweig until 1895, when Beckmann was eleven years old, just before his father's death.

11. Leipzig was located at the intersection of several main trade routes and known for centuries as a trade city. The Brühl, just west of where Beckmann was born, was the center for the fur trade.

12. New housing regulations to accommodate the vast increase in Frankfurt's population in 1919 had forced the Battenbergs to move to a new home at Schöne Aussicht 9. After living several months at the home of Heinrich Simon, Beckmann moved into the studio at Schweizer Straße 3 that Ugi Battenberg had given him.

13. Dr. Eugen Weidner (1861–1926) ran a sanatorium in the Königspark in Dresden-Loschwitz that Beckmann, Meier-Graefe, and many of their friends visited. Beckmann did a lithograph of Weidner (1921, H. 181).

14. Beckmann lived with his sister and her first husband in Falkenburg, Pomerania, for only three years.

15. Beckmann-Tube was engaged by the Graz opera in 1918.

16. Beckmann first exhibited G. 31 (1905) and G. 53 (1906).

17. The Free Secession would be dissolved at the height of the hyperinflation of spring/summer 1923.

18. Beckmann executed eight sculptures, but only much later.

19. In Weimar Beckmann had studied in Smith's life class, although Smith might well have had him study from the antique as well. Beckmann took the antique class of Otto Rasch (1862–1932).

20. According to Beckmann-Tube, "Erinnerungen an Max Beckmann," p. 165, this was a painting of a horseback rider.

21. As noted previously, there were no Augustinian monasteries in Courtrai: Beckmann was first in the cloister of the Picpussen or Holy Hearts and then in the Passionistencloster.

22. Beckmann did a drawing of Dr. Spinola (1915, W. 243).

23. As noted earlier, Beckmann owned the complete five-volume German edition of Poe, translated by Hedda Moeller-Bruck and Hedwig Lachmann Landauer.

24. Beckmann seems to refer to his continued effort to establish his independence from Cassirer by relying on the support of I. B. Neumann, Piper, and his own sales. In 1923, however, Neumann suddenly left Berlin for New York, and Beckmann returned to Cassirer; Beckmann and Cassirer signed a contract for a Berlin show that would open in January 1924, shortly after the appearance of the Piper monograph, and for subsequent work and exhibitions.

AUTOBIOGRAPHY

This text originally appeared in an untitled book printed privately in sixty copies for R. Piper und Co. on the occasion of the twentieth anniversary of the publishing house: *Dem Verlag R. Piper und Co. zum 19. Mai 1924* [Magdeburg: A. Wohlfeld, 1924], pp. 10–11. This translation by Peter Wortsman was first published in Hans Belting, *Max Beckmann: Tradition as a Problem in Modern Art* (New York: Timken, 1989), p. 111. The original is in the Piper Archives in Munich.

1. The two seem to have corresponded little in the months preceding this statement. Beckmann had written Piper a single long letter after the close of the Cassirer show, in which he noted that not enough copies of the Piper monograph were available for critics who wanted to review it (February 23, 1924, *Briefe*, 1:246–47). Beckmann had been exasperated in December when Piper inexplicably withdrew his own paintings from the Cassirer show; Beckmann begged him to reconsider, and the works were ultimately included.

2. See Piper, *Briefwechsel mit Autoren und Künstlern 1903–1953*, pp. 24–25, 174 (Beckmann to Piper, May 1924).

3. Beckmann's reference suggests he had been reading Hörbiger's and Fauth's *Glacial-Kosmogonie* (The glacial cosmogony) (Kaiserslautern: Hermann Kaysers Verlag, 1912). See Michael J. Neufeld, "Hörbigerism," *Science* 262 (December 24, 1993): 1069–2070; Robert Bowen, *Universal Ice: Science and Ideology in the Nazi State* (London: Belhaven, 1992).

In the summer of 1995, Stephan Lackner confirmed Beckmann's interest in such theories.

4. Pelikan was the German ink and oil-paint manufacturer located in Hannover.

5. Much recent criticism, especially Meier-Graefe's essay in the Piper monograph, had celebrated Beckmann as a Berliner and expressed surprise that he lived in Frankfurt am Main, even to the point of wondering what effect Frankfurt could have on him. See Meier-Graefe in Glaser et al., *Max Beckmann*, pp. 27–34.

6. Though Beckmann and Beckmann-Tube had lived separately since 1915, he had regularly visited her in Graz since 1918 and frequently traveled with her before they were finally divorced in 1925. The two continued to meet—both openly and secretly—throughout the 1920s and 1930s. They remained on amicable terms throughout their lives.

7. Beckmann would resume travel to Italy only the following summer, in July 1924, when he, Minna Beckmann-Tube, and Peter vacationed in Pirano (Piran) near Trieste.

8. Hörbiger's study presented a theory of the creation of meteors.

"THE SOCIAL STANCE OF THE ARTIST BY THE BLACK TIGHTROPE WALKER"

This text was first published by Peter Beckmann in *Sonderdruck für die Teilnehmer des Pirckheimer-Jahrestreffens vom 25. bis 27. Mai 1984 in Cottbus*, ed. Hans Marquardt (Leipzig: Philip Reclam Jr., 1984), pp. 6–7. Peter Wortsman's translation was first published in Belting, *Max Beckmann*, pp. 115–16. The present edition is based on those publications. Beckmann's handwritten corrections on the typescript copy belonging to the late Peter Beckmann are noted in *Briefe*, 2:325–26.

1. Beckmann to Karl Anton von Rohan, January 1, 1927, *Briefe*, 2:76–79.

2. Fritz Wichert (1878–1951), the former director of the Mannheim Kunsthalle, had been called to Frankfurt to organize and lead the new school. On the school's history and Beckmann's teaching, see Eduard Beaucamp, "Die Frankfurter Kunstschule in den zwanziger Jahren," and Günther Vogt, "Ein hervorragender Anreger junger Talente," in *Städelschule Frankfurt am Main* (Frankfurt: Waldemar Kramer, 1982), pp. 63–81, 96–101.

3. Beckmann to Mathilde von Kaulbach, probably June 10, 1925, *Briefe*, 1:295. According to Peter Hayes, *Industry and Ideology: I. G. Farben in the Nazi Era* (Cambridge: Cambridge University Press, 1987), p. 55 n. 89, Lilly von Schnitzler and Rohan openly carried on an affair until Rohan was married in June 1933. In his letter to his fiancée, Beckmann described Rohan as Lilly's "prince, who outwardly, in any case, looked more like a clerk."

4. Beckmann to Mathilde von Kaulbach, June 11, 1925, *Briefe*, 2:297.

5. For a short time the journal was supported with funds from the I. G. Farbenindustrie.

6. Although *Europäische Revue* continued to appear throughout the Third Reich, Rohan was replaced as editor around 1935.

7. On Rohan and the many European movements of his day, see Paul Michael Lützeler, *Die Schriftsteller und Europa: Von der Romantik bis zur Gegenwart* (Munich: Piper, 1992), pp. 312–64; Carl H. Pegg, *Evolution of the European Idea, 1914–1932* (Chapel Hill and London: University of North Carolina Press, 1983).

8. Rohan described the groups' programs and differences in "Der Horizont," *Europäische Revue* 1 (October 1925): 61–70.

9. Binding, a writer who lived in Frankfurt, was well-known to Beckmann through Heinrich Simon's Friday luncheons. A photograph of the delegates to the meeting appears in Sigrid Bauschinger, ed., *Ich habe etwas zu sagen: Annette Kolb, 1870–1967* (Munich: Diedrichs, 1993), p. 143.

10. Beckmann to Mathilde Beckmann, October 19, 1926, *Briefe*, 2: 73–74.

11. Beckmann to Günther Franke, [October 1926], *Briefe*, 2:73. I. B. Neumann was still Beckmann's chief dealer, but had taken up residence in New York and left Franke in charge of his Munich concerns and Karl Nierendorf (1901–92) in charge of his Berlin office. In the summer of 1924, after Paul Cassirer and Beckmann had signed their contract, Neumann had returned to give Beckmann a new contract that would take effect in 1925. At this time Beckmann was unhappy with both Nierendorf and Franke, and he was delighted to find a strong new Berlin dealer in Alfred Flechtheim (1878–1937), who took over several of Cassirer's former artists after Cassirer's suicide in 1926.

12. See Beckmann and Schaffer, *Bibliothek*, pp. 45–49.

13. Friedrich Wilhelm Nietzsche, *Thus Spoke Zarathustra*, trans. R. J. Hollingdale (Harmondsworth: Penguin, 1971), pp. 39–53, "Zarathustra's Prologue."

14. Through this period Beckmann's critical fortunes had been mixed; the many postwar political polarizations also had a marked effect upon Beckmann criticism. Though Beckmann had won major support in Meier-Graefe, Hausenstein, Piper, and the *Frankfurter Zeitung*, he remained disappointed and angry that he had still not scored a major success in Berlin. Ludwig Justi (1876–1957), the director of the Berlin Nationalgalerie, was much more interested in abstraction and long avoided acquiring Beckmann's works for his museum. A turning point came in 1927, when a group of Meier-Graefe's friends gave Beckmann's *Bark* (1926, G. 253) to the Nationalgalerie to commemorate the critic's sixtieth birthday; the following year the museum acquired Beckmann's *Self-Portrait in Tuxedo* (1927, G. 274). See Eugen Blume, "Ludwig Justi und die klassische Moderne im Museum der Gegenwart am Beispiel der Sammlung der Zeichnungen in der Nationalgalerie zu Berlin zwischen 1919 und 1933," Ph.D. dissertation, Humboldt University, Berlin, 1994.

15. As Beckmann's correspondence reveals, Mathilde Beckmann was influential in establishing and maintaining important contacts for him.

"THE ARTIST IN THE STATE"

This essay was first published in Max Beckmann, "Der Künstler im Staat," *Europäische Revue* 3 (July 1927): 288–91; the translation by Peter Wortsman was first published in Belting, *Max Beckmann*, pp. 112–15. The following text was based on those versions. The late Peter Beckmann had a typescript copy of the original manuscript.

1. Among several shorter pieces the other major essays in this issue included Carl J. Burckhardt (1891–1974), "Der Wasserfall"; Willy Hellpach

(1877–1955), "Deutsche Konkordate und römische Europapolitik"; Marcel Jouhandeau (1888–1979), "Die unheilige Pieta"; Johannes Linneborn (1867–1933), "Das Konkordat: Ein Bekenntnis zum Frieden"; Ivan Luppol (1896–1940), "Das philosophische Denken in der Sowjet-Union"; José Ortega y Gasset (1883–1955), "Bemerkungen zu einer Charakterologie"; and Peter Reinhold (1887–1955), "Deutsche Finanz- und Wirtschaftspolitik."

2. Summaries of the conference proceedings are found in the Morgenblätter of the *Neue freie Presse* (Vienna), October 19, 1926, p. 7; October 20, 1926, p. 8; October 21, 1926, p. 8; and in Max Clauß, "Die dritte Jahresversammlung des Verbandes für kulturelle Zusammenarbeit in Wien vom 18. bis 20. Oktober," *Europäische Revue* 2 (December 1, 1926): 196–200.

3. Alfred Weber was less well known than his older brother, the sociologist Max Weber, but was renowned and esteemed as a national economist who taught in Heidelberg from 1907 to 1933 and frequently worked with his brother. After World War I he helped found the left-liberal German Democratic Party. Weber found the war a European, and not just a German, crisis and thereafter devoted himself chiefly to dealing with the new economic and social forms Europe could adopt. He regularly attended Rohan's meetings, gave a major address at the 1926 Vienna meeting, and was a frequent contributor to the *Europäische Revue.*

4. Weber's address was published as "Der Deutsche im geistigen Europa," *Europäische Revue* 2 (February 1, 1927): 276–84; his comments on Nietzsche were on p. 284.

5. Karl Anton von Rohan, "Europas Verantwortung," *Europäische Revue* 2 (January 1, 1927): 205–8.

6. Rohan in editorial note to "Der Künstler im Staat," p. 288.

7. Among the many antecedents of this idealism is Schiller's *Über die ästhetischen Erziehung des Menschen in einer Reihe von Briefen* (Letters on the aesthetic education of man, 1795).

8. Richard Wilhelm, "Der Priester in Europa," *Europäische Revue* 3 (April 1927): 28–39. Beckmann had been introduced to Wilhelm on the same occasion when he first met Rohan at the Schnitzlers' and is said to have interacted with him on several occasions thereafter (Beckmann to Mathilde von Kaulbach, probably June 10, 1925, *Briefe*, 1:296).

9. Beckmann specifically recalled this passage of "The Artist in the State" in an annotation of July 10, 1939, to a passage in volume 1 of Helena Petrovna Blavatsky's *Secret Doctrine.* In that passage, a Vedantic Brahman says, "I am myself 'God'"; Beckmann wrote, "Said by me in Frankfurt a. Main 1921—written circa 26–27. Probably a 'sorry God'" (noted in Beckmann and Schaffer, *Bibliothek*, p. 184).

10. It is difficult to determine exactly when Beckmann began his readings in theosophy. The volumes noted in Beckmann and Schaffer, *Bibliothek*, pp. 108–328, 469, indicate he owned German editions of Blavatsky's *Nightmare Tales* (1925), *Secret Doctrine* (a one-volume edition of 1932 and a three-volume edition of 1920–21 purchased in 1933), and *Isis Unveiled* (1922). His annotations indicate that he read most substantially in them beginning in the Nazi period in the mid- and late 1930s.

11. The tense mood in that painting might also reflect the stormy international crisis that broke the same month of Beckmann's opening. This was the revelation of the secret German-Austrian trade agreement in mid-March 1931, an action that Rohan had long championed and continued to defend in the following months.

12. Rohan's editorial disclaimer appeared at the bottom of the first page of the essay (p. 288). This and the annotation that indicated that the essay was part of a series called "Die Europäer" were not included in the Wortsman translation in Belting. The German reads: "Wir sind stolz darauf, dieses erschütternde Bekenntnis des großen Künstlers zu veröffentlichen, trotzdem wir uns gewissen extremen metaphysischen Folgerungen, losgelöst von ihrer tief menschlichen Bedeutung keineswegs anzuschließen vermögen."

STATEMENT IN THE CATALOGUE OF THE MANNHEIM KUNSTHALLE RETROSPECTIVE

This translation by Reinhold Heller is based on *Max Beckmann: Das gesammelte Werk* (Mannheim: Städtische Kunsthalle, 1928), pp. 3−4. The statement was originally published without a title and was identified only by Beckmann's name at the end. It was subsequently published under the title "Sechs Sentenzen zur Bildgestaltung" (Six sentences on the construction of a painting), but that was not Beckmann's title. A typescript copy of the manuscript, which Beckmann originally submitted with a letter, is in the archives of the Mannheim Kunsthalle. Both are reprinted in Beckmann to Gustav Hartlaub, February 7, 1928, *Briefe*, 2:106−8.

1. In the letter sent with his text Beckmann asked that Hartlaub contribute to the catalogue, which Hartlaub did: see *Max Beckmann: Das gesammelte Werke*, pp. 5−8. See Hille, *Spuren der Moderne*, pp. 221−73. For Beckmann's correspondence with Hartlaub see *Briefe*, 2:90, 103−9.

2. On the exhibition and the events that preceded it see Hille, *Spuren der Moderne*, pp. 276−309.

3. See Hans-Jürgen Buderer, *Entartete Kunst: Beschlagnahmeaktionen in der Städtischen Kunsthalle Mannheim 1937: Kunst und Dokumentation 10* (Mannheim: Städtische Kunsthalle, 1987−90).

4. See Norbert Miller, ed., *Gustav Friedrich Hartlaub: Kunst und Magie* (Hamburg and Zurich: Luchterhand, 1991).

5. Hille, *Spuren der Moderne*, pp. 236−39, 240−41, 251−55. Wichert acquired both *Christ and the Woman Taken in Adultery* and *Portrait of an Old Woman (Frau Tube)* (1919, G. 201) in 1919.

6. Ibid., pp. 256−58.

7. On the show and Beckmann's position in it see ibid., pp. 84−155, 259−61; Helen Adkins, "Neue Sachlichkeit: Deutsche Malerei seit dem Expressionismus, Mannheim 1925," in Berlinische Galerie, *Stationen der Moderne* (Berlin: Berlinische Galerie, 1989), pp. 216−35.

8. Nathan Olivera (b. 1928), for instance, noted that at least in California in 1950 "Beckmann didn't articulate visual relationships or criticism" (see his "Afterword" in Peter Selz, *Max Beckmann: The Self-Portraits* [New York: Gagosian Gallery, 1992], pp. 108−9). In addition to Olivera's, the best accounts of Beckmann's teaching are found in Marie Louise von Motesiczky, "Max Beckmann als Lehrer" (1963), unpublished manuscript in Beckmann

Archives; Dorothy Seckler's interview, "Can Painting Be Taught?" included in this volume; Vogt, "Ein hervorragender Anreger," pp. 96–101.

9. As critics began to attack modern art and artists in Frankfurt in the later 1920s, they noted Beckmann's prolonged absences from Frankfurt. When the Nazis fired Beckmann from his position on March 31, 1933, his teaching record was still a bone of contention. See Fritz Wichert to Beckmann, March 9, 1933, copy in Mathilde Beckmann estate.

10. Wassily Kandinsky, *Punkt und Linie zur Flache* (Dessau: Bauhaus, 1926); Paul Klee, "Wege des Naturstudiums," in *Staatliche Bauhaus Weimar, 1919–1923* (Weimar-Munich: Bauhausverlag, 1923); idem, "Schöpferische Konfession," in Edschmid, *Schöpferische Konfession*, pp. 28–40.

11. On this exhibition see Hille, *Spuren der Moderne*, 158–219.

12. Beckmann would have gained an acquaintance with the Pythagoreans not only through his readings in Kant and Schopenhauer but also in his more extensive reading in philosophy in the 1920s, perhaps guided by Paul Deussen's *Allgemeine Geschichte der Philosophie* (Leipzig: F. A. Brockhaus, 1920–23) and by readings in theosophy.

13. See Buenger, *Max Beckmann's Artistic Sources*, pp. 182–223.

14. In this and in his many other assertions on art's needs to be of its time and to express a sentiment or temperament, Beckmann echoes Émile Zola's definition of a "work of art as a corner of the universe seen through a temperament" (see Émile Zola, "The Realists in the Salon, May 11, 1866," quoted in Elizabeth Gilmore Holt, *From the Classicists to the Impressionists* [New York: Anchor, 1966], p. 388).

ANSWER TO *FRANKFURTER ZEITUNG* QUESTIONNAIRE ABOUT POLITICS

This translation by Barbara Copeland Buenger is based on the version in "'Nun sag,' wie hast Du's mit der'—Politik?" *Frankfurter Zeitung* 73 (December 25, 1928): 2–4. Beckmann's original manuscript has not been found.

1. Simon first published an article on Beckmann in *Das Kunstblatt* 3 (September 1919): 257–64; his monograph, *Max Beckmann*, was published in the series *Die junge Kunst* (Weimar: Kiepenheuer, 1929).

2. On various intellectual positions in the Weimar Republic, see Dagmar Barnouw, *Weimar Intellectuals and the Threat of Modernity* (Bloomington and Indianapolis: Indiana University Press, 1988). On Beckmann's reaction to the wartime and postwar politicization of the intellectuals, see Buenger, "Max Beckmann's 'Ideologues.'"

3. The title question comes from the scene in Martha's garden in *Faust*, act 1, where Gretchen asks Faust what he thinks about religion: "Nun sag, wie hast du's mit der Religion? / Du bist ein herzlich guter Mann, / Allein ich glaub, du hältst nicht viel davon" (lines 3415–17). The "Gretchen-Frage" is often raised in situations asking fundamental questions about beliefs or values.

4. The respondents included the industrialist Ernst von Borsig (1869–1933); the general secretary of the German Reich committee for physical exercises, Karl Diem (1882–1962); the natural historian Fritz Drevermann (1875–1932); the writer Annette Kolb; the Austrian pianist and composer

394 Notes to Pages 298 – 300

Arthur Schnabel (1882–1951); the director of the Senckenberg pathological institute, Bernhard Fischer-Wasels (1877–1941); the poet Hans Johst (1890–1978); the architect Erich Mendelssohn (1887–1953); the art historian Wilhelm Pinder (1878–1947); the merchant Alfred Leonard Tietz; and the editor of the journal *Soziale Praxis* (Social practice), Frieda Wunderlich (1884–1965).

"ON MY PAINTING"

This text is based on the English translation by Mathilde Q. Beckmann, first published by Robert Herbert in *Modern Artists on Art* (Englewood Cliffs, NJ: Prentice Hall, 1964), pp. 131–37. A typescript of the original German text is in the library of the Museum of Modern Art, New York.

1. The fullest accounts of the exhibition and its background are found in Cordula Frowein, "Ausstellungsaktivitäten der Exilkünstler," in *Kunst im Exil in Großbritannien, 1933–1945* (Berlin: Fröhlich and Kaufmann, 1986), pp. 35–38; Stephan Lackner and Helen Adkins, "Exhibition of 20th Century German Art, London, 1938," in Berlinische Galerie, *Stationen der Moderne*, pp. 314–37; and Keith Holz, *Modern German Art and Its Public in Prague, Paris, and London, 1933–1940* (Ann Arbor: University of Michigan, 1992), pp. 208–41.

2. Beckmann to Mathilde Beckmann, August 19, 1936, *Briefe,* 2:263–66, 453.

3. Stephan Lackner, *Max Beckmann: Memories of a Friendship* (Coral Gables: University of Miami Press, 1969), p. 11.

4. A copy of the moving invoice and a letter from Buchholz to Beckmann (August 10, 1937) are among the Beckmann notebooks in the National Gallery of Art, Washington, DC.

5. Lackner, *Memories of a Friendship*, pp. 28–41, 66–75, 101–6.

6. In his move, Westheim lost most of his property and his substantial art collection.

7. *Freie deutsche Kunst* (Maison de la Culture, Paris, November 4–18, 1938). On this exhibition and its origins in response to the London show, see Frowein, "Ausstellungsaktivitäten der Exilkünstler," pp. 35–37; Inka Graeve, "Freie Deutsche Kunst," in Berlinische Galerie, *Stationen der Moderne*, pp. 339–49; Holz, *Modern German Art*, pp. 180–241, 275–93; Hélène Roussel, "Die emigrierten deutschen Künstler in Frankreich und der Freie Künstlerbund," in *Exilforschung: Ein internationales Jahrbuch* (Munich: Text + Kritik, 1983), pp. 173–211.

8. Beckmann to Günther Franke, February 3, 1934, and [end of October 1935], *Briefe,* 2:240, 253.

9. In 1935 Beckmann painted portraits of Rudolf Binding (1935, G. 425) and Heinrich George and his family (1935, G. 416). Binding, who had frequently joined Beckmann at Simon's Friday tables and was a fellow member of the German delegation to Rohan's Verband für kulturelle Zusammenarbeit in Vienna in 1926, did not become a party member but strongly sympathized with the cause, which he celebrated as a sign of the rebirth of the nation in his *Antwort eines Deutschen an die Welt* (1933). Beckmann seems to refer to that position by portraying Binding in an inspired pose with a

raised arm and a text. George, whom Beckmann knew in Frankfurt and continued to befriend at least through the late 1930s, became a party member in 1933 and president of the Reich Chamber for Theater in 1935.

10. This letter was quoted in Lackner, *Memories of a Friendship*, p. 38. The full letter is published in the German edition, *Ich erinnere mich gut an Max Beckmann* (Mainz: Florian Kupferberg, 1967), pp. 36–37.

11. The London planners finally dropped the names of all Jews and eminent émigrés from the list of the show's sponsors and organizers.

12. Following the lead of Fischer, *Max Beckmann*, Margot Orthwein Clark (*Max Beckmann: Sources of Imagery in the Hermetic Tradition* [Ann Arbor, MI: University Microfilms, 1975], pp. 158–323) made extensive inquiries into Beckmann's knowledge of the kabbalah. The volumes noted in Beckmann and Schaffer, *Bibliothek*, include no specific books on the kabbalah, and it seems likely that Beckmann learned most about it from his readings in and about philosophy, religion, and cosmogonies, especially in Blavatsky's *Secret Doctrine* and *Isis Unveiled*.

13. At the time the Beckmanns lived at Rokin 85, a tobacco processor still had an office on the ground floor; earlier, the entire building had been used as a tobacco storehouse.

14. Beckmann's mention of Oannes Dagon suggests that he had been reading about the kabbalah, Oannes Dagon, and the last days of drowned continents in Blavatsky, who repeatedly explored those subjects, as well as in other sources. The god Oannes or Dagon (to whom Blavatsky often refers by both names) was part man, part fish; in the Bible and in Babylonian culture, Dagon was one of several gods of fertility. According to many different accounts, the god brought culture and civilization to the Babylonians at a time they were still acting like animals.

As is indicated in Beckmann and Schaffer, *Bibliothek*, Beckmann owned many other books that also covered these subjects, including Alexander Bessmertny, *Das Atlantisrätsel* (1932); Ignatius Donnelly, *Atlantis: Die vorsintflutliche Welt* (1911); Fritz Drevermann, *Meere der Urzeit* (1932); and Hermann Klaatsch, *Der Werdegang der Menschheit und die Entstehung der Kultur* (1920).

15. Just as in his art, his plays, and his other writings, Beckmann repeatedly mixed diverse images in this talk. He might have been reminded of Samothrace by his recent visits to Paris, where he would have seen the great Hellenistic Nike of Samothrace (ca. 200 B.C.) in the Louvre, but he probably had also recently read of the Samothrace mysteries in Blavatsky. The mountainous island of Samothrace, which had little political importance in antiquity, was known chiefly for its cult of the Cabeiri, gods of fertility.

Beckmann would have known much about Piccadilly and Wall Street, both crowded centers of business and personal interaction that typified the dangers and racy attractions of the metropolis, from his earlier visit to London and his general knowledge of popular culture. He might also have known that one of the most famous markers amid the frenzy of Piccadilly Circus was a statue renowned as a statue of Eros, but actually the *Angel of Charity* (1892–93) by Sir Alfred Gilbert (1854–1934).

16. Blavatsky discussed many different cultures' concepts of the duality

of God or gods and dualism in life and religious feeling. The spring before he delivered this talk, on April 17 (Easter), 1938, Beckmann had annotated a section of Blavatsky's *Secret Doctrine* on dualities of light and dark and good and evil with comments on the Nazis and black and white. The *Anschluß* of Austria had occurred a month before, on March 13.

See Beckmann and Schaffer, *Bibliothek*, p. 194.

17. Beckmann's mention of both Ur of the Chaldees and Tell Halaf reflects the substantial contemporary interest in ancient Near Eastern cultures. Sir Charles Leonard Wooley (1880–1960) had begun publishing his findings on Ur, the biblical "Ur of the Chaldees," in the 1920s. As noted in Beckmann and Schaffer, *Bibliothek*, pp. 472, 505, Beckmann owned a 1938 German edition of Edward Chiera's *They Wrote on Clay*, a study of ancient Sumerian civilizations, and a 1930 German edition of Woolley's *Ur and the Flood*.

Tell Halaf or Guzana, far to the northwest of Ur, directly below the current border of Turkey and Syria, is an archaeological site of ancient Mesopotamia on the headwaters of the Khabur river near the modern city of Ra's al-'Ayn, Syria. The excavation was undertaken between 1899 and 1927 by the German archaeologist Baron Max Adrian Simon von Oppenheim (1860–1946). Oppenheim, who published an account of the excavation in 1931, exhibited and reconstructed the vast store of the findings in the Tell Halaf Museum in Berlin, a former railroad barn in an industrial area of Lützow, just north of Charlottenburg, at Franklinstraße 6; most of its sculpture and records were destroyed in an air raid of 1943. See Dale M. Brown and the editors of Time-Life Books, *Sumer: Cities of Eden* (Alexandria, VA: Time-Life Books, 1993); Jeanny Vorys Canby, "Guzana (Tell Halaf)," in *Ebla to Damascus: Art and Archaeology of Ancient Syria* (Washington, DC: Smithsonian Institution, 1985), pp. 332–338; Max von Oppenheim, *Tell Halaf: A New Culture in Oldest Mesopotamia*, trans. Gerald Wheeler (London: G. P. Putnam's Sons, [1933]).

Crete, known as the center of the Minoan culture that flourished ca. 1600 B.C., had also been the subject of recent publications and excavations by both Germans and British, including Heinrich Schliemann (1822–90) and Sir Arthur Evans (1851–1941).

18. Little more than a week before Beckmann gave his talk, from July 10 to 13, 1938, Howard Hughes and his crew members completed a record-breaking flight around the world in 91 hours, 14 minutes, and 10 seconds in a modified Lockheed Super Electra. See David Baker, *Flight and Flying: A Chronology* (New York: Facts on File, 1994), p. 232.

In the 1930s Lise Meitner (1878–1968), Otto Hahn (1879–1968), Fritz Strassmann (b. 1902), Otto Frisch (1904–79), and many other colleagues—including Enrico Fermi of Rome, who won the Nobel Prize for physics on November 10, 1938, as he was preparing to leave Italy for exile in New York—studied the bombardment of elements by neutrons. The press thus carried many stories about splitting the atom before the first public announcement of nuclear fission in January 1939. Although Beckmann would not have known it, Meitner, a Jew, had fled Nazi Germany for Amsterdam just days before his talk.

19. The preceding two and a half paragraphs are a slightly changed version of sections 1 and 2 of Beckmann's 1928 Mannheim essay.

20. As suggested by Holz, *Modern German Art,* pp. 234–35, Beckmann probably associated collectivism with the policies of both Nazi Germany and the Soviet Union. But he might also have been inspired by talk of collectivism and the collective unconscious in Carl Jung's *Die Beziehungen zwischen dem Ich und dem Unbewußten* (The relations between the ego and the unconscious, 1928), which he owned in an original German edition: see Beckmann and Schaffer, *Bibliothek,* pp. 355–56. Jung observed that "the greatest danger of all is the premature dissolution of prestige by an invasion of the collective psyche. Absolute secrecy is one of the best known primitive means of exorcising this danger. Collective thinking and feeling and collective effort are far less of a strain than individual functioning and effort; hence there is always a great temptation to allow collective functioning to take the place of individual differentiation of the personality" (*The Portable Jung,* trans. R. F. C. Hull, ed. Joseph Campbell [New York: Viking, 1971], p. 98).

21. These two paragraphs are a slightly varied version of sections 4 and 5 of Beckmann's 1928 Mannheim essay.

22. David Hume, the Scottish philosopher, historian, economist, and essayist known especially for his metaphysical skepticism and empiricism, denied the possibility of verifying the truth of human knowledge, which he said consisted only of impressions and ideas, or of knowing the self, which he saw as only a succession of impressions and ideas. He saw philosophy as the inductive science of human nature and concluded that man is more a creature of sensitivity and practical sentiment than of reason. His writings, including *A Treatise of Human Nature* (1739), *An Enquiry concerning Human Understanding* (1748), *A Dissertation on the Passions* (1751), and *An Enquiry concerning the Principles of Morals* (1751), were extremely influential on Kant and German idealism, and Beckmann could have read about him in Kant, Schopenhauer, Deussen, and Blavatsky if he had not read Hume's own writings. (No volumes of Hume were in his library.)

Herbert Spencer, the English socialist and philosopher whose first writings on evolution predated Charles Darwin's, was chiefly concerned with the individual and with an ethics based on social relationships. Spencer's theory of social evolution advocated the preeminence of the individual over society and of science over religion, but he also believed that individualism would prevail only after an era of socialism and war. For Spencer evolution was a process of natural changes governed by law and manifesting a mystic force— the Unknowable—beyond human comprehension. Beckmann's final library contained no volumes by Spencer, but he could have read about Spencer in many different sources.

23. This paragraph is a slightly varied version of section 6 of Beckmann's 1928 Mannheim essay.

24. The speech and its imagery come not from *Temptation* but from the end of Beckmann's play of 1923–24, *The Ladies' Man.* The protagonist, the world traveler Maxim von Plessart, and his companion Dr. Leo Ralf, are the only survivors of a shipwreck en route to Australia. They have landed on

a beach where cannibals indicate that one is to stay and become their god—thereby gaining access to all the women he wants—and one is to embark toward the unknown in a canoe. Maxim, previously a notorious womanizer, makes this speech, drinks three cups of palm wine, and goes into the unknown to find the gods, "my friends since the beginning of the world." From Dagmar Grimm's copy of the unpublished, uncompleted manuscript.

25. This turn of phrase points to Beckmann's familiarity with the Pythagoreans and their numerical theories and cosmogonies, which were felt to reflect the harmony or music of the spheres and included a belief in a central star or sun. Blavatsky spoke extensively of the Pythagoreans and the central suns of many different cosmogonies in both *The Secret Doctrine* and *Isis Unveiled*. As noted in Beckmann and Schaffer, *Bibliothek*, Beckmann also owned several books that dealt with Pythagoras and the Pythagoreans, including Egmont Colerus, *Pythagoras* (1936 German edition); Deussen, *Allgemeine Geschichte der Philosophie*, 2:1; and Wilhelm Nestle, *Die Vorsokratiker* (1929).

Beckmann's constellation is especially rich and problematic. In trying to "escape from the square on the hypotenuse" the figure from Beckmann's *Temptation* defies or breaks the accepted law of the Pythagorean theorem (the square on the hypotenuse equals the sum of the squares on the other two sides) to make a new constellation. In this, Beckmann suggests, the arts and the imagination break the normal laws of the world.

His allusion to the Hebrides Islands off the west coast of Scotland, a location made famous by Felix Mendelssohn's *Fingal's Cave* or *Hebrides Overture* (1830–32) and by Sir Walter Scott, evokes a wild and fabled terrain of the ancient Celts.

Whereas Beckmann could have read of the central sun of many different cosmogonies—including the Pythagoreans'—in Blavatsky, he could have read of red giants only in contemporary writings on astronomy. As noted in Beckmann and Schaffer, *Bibliothek*, p. 487, he owned at least two books by the British astronomer Sir James Jeans (1887–1946), published in 1938 or earlier.

Red giants are one phase in the evolution of stars, a phenomenon recognized and identified only in the early twentieth century, particularly in the work of Ejnar Hertzsprung (1873–1967) and Henry Norris Russell (1877–1957). The term *red giant* was in common use by 1938 even though the astrophysics of the red giants was not yet fully studied.

26. With "Homer in the porter's lodge" Beckmann recalls Henri Rousseau's calling as a customs man as he expresses his admiration for Rousseau's poetic art. Rousseau had been a favorite of Beckmann's for a long time, especially as he abandoned his classical baroque figural rhetoric for a more simply volumetric style during and after World War I: see Buenger, *Max Beckmann's Artistic Sources*, pp. 158–65; Carolyn Lanchner and William Rubin, *Henri Rousseau* (New York: Museum of Modern Art, 1984), pp. 35–89. As noted in Beckmann and Schaffer, *Bibliothek*, Beckmann owned Wilhelm von Uhde's *Henri Rousseau* (1914).

27. The English poet and artist William Blake was another figure Beck-

mann would have honored as a "primitive." Blake would have appealed to Beckmann with his interests in theosophy and in the German mystic Jakob Böhme; his ability to deal with the world in a period of turmoil; his warm voice of assurance; and his images, spiritual visions, and prophecies that would have been most suggestive to Beckmann as he formed his own increasingly hermetic language in the 1930s. As noted in Beckmann and Schaffer, *Bibliothek*, pp. 469, 489, Beckmann owned at least two volumes on Blake, the catalogue of an exhibition held in Paris in 1937 that he would not have seen, *Aquarelles de Turner: Oeuvres de Blake* (Bibliothèque Nationale, Paris, January 15–February 15, 1937) and a volume by Adolf Knoblauch (1924).

28. Though Beckmann admired Blake and his imaginative world, the words and content of this passage seem to be Beckmann's alone. The Blake concordance and indices indicate no similar dwelling on the object or on objectivity, the pursuit of which had been Beckmann's central philosophical, spiritual, and artistic concern for years.

SPEECH GIVEN TO HIS FIRST CLASS IN THE UNITED STATES

This text is taken from a transcript of the original text translated by Mathilde Beckmann in the Beckmann Archives, Munich. The lecture was also read in the City Art Museum, St. Louis, on October 28, 1947.

1. Noted in Max Beckmann, *Tagebücher, 1940–1950*, collected by Mathilde Q. Beckmann, ed. Erhard Göpel (Munich: Albert Langen–Georg Müller, 1955), pp. 162–63, where Beckmann exclaimed that the war had lasted one and a quarter years longer for him than for others.

2. *Max Beckmann 1948* (City Art Museum, St. Louis, May 10–June 28, 1948). The show was subsequently exhibited in Baltimore, Cambridge, Detroit, Los Angeles, San Francisco, Minneapolis, and Boulder.

3. The fullest accounts of Beckmann's years in America are found in Walter Barker, "Max Beckmann in America," in Gohr, *Max Beckmann*, pp. 111–31; Mathilde Q. Beckmann, *Mein Leben mit Max Beckmann* (Munich: Piper, 1985); Beckmann, *Tagebücher, 1940–1950*; and Lackner, *Memories of a Friendship*, pp. 106–26.

Part of the St. Louis retrospective of Beckmann was shown in Boulder: *Max Beckmann 1948* (University of Colorado Museum, Boulder, June 28–August, 31, 1949). Mills College mounted a new exhibition of Beckmann arranged by Valentin and Alfred Neumeyer (1900–1973), the director of the art gallery and a professor of art history. The show consisted largely of works from the collections of Stephan Lackner and his father, Sigmund Morgenroth (1874–1964), who had since moved to Santa Barbara, and of prints and drawings lent by Valentin (*Max Beckmann: An Exhibition* [Mills College Art Gallery, Oakland, July 12–August 13, 1950]).

4. Olivera, "Afterword," pp. 105–6, stressed the great importance of seeing the European expressionists Beckmann, Munch, and Kokoschka in quick succession in San Francisco's M. H. de Young Museum just prior to studying with Beckmann himself.

5. Beckmann described the event and his first impression of the class in *Tagebücher, 1940–1950*, p. 211.

"LETTERS TO A WOMAN PAINTER"
The text was written on the invitation to speak at Stephens College on February 3, 1948. It was translated by Mathilde Beckmann and Perry Rathbone and read by her in Columbia, MO, on February 3, 1948, and subsequently at several other colleges and art schools. The first English version of the letters was published in *College Art Journal* 9 (autumn 1949): 39–43. This text is based on that version. Peter Beckmann received a copy of the "Letters" soon after Beckmann delivered them and quickly sought to get them published in Germany. They were published in part in *Die Neue Zeitung* in Munich on June 17, 1948.

1. Information from the Boone County Historial Society, Columbia, MO, which houses the Montminy Gallery, where many of the works of Pierre and Tracy Montminy may be seen.

2. *Tagebücher, 1940–1950*, pp. 227, 228, 230, 231, 234, 235–36.

3. Primarily a college town, Columbia was the home of Stephens, the University of Missouri, and Christian College.

4. *Tagebücher, 1940–1950*, p. 235.

5. Beckmann returned to arguments about the poverty of modern art and experience that he had long made. What he did not note here—as he did repeatedly in his diaries—was that automobiles, photographs, and movies were all things that fascinated him. Indeed, Beckmann often used photographs as a point of departure for his paintings.

6. From the time of his earliest notes on Schopenhauer and Kant and in his notes on Buddha and various philosophies, Beckmann had always renounced philosophies of asceticism.

7. Beckmann's first published mention of Camille Pissarro, with whose works he would have been familiar. Beckmann would also have known many examples of Piero della Francesca (1416–92) and Andrea di Cione, known as Orcagna (ca. 1308–ca. 1368), through studies, travel, and museums.

8. Beckmann and Schaffer, *Bibliothek*, p. 490, indicate that Beckmann owned at least one book on Lao-tse. Lao-tse's chief teachings hold that the world is effortlessly governed by Tao (the path or method), the source of all life and the basic unity of all the contradictions and distinctions of existence.

SPEECH FOR FRIENDS AND FACULTY DURING COMMENCEMENT WEEK ACTIVITIES
The text was first read by Mathilde Beckmann in the Women's Building of Washington University, St. Louis, on June 5, 1950. This version is based on the English translation by Jane Sabersky (1911?–83). A typescript copy of the manuscript is in the University Archives and Research Collection, Washington University Libraries, St. Louis.

This text has traditionally been listed in the Beckmann literature as "Speech for the Friends and the Philosophy Faculty of Washington University," a title that presumably comes from the Beckmanns. Beckmann did not specifically address an official organization of friends or the philosophy faculty of Washington University; the talk was one of several lectures offered by recipients of honorary degrees during the university's commencement week (May 31–June 6, 1950). See Mathilde Q. Beckmann, in Erhard Göpel, ed., *In Memoriam Max Beckmann* (Frankfurt: K. G. Lohse, 1953), p. 57.

1. Kenneth E. Hudson to Beckmann, May 3, 1950, Washington University Archives. In the same letter Hudson also proposed a small exhibition of eight or ten Beckmann paintings in the Women's Building for the occasion, but the exhibition does not seem to have taken place.

2. Described in *Tagebücher, 1940–1950*, pp. 375–77.

3. The owner of the Famous Barr department-store chain, Morton May first met Beckmann only near the end of the latter's St. Louis stay, in March 1949; he had seen and bought his first Beckmann in the company of his brother-in-law, Maurice Freedman (1904–85) at a show at the Buchholz Gallery in May 1948. May then commissioned Beckmann to paint his portrait (1949, G. 785), and the two became good friends. May purchased some other works in Beckmann's lifetime and decided to form his large collection only some time after Beckmann's death.

4. Joseph Pulitzer, Jr., and his first wife Louise (1914–68) were close friends of the Beckmanns from the moment of their arrival in St. Louis and did much to assist them. Beckmann did an uncommissioned portrait of Louise Pulitzer (1949, G. 781), and she sat as model for three drawings related to the painting.

5. The citation read by Kenneth Hudson was: "I have the honor to present Max Beckmann, artist and teacher. Master of the art of painting, he has fought courageously and without compromise for the right of the artist to express his personal vision and to condemn all bigotry and despotism. Defamed by the Nazi dictators, he fled Germany to self-imposed exile in Amsterdam. Soon overtaken by the invasion, he precariously survived the occupation—all the while placing on canvas his denunciation of all that strives to destroy the dignity and humanity of man. His paintings, philosophical in concept, monumental in execution, rank among the major works of our century. Washington University is proud to have counted him among its faculty. I commend him to you for the degree of Doctor of Fine Arts" (press release in the Washington University Archives).

6. From *Washington University Student Life*, May 19, 1950, p. 3. Pandit was the sister of Prime Minister Nehru.

7. Beckmann arrived in St. Louis on June 3 on the Knickerbocker, a train of the New York Central line. Each Pullman car had its own name.

8. The American artist George Catlin (1796–1872) was renowned for his carefully descriptive depictions of landscapes of the American frontier and portraits of Native Americans. He is much better known for his portraits than for his landscapes, and in the 1940s few of his works were to be seen outside of Washington, DC. Beckmann would have had the opportunity to see at least sixteen of Catlin's landscapes, however, in a major exhibition, *Mississippi Panorama* (City Art Museum and Historical Society, St. Louis, 1949), shown when he lived in St. Louis, and he retained a copy of the show's catalogue in his library (Beckmann and Schaffer, *Bibliothek*, p. 493). Catlin was essentially self-taught, and Beckmann probably enjoyed the landscapes both for their striking colors and for their fresh, unacademic manner.

9. Forest Park, created for the Louisiana Purchase Exposition in 1904, contained the museum and the Jefferson Memorial and directly adjoined the grounds of Washington University. The Jefferson Memorial, at DeBaliviere

Avenue on Lindell Boulevard, is a classical two-story white limestone struc-
ture built on the site of the main entrance to the Louisiana Purchase Expo-
sition in 1904. Washington University's School of Fine Arts, as it was then
called, was located in Bixby Hall, where Beckmann also had his studio.

A coeducational school originally established as Eliot Seminary in 1853,
Washington University was renamed in 1857 and moved to its new cam-
pus—also on the grounds of the exposition—in 1905. The university's 169-
acre Hilltop Campus is located between Skinker Road and Big Bend Avenue,
north of Forsythe Boulevard, at Lindell Boulevard and Skinker Road.

Now called the St. Louis Art Museum, the City Art Museum on Art
Hill in Forest Park is partly housed in a pavilion originally designed by Cass
Gilbert (1859–1934) as the central art building of the exposition of 1904.

10. The Beckmanns left St. Louis on June 15, 1949, to spend the sum-
mer in Boulder, CO, and moved to New York on August 30, where they lived
in an apartment at 234 East 19th Street near Gramercy Park. On May 1,
1950, they moved to an apartment at 38 West 69th Street, directly adjoining
Central Park.

"CAN PAINTING BE TAUGHT? 1. BECKMANN'S ANSWER"

The text was first published in Dorothy Seckler, "Can Painting Be
Taught?" *Art News* 50 (March 1951): 39–40, the source of the following
version. The same article, pp. 40, 63–64, also contained the reply of the
German-American artist Hans Hofmann (1880–1966).

1. Noted in *Tagebücher, 1940–1950*, p. 374.

2. The series included interviews with Amédée Ozenfant (1886–1966),
Will Barnet (b. 1911), Beckmann, and Hofmann (*Art News* 49 [October
1950]: 44–45, 61; 49 [November 1950]: 44–45, 64; 50 [March 1951]: 39–40,
63–64).

3. Seckler regularly spent summers in Woodstock, Yaddo, Province-
town, and Europe. She received an award from the American Federation of
Arts for her writing on art and in 1985 received an artists' award from the
Adolf and Esther Gottlieb Foundation. This information on Dorothy Seckler
was provided by the Provincetown Art Association and Museum and Will
Barnet.

4. Dorothy Seckler, *Provincetown Painters, 1890s–1970s* (Syracuse:
Everson Museum of Art, 1977).

5. Mathilde Q. Beckmann, *Mein Leben mit Max Beckmann*, pp. 90–91.

INDEX